IMPRESSIONISM

IMPRESSIONISM

By the editors of Réalités

Preface by

René Huyghe

CHARTWELL BOOKS INC. CHARTWELL BOOKS INC.

This book was produced by the editors of Réalités under the direction of Jean Clay

Layout by Jean-Louis Germain

Published by Chartwell Books Inc.
A Division of Book Sales Inc.
Raritan Center Business Park
114 Northfield Avenue
Edison, NJ 08818
A Helvetica Press Production

Originally published in French under the title *L'Impressionnisme*, copyright © 1971

by Librairie Hachette et Société d'Etudes et de Publications Economiques

This edition © 1973 by Librairie Hachette et Société d'Etudes et

de Publications Economiques

Isbn 0-89009-657-0

Library of Congress Catalog Card Number: 72-80341

Printed in Italy

Contents

Preface by René Huyghe 6

Introduction 7

The Events, The Men 9

The Precursors 30

The Artist's Point of View Shifts 52

Objects and Environment Interpenetrate 88

Color Acquires Its Independence 145

The Work Is . . . a Section of Nature 186

The Painter Minimizes Perspective. . . 220

The Artist Solicits the Spectator's Optic Nerve . . . 270

Prices by François Duret-Robert 302

Index of Painters 312

List of Illustrations 314

Bibliography 318

Credits 319

Preface

The Impressionists attempted to introduce into painting independent appearance, free of cultural or intellectual—we would almost say mental—ties. Their will to submit themselves to physiological vision was for them a search for an uncompromising realism, which ironically was to lead beyond realistic painting. From pure look to pure painting was but a step which was soon taken by nonrepresentational art. On seeing Monet's "Haystacks" Kandinsky discovered abstraction. He merely had to adjust the objects depicted in a manner to sever their final moorings with identifiable reality.

The nineteenth-century academic painters conceived a composition as a theatrical scene or as a view from an open window, that is, the subject was depicted from a spatially removed viewpoint. Thanks to outline and modeling, bodies and objects were like actors positioned by a stage director. The supposed distance of the spectator, grouping these into a unified field, reduced them to a similar scale, aiding the viewer in his perception and understanding. Memory and habit had as much function as the eye.

Suddenly the Impressionists negated this corporeal separation of the elements. They scattered light in spots and contradicted the cerebral by the optic. It was not easy for them, however, to strip perception of what it knew in order to return it to innocent sensation. Modern psychology has proved this. Actually man is prepared for what he is going to see; he recognizes what he already knows and almost what he is seeking. His look is as crowded with all he has stored in his brain as with what he receives from the outer world.

At first the contemporaries of the Impressionists were confused by the artists' new vision, stripped as it was of illusion of form and outline, the usual references which enabled the spectator to define an object. They needed a generation or two to be educated to situate and define things largely by color. Once this had become habitual, the public ceased to be confused. In other words, the viewers had learned to associate color with the *idea* of the sight it recorded. From that moment, Impressionism was essentially a realistic mode of depiction. As a result, it was spoiled. No longer do we recognize it as the fresh and revolutionary force it was.

In this book we rediscover Impressionism. It restores to the style its original intent, which was to return to vision a kind of virginity, to make it a discovery rather than a recognition. It reveals the means whereby the new school severed the moorings which coupled nature and mental habits. It shows how familiar references were eliminated. This book enables the artists to be discovered anew as they were and as they are. It reveals how they tore away bands which gave painting the immobile form of a mummy. It restores to Impressionism the fresh impulses of its uncompromising life.

René Huyghe
of the Académie Française,
Professor of the College de France

Introduction

In 1872 Claude Monet painted from his window in Le Havre a view of the port in the mist. Exhibited at the gallery of the photographer Nadar two years later under the title "Impression, Sunrise," the picture aroused the irony of one Louis Leroy, a reporter for *Le Charivari*, who derided an "Impressionist school." The die was cast. This was the name henceforth given to the group of young painters who, headed by Monet, were about to upset four centuries of tradition.

"Critics have always made with pride the most painful confessions," wrote Félix Fénéon. As the years passed, Leroy prided himself greatly on having baptized the new school. Actually, when he first used the term, it had been around studios and brasseries for some fifteen years. At any moment, Baudelaire, Corot, Daubigny, Boudin, Jongkind, Manet, and their friends would mention *impression*. The name of a movement remained to be given. A century after Leroy, the name still holds—a century that has inspired a hundred histories of Impressionism.

The chronological and anecdotal unfolding of the out-of-door school and of the groups associated with these painters has already been explained in a masterly manner, rich in detail, in two works by John Rewald. We believed that for this volume a fresh approach was necessary. Availing ourselves of paintings, drawings, photographs, and other iconographic material—almost five hundred documents, almost all in color, the first time such a large number has been used in a book devoted to Impressionism—we have grouped this splendid material by aesthetic categories and in accordance with plastic problems. We based our reasoning on *form* and *space*, arranging the paintings according to the six major pictorial devices which characterize Impressionism. By a systematic distribution of paintings demonstrating these—the flattening of perspective, asymmetrical composition, and so forth—we have hoped to show the innovations of these painters, in a manner that before the spectator simply allows himself to be swept away by the beauty of the works, he might grasp their mechanisms.

This classification excludes both monographic chapters—centered on a single painter—and a too scholarly respect for chronology. It also dismisses the classic separation of Impressionism and Post-Impressionism, which is a largely arbitrary distinction. Although Monet and his friends were especially interested in rendering the fleeting, the instantaneous, the impression, other preferences, equally determining, were common to both generations. We shall not be surprised to find side by side a Vuillard and a Caillebotte, a Monet and a Gauguin. What may link two paintings, for example, is a distortion of

perspective or a new use of the close-up view. Finally, many of these works are logically included in several of our categories. A Van Gogh may be both off-center and violently colored, yet at the same time revealing Neo-Impressionist techniques. On each occasion, the painting has been classified according to its chief characteristics.

Painting is related to the psychology of the period which produced it. It reveals and expresses the relationship of a society to the world. During the time of the Impressionists, the function of painting was obscured by Academicism. In 1884—twenty-one years after Manet's "Olympia"—the subject imposed at the Ecole des Beaux-Arts for the Prix de Rome was formulated in the following terms. "After Lucretia has killed herself, Brutus draws out the dagger which she used and, holding it, swears to pursue Tarquinius and his race and no longer to endure kings in Rome. Near the dead woman will be represented Collatinus and her husband Luciolus, her father, and Valerius Publicola, all repeating Brutus' vow." This was the period of the academician Bouguereau—the "Raphael of the Bon Marché" (a popular department store)—and his associates. The vision of the world which they suggested had its coherence. Of the official style, we can repeat what Roland Barthes wrote of the use of the past tense in the novel: "It is the expression of an order and consequently of a euphoria." Nothing moves, the world is immutable and without contradictions. The mission of painting was to reassure the beholder and banish the tensions of reality.

Academicism scrupulously respected the old methods, chiefly balanced composition and perspective, by now four centuries old. Objects were centered, the painting was a closed entity within itself, each detail taking part in the arrangement of the work. Compact, solid, dense objects were separated one from another; there was no confusion of material. Nature was a catalogue of various substances and merchandise, an account of which was given by the painter, thanks to his unmysterious skill and practice. Light illuminated the object with no attempt either to dissolve it or to blend it with the others present. Color was an element of additional documentation on the identity of these objects. Once and for all leaves were green, apples red, and pitchers brown.

It was this static scheme, the reflection of a society which wished to be eternal, that the Impressionist painters were going to explode, sweeping away conceptions both of space and of matter totally unadapted to the scientific and technical evolution of the nineteenth century. This *dismantling* of the classic framework was hinged around six principal axes which correspond to the six chapters of this book.

1. Beginning with Degas, the artist's point of view shifts. He breaks up the visual field, questioning surrounding nature by means of strange angles, exaggerated perspective, and asymmetrical balance.

2. Objects and environment interpenetrate, dematerializing them. The disparate components of reality mingle in light. Texture and material lose their density. No longer are objects solid and compact.

3. Color acquires its independence. With Gauguin and Van Gogh, it has less and less a descriptive function and tends to become the chief subject of the painting. Henceforth what counts is the direct impact of chromatic radiation on the spectator, regardless of the representational anecdote.

4. The artist no longer seeks to *compose* his work. Instead of being an ensemble of forms balanced within the canvas, the painting becomes a section of nature which extends beyond the setting. The painter relentlessly turns his attention to a limited small part of the natural world and analyzes the laws of light, reflection, and shadow.

5. The painter minimizes perspective and brings space back to its two dimensions. Depth becomes indistinct and hazy. Landscape verticalizes itself. Painting relates itself to the picture plane.

6. The artist solicits the spectator's optic nerve. Playing with the reflexes of the retina, he imposes certain associations, certain clashes between colors. By the methodical organization of its effects, his work engages and disturbs our visual system.

These six analyses are preceded by a chapter providing insight into the relationships between artistic research and the sociopolitical conditions during the Second Empire and the Third Republic. We shall attempt to show how, from 1870 to the beginning of the twentieth century, painters, despite themselves, were led to form themselves as an *antisocial* group.

The captions accompanying the illustrations are composed with the intention of reflecting so far as possible a dual point of view. We shall find simultaneously the attitude of the period—statements by contemporaries, critics, friends—and that of the present day as fashioned by the various forms of twentieth-century art. Certainly a knowledge of the past helps for a better understanding of the meaning and origin of a movement, for example, the Barbizon School saw the introduction of Impressionism. But inversely, Picasso enlightens us on Cézanne, Matisse on Gauguin, Kandinsky on Monet. By exploring the language of their predecessors and pushing their analyses further, painters are in the last analysis the best critics.

Such is the principle underlying this book. The reader will find works dating from the twentieth century and often from recent years. It is Impressionism as it is seen today which we are illustrating, Impressionism turned toward us.

The Events, The Men

Why were the Impressionists hated, vilified, treated as "insane," "monkeys," "Communards"? Why this rage toward a small group of seemingly inoffensive painters? Let us look at their peaceful paintings, their delightful landscapes of the Ile-de-France, their smiling women. Where is the evil, the "moral fading" denounced by the academic painter Léon Gérôme or, as described by the critic Albert Wolff in *Le Figaro*, "The frightful sight of human vanity lost to the point of insanity"? A century after publication, the collection of texts written against the Impressionists remains an amazing subject. Not only are they reproached for being incapable persons and nonentities; they are also rotten, anarchists, accomplices of the current extremism. In 1865 Jules Claretie, referring to Manet, said, "Who is this yellow-bellied odalisque, disgraceful model found I know not where and who pretends to represent Olympia? Which Olympia? Doubtless a courtesan, Monsieur Manet will not be reproached for idealizing foolish virgins, he who makes dirty virgins." Eleven years later, referring to the second Impressionist exhibition, *Le Constitutionnel* wrote, "We insist on freeing ourselves completely from the responsibilities of these doctrines which we regard as especially dangerous and in the face of which we are firmly decided to remain constantly uncompromising." The same theme was taken up by *Le Moniteur*. "The uncompromising members of art are joining up with the uncompromising members of politics: this is quite natural." Fifteen years went by. In reference to the Caillebotte bequest of Impressionist paintings to the State, Léon Gérôme stated, "They are doing shitty painting, I am telling you. People are joking and saying, 'This is nothing. Wait. . . .' No. It is the end of the nation, the end of France." After the Dreyfus Affair, Richefort stated in 1903, "When we see nature as interpreted by Zola and his common painters, it is quite simple that patriotism and honor appear to you in the form of an officer handing over to the enemy the country's defense plans. The love of physical and moral ugliness is a passion like any other."

From where then did these "traitors" and outlaws come? From the rabble, from the dregs of the populace? Almost every one of them was from solid middle-class stock. The Manet and Degas families belonged to the financial aristocracy, Toulouse-Lautrec to the great nobility. Berthe Morisot's father was a magistrate, Cézanne's and Bazille's parents were people of distinction in the South of France, those of Monet,

Pissarro, Cross, Signac well-to-do merchants. Only Renoir was of modest origin. Trained early in life to earn a living, he was to get by better than the others.

Were they political agitators? Even less. In 1870 Monet and Pissarro fled to London. Cézanne hid away at L'Estaque. Although a member of the National Guard, Manet by no means forgot his paintbrushes. Writing to his wife, he stated, "My soldier's sack is provided with all I need to paint and I shall soon begin to make a few studies from nature." Berthe Morisot was to relate how "he spent his time during the siege changing uniforms." During the Commune, Sisley worked at Louveciennes, not far from Renoir, who was then living at his mother's. As for Degas, he was resting in the country at the estate of his friends the Valpinçons, wealthy collectors, who owned Ingres' "Turkish Bath." Manet was at Bordeaux, Berthe Morisot at St.-Germain with Puvis de Chavannes. Apart from two lithographs by Manet, nothing in their work reveals the great quarrel which steeped Paris in blood in 1871.

Far from spitting on the official institutions, the Impressionists suffered a thousand deaths for not belonging. It was for lack of something better that they became resentful loners, so to speak. Some did everything in their power to win over the official Salon jury. Renoir refused "to play the martyr." All things considered, they were all to exhibit at least once in what Cézanne was to call, not without envy, "Bouguereau's salon." Manet dreamed of being awarded the Legion of Honor, a wish which was to be granted. The Salon was the true wrestling ground. "This is where we must be measured," he explained. Refused in 1869, Monet wrote, "This fatal refusal almost takes away my daily bread, and although my prices are anything but high dealers and collectors turn their backs on me. It is especially painful to see the lack of interest in an art object which has no market." Official consecration was the sole means of earning a livelihood from one's art. Other than the urgency of material problems, the majority of the Impressionists were to continue hoping for recognition, even belated, from their academic fellow-painters. Raised in the myth of the institution, it was hard for them to tolerate such refusal. The public was nothing less than the well-to-do middle class into which they themselves were born and which now made fun of them.

Thus sick at heart—and not without a struggle—they decided to exhibit separately only to be amazed at the

scandal their works created. (With the exception of Pissarro, not a one was to take part in all the Impressionist exhibitions.) But how could they show their work? How could they make themselves known? Far from rejoicing in the noisy reputation they had created, they regretted it. In addition, they were models of virtue. Relentless workers, ascetics, setting up their easels in all weathers, painting fifteen hours a day, sacrificing family and comfort to their vocation, they possessed the qualities which had assured triumph in the small business milieu where most of them had first seen the light of day. They devoted to painting the same obstinate patience as, for example, Aristide Boucicaut (1810–77), the French merchant who together with his wife created the Bon Marché, a famous Paris department store frequented chiefly by women.

Nevertheless they possessed some particular quality that made them outcasts. What then made them so exasperating to their milieu and their society? For centuries, since the Renaissance, art and the mercantile society had lived on good terms. Better still, in their modern form they were born at the same time. The urban, commercial, and banking capitalism which had risen to power in the Italian cities in the fourteenth and fifteenth centuries was contemporary with the invention of linear perspective and of the Euclidian spatial scheme offered by the Van Eyck brothers, Masolino, Paolo Uccello, and Brunelleschi and codified by the architect and theorist Alberti. "As early as the sixteenth century," noted Pierre Jeannin, "the constant handling of measures and measurements developed a greater aptitude for rationalizing quantity." Mercantile rationality replaced the magical conceptions of the medieval world. Bookkeeping, warehousing, and circulation of merchandise necessitated manuals of arithmetic and conversion tables. The spirit of precision was born. Now, this arithmetical and quantified conception of the physical world proper to the mercantile middle class of the fifteenth and sixteenth centuries precisely corresponded to the projective methods of Renaissance painting. Perspective also was a reduction of the world to a quantifiable regulating line, the expression of a rationalism. On the one hand, we see the painter enclose his landscape in the yoke of a unitary rule which brings into a single common order the infinite diversity of nature. On the other, we see the merchant turn to accountancy, classify his products, and organize the world as though it were some huge

flow of goods. Despite differences in aims and means, the attitude was the same. Painter and merchant viewed the world as an object to be interpreted and changed and for this they had confidence in the individual.

The Renaissance exalted the hero, the great captain, the man of action, the businessman, in short, individual initiative. In traditional religious paintings the donor gradually occupied the entire space, soon resulting in the easel-picture portrait. The visual system of the period—based on a single point of view and the hierarchic organization of space stemming from the painter's eye—was an anthropocentrism, an apology of the person. The world was dominated by men of prodigious imagination. Never was there a greater spirit of enterprise, of audacity, or of working power. One must be blind not to see in someone like Jacob Fugger, the Augsburg banker, a "creativity" in full expansion, embodying a revolutionary capacity to change matter and society. The models developed in such cities as Nuremberg, Augsburg, Antwerp, Bruges, Lyons, Geneva, Lisbon, and Seville were literally to upset the face of the globe. Here modern capitalism was invented, even though its role in an overall production dominated by feudal structures was still a minor one.

Merchants, like artists, had their eyes turned toward the unexplored continents. As Pierre Jeannin notes, "Dürer's taste for the exotic, his curiosity for strange objects from overseas, expressions of a passionate research of the unknown, harmonized perfectly with this passion for discovery which drove the adventurer to ever more distant horizons in promise of still greater profit." Merchant and painter waited side by side on the quay for news of the virgin continents.

Thus there was nothing unusual in such feelings which united the artist to the merchant, for their vision of the world was the same. The most advanced form of painting harmonized with the rising, dynamic, prodigiously inventive class of great international trade. This harmony was to last three centuries, then to be spoiled by Romanticism. On the eve of Napoleon's rise to power, the artist no longer recognized himself in the world which was developing around him. At first he condemned it in the name of aristocratic values inherited from tradition. His disgust was a form of nostalgia. With Stendhal, the hero constantly weighed interest against passion, and it was passion that tipped the scale. With Balzac, it is the contrary: Men of feeling are crushed by men of money. Like a ghost, Delacroix

The Siege of Paris: Animals in the zoo are killed and eaten.

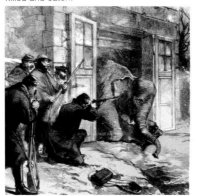

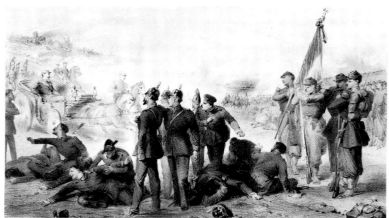
Sedan, September 1, 1870. The capitulation of the imperial army.

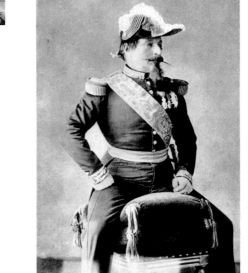
Napoleon III posing for an equestrian painting.

Anticommunard propaganda dish: the fall of the Vendôme column, May 16, 1871.

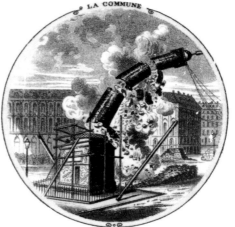

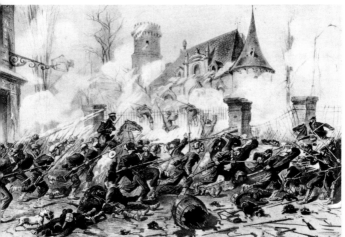
The blockade of Paris. The sortie of the royal marines on December 21, 1870.

makes his way through a society whose motivations escape him. "What is real in me," he wrote, "are these illusions which I create with my painting. The rest is quicksand." Rejected by the community, he shut himself up in his studio; he was refused on six occasions to be elected to the Academy. Meanwhile the world was changing and its rhythm accelerated. The France of landed proprietors gave way to the merchant middle class under the care of the "citizen king"—this is exactly what Balzac describes in his novels. The merchant middle class then changed into an industrial bourgeoisie, the factory replacing the workshop. This was the third stage, we are now in Zola's world. The twenty years or so of the Second Empire were decisive in the changes which occurred in France, thanks to the rise of metallurgy, the construction of the great railroad lines, and the foundation of important banks, like the Crédit Lyonnais in 1863 and the Société Générale in 1864. Department stores, great newspapers, the telegraph, the metal ship, and the widespread use of the screw propeller were other manifestations. Industry

offered itself gigantic *fêtes* in which, wonder-struck, it discovered its own power. The Universal Exhibition of 1867 marked the height of the Empire and confirmed the role of Paris as a capital of luxury and fashion. The Exhibition of 1889, crowned by the Eiffel Tower, was to celebrate the marriage of the arts and industry at the same time as it acclaimed colonial conquests and promises of raw materials and overseas markets.

However, this increasingly accelerated industrialization, which characterized the second half of the nineteenth century, created disquieting processes which were badly known and ill-controlled. The first of these was the appearance of a proletariat, often ready for combat, which soon tried to organize its ranks. This resulted in bloody encounters in the Loire in June, 1869, in the Aveyron in October, in Saône-et-Loire in the spring of 1870. The First International occurred in 1864. Karl Marx's *Capital* was published in French translation in serial form in 1872. Towns and cities were overgrown with uprooted people. Le Creusot, for example, went from a population of 9,000 in 1852 to

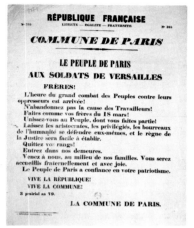
Commune poster, May, 1871

"The Barricade," lithograph by Manet. The attitude of the firing squad was inspired by *The Execution of the Emperor Maximilian* (see page 226).

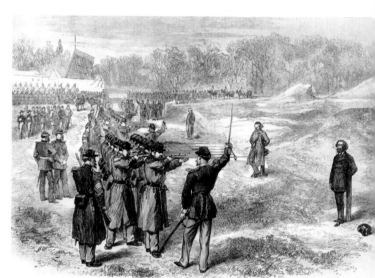
Execution of three leaders of the Commune: Rossel, Ferré, and Bourgeois, November 1871.

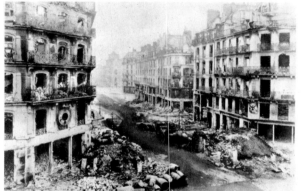
Rue de Rivoli at the end of the insurrection, May, 1871.

*The war, the fall of the Empire
and the Commune created
an atmosphere of intolerance
which proscribed new ideas.*

25,000 in 1869. The same held true for the mining centers in the North and in the Massif Central. In Paris, which numbered 2,000,000 inhabitants in 1870, the working class continued to grow and at the close of the Empire numbered 500,000 including 112,000 women. They earned two francs a day for thirteen hours of work, 500 francs a year, counting the dead season. The rent for a garret was 120 francs.

A storm was brewing, as fear spread. Between 1827 and 1851 barricades were erected in the streets of Paris on nine occasions. There was an attempt to shove aside this threatening, discontented mass. In Balzac's Paris, the social classes still lived vertically, so to speak. On the street level was the shop, the middle-class apartment above, and finally the garret for the poor. Napoleon III decided in favor of a separation which this time was to be horizontal. Baron Georges Haussmann tore up the old quarters, installed the railroad stations at the far ends of new thoroughfares, and drove the working classes in the direction of Belleville, Ménilmontant, and Levallois rather than toward the

urban center. "One of the meanings of the Commune," wrote Henri Lefebvre, "was the return in force toward the urban center of these workers driven in the direction of the suburbs and outskirts, their reconquest of the city, this possession among possessions, this value, this work which had been wrenched from them."

We must realize this atmosphere of insecurity and constant social tension in order to understand the attitude of those men who, in the 1870's, saw themselves given a new aesthetic entitled "Impressionism." The public that formed the potential clientele of Monet and his companions was psychologically on the defensive. Gone were the days of the triumphant Medici and of men like Jacob Fugger. The ruling class found itself at grips with a runaway industrialization, with its own dynamic power, ushering forth new social levels and new urban concentrations. Personal relationships, old communal hierarchies, the balance between city and country were all torn apart. It was the scale that changed. Industrial society created its own landscape—that of Zola's novel *Germinal*—and its own

General Boulanger, supported by popular discontent and the spirit of revenge, threatened to march on the Elysée Palace and by a *coup d'état* make himself master of France.

A financial scandal broke out during the construction of the Panama Canal, compromising several members of parliament.

In 1887 Jules Grévy was forced to resign as President of the French Republic because his son-in-law had illegally sold national decorations.

The Third Republic continued its policy of colonial expansion. The imperial conquest of Cochinchina was followed in 1882–1885 by the Tonkin operation.

type of man, the proletarian. "Until then it was the middle-class ideology," writes Roland Barthes, "who itself gave the measure of the universe, occupying it without challenge. . . . Henceforth this same ideology merely appeared as one ideology among other possible ones; the universe escaped it, it could transcend itself only by self-condemnation." The disturbances of February and June, 1848, were a memory common to everyone. The time was still quite recent—only twenty-two years had passed to 1870 and the flight of Louis-Philippe. The series of events began as a ministerial crisis, then turned into a riot, destroying a dynasty. The time is well described by the art historian, Henri Focillon, in his work on nineteenth-century painting. "Clubs saw the appearance of orators and leaders who had nothing in common with the known parties or with the acknowledged opposition, but who seemed to emerge from the most secret crypts of the people's uneasiness and poverty, mingled with prophets and ham actors, practitioners of the strangest religions. The working-class associations themselves embraced

only a part of the masses. From February to June what rose from the depths, what appeared evident in full daylight for the first time, was not only a new generation but also a noisy, unknown world raised not to defend its rights but to create them and to impose their authority and to give a new basis to life in society and the organization of work. Cavaignac's troops crushed it at the barricades to defend order and legality, and the frightened middle class and peasantry accepted the Bonapartist dictatorship. . . . The awakening and defeat of the people, however, had changed the course of the century, not so much by its political consequences as on account of the advent of a new idea of man and of modern man." The crisis of 1848 ruined the illusions of liberalism. A social war was brewing and about to break at any moment. Nothing less than a "providential man" was needed to reassure the middle class and to end an unbearable tension. Monarchist under Louis-Philippe, the financial oligarchy became Bonapartist in 1851. Only a strong power could restrain all the impatience and injustice

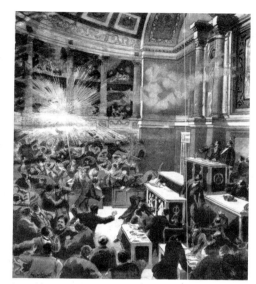

Anarchists applied ''propaganda by fact.'' Vaillant threw a bomb into the National Assembly (*above*); Caserio assassinatd President Sadi Carnot on June 24, 1894 (*left*); Ravachol was arrested, after he had made several attempts at criminal acts (*right*).

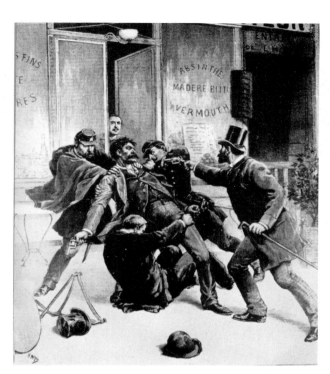

Nourished on ideas by Marx and Proudhon, the working-class movement organized itself into parties and syndicates.

Financial scandals and colonial adventures poisoned the political atmosphere and favored the expansion of socialist and liberal ideologies.

stemming from the industrial revolution. "In every stock exchange of Europe," wrote the *Economist* four days before the *coup d'état* of December, "the president is currently known as the sentinel of order."

In 1870 the Franco-Prussian War saw the whole thing begin once again; the collapse of the Empire, a subject of ridicule as a result of a pitiful defeat, the Siege of Paris, famine (5,000 died in August, 12,000 in December, 19,000 in January). Finally there was the Commune, preceded or accompanied by torches in Lyons, Marseilles, Toulouse, Le Creusot, St.-Etienne. The panic and horror could be read not only in the communiqués from the government of the National Assembly at Versailles. Liberals and republicans had their word to say. Zola, Manet's friend and defender, treated the Communards as "mad beasts" and "furious madmen." The day after the massacres, he wrote, "The bodies have remained practically untouched almost everywhere, heaped into corners, decomposing with amazing rapidity doubtless because of the drunken state in which these men had been struck." Writing to

George Sand on October 18, Flaubert stated, "I find that the entire Commune should have been condemned to the galleys and these bloody imbeciles forced to clear away all the ruins of Paris, chained to the neck as mere convicts." Courbet, a minor member of the Commune, was arrested on June 7 and soon taken to Versailles to be judged. Barbey d'Aurevilly stated, "We should show all French citizens Courbet locked in an iron cage at the base of the [Vendôme] column. We will make people pay to see him." Alexandre Dumas fils had his word to say. "What fabulous coupling of a slug and a peacock, what genetic antithesis, what sebaceous boozing, could have generated, for example, this thing known as Monsieur Courbet? Under which cloche, with the aid of which manure, following which mixture of wine, beer, corrosive mucus and flatulent edema rose this sonorous and hairy courage, this aesthetic belly, incarnation of the imbecilic and impotent self?" This was the tone adopted by the intellectuals. That of the conquerors was less literary: thirty thousand executions.

Financial and industrial capitalism exerted an

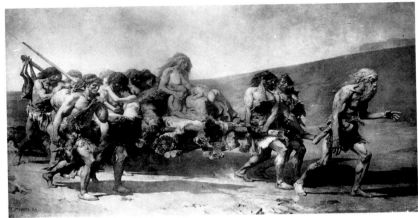
Cormon. "The Flight of Cain." 1880.

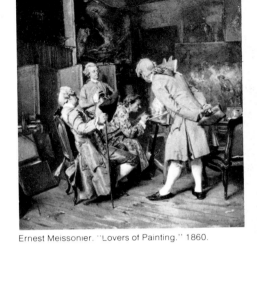
Ernest Meissonier. "Lovers of Painting." 1860.

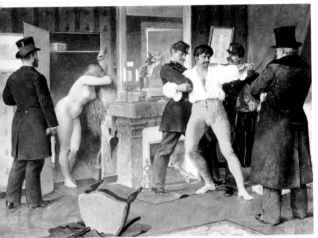
Jules Garnier. "The Proof of Adultery." 1883.

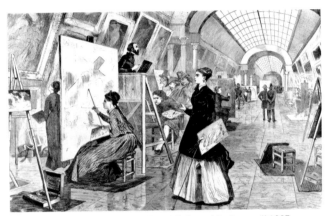
Winslow Homer. "Copyists in the Grand Gallery of the Louvre." 1867.

ever-increasing control of production in France at the close of the nineteenth century. Having at its disposal, thanks to technical progress, a constantly growing mastery of material, and reigning within the country over economic empires and without over the colonial empires, it could oppose everything that denied its omnipotence. It felt itself the end and finality of history. It is here that we rediscover aesthetics. It has often been observed that the image which the ruling classes wanted to give of themselves in the time of Napoleon III was largely based on the past. The captains of industry sought their cultural symbols in Louis XV. They wanted a decorum which would express continuity, stability, eternity. On the one hand, they created the instruments of a modern society by their technical ability, and on the other, they collected reassuring images the purpose of which was to point out their belonging "by divine right" to the country's elite. "At his counter, the private man considers reality," noted Walter Benjamin, "at home he wants his illusions to be maintained. . . . To give substance to his private

atmosphere he banishes society and business from his mind. Thus came into being interior phantasmagories." It was a question of both ennobling the present and giving a middle-class tone to the past.

Following the example of Louis Napoleon, who adopted his uncle's striking oratory style and theatrical rituals, the newly enriched of the 1870's collected the "outer signs" of distinction which should legitimize their position at the head of business affairs. "Monsieur Prudhomme is the contemporary art patron," wrote Zola in 1868. The dictatorship exercised by Ingres from 1840 to his death in 1867—he was president of the Ecole des Beaux-Arts in 1850, senator in 1862—stemmed for the most part from his permanent reference to the past. His words were reassuring. According to him, the artist should scrupulously copy nature . . . but after the manner of the ancient masters. They understood everything once and for all. No one could do better. "Classical figures are beautiful only because they resemble beautiful nature. Any nature will always be beautiful when it resembles beautiful ancient figures."

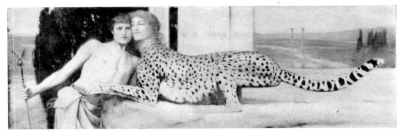

Fernand Khnopff. "Art, the Caress, the Sphinx." 1896.

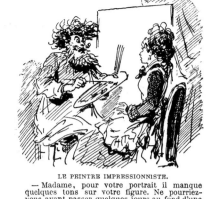

Le Charivari, ("the Impressionist painter"). 1877.

LE PEINTRE IMPRESSIONNISTE.
— Madame, pour votre portrait il manque quelques tons sur votre figure. Ne pourriez-vous avant passer quelques jours au fond d'une rivière?

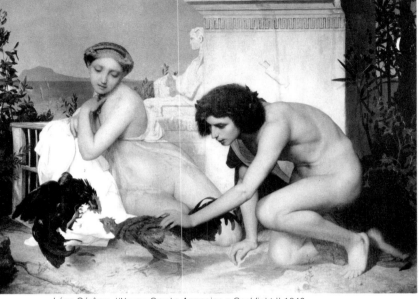

Léon Gérôme. "Young Greeks Arranging a Cockfight." 1846.

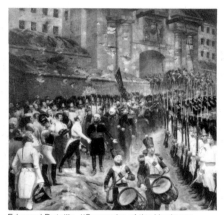

Edouard Detaille. "Surrender of the Huningue Garrison." 1892.

Conventional art occupied the scene. It reigned at the French Institute and at the Ecole des Beaux-Arts, and it led a hateful war against Impressionism.

What is stated in this postulate is not only Ingres' worship of the Greek canon but even more the idea that physical reality had been definitively explored five centuries before the Christian era. It was useless to return to nature: The psychosensorial relationships of man with the world had been determined forever. By a feature characteristic of the pseudorationalist spirit of the nineteenth century, reality was enclosed in a yoke considered immutable. Time and history were embalmed. The norms were set and declared eternally valid. The paradox is that such a profoundly static thought could have been regarded as the most fitting and appropriate at a period which became a prey to a prodigious technical and scientific acceleration.

This same period, with its marked taste for inquiry and analysis, which witnessed Claude Bernard's invention of experimental medicine, led Hippolyte Taine to write, "The matter of all science today is of all well-chosen, important, significant, fully circumstantiated and carefully noted small *facts*." These contradictions well marked the true function of art during this period of mutation, namely, to reassure, to take root, to create a link with the past. Maurice Denis and Picasso had to appear to see in Ingres' painting other formal merits than those of Phidias, Raphael, and Bronzino. The painter of the "Turkish Bath" was to fascinate Degas, Seurat, and the nineteenth century for the abstract splendor of his outlines, the musical complexity of his harmonies, his incomparable manner of balancing observation and geometry. If Ingres lasted, it was because he spent his life violating the rules whose defender he none the less remained. The posterity of Neoclassicism other than Ingres proved a disaster. Gérôme, Boulanger, Couture, Cabanel, Henner, Bouguereau, Lefebvre, Bonnat—the important academic painters of the time—were for the most part to pursue the Impressionists with ferocious hatred. Their eclecticism was rampant. They combined historical style, every mixture, every form that might fascinate. Formulas borrowed from Correggio were used to soften the "Roman" proportions, while the memory of Van Dyck served to lengthen the neck of some calico queen.

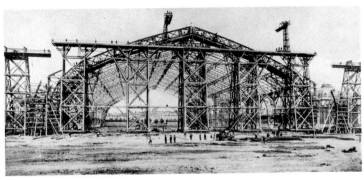

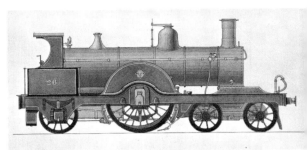

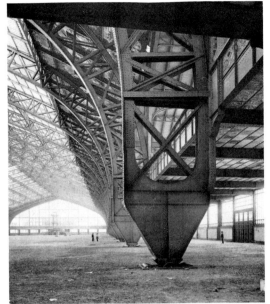

Dutert and Contamin, the Galerie des Machines at the Universal Exposition of 1889 (345 feet wide). Left, the construction, below left, the gallery during the Exposition. Below, the system of pillars.

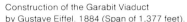

Johnson locomotive. 1889.

Construction of the Garabit Viaduct by Gustave Eiffel. 1884 (Span of 1,377 feet).

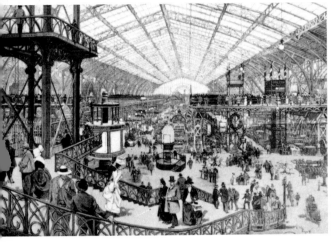

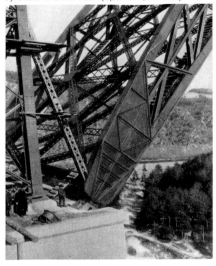

During the entire second Empire the ancient mode was rife. Behind the invasion of many a Daphne, Galatea, Venus, satyr, and bacchante reigned the most commonplace prosaism. "It is solely a matter of transporting communal, vulgar life into a Greek setting," remarked Baudelaire. "Thus we see ancient kids playing with an ancient ball and hoop or with ancient dolls and ancient toys." Meissonier—"the giant of dwarfs," as Degas described him—according to the circumstances would go from the Dutch genre scene to the historical painting, from a Louis XV playlet to a Venetian sunset. Whatever the subject—smutty, edifying, or mundane—one rule held true, a finicky precision of detail. "When a painting leaves the hands of Monsieur Meissonier," wrote Théophile Gautier, "it is certain that it cannot be taken any further. And in fact it is ready to defy the monocle of the most difficult art lover and find itself hanging on the wall among precious, rare, and much sought-after masters." In the polish of a painting, the middle-class Frenchman, feeling reassured, could study "the beautiful work." It

was something that counted in working hours. Nothing bothered him more than a sketchy, ruined painting. Precision, however, was not realism. What was more precise than a Courbet? "No one better than he painted flesh, fabrics, coats, rocks, everything that weighs and holds, a woman's body in full bloom, strong and soft, a landscape of his country, in its coherence and force," writes the art historian Henri Focillon. All this, however, displeased the bourgeois.

Courbet exasperated a society which was to make Offenbach its Lulli, Garnier its Mansart, and Barbedienne its Michelangelo. His work was *too* real and he added to it. He revealed things as they were without cultural makeup. Moreover he himself resembled everything that the bourgeois wished to forget; he was the son of well-to-do farmers, the grandson of Jacobins, noisy, common to the core. His "Burial at Ornans" was greeted with laughter. The emperor, people said, would have struck with his riding crop Courbet's "Bathers." Courbet was consecrated "leader of the disgraceful school." "On pretext of

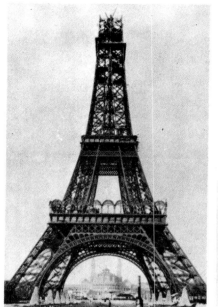

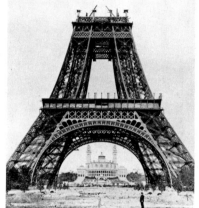

Technical progress, the industrial and metallurgical revolution, emphasize the changing state of French society.

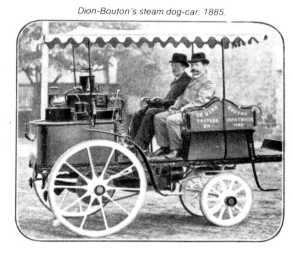

Dion-Bouton's steam dog-car. 1885.

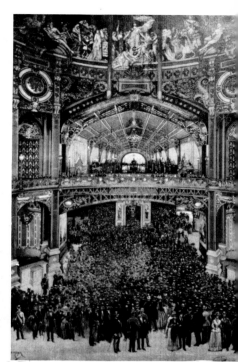

The Eiffel Tower (7,000 tons of metal). Three stages of its construction. 1889.

The Universal Exposition of 1889. Inauguration of the Palace of Various Industries.

realism," wrote Théophile Gautier, "he slanders nature horribly. The least chosen aspect of nature is neither so ugly nor so disgraceful nor so botched." The same reaction was encountered by the gentle Barbizon School with its paintings of undergrowth and herds of cows reminiscent of works by Hobbema and Potter. In the words of the Count de Nieuwerkerke, imperial director of the Beaux-Arts, "This is the painting of democrats, of those men who do not change their linen and who want to thrust themselves on mundane people: this art displeases and disgusts me." This modernity was at the same time sought by Baudelaire, who discovered it only among two misunderstood artists, Constantin Guys and Edouard Manet. The latter's "Luncheon on the Grass," stiff and cold, scandalized the emperor in 1863, the very year he purchased Alexandre Cabanel's "Birth of Venus," a lustful woman stretched out on the crest of a wave. In 1855 the famous writer Paul de Saint-Victor explained, "We prefer the sacred 'Lucus' where fauns travel to a forest alive with woodsmen; a Greek spring with its bathing nymphs to the Flemish pond with its

dabbling ducks; and the half-nude shepherd who with his Virgilian crook prods his rams and goats in the Georgic paths of a Poussin to a peasant who, smoking his pipe, climbs the path of a Ruysdaël."

This cardboard nobility was the spirit of the time. While a student in Gleyre's studio, Monet was told, "It's not bad, but the breast is too heavy, the shoulder too powerful and the foot excessive." To which he timidly replied, "I can draw only what I see." On these words, the master dryly retorted, "Praxiteles borrowed the best elements of a hundred imperfect models in order to create a masterpiece. When you do something, you must think of the works of antiquity." That same evening Monet drew Sisley, Renoir, and Bazille aside and said to them, "Let's get out of here. The place is unhealthy. There is no sincerity."

They were to seek this sincerity in vain. Gradually they had a presentiment that this official art opposed to them everywhere was a mask, a stucco façade, a camouflage within which were perpetuated and developed the prosaic, pitiless, often inhuman

Manet photographed by Nadar.

Berthe Morisot in 1875.

Nadar's studio at 35 Boulevard des Capucines, the scene in 1874 of the first Impressionist exhibition.

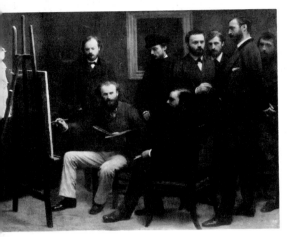

Henri Fantin-Latour. "The Studio at les Batignolles." 1870. Manet surrounded (left to right) by Schelderer, Renoir, Zola, Maître, Bazille, and Monet.

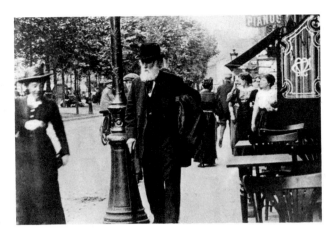

Edgar Degas, almost blind, in Paris during World War I: at left, on the Boulevard de Clichy; below, in a garden.

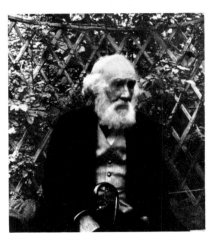

mechanisms of economic competition and the struggle for profit. The Empire and the Third Republic were all the more "Greek" since a materialist society was finding its strength, a setting in which the political factions which were disputing their positions—Legitimists, Bonapartists, moderate Republicans, members of the Left Center—all had the same selfish conception of power. "The Republican personnel [of the 1870's] stemming from the provincial body of clerks attached to the courts of justice, also from the freemasons' lodges," wrote Professor Goguel, "were exclusively middle class, in the most pejorative sense of the term, passionately attached to the Civil Code, to landownership and to profit. This narrow individualism prevented it from being aware of social problems and, even more as time went on, the increasing importance of these problems in public life." Official art, "supplement of the soul," of a soulless society, lacking spiritual *élan* and a collective project, had nothing in common with the obscure and passionate research by the young Impressionists. Later Emile Bernard was to

remark, "The idea of beauty was not in Cézanne. He had only the idea of truth." A truth desired by no one. Pissarro, writing to his son in December, 1883, said, "Everything the bourgeoisie has admired for the past fifty years falls into oblivion, becomes outdated and ridiculous. We have to give these people a dig in the ribs, to shout to them for years, 'Here is Delacroix! Here is Berlioz! Here is Ingres!' and so forth." Faced by this phenomenon of rejection which dismissed any authentic research, the small world of these painters only gradually gained force. The first generation tried to convince the public. They attacked academicism. In a letter to the superintendent of the Beaux-Arts written in 1886, Cézanne stated, "I cannot accept the illegitimate judgment on the part of fellow-artists to whom I have not set the task of appreciating me." In 1870 he explained to a journalist, "Yes, my dear sir, I paint as I see, as I feel. And I have very strong sensations. They also feel and see as I do, but they dare not. They produce Salon painting. But I dare, sir, I dare. I have the courage of my convictions—and he

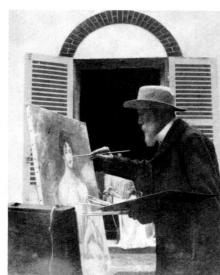

Pierre-Auguste Renoir.

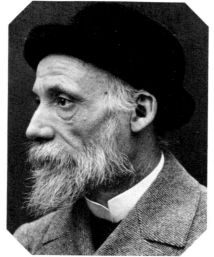

Renoir painting in Fontainebleau. September, 1901.

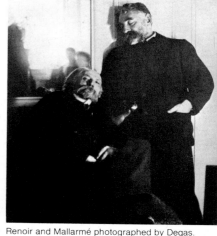

Renoir and Mallarmé photographed by Degas. About 1890.

Degas in the country at the house of the Fourchy family.

*Since "order was everything,"
Manet, Degas, Renoir, peaceful
members of the middle class, were
banned by the official artistic
society.*

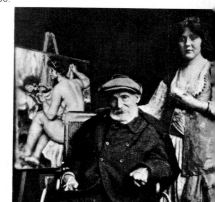

Renoir and his model Gabrielle.

laughs longest who laughs last!" And in referring to the official Salon, visited by 58,000 people in 1857 and by 400,000 in the 1880's, Zola wrote, "Never have I seen such a heap of mediocrity. There are 2,000 paintings. . . . Of these 2,000 canvases, ten or twelve address you in a human language, the others relate perfumers' stupidities." He stigmatized "those whose minor manner has a small success and who grip this success between their teeth, growling and threatening any fellow-artist who approaches. . . . Art has been blotched, combed with care, it is a worthy bourgeois in slippers wearing a white shirt." (1866)

The second generation, however, of Gauguin, Van Gogh, Signac, was not content with attacking the Salon, but gave it up completely as lost. This was the beginning of wandering painters, madmen, and alcoholics. The entire system was attacked. The invectives of Baudelaire's *Fusées* sound like an echo, "Your wife, oh bourgeois! Your chaste half, whose legitimacy makes poetry for you, henceforth introducing into legality an irreproachable infamy, vigilant and

amorous guardian of your safe, will be nothing more than the perfect ideal of the kept woman. With childish nubility, your daughter, in her cradle, will dream that she will sell for a million francs." In his most famous novel, *A Rebours*, Huysmans went even further. "Reassured, jovial, the bourgeois reigns, owing both to the power of his money and the contagion of his stupidity. The result of his rise to power had been the crushing of all intelligence, the negation of all probity, the death of all art. In fact degraded artists had gone down on their knees and ardently covered with kisses the fetid feet of high-horse dealers and low satraps whose alms enable them to live!"

In 1886 Van Gogh exclaimed, "We are in the last quarter of a century which will end in colossal revolution." In 1890 Gauguin said, "A terrible ordeal awaits the next generation in Europe: the kingdom of gold. Everything is rotten, both men and the arts." Alfred Jarry, presenting the monstrous figure of his Ubu, explained to the public that Ubu was "his base double." (His *Ubu Roi*, a satirical drama which he had

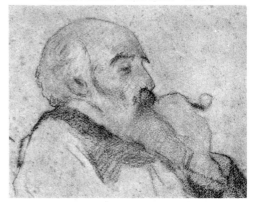
Camille Pissarro. "Self-Portrait." 1877.

Alfred Sisley.

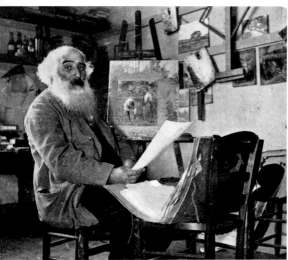
Camille Pissarro in his studio at Eragny. About 1897.

Monet, Pissarro, and Sisley, the trio of classic Impressionism, spent their lives at the heart of nature, scrutinizing the slightest changes of light.

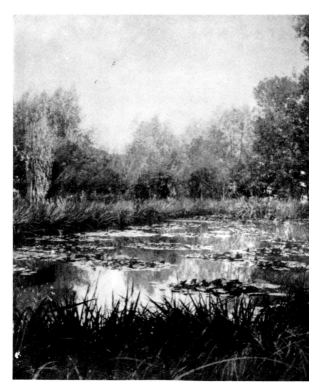
Monet's pool of water lilies at Giverny.

written at the age of fifteen in collaboration with a classmate, was presented in expanded form at the Théâtre de l'Oeuvre on December 10, 1896.)

As rejection of accepted values there were three means: Messianism, geographical escape, and politics. Viewed by Cézanne, Van Gogh, and Gauguin, the painter became a kind of saint, a *maudit* (cursed person) who despite everything pursued his task, bearing on his shoulders the sins of the world. Gauguin identified himself with the suffering and abandoned Christ (pages 168–69). "It is difficult to be in his company," wrote Van Gogh, "without thinking of a certain moral responsibility. . . . He likes to show that a good painting ought to be the equivalent of a good deed." As for himself, Van Gogh added, "A painter ruins his character by working hard at a painting which makes him sterile for many things, for family life, and so forth and so forth. . . . He paints not only with color but also with abnegation and self-denial and a broken heart. . . . To be a link in the chain of artists, we pay the stiff price of health, youth, freedom, which we by

no means enjoy, any more than the horse who is dragging a cab of people who are off to sample the joys of spring." Cézanne, relentlessly fighting away in the countryside, ignored by all for twenty years, explained, "Art is a priesthood which requires pure souls who belong to it entirely."

Rather than this "priesthood," others preferred escape to artificial or exotic paradises. This was the myth of the great departure, echoed in Mallarmé's

Fuir, là-bas, fuir . . .
Je partirai! Steamer balançant la mâture
Léve l'ancre pour une exotique nature!

Emile Bernard cried out in exultation "Oh, to leave with no worry about anything, to go very far, very far. To leave this abominable European life, these cads, these dunces, these satiated scoffers, this pestiferous crew. . . ." Gauguin spent years in a constant obsession of exile toward innocent lands far from the sordid realities of Europe.

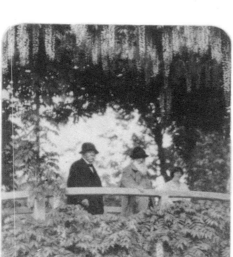

Monet with Clemenceau on the Japanese footbridge at Giverny.

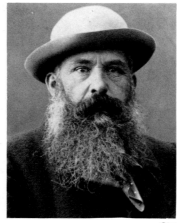

Claude Monet.

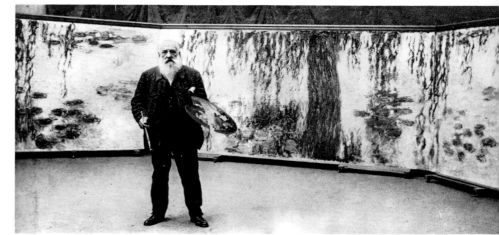
Monet in the studio at Giverny.

Others preferred inner exile. Des Esseintes, the hero of Huysmans' *A Rebours*, incarnated to the point of caricature the *décadentisme* of those whom Signac in his journal called the *Symbolos*. Far from the hurly-burly of the foul crowds, Des Esseintes cultivated a studious decay, nourishing himself on scholarly hysterias, speaking ironically of the "innate stupidity of women," to which he preferred the "sight of locomotives." Deliberately and comfortably installed in a refined world of odors, colors, and tactile sensations, of "natural flowers in imitation of artificial ones," he stated that "artifice is the distinctive mark of man's genius" and that "nature had done its time; the disgusting uniformity of its landscapes and its skies had definitely exhausted the attentive patience of refined persons." We recognize here the theories of Maurice Barrès, novelist, and the attitudes of a Comte Robert de Montesquiou (who inspired the Charlus of Proust's *A la recherche du temps perdu*) who, dressed in mauve, attended a concert explaining that "one should always hear Weber dressed in mauve." All this *autisme* led to

confusion and caricature. The majority of the Symbolists were to lose themselves in Pre-Raphaelite mysticism and deliberate eccentricity. For a time they gathered around an eccentric self-styled Sâr Peladan who called himself the "Maccabaeus of the Beautiful."

Scandals succeeded one another in what G.-Albert Aurier called "our deplorable and putrid fatherland"—the Wilson affair in October, 1877, which led to the resignation of the president of the Republic, the birth of Boulangism (principles adopted by General Georges Ernest Boulanger, French minister of war), Panama, the Tonkin and Madagascar invasions. In 1882 workers rose up in revolt at Montceau-les-Mines and in Lyons, and in 1886 strikes occurred at Decazeville and Vierzon. The economic crisis of 1883–87 created unemployment and social unrest. On May 1, 1891, troops fired on a crowd at Fourmies, killing ten persons, including two children. Anarchy gained ground, finding its expression in the bombs thrown by Ravachol, Vaillant, Henry. In 1894 Sadi Carnot, the new president of the Republic, was

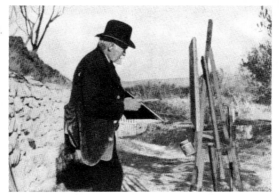

Cézanne painting near Aix (photographed by Maurice Denis). 1904.

Paul Cézanne in 1861.

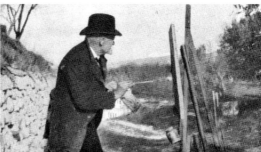

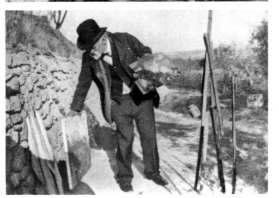

Cézanne on the outskirts of Auvers, his paint box strapped to his back. 1873.

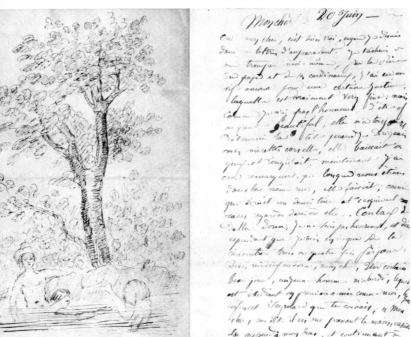

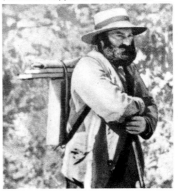

A letter from Cézanne to Emile Zola, his childhood friend. June 20, 1859.

assassinated by Caserio. During his trial Emile Henry explained that he was drawn to terrorism "by a deep hatred, increased daily by the revolting sight of this society in which everything is mean, shady, ugly, a hindrance to the outpourings of human passions, to the generous tendencies of the heart, to the free upward flow of thought." And he added, "It was then that I decided to mingle with this concert of pleasant accents a voice which the bourgeois had already heard but which he thought dead with Ravachol, namely, that of dynamite." When it was pointed out to him that innocent victims had died, he stated, "The house which contained the Compagnie de Carmaux was inhabited only by bourgeois. Consequently there were no innocent victims."

Artists and writers stated their sympathy for the anarchists. Félix Fénéon, Henry's friend, was arrested on April 25, 1894, for keeping explosives. He spent two months in prison where he was joined by Maximilien Luce, one of the Neo-Impressionist painters. Pissarro went into exile in Belgium. His opinions, like those of

Cross, Signac, Vallotton, and Steinlen, became more and more unequivocal. In 1883 he wrote, "Sentiment or rather sentimentality cannot without danger be in circulation within a rotten society which is in a state of decomposition." In 1887, speaking of painters, he said, "All those who labor with their hands, with their brain, who create work are proletarians when they are dependent on intermediaries. With or without overalls. . . ."

The 1890's saw the increase of politico-artistic meetings. The Club de l'Art social included among its members Lucien Descaves, Camille Pissarro, Jean Grave, and Louis Michel. Mallarmé, questioned about the criminal attempts, replied that he could not "discuss the acts of these saints." According to the realist writer Octave Mirbeau, "Everything will change at the same time, literature, art, education, everything, after the general upheaval which I am expecting this year, next year, in five years, but which will come, I am certain." The small Symbolist reviews proliferated beginning in 1885—*Le Décadent, La Vague, Le Mercure de*

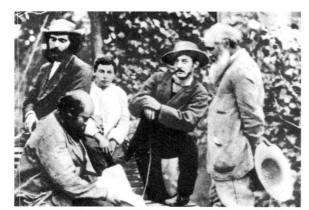

Cézanne seated in Camille Pissarro's garden at Pontoise. (Pissarro is standing on the right.) 1877.

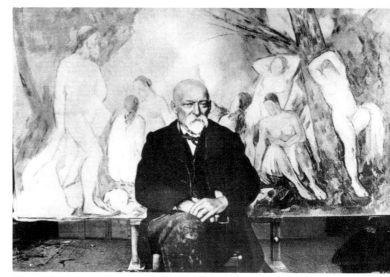

Cézanne in his Aix studio, seated before his "Great Bathers." (Photographed by Emile Bernard.) 1904.

Mont Ste.-Victoire, Aix-en-Provence.

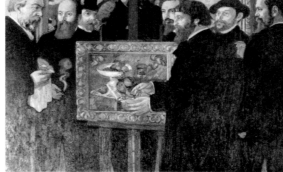

Maurice Denis. "Homage to Cézanne." 1900.

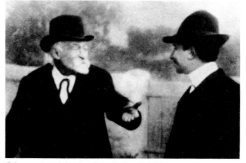

Cézanne and Gaston Bernheim de Villers. Aix-en-Provence. 1902.

France, La Revue Blanche, La Cravache to name some of the most important. They represented a paradox. On the one hand, they cultivated an aristocratic language of extreme preciosity—Wyzema, who introduced Wagner to the French, claimed for example that the "aesthetic value of a work is always in reverse ratio to the number of minds capable of understanding it." On the other, they advocated social revolution.

All the contradictions among various types of anarchism should not, however, mask the essential hostility for a quarter of a century toward the latest and most lively developments in art. The affair of the Caillebotte bequest occurred in 1894, twenty-two years after the birth of the Impressionist movement. The State, supported by the Academy, politicians, and numerous journalists, refused eight Monets, eleven Pissarros, two Renoirs, three Sisleys, and two Cézannes because they were considered unworthy to become part of the national collections. On this occasion the insults offered to the Impressionists were even greater than those during the group's first exhibition, according to

Rewald. Similar opposition, moreover, continued into the twentieth century with Fauvism, Cubism, Dada, De Stijl, Surrealism, and other movements. Some of the most important reasons for the battle must be found in the pictorial language. What occurs in Impressionism is the denial of the Renaissance conception of space. During Manet's time, most painters and art lovers strongly believed that the projective method invented in the Flemish and Florentine studios at the birth of modern times was the final solution to every painting problem. The squaring of the circle had finally been solved. The problem was to represent faithfully on a two-dimensional surface a reality—landscape or figure—which had three. The solution was monocular perspective. As we pointed out at the beginning of this chapter, in the orthodox Renaissance system, representation of reality on the canvas obeyed a regulating line. All the *receding lines* converged toward a *vanishing point*. Every object was contained in a pictorial space according to the painter's rational estimate of its volume and distance. "Perspective,"

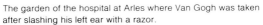
The garden of the hospital at Arles where Van Gogh was taken after slashing his left ear with a razor.

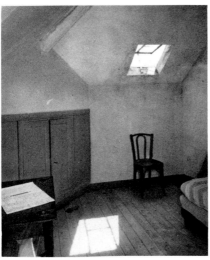
The room at Auvers in which Van Gogh died.

Van Gogh (back view) in conversation with Emile Bernard at Asnières. 1887.

The "yellow house," Place Lamartine at Arles, where Van Gogh and Gauguin lived together in 1888.

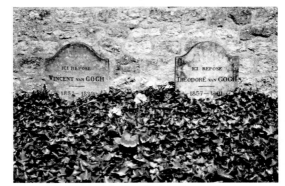
The graves of the Van Gogh brothers at Auvers.

wrote Leonardo da Vinci, "is nothing more than the vision of a rear plane, a sheet of smooth and perfectly transparent glass on the surface of which every object is projected toward the eye according to the pyramids intercepted by the sheet of glass."

In addition to Alberti's perspective, various other solutions were suggested by Renaissance artists to effect a system of space. What interests us here, however, is that they all affirmed a mathematization of the visual field. The different components of nature in a painting were linked by a numerical relationship in obedience to one and the same topographical coherence. This quantification of reality was characteristic of humanism which saw in nature the reflection of its own mental constructions. Men believed in the harmony of spheres and imagined a cosmos submitted to Euclidean geometry.

During four hundred years the Renaissance perspective scheme passed through various stages. Rich and fluctuating in its developing phase, upset on several occasions by Mannerism, Luminism, and other movements, nevertheless it retained an important role until the nineteenth century. Here, under the badly understood influence of Poussin and of the Italian schools, it solidified and stiffened into studio formulas. As Pierre Francastel observed, "The realistic value of linear perspective was only proclaimed in the academies toward the close of the nineteenth century." Distributed daily by every sort of medium—engravings, paintings, popular prints which also took on an academic quality in the nineteenth century—the Renaissance conception of space finally appeared as the very image of reality. One had to wait until 1924, when the noted art historian Erwin Panofsky revealed his insights into the subject, to become aware of the entirely relative character of the Florentine spatial scheme. Monocular perspective was an arbitrary system of signs and not, as Pierre Francastel remarked, "an objective, realistic representation of the world discovered one fine morning in the Quattrocento by some Newton of painting. . . . It is not a rational system better adapted than any other to the structure of the human mind; it by no means

The house at Pont-Aven (left of the photograph) where Gauguin stayed.

Gauguin in Breton dress. About 1890.

The Tahitian coast where Gauguin settled down in 1891.

The time of dropouts, rebels, and chimerical voyages began. Gauguin's hopeless flight to the tropics corresponded to Van Gogh's inner exile.

corresponds to an absolute progress of humanity in the ever more adequate representations of the outer world on a two-dimensional plastic surface. It is one of the aspects of a conventional means of expression based on a certain state of techniques, of science, of the social order of the world at a given moment."

Although one had to wait until 1924 to see this relativity of classical perspective formulated by Panofsky, for three-quarters of a century the painters themselves had grasped its limits. No longer did they recognize their experience of reality in these regular grills set against the variety of nature. "Experienced perspective, that of our perception, is not geometrical perspective," explains Merleau-Ponty. Manet and his companions had a vague feeling that behind the Renaissance system was an outdated message. This message seemed to say that the world was simple, stable, organized, capable of being dominated, a garden laid out in the French style in which nothing escapes the certainties of the eye and thought. Man was the *Deus in terris* of this universe without contradictions.

"What does the rational economy of the classical language mean," asked Roland Barthes in reference to literature, "other than that nature is full, capable of being possessed, without flight or shadow, submitted entirely to the network of speech?"

Nothing in the daily experience of the men of the nineteenth century, caught up in the tumult of an ever-hastening historical process, suggested serenity. The Renaissance scheme had adapted itself to a vision of the world based on the state of knowledge and practice known to the Quattrocento, but how could it be applied to the century of Charles Darwin, of Claude Bernard, and of James Clerk Maxwell? As Newton had already stated in the eighteenth century, "I do not know what I may appear to the world: but to myself I seem to have been only like a boy playing on the seashore and diverting myself and now and then finding a smoother pebble or a prettier shell than usual, whilst the great ocean of truth lay all undiscovered before me." Newton's ocean was without limits and any pretension to codify once and for all the laws of nature

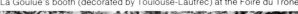

The female clown Cha-U-Kao.

Yvette Guilbert.

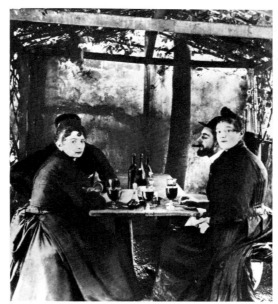

Toulouse-Lautrec at the Moulin de la Galette with La Goulue (on the right).

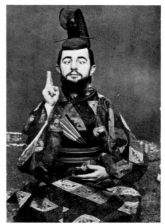

Toulouse-Lautrec dressed as a Japanese.

Toulouse-Lautrec. "Self-Portrait Caricature."

was felt by the painters to be ridiculous. Our nervous system seizes only a narrow fringe of reality, an infinitely small part of the undulating field, beyond which opens the immense realms of the *imperceptible*.

How could painters ever hope to stick to the art valid for Raphael when they knew, for example, that a color struck the retina at the rate of 500,000,000 vibrations per second? How could Monet and Pissarro paint the same apple as Chardin when their period was becoming aware of atomistic effects? In the fifteenth century color for Van Eyck was a pigmentary mixture, like burnt siena, spread out on a surface. For Monet it was a play of waves which first blend in nature (a red radiating on the juxtaposing white surface), next in the painter's eye (which according to its own fashion acts subjectively on the object perceived), then on the canvas (by the chemical mixture of pigments), and finally in the spectator's eye (according to how far he stands from the work and the size of the painted surface).

In the face of an ever-increasing reality influenced by science and technique, the artist refused to continue an ancient lie in the form of pretension to objectivity. No longer did he seek to show us *true* nature, the essence of the world as it is, but more modestly his point of view, his *impression* of this nature. Had not Cézanne himself stated, "For an Impressionist to paint from nature is not to paint the subject but to 'realize' sensations." The painting no longer described reality but *our experience of reality*, that is, not what the eye saw but the manner of seeing. The painting becomes a document on the fragmentary state of the vision of a certain moment of history. The work reveals man's conception of his situation in the world at a certain stage of evolution of his species and in function of the information received about his status in the universe. Each time a fresh piece of information questions the reigning definition, man gains a new awareness of his relationship with the world—and the artist within the pictorial space represents a new visual system which explains it. At this very moment emerges the *deconstruction* of the former system and the setting up of a new scheme.

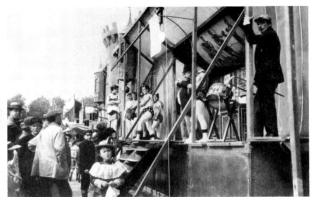
Traveling show at Chatou. About 1885.

Georges Seurat.

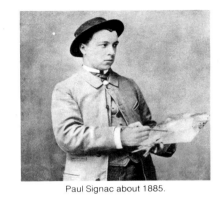
Paul Signac about 1885.

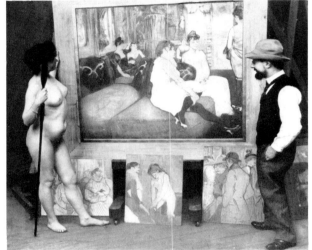
Toulouse-Lautrec in his studio.

Whether the second generation turned to popular folklore or, like Seurat, to the austerity of an implacably rational method, it planned to increase and extend Monet's optical sensualism.

Paul Signac before his painting, "The Port of La Rochelle."

With Impressionism the conception of a marked out and preorganized world was finally discredited. A geometrical, formal conception gave way to a subjective, intuitive one. Cézanne's wild eye pulverized the classical regulating outline. He composed his subject according to the disorderly solicitations of nature, obeying the imperious dictation of the stimuli. Men soon became so aware of the infirmity of their senses in the presence of the infinite complexity of time and space that they attempted to determine its laws beyond immediate representation—leading to abstraction. What the Impressionist refused was a confrontation between man and matter. No longer did he feel himself a spectator, a witness of reality. Nor did he continue to believe in the opposition between the self and the nonself. As Heisenberg wrote, "The ancient division of the universe into an objective unfolding in space and time on the one hand, into a soul which reflects this unfolding, and on the other, a division corresponding to that of Descartes into *res cogitans* and *res extensa*, is no longer suitable as a point of departure if one wishes to understand the modern sciences of nature. . . ." There was not on one side the artist and on the other—spread out before his eyes—the thing-world capable of being manipulated as a still life, a utensile, a piece of merchandise.

Each Impressionist painting relates the history of a liberation: Life has escaped from a rigid system of signs which sought to formalize it. The raw experience of vision denies the classic order in which man had believed. We are implicated, contaminated by nature. No longer is man the imperious arranger, the organizer. The world turns round without us. The Impressionist public was to discover, not without amazement, the autonomy of reality from man's visual and mental habits. For the bourgeois society of the nineteenth century, both positivist and pragmatist, the denial of traditional concepts was a revolution. An order that thought itself to be universal, finally realized that existence on every level is mutable. Each creator in his own sphere—Marx, Cézanne, Mallarmé, and soon Freud—offered a demonstration of the same truth.

The Precursors

Among the rumors circulated about the Impressionists seemingly the most plausible was their lack of culture. Only a base ignorance of great art could explain the mad overflowings of the "spot school." "The complete absence of any artistic education prevents them from ever crossing the deep moat which separates an experience from a work of art," wrote Albert Wolff in 1876 to his readers in *Le Figaro*. That same year Jules Claretie stated in his *Salon*: "Monsieur Manet has not made sufficient artistic studies and whatever talent for writing a man may have, he will always lack something if ignorant of spelling." The writer Bertall in *Le Soir* imagined himself a guide leading them to the museum. "It is useless to take them before the Titians, the Rembrandts, the Van Dycks, the Paolo Veroneses and so forth and so forth, before all the immutable masterpieces bequeathed by time."

The Impressionists, however, had visited the Louvre long before reading Bertall's article. In 1862 Manet met Degas there, the future painter of ballet dancers copying a Velázquez. Manet himself attacked Tintoretto's "Self-Portrait" and a "Virgin" by Titian. For his famous "*Déjeuner sur l'herbe*" ("Luncheon on the Grass") he took his inspiration from Giorgione's "*Concert champêtre*." He was to study one by one every museum in Europe from Prague to Madrid. Degas spent two years in Italy constantly sketching. Like Seurat later on, he admired Ingres and in his drawing almost achieved the master's quality. Cézanne also was to make many long visits to the Louvre, seriously studying Veronese, Poussin, and Chardin. Renoir analyzed the composition of the left section of Veronese's "Marriage of Cana," a theme he used in his "Luncheon of the Boating Party" (pages 110–11). He had a passion for Velázquez's "Infanta Margarita," which did not prevent him, during his period of reaction, to be influenced by Raphael, Boucher, and Ingres.

Frequent visitors to the museums, the Impressionists were chiefly attracted by the painters of light. And very logically, they sought their encouragement and took it from the Venetian painters, Rembrandt, Velázquez, Claude Lorrain, Watteau. Here they found a foretaste of what they were looking for, namely, the dilution of form and the eating away of the outline. El Greco, trained in Venice under Tintoretto and rediscovered in the nineteenth century, anticipated Cézanne's handling of forms. His backgrounds and figures, all represented with the same tortured distortion, interpenetrate. The frontality of Poussin's compositions and the muted radiation of his colors fascinated Cézanne, who perceived something other than mere classical formulas. During a trip to Holland in 1872 Manet studied Frans Hals and received a lesson in freedom. The painter of Haarlem strengthened his will to express life by what is unclear, trembling, and unfinished. The same preoccupation was to be rediscovered in the washes and watercolors of Constantin Guys, his elder by thirty years, a virtuoso of the instantaneous, the "painter of modern life," an outstanding draftsman whose merit, long underestimated, was not ignored by the painter of "Olympia." Manet painted Guys' portrait and collected his drawings; there were sixty in his possession when he died in 1883.

If we were to render an account of the various historical currents which irrigated Impressionism, we would have to mention the entire history of art. When a new school makes its appearance, we are first struck by its singularity. In 1907 Picasso seemed extravagant. Ten years later we find him becoming Cézanne's successor, and it was Mondrian who created a scandal. One of the paradoxes of Impressionism stemmed from its twin romantic and realistic affiliation. From Romanticism it borrowed technique, though rejecting its themes. Renoir redid Courbet with Delacroix's coloring. Manet, who believed only in the truth of the moment, found in the visionary Goya not only encouragement but that "spontaneity" and that "haziness" which delighted him in Frans Hals. The Spaniard knew how to trap the impression, the passing scene. Though he never left the studio, he saw in spots. According to a contemporary, "Goya painted far from his model, seizing the masses and effects, the natural aspects and attitudes, never bothering about lines and contours." In addition, he pulverized classical concepts of composition, cutting away his surfaces with diagonals. His was an abrupt world with off-center masses, volumes in acrobatic positions, jumps in chromatic scale, and quite often a denial of perspective. Another influence from Romanticism was Turner, to whom a cosmic vision was more significant than a precise observation of reality. The physical world was merely an alibi for his immense canvases where forms all but dissolve. By drowning the object in light, Turner taught Pissarro and Monet to disdain line and local color.

In Constable, however, Delacroix, the artist who painted the "Massacre of Scio," discovered the principle of the separation of tones. This was one of those moments when the two great nineteenth-century currents—Romanticism and Realism—crossed and fertilized. "Constable," wrote Delacroix in his *Journal*, "says that the superiority of green in his meadows stems from the fact that it consists of a host of different greens. The error of intensity and of life in the greenness painted by the average landscape artists is the result of his usually employing a uniform tone. What he says here about the green of the meadows can be applied to every tone."

Delacroix used it, dividing his colors with increasing boldness (page 34) and achieving by means of long threadlike brushstrokes the optical combination which Seurat, thirty years later, was to turn into a system in attempting to form "those kinds of diamonds which flatter and

delight the eye independently of any subject or imitation." The great formal eccentricities, however, were to be found in British and German mystical painting. The first merit of the mystic painters lay in their negative strength. Blake, Palmer, Friedrich, Runge, Stifter (pages 36–37)—also Füssli—contradicted the strict Neoclassical and archaeological schemes imposed by official theorists. In his ecstasies, Runge, like Blake, questioned the horizontal stability of the Renaissance composition and launched into gyratory reveries which defied the law of gravity. A light comes from an undefined source to illuminate landscapes, each object of which houses the Spirit. "God is everywhere," explained Friedrich, "even in a grain of sand. . . . I represented him by painting reeds." Palmer stated, "We must try to bring from behind the hills some of that mystic glimmer comparable to that which illuminates our dreams." With German Romanticism the Impressionists had no direct contact. But Delacroix, whose German and Flemish ancestry on his mother's side is mentioned by René Huyghe in his work on the painter, retained something of it.

In the presence of the twisted cypresses of St.-Rémy, Vincent van Gogh's profoundly religious soul, utterly fed by puritan Calvinism, discovered the passionate and feverish expression of a Palmer or a Runge. Less mystical was the mountainous landscape school which developed in Switzerland at the turning of the nineteenth century with such painters as Caspar Wolf, expressing a fresh interest in nature, though in this case it was solemn and dramatic. The monumental abstraction of their subject matter—glaciers, barren rocks, jagged mountain chains—inspired strange compositions with vertical axes and disproportions which jarred with the traditional canons of art. The same held for the watercolors of a man like Alexander Cozens. Influenced by the Far East, his style, based on spots and gestural automatism, opened the way at the height of the eighteenth century for an entire pleiad of landscape painters: his son Joseph Robert Cozens, Francis Towne, Thomas Girtin, John Constable, Richard Bonington, and John Sell Cotman (page 40). They painted out of doors and found formulas for a surprising freedom, including frontal poses, spontaneity, and asymmetric balance. At the close of the eighteenth century England, Switzerland, and Italy witnessed a coming and going of artists. They traveled around France, which remained relatively unknown. French landscape painters, however, made a pilgrimage to Rome, where about 1750 Joseph Vernet painted harbor and shipwreck scenes bathed in a fine light.

Pierre-Henri de Valenciennes, in his techniques and his writings, was an immediate precursor of Impressionism. With him we leave the Romantic to consider the analytical aspect based on careful observation (pages 32–33). In 1800 he published a work "on the landscape

genre" in which he distinguished the "realistic landscape which makes us see nature as it ought to be." He suggested replacing topographical perspective by that of feeling—which Cézanne was to do—and recommended coloring the shadows, a practice dear to Monet. He also recommended never working more than two hours on the subject since the light changes, transforming the values and altering the vision. Michallon (page 33) and Corot were to be influenced by him. A lesser known artist like the Dane Fritz Melbye, Pissarro's first teacher in the tropics, also belonged to this Roman landscape tradition in which a luminous effusion of light softened what had been exaggeratedly severe in the classical treatment.

While painters in Italy easily allowed themselves to be charmed by the past, England was already facing the Industrial Revolution. The early years of the nineteenth century heralded the "age of coal and iron." The first locomotive dates from 1804. In 1830 there were twenty miles of rails and in 1854 six thousand. British industry progressed at an astonishing pace. In the face of this accelerated rise of the machine with its cortege of ugliness, painters reacted instinctively by romanticizing the view. In their scenes of some industrial complex, we feel their latent hostility toward the subject. In the distance a bluish smoke winds above trees. In the foreground are a plough wheel and a column shaft to recall "real" values.

"What I should like to express in my paintings," explained Constable, whose influence on Delacroix we have mentioned, "is light, dew, a breeze, blossoming nature, freshness, nothing at all of what has been painted until now." In his sketches, his watercolors, and his oil paintings on paper (page 41), he captured in a second a cloud passing and the dotted effect of the sun on foliage. "No two days are alike," he said, "nor even two hours, and ever since the creation of the world no two leaves on a tree are the same." This is almost the tone of the Impressionists. In 1871 Pissarro, in much the same spirit, painted in London some of his best works. Constable often treats nature as large close-ups, concentrating his attention on a root (page 211), a thicket, or rushes scattered at the far end of a pond. His was a close, realistic vision in contrast to that of Turner. The painter's work became a careful inquiry into both the physical world and his own vision.

The second generation of British Naturalist painters pursued Constable's effort. With David Cox (page 40) we definitely enter the realm of sensorial landscape painting. A secret affinity seemed to link the watercolor painter born in Birmingham to Frenchmen such as Monet, Pissarro, and Renoir. Not that Cox was a forerunner of the Impressionists. Eugène Boudin and Johan Jongkind and not the English were to teach the young Monet the taste for luminous transparency and the magic of atmospheric changes. When Monet met Boudin at Le Havre,

he was seventeen years of age. The master of beaches and skies (pages 46–47) literally placed a paintbrush in his hand. "At his insistence," related Monet, "I agreed to work with him out of doors. I bought a paint box and there we were, off for Rouelles, with little conviction on my part. Boudin planted his easel and set to work. I glanced at him with some apprehension, then with greater attention, and suddenly it was like a veil torn apart: I understood and grasped what painting could be. The sole example of this artist in love with his art and his independence announced my destiny as a painter."

More important perhaps was the role assigned to Jongkind (pages 46–47). "Any landscape of any value at the present time," wrote Edmond de Goncourt in 1871, "stems from this painter, borrowing his skies, his atmospheres, his terrains." With the young Monet Jongkind proved particularly cordial. "He insisted on seeing my sketches, invited me to go and work with him, explaining to me the 'why' and 'how' of his style and thus completing the teaching which I had already received from Boudin. From that moment on, he was my real master."

These two teachers moderated in Monet and his friends what the powerful presence of a Courbet, whose fluency dominated the Realist school, would perhaps have exaggerated. They soon realized the limit of a style which, while treating daily life, was nevertheless associated with studio prestige and *cuisine*. Boudin, Jongkind, and Corot (pages 42–43) taught them to lighten the Barbizon color scheme, covered in "quid juice." Barbizon painters like Dupré, Diaz, Millet, Rousseau, and Daubigny formed the link with the seventeenth-century Dutch tradition, painters such as Ruysdael, Hobbema, Van Goyen, Cross, and Van der Neer. The Impressionists realized the limits of this painting which sought, in simplicity of effect, a spirituality, a "pathetic" quality foreign to their agnostic positivism. Instead they were to create an aesthetic of subjective vision of what they experienced. No longer did they paint the landscape but rather the perception of this landscape. Influences received by chance during visits to museums and from the study of the history of art changed into a war machine against the composition and space based on Renaissance concept. It was both a critical and constructive achievement effected by the conjunction of a multitude of efforts. The destruction of classical space was to be the work of a team.

The scales fall from the painter's eye.
He breaks up the immutable order of
classical nature and responds to the
pleasures of immediate sensation.

Achille-Etna Michallon. "View of a Sicilian Harbor." About

Pierre-Henri de Valenciennes (1750–1819). "The Ruins of the Villa Farnese." Paper on cardboard. 10.1 x 15.6 inches.

Paper glued to canvas. 7.4 x 15.2 inches.

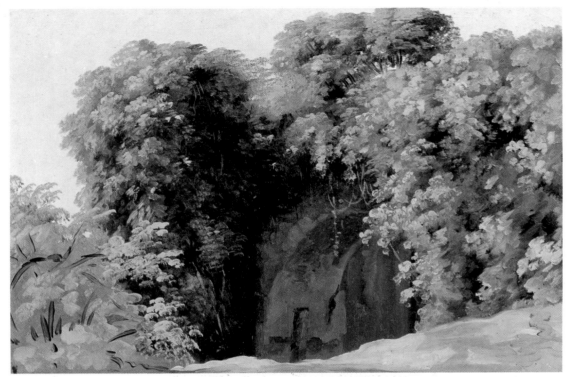

Pierre-Henri de Valenciennes. ''Entrance to a Grotto.'' Paper on cardboard. 10.9 x 15.6 inches.

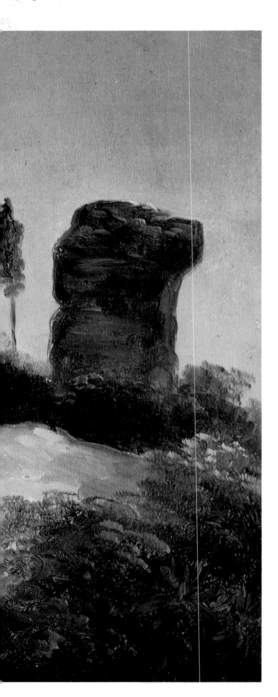

AT THE TURN of the nineteenth century, landscape was midway between Romanticism and Realism and expressed a dual atmosphere—on the one hand an overflowing pantheism and a dilution in the universal, and on the other, the taste for concrete and methodical observation of nature. Jean-Jacques Rousseau's *Emile* appeared in 1762 with the "profession of faith of a Savoyard vicar." This was the period of reveries and of studious meditations. While out on a stroll, Rousseau botanized and examined physical phenomena. Achille-Etna Michallon, who was in Italy a few years before Corot, suggested "taking a good look at nature and naïvely reproducing the scene with the greatest care." Through the influence of Claude Lorrain, the taste for true detail made a breach in a form still linked with Renaissance spatial schemes. Michallon's fishermen (*above*), working at the seashore and under a dramatic sky, may be compared to Monet's paintings of Etretat half a century later.

The majority of the artists painting landscapes in Italy gave their patrons and colleagues solemn compositions inspired by classical canons, while in their portfolios they kept their sketches. The freshness and freedom of the latter were a foretaste of what painting was to be in the second half of the nineteenth century. The ephemeral and the luminosity of nature were Valenciennes' themes in an amazing series of sketches now in the Louvre. The artist made these brief sketches of the Roman countryside on the spot with little concern for balance or construction. For a better understanding of the role of sunlight, he painted the same site at different hours and advised his pupils to follow this method. This concept was to be taken up by Jongkind and Monet. He did studies of clouds and fog and recommended painting after the rain. He would become fond of a rock, a tree trunk, a thicket. He prophesized a number of the attitudes of the Impressionists.

Eugène Delacroix. "The Death of Sardanapalus." Detail. 1827.

Eugène Delacroix. Close-up of the harness in "The Death of Sardanapalus."

Eugène Delacroix (1798–1863). "St. George Destroying the Dragon." 1847. Oil. 10.9 x 14 inches.

Background and foreground interpenetrate. Renaissance depths are diluted in romantic imagery.

THE ROMANTIC COLOR scheme diluted outline. Figures are part of the half dreamlike, half vaporous atmosphere in which the entire composition is bathed. No longer do they stand out in the foreground but rather consist of the same substance. In Girodet's "Ossian" sketch (*right page*) and in Delacroix's "St. George Destroying the Dragon" (*above*), texture envelops the whole composition. Spaces overlap, depth becomes ambiguous, and spacing is upset. "Such figures as Horace and Paris painted by David may one day, somewhere, encounter Piero della Francesca's Queen of Sheba but never Girodet's Ossian," wrote the art historian Pierre Francastel to point out the change which had occurred between David's graphic style and the more fluid one of his pupils. Awarded the Prix de Rome in 1789 for his "Joseph Recognized by His Brothers," Girodet received a commission for a fresco in 1801 from the architect of the palace La Malmaison. Scottish mythology was then popular. Napoleon, a fervent reader of James Macpherson's poem *Ossian*, was well pleased with the final fresco. Referring to this work, Girodet said, "It is entirely of my own creation and no model served as inspiration." His later work, including the melodramatic "Deluge," became conventional.

Imagination, the "queen of faculties," as Baudelaire described it, inspired Delacroix. The Impressionists, however, were to be interested chiefly in his technique. Delacroix was Cézanne's idol. Among the projects dearest to the painter of Aix was a homage to the artist of the "Women of Algiers," in which he planned to portray himself along with Pissarro, Monet, and the collector Chocquet. As early as 1881 Seurat carefully studied Delacroix's "Fanatics of Tangiers." In 1899 Signac was to acknowledge in "his lofty and clear genius" the source of all their research. As for Baudelaire, the poet stated, "One would think that this painting, like sorcerers and magicians, projects its thought at a distance. . . . It seems that this color thinks by itself independently of the objects it clothes." An enlarged detail of "Sardanapalus" (*above*) reveals how Delacroix separated his tones to let them mingle in the spectator's retina.

Anne-Louis Girodet de Roucy known as Girocet-Trioson (1767–1824). ''The Shadows of French Heroes Received by Ossian in Odin's Paradise.'' 1801. Oil on wood. 13.3 x 11.3 inches.

Caspar David Friedrich (1774–1840). "Rocky Landscape." About 1812. Oil. 36.7 x 28.5 inches.

Northern mysticism produced surreal landscapes, heralding the violent art of Van Gogh.

Samuel Palmer (1805–81). "The Magic Apple Tree." About 1830. Watercolor. 13.3 x 10.5 inches.

...pp Otto Runge (1777–1810). "Birth of the Human Soul." About 1805. Oil on ...d. 14 x 12.9 inches.

Adalbert Stifter (1806–68). "Landscape of the Teufelsmauer." About 1845. Watercolor. 4.7 × 5.85 inches.

A MAGICAL realism steeped in mysticism invaded Northern landscape painting. The German Romanticists excelled in expressing the latent presence of the sacred element in the slightest piece of rock or dead tree trunk. In their own manner these painters contributed to transcending the rigid eighteenth-century values. They became the link with the sixteenth-century artist Albrecht Altdorfer on the one hand and Van Gogh and Redon on the other. In this painting of anguish and fantasy, of metaphysical questioning and violent affirmation of God nature seems to be held in a gigantic silence. "Painting for [Casper David] Friedrich was a veritable priesthood, a worship returned to light," wrote Marcel Brion. With him this light is often lunar and unreal. "The sole true source of art is our heart, the language of a pure and candid soul," explained the artist. "A painting which cannot gush forth from there is mere jugglery." The son of a candle merchant, familiar with the wild shores of the Baltic, Friedrich's

entire life was to be marked by a tragedy which occurred when he was young. One day while skating with his brother Christopher, the ice broke and his brother disappeared below before his eyes. Friedrich was then thirteen. This may explain that discreet melancholy and taste for ruins which the artist expressed in his mountainous landscapes (*left page, above*) and in his seascapes. With his friends Philipp Otto Runge (*above, left*), who died of tuberculosis at the age of thirty-three, the main theme is that of a perpetual return to birth, to a world in which time and space were circumscribed in an eternal gyration and closed to itself. "I want to hold back the spirits which float in space at that hour when the sun is setting and moonlight gilds the clouds. . . . Behind each flower we should see a living being," he wrote.

The affinities between Runge and Samuel Palmer have often been emphasized. Deeply religious, orphaned from childhood, Palmer was fascinated

by William Blake, whom he met when he was nineteen. Blake said to him, "He whose imagination does not create a line stronger and more beautiful, a light stronger and more beautiful than the poor eyes of the mortal can see—has no imagination whatever." In his Kentish landscape (*left page, right*) bathed in an alchemistic light of gold and night which announces Van Gogh's yellows, the curve of the hills echoes that of the sheep, the trees lean and fold to form an arch above the shepherd. In his curious and arid watercolors (*above*) Adalbert Stifter establishes the presence of tellurgic energy, the muted presence of the earth. He would collect pebbles along the roads, arrange them in a basin and cover them with water. As Marcel Brion explained, "He and his servant would then shake this basin until the pebbles in the water were arranged to their satisfaction." This explains the strange texture and disturbing color of his lava landscape.

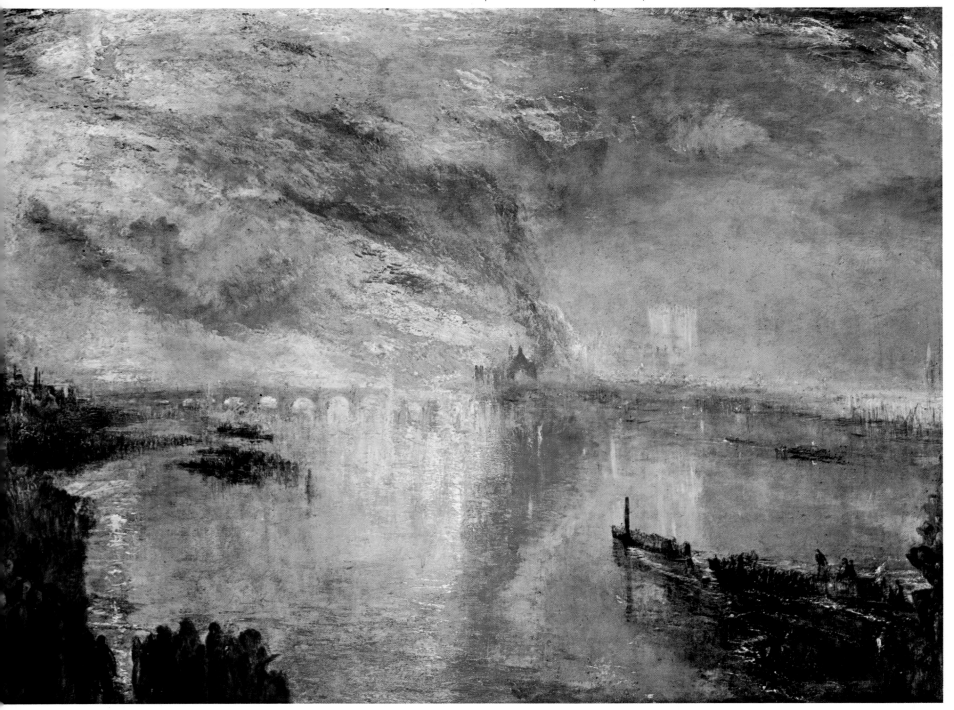

LIGHT ON the red of flames, the black of smoke and the white of snow, this is how Turner conceived his work. The obsession of the entire life of this visionary was to paint better than Claude Lorrain. In his will he specified that one of his works should hang permanently alongside a seascape by the French master in exchange for which he bequeathed to the British nation 19,000 drawings and more than 200 canvases. No one prior to the nineteenth century had gone so far as Turner in the evaporation of form, and no one realized better than he how much each particle of matter is part of a whole that is in a constant state of change. His canvases are huge surfaces of a powdery texture illuminated by a radiation which he himself described as "divine." The artist

seems to paint both the origins of the world and the final cataclysm which will engulf the human race. Immediate reality—the Houses of Parliament on fire (*above*) or a snowstorm (*right page, below*)—is for him merely the first inspiration which will release his reverie.

At first the Impressionists were fascinated by Turner. Pissarro and Monet fled to London in 1870. "In the midst of the ninety [Turner] paintings in the National Gallery," related Gustave Geffroy, "they had the thrill of a happy encounter, the warning shock of instinctive attraction, the joy of seeing that what they were seeking had already haunted another mind and that achievement had begun." Soon accused of being mere pupils of the lyrical Englishman, they were

not long in keeping their distance. "Although Turner and Constable were useful to us," wrote Pissarro in 1903, "these painters made us realize that they had failed to understand the *analysis of shadows*, which with Turner is always rank obstinacy of effect, a hole. As for the division of tones, Turner confirmed to us his value as a method but not as accuracy or nature."

And Monet was to remark that already before 1870 he was more realistic and analytical than Turner, adding that the British artist was "unlikable because of the exuberant romanticism of his imagination."

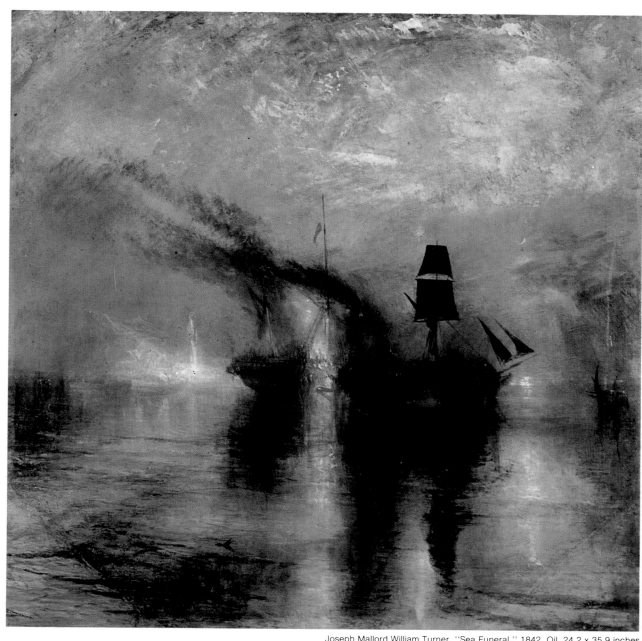

Joseph Mallord William Turner. "Sea Funeral." 1842. Oil. 24.2 x 35.9 inches.

Joseph Mallord William Turner. "Snowstorm, Avalanche and Inundation of the Aosta Valley." 1837. Oil. 35.9 x 47.6 inches.

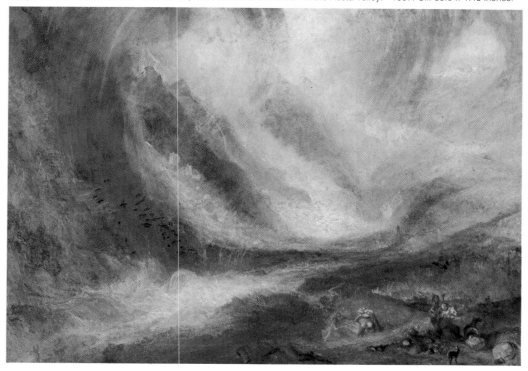

Turner breaks up the disparate components of the visible world. Water, fire, sky, and earth are drowned in the impalpable.

David Cox (1783–1859). "The Night Train." About 1856. Watercolor. 10.5 x 14.4 inches.

David Cox. "Sun, Wind, and Rain." 1845. Watercolor. 17.5 x 23.4 inches.

John Sell Cotman (1782–1842). "Ganton Park, Norfolk." 1831–32. Watercolor. 16.4 x 11.9 inches.

To the onslaught of the Industrial Revolution, British art responded with poems dedicated to light.

John Constable (1776–1837). ''The Grove in Hampstead.'' 1821–22. Oil on paper. 9.4 x 11.7 inches.

By USING methods best adapted to their requirements of speed and direct observation of nature, British artists of the first half of the nineteenth century foreshadowed the Impressionist attitude. "What! Always comparing old, black, smoky and filthy canvases to God's work!" exclaimed Constable. Anticipating Cézanne, he added, "When I sit down, pencil or brush in hand, before a scene of nature, my first concern is to forget that I ever saw a painting."

The fascinating quality of these sketches, which were not destined for the public but were made as studies, is the spontaneity of the painter's eye (*see also* page 211). No preliminary line leads Constable's hand in his rapid, rough search for reality. His intuitive brushstroke is marvelously adapted to the quest for the ephemeral. "The Grove in Hampstead" (*above*) was painted from a window, doubtless on seeing a rainbow. Constable—fifty years before the advent of Impressionism—paints the trees in an abrupt manner. Here and there he heightens the gray-green trees with a spot of red. John Sell Cotman's vision, however, was a more formal one. He devoted the first part of his life to watercolors painted without shadows, akin to Oriental art or the Cloisonnism of Gauguin. He later fell under the influence of Turner and Bonington, and his conception of nature became a more fluid and familiar one (*left page, below right*). The foreshadowing of Impressionism, however, was most evident in David Cox (*left page*). His art, so amorous of nature and so sensitive to the slightest vibrations of the countryside, was a reaction to the industrialization of his country. In his "Night Train" (*left page, above*) the mechanical world in the distance is contrasted to the horses—symbols of freedom—in the foreground.

Charles-François Daubigny (1817–78). "Sunset on the Oise." 1865. Oil. 15.2 x 26.1 inches.

The rebirth of French landscape found expression in the capture of the instantaneous.

Théodore Rousseau (1812–67). "Oaks." Undated. Oil. 20.7 x 25 inches.

MODEST EXPLORERS of underbrush and glades, the Auvers and Barbizon painters reestablished both landscape as a genre and the Ile-de-France as a subject. Despised during the First Empire, crushed under the weight of historical paintings, limited to the solemn descriptions of the Roman country-side, landscape before Barbizon—and despite Constable's success and Géricault's experiments—was considered typical of the *petite manière*. As a result, after welcoming Théodore Rousseau's early work (*above*), the Salon refused his canvases for eight years, disregarding the sincere charm of an art in which flecks of light were deliberately treated as half tones.

Charles-François Daubigny. "Sunset on the Oise." Detail.

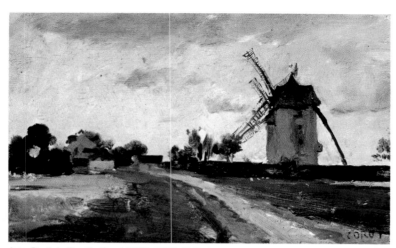

Jean-Baptiste-Camille Corot (1796–1875). "Windmills on the Picardy Coast." About 1855–65. Oil. 3.5 x 11.7 inches.

Jean-François Millet (1814–75). "Spring." 1868–73. Oil. 33.5 x 43.7 inches.

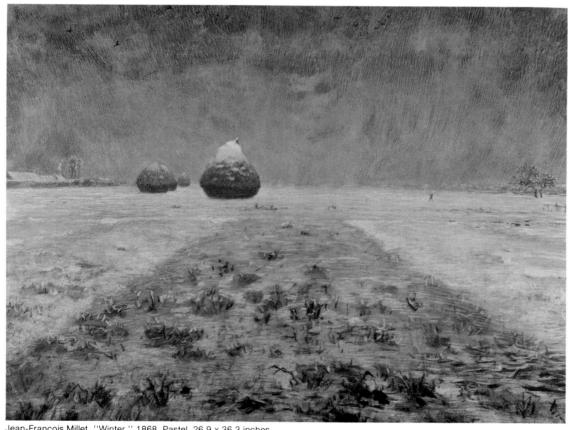

Jean-François Millet. "Winter." 1868. Pastel. 26.9 x 36.3 inches.

BARBIZON, HOWEVER, bore in itself the seeds of the Impressionist revolution. This painting favored luminous and changing subjects, the subjective point of view, simplified composition, and finally the practice of painting out of doors. The Barbizon artists followed the practice of working in the countryside and finishing a painting in their studio.

The depiction of water and reflection, which was to make Monet one of the giants in the history of art, is found earlier in Charles Daubigny's work. In 1857 he built a barge, the *Botin*, surmounted by a small cabin—Monet was to do the same fifteen years later (*see* pages 98–99)—and spent a wandering life exploring the Seine basin, paint-

ing on the spot his amazingly fresh "impressions."

Paul Durand-Ruel related how, in London in 1870, Daubigny introduced him to Claude Monet. " 'Here is a young man who will be greater than all of us.' On seeing his unusual paintings, I was a bit lost and hesitated. Daubigny said to me, 'Buy them. I promise to take back those you cannot get rid of and to give painting in exchange, since this is what you prefer.' "

Corot, whose success definitely came to him only when he was almost sixty, also proved a mediator and a friend to the new generation. When he was Berthe Morisot's teacher, he recommended constantly returning to the subject and never forgetting the first impression. In his

"Windmills on the Picardy Coast" (*left, above*) the frontal treatment of the foreground already announces the Pissarro of the 1870's.

Jean-François Millet, who settled at Barbizon in 1849, was in love with thick and fertile soil, even when sometimes hidden by a layer of frost (*above*). The art historian and critic Bernard Dorival compared Millet to the religious poet Charles Péguy. Louis-Emile-Edmond Duranty, the Parisian-born novelist and theorist of Realism, called him the "Homer of the modern countryside." Van Gogh, while he was at St.-Rémy, made many painting copies of Millet's engravings, and he was not to forget his undisguised perspective with vanishing lines planted into the landscape. 43

Paul Huet (1803–69). "Landscape, the Elms of St.-Cloud." 1823. Oil. 16.4 x 20.3 inches.

The artist exalted the chemistry of pigments. He shortened his perspective and revealed a new subjective space.

Adolphe Monticelli (1824–86). "Negress Holding Birds" ("The Palace of Scheherazade"). About 1878. Oil on wood. 11.7 x 15.6 inches.

François-Auguste Ravier (1814–95). "Garden of a Roman Villa." About 1842. Paper glued to cardboard. 9.8 x 10.5 inches.

An entire *cuisine* of rich material invaded painting. The artist tried to make the very substance of the painting a textural delight. He emphasized the impasto, the spots with blended outline, the accumulation of glazes which gave the texture an ambiguous and fascinating denseness. Henri Focillon, referring to Monticelli's color (*left page, below*), mentions his impasto "which is often taken and shaped with a knife, often collected, worked in dusty conglomerates at a regular rate, tapping them with a small, round, and short brush." Cézanne's curiosity was aroused by such effects. He often visited his friend in Marseilles, where in 1870 the old Monticelli had returned to settle and, while poverty-stricken, had continued his alchemist experiments. The two would often paint together from the subject, even spending a month, knapsack strapped to their shoulders, in the Aix countryside. Cézanne studied his fellow artist to pierce his personal secrets of handling pigment. Van Gogh was also fascinated. Speaking of Monticelli, he stated, "I sometimes think I am really continuing that man."

Romanticism was one of the chief characteristics of the work of Paul Huet (*left page, above*), who in the 1820's painted foliage scenes with a dramatic note. He offers the vision of wild, often tempestuous nature—as later in his Honfleur storms—disregarding the criteria of composition and formal balance which dominated the teaching of Gros and Guérin, whose pupil he had been. Huet is often as free and direct as Constable whom he was not to discover until the Salon of 1824. The friend of Dupré, of Diaz, and of Théodore Rousseau, he was among the champions of sensible and subjective landscape which triumphed at Barbizon. François-Auguste Ravier and Antoine Chintreuil, both born in 1814, the first in Lyons, the second in Paris, were in close contact with Corot. Ravier met him in the Roman countryside in 1839, and Corot appreciated Ravier's sense of light. What strikes us even more today in this little-known artist is the boldness of his foreshortening which contracts depth after the fashion of certain works by Cézanne painted in the 1870's. In his "Garden of a Roman Villa" (*above*) the oblique tipping of the trees (on the right) emphasizes a spontaneous view. A similar perspective is evident in Chintreuil (*opposite*), whose titles such as "Space, Rain, and Sunshine" announce Impressionist themes. For this sickly, solitary, poor painter, a former pupil of Corot, the Ile-de-France was the occasion of delicate poems in which Redon rightly distinguished "that tender and gentle genius which reveals itself in a simple manner and in such a discreet form and whose profound and passionate reserve is echoed only in a number of select souls."

Antoine Chintreuil (1814–73). "The Coast." About 1850–57. Oil. 8.6 x 10.9 inches.

Johan Barthold Jongkind (1819–91). "Boat Wash House on the Seine." About 1855. Watercolor. 11.7 x 18.3 inches.

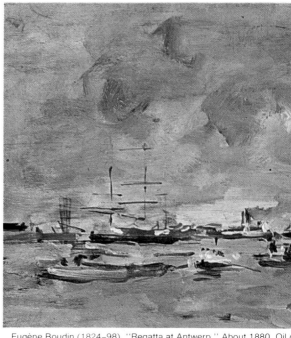

Eugène Boudin (1824–98). "Regatta at Antwerp." About 1880. Oil on

Johan Barthold Jongkind. ""*Au Roi du désert.*" About 1954. Watercolor. 11.3 x 14.8 inches.

Johan Barthold Jongkind. "View of Grenoble." 1877. Watercolor. 9.4 x 14 inches.

MONET'S IMMEDIATE precursors and his companions were haunted by the desire to depict the fleeting moment. The "Seascape" of 1874 (*right page*) reveals Courbet as the "powerful worker, with a wild and patient will," as described by Baudelaire. A peasant as well as a hunter, Courbet wanted to paint nature within reach and express the truth of its matter seen at its closest. One day when asked what he was painting, he had to step back to study the canvas before recognizing the subject. In 1862 he gave a course for a few months in the Rue Notre-Dame-des-Champs and posed a live pony as well as an ox. He believed only in what he saw and what he could touch. "I maintain that painting is basically a concrete art," he stated, "and it should exist only in the representation of real and existing things." Vain but honest and, as Zola described him, "terribly rowdy," Courbet had promised himself never "to deviate a hair from his principles" nor "to lie a single instant to his conscience," nor to paint "even as much as a hand purely to please someone or to sell more easily." From the beginnings of Impressionism, he tried to support those painters younger than himself. This was the period when Renoir, Cézanne, and Monet tried to imitate him to the very point of turning to his palette knife technique. "I have a precious memory of these relations," said Monet. "Courbet was always so encouraging and good to me, to the point of lending me money at the most difficult moments."

The same generosity was found in Eugène Boudin, a modest observer of the Channel beaches, admirer of Dutch painters, of Guardi, and of Watteau. "Everything that is painted directly on the spot always has a strength, a power, a brushstroke vivacity which is no longer found in the studio," he explained to the novice Monet. "One must show extreme stubbornness to retain the first impression, which is the right

ed wood. 8.2 x 14.4 inches.

Grenoble

Courbet, Jongkind, and Boudin
make transparent air their favorite theme.

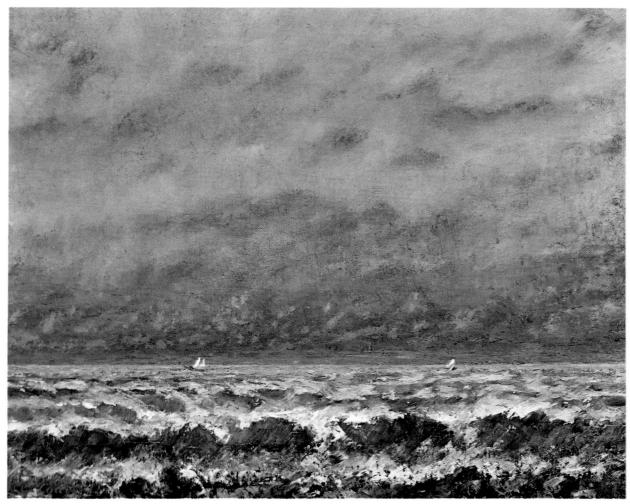

Gustave Courbet (1819–77). "Seascape." 1874. Oil. 17.9 x 21.45 inches.

one." Among his masterpieces is the "Regatta at Antwerp" (*above, center*). In these flags the unstable blues and reds palpitate beyond their outlines, as though the eye, struck by the liveliest spots, had kept the impression for a longer moment. Color became independent of form. Thirty years later Raoul Dufy, a native of Le Havre, was to resume and develop the same method.

Johan Barthold Jongkind was one of the most influential of the precursors of the Impressionists. As Bernard Dorival described, Jongkind's watercolors express an almost emotional feeling for light. His vibrant and light brushstroke captured the impalpable transparency of the air. Whether he painted the Seine, the shanties of Montmartre, or a mountain chain above Grenoble, whether wandering along the roads of Holland, Savoy, or Normandy, this alcoholic vagabond, whom on countless occasions many considered lost to painting, had a prodigious gift for the imperceptible changes of atmosphere.

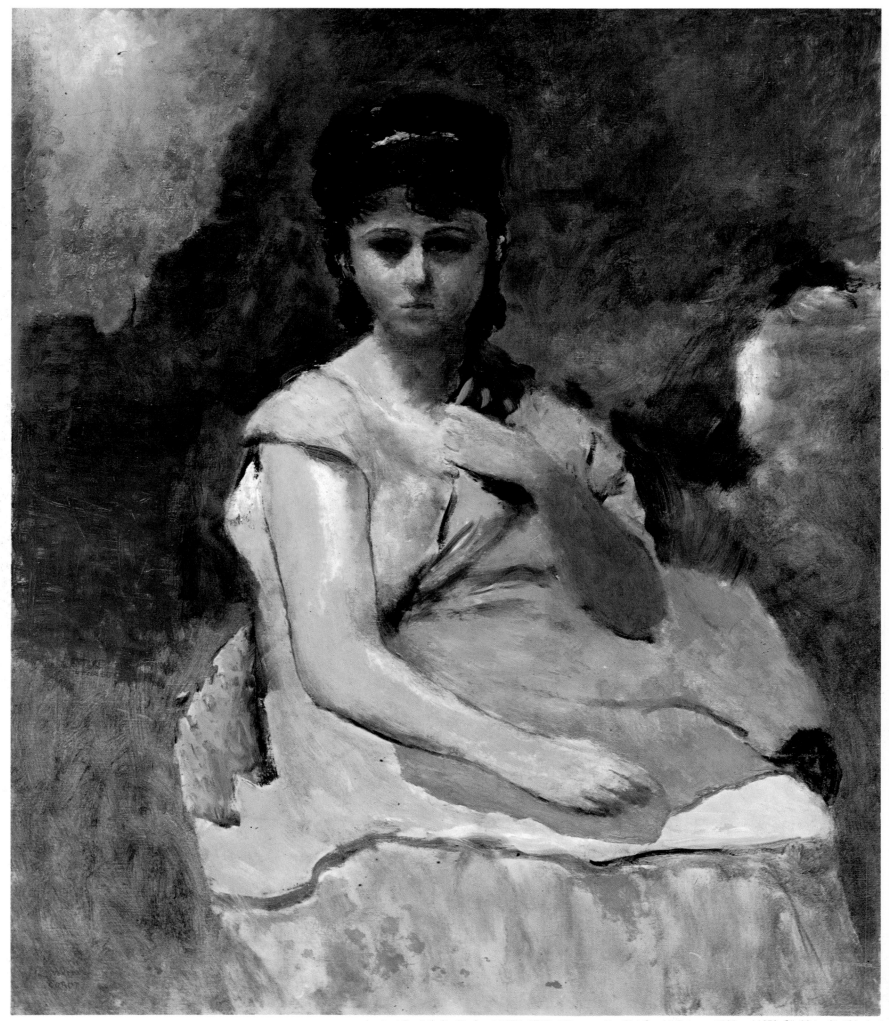

48 Jean-Baptiste-Camille Corot (1796–1875). "Woman with a Pink Scarf." Between 1865 and 1870. Oil. 26.1 x 21.45 inches.

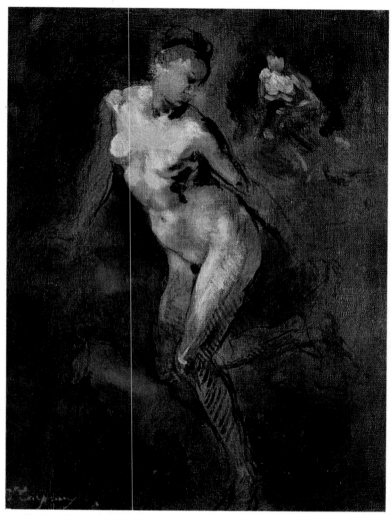

Jean-Baptiste Carpeaux (1827–75). "Nude Study." Undated. Oil. 15.6 x 12.5 inches.

Jean-Baptiste Carpeaux. "Portrait of Charles Carpeaux." 1874. Oil. 15.6 x 12.5 inches.

In the trembling of these
faces are the first crises of
the human figure.

THE HUMAN figure by no means escaped the metamorphosis of vision. In the regal simplicity of the portrait of Mariette, Corot's model (*left page*), the flattening of perspective is as emphasized as in Cézanne's paintings (pages 237 and 241). The rendering is based on the interpenetration of the foreground and the background. The figure gradually emerges from an atmosphere of cloudy forms which often seem to stem from the area in front of the silhouette. This feeling is emphasized by the frontal view of the clothing, by the flat treatment of the arms, by the drawing with its outline indistinct in some parts, and by the rendering of the background in the same way as the figure. Corot painted figures when his health forbade him to work out of doors and to travel. A great many figure studies were made during the last ten years of his life. The public failed to appreciate them and preferred his landscapes. The Corot exhibition held at the Musée de l'Orangerie, in Paris, in 1936 revealed to a surprised public the painter of female faces. Picasso, who in his Harlequins painted during his Rose Period—often in a range of tone quite similar to that seen in the portrait of Mariette shown here—had recognized in the portraitist Corot one of the masters of French art.

Whereas Corot had an airy feeling, Jean-Baptiste Carpeaux is dark and dense. This well-known sculptor did more than 3,000 drawings and 10 paintings unfamiliar to the public, rich in color and texture, taking his place between Frans Hals and Alessandro Magnasco on the one hand and Manet on the other. Carpeaux, who was often accused of sculpting as a painter because of his broken light and textured surface (page 93), painted as a sculptor. In the portrait of his son (*above, right*) he applied thick color somewhat after the fashion of his terracotta figurines, in which the clay was rolled in his hand, then crushed with his thumb. His expressionist lighting effect, the luminous tones against a dark background, announce a powerful and determined painter. His pictorial work resembled the portrait which the Goncourt brothers gave of him in 1865: "A nervous, violent, exalted nature, a hacked-out figure constantly moving, the muscles changing from place to place and the eyes of an angry workman. The fever of a genius in the skin of a marble mason."

Pierre Puvis de Chavannes (1824–98). "The Dream." 1883. Oil. 32 × 40.15 inches.

THANKS TO a trio of Symbolists, whose spatial and chromatic conceptions were to influence Gauguin, Seurat, and their followers, as early as the 1880's the conquests by the Impressionists were to be questioned. Odilon Redon was Monet's age, Puvis de Chavannes his elder by sixteen years, and Gustave Moreau by fourteen. Their approach to painting, however, was not to be known until later on when those who had grouped themselves around Monet had entered a crisis.

The former student of Delacroix and of Couture, Puvis de Chavannes was the greatest decorator of his time, covering huge surfaces throughout France. His range, to quote Félix Fénéon, was "an art of dreams, of silence, of slow movements, and of peaceful beauty." Order was his leitmotiv. He stated, "I am convinced the best orderly conception is found at the same time to be the most beautiful. I love order because I passionately love clarity." He triumphed, thanks to his feeling for space and to his taste for simplification. With him, the muraled wall was never cluttered; it "breathed."

Where Chavannes is noble and calm, Odilon Redon was secret and emotional. He was a kind of German Romanticist lost in a generation entirely devoted to a naturalism which he found "a bit stupid." His work stemmed from reality but was nourished by his dreams after the fashion of Max Ernst in the twentieth century. "It is only after a deliberate desire to represent in a more careful manner a blade of grass, a stone, the section of an old wall that I am as though caught in a torment to create the imaginary," wrote Redon. . . . "I spend hours,

Dreams and fantasies invade painting. On the fringe of Impressionism they announce the discovery of an unknown continent: the unconscious.

Gustave Moreau (1826–98). "Salomé or the Spectre." 1876–80. Oil. 57.8 x 40.6 inches.

Odilon Redon (1840–1916). "The Birth of Venus." About 1910. Pastel. 32.4 x 25 inches.

Odilon Redon. "The Spectre." Before 1900. Oil on wood. 20.3 x 14.4 inches.

or rather the whole day, spread out on the ground in deserted country places, watching passing clouds and following with the greatest pleasure the enchanting effect of their changing transience." He belonged to the family of such men as Francisco Goya and Edgar Allan Poe, enslaved to the vagaries of his unconscious, cultivating an uneasiness which he transfigured in richly blended and sparklingly colored pastels.

Even more mysterious was Gustave Moreau. Shut up in his strange laboratory in Rue Rochefoucauld in Paris, he created canvases that were heavy draperies, treated abstractly and filling his compositions with blood-red, gold, or dark blue areas. Their ambiguous, morbid, and opulent texture herald a taste for nonrepresentational painting as well as a fascination for materials. He spotted his color, which is also characteristic of his time.

The artist's point

of view shifts.
It re-arranges
the visual field.

Claude Monet. "Still Life with Eggs." 1910.
The artist, painting his subject as seen from above and with an asymmetrical composition, questions our visual habits.

Honoré Daumier. "Crispin and Scapin." About 1860.
Daumier inaugurates strongly shadowed theatrical lighting. Degas and Toulouse-Lautrec later followed his example.

Vincent van Gogh. "Shoes." About 1886.
Two different perspectives are used here, the one for the tile floor, the other for the shoes.

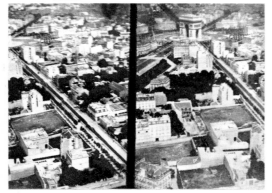

Nadar. "Views of the Place de l'Etoile."
Nadar's aerial photographs offer an unexpected vision of the urban landscape.

Of all the attacks made by the Impressionist generation on the spatial conceptions stemming from the Renaissance, the most spectacular was that of asymmetry. Classical painters—and all the more so their academic followers in the nineteenth century—had a sovereign regard for nature. The world was spread out before their eyes like an organized theater, the painter adjusted his easel for eye level, set the line of the horizon in the center of the canvas, and permitted himself only a slight deviation from the most distant view or from the foreground. The "natural" view was this face-to-face confrontation between an "immutable" reality and an "objective" eye which merely sought to record it externally, as it was in its balance and its "finish." The landscape was composed around an axis perpendicular to the horizon line and parallel to the ground.

With Impressionism this axis was dislocated and upset. Certainties were shattered. Space turned. It was as though an amateur photographer were unable to *center* his subject. Parts of figures appeared (page 62), floors invaded the field (page 68), objects were brutally cut in two (pages 82–83), the horizon line was painted above or below the painting (page 78).

The figure meanwhile lost its importance. No longer was it invariably seen enthroned in the center of the canvas; nature and decor were reassuringly arranged around it. It was cut up into sections, crushed against the ground which rose up, consigned to the edges, relativized in the confusion of objects and planes. It counted less than some pillar in the foreground or a table which occupied two-thirds of the composition (page 84). The human form itself, represented at unusual angles, no longer offered its familiar outline. Observed laterally, it became something else, blending in a puzzle of composite forms (pages 62–63) in which its outlines and its independence were negated.

Whereas the Renaissance had imposed a unitary space, with every pictorial element obeying the same regulating outline, the same law of perspective, the same geometrical setting, some painters, Van Gogh first of all, now used several vanishing lines. Shoes seen in close-up are painted from above, the tile floor on which they have been placed is viewed almost as though facing the spectator. The reason for this is that the artist has reconstructed what he has experienced and not what he *knew* of reality. He has considered not objective logic but a momentary experience. He has noticed the shoes first as a detail, a close-up, then felt the invading presence of the tile floor, and he has rendered this presence by depicting the floor in a frontal view. Here the experience was successive and not simultaneous.

Visual distortion, asymmetry, breaking up the classical visual scheme were first imposed by those Impressionists who were city dwellers. As early as 1859 Degas had observed in his *Notebooks*, "No one has ever painted houses or monuments from below, underneath or very close, as they are seen when one passes in the street." Paris was then a pedestrian's city in which space was absorbed at a walking pace. "With Manet," explained his friend Antonin Proust, "the eye played such a great role that Paris has never known such a stroller as he nor a stroller who strolled more profitably. . . . He would draw in his notebook a mere nothing, a profile, a hat, in short, a fleeting impression."

The accelerated urbanization which was carried out in the nineteenth century, the reconstruction of Paris by Haussmann, new vertical buildings, all created an artifical space, a jagged vision which was a more closed one, with perspective planes and horizons disappearing in plunging views and acrobatic angles (pages 76–77). In the 1850's the aerial photographs taken by Nadar from a balloon

revealed both an unknown image of the city, compact, huge, and well designed, and a fresh way of seeing it, that is, almost directly above the subject, with no stepping back or transition. These images, popularized by countless engravings, doubtless played a liberating role in the painters' vision.

Contrary to the general belief, this did not hold true for current studio or landscape photography which, as Pierre Francastel has pointed out, shared a close role with the Renaissance conception. The choice of subject matter created a spatial perspective directly inspired by classicism. Photography copied painting. The photographer Demachy imitated Corot. In the twentieth century cameras with close-up and wide-angle lenses proved by the diversity of their effects the relativity of traditional space. Painters preceded photographers. The close-up, like the wide-angle effect, was common among Impressionist painters (pages 81 and 85, 228 and 255). Some of the truly innovative photographs in the nineteenth century were in fact taken by painters like Degas who, using the camera, tried to transpose his research onto canvas.

Photography played a decisive role on other levels than the aesthetic. The photographer, now able to re-create the ancient visual scheme and to do so in multiples—since 1852 the invention of wet collodion had reduced posing time and increased the number of prints that could be made—could now compete with the Neoclassic *petits maîtres* whom he eventually eliminated entirely. Everything that was not an innovation became commonplace. The notion of perfection, the sterile struggle for a polished work, became meaningless—all to the distress of academic painters. Delacroix, in his *Journal*, describes them as "overwhelmed by the perfection of certain effects which they found in the daguerreotype." Photography robbed them of both a clientele and a function, namely, the reproduction of the human face, the capturing of time. One innovative pioneer, Disderi, created the "visiting card," the forerunner of the photo machine: eight inexpensive snapshots of the same person.

The painter was thus driven to adopt an offensive attitude; photography forced him to see further than the immediate reality which surrounded him. Henceforth he was going to orient his research on two levels: a more profound investigation of the complex mechanism of matter and energy (see Chapter IV) and a sharper grasp of the real mechanisms of perception. Not only did he show nature but also *how* this nature was perceived. It was here that the notions of points of view, of asymmetry, of the significance of lateral areas acquired their full importance.

There were certainly times in the history of Western art when classical geometrical perspective was not used. First of all, during the period of its development. Both Erwin Panofsky and Pierre Francastel have pointed out that Alberti's scenographic cube was nothing more than a reduction, if not an impoverishment, merely one of the possible methods of projecting three-dimensional space on a two-dimensional plane. They mention, among others, Giotto's cut-up space, Paolo Uccello's bifocal perspectives, and Jean Fouquet's circular spaces. Here and there during the course of generations appeared unorthodox solutions which, along with others, established themselves in the nineteenth century when painters attempted to restore—beyond the framework of a geometrical system—the experience of subjective vision.

Mannerism with its foreshortenings and its curious perspectives imposed its distortion on the monocular system. It evolved in the sixteenth century, a period of doubt and uneasiness resulting from the onslaughts of Protestantism. But its

Anonymous Japanese print. "Scene with Two Actors." Late seventeenth century.

Hokusai. "Two Fishing Barks on a Swelling Sea." Early nineteenth century.

Utamaro. "Flower Festival at Yoshiwara" (detail). About 1785.
Japanese artists did not use European perspective. Their receding lines do not converge toward a single point but, in most cases, are parallel.

distortion by no means pretended to be more truthful than Renaissance perception of the relationship between the eye and things. Quite the contrary. Its aim was to awaken, suggest, exalt, disarm the spectator, to create an unbalance and a dizziness, and to question kinesthetic stability. It tended toward reverie, the obsessional, morbidity, imagination. The petrified explosion of the Baroque emphasized this. The cupola frescoes by Correggio and Giulio Romano, far from tending toward fragmentation and dispersal, envelop us in an illusionist chaos which, since it is realistic, is all the more effective. We find ourselves at an epicenter, while clusters of bodies rush toward us, as we enter a gyration the final result of which is disorientation. Nothing here evokes the realistic cold analysis of a Degas. In the Baroque, there was a school of illusion, and in Degas a prosaic investigation into the state of modern vision.

Obviously affinities with Japan were much greater. We know how astonished the Impressionists were when they discovered preoccupations similar to their own in prints by Utamaro, Hokusai, and Hiroshige. The Treaty of Kanagwa (March 31, 1854) opened two ports in Japan and accelerated communication between the two worlds. Japanese merchandise was soon on sale in Paris. The year 1862 saw the opening of a shop called La Porte Chinoise which soon attracted artists' attention. Whistler collected blue and white porcelain as well as ceremonial robes. The Japanese print invaded the painter's studio. Monet and Renoir owned several of them. Referring to Pont-Aven Emile Bernard later was to explain, "The study of Japanese *crépons* [drawings on paper] led us to simplicity." In 1893 Pissarro exclaimed, "The Japanese exhibition is wonderful! Hiroshige is a marvelous Impressionist. Monet, Renoir, and I are carried away with enthusiasm. I am happy to have painted my snow and flood effects; these Japanese artists convince me of our attitude toward the visual."

This was the period when many painters—Monet, Van Gogh, Gauguin, Cézanne, the Nabis—produced work based on a Japanese model. They admired in Oriental art such devices as the bird's-eye perspective increasing the ground and restricting the horizon, a rooftop often removed to permit the eye to plunge into the setting; the bold layout that in the center left large empty spaces free; the spread-out surfaces for sea, sky, earth; the close-up of a tree trunk or of a pillar which crosses the foreground of the scene and continues beyond the setting; the suspension of a massive element—a huge terrace, the corner of a house—which rises in the upper part of the design or in the side, leaving the lower part free.

More generally speaking, these painters were impressed by a use of perspective which was strangely opposed to Western usage. The Japanese were not subservient to the dominant rule of Western painting in which the vanishing lines converged to a single central point. To represent the two lateral sides of a chessboard in space, they would lay out two parallels, even two lines which spread apart as they extended to the background. This *reversed* perspective was by no means the result of chance. For the Japanese, nourished on Zen Buddhism, it was illogical to organize pictorial space from the Western eye. Whereas the Western scheme postulated a central observer planted in the face of nature, a demiurge who arranged his canvas according to a regular scheme which he himself related to a geometrical vision of reality, the Japanese, quite the contrary, felt himself immersed in a chaos of which he was but an infinitesimal part. He was neither the measure nor the anchoring point of the world. He constructed the world freely, the vanishing lines receding in all

Leonardo da Vinci. "Man According to Vitruvius' Proportions." About 1492.
Man "in the square" and "in the circle" postulates a close relationship between nature and geometry, between intellectual speculation and the organic world.

Henri Matisse. "Les Capucines." 1912.
Twentieth-century art remembered and developed Degas' compositional audacity. In "Les Capucines" Matisse, by the artifice of a painting in a painting, interlocked two dissimilar spaces.

directions by no means submitting to the anthropocentric point of view cherished by the West since the Renaissance.

Here we rediscover the Impressionists. Not that they copied Japanese art but that they recognized in it the feeling which inspired them. For these painters, who no longer believed in the strong certainties followed by their ancestors, who noted the infinite complexity of a universe in which man is but an accident (see Chapter I), it was a strange encouragement to discover huge zones of ancient cultures—the Chinese and Japanese civilizations—in which the principles which their Western culture believed to be the truth of mankind, the most faithful and objective approach to reality, were utterly neglected. They realized that Alberti's monocular perspective was but one system among others associated with a certain moment of European thought. For the painter it was a question now of leaving this realm.

Between the two cultures—the profoundly religious one of Zen Buddhism and the agnostic one of the Parisian painters—it was not a matter, then, of mechanical imitation but of an encounter. After all, Egyptian artists had already used flat areas (a fact Gauguin was not to forget), while Chinese perspective had invaded Western decorative art as early as the eighteenth century. Painters could have turned to this for inspiration but were not to do so until the moment when collective awareness had developed sufficiently—through science, art, and technique—to seek new visual representations of the world.

Between Japanese art and Impressionism, there were many differences. The print often imposed an ideographic vision of reality. Details were accumulated as so many conventional signs of woman, branch, and house *in general.* A code seemed to preside over the choice of figures, of prototypes, even if the subject was an everyday one. Impressionism, on the other hand, never showed *woman* but *a* woman, that is, never the general but the particular, at a specific time and place. The Japanese artist transcended the ephemeral in search of a reality beyond time, whereas the Impressionist captured the fleeting moment.

Symmetry postulated a stable state of the universe, an immutable, unmoving world free of the uncertainties and confusions of subjective consciousness. As Pierre Francastel remarked, "For the Renaissance there existed a set relationship between human proportions and the universal order." Confidence characterized the representation of man *ad quadratum* and *ad circulum* "which would continue to enjoy favor for generations." It was this relationship of identity, of continuity, of reflection between macrocosm and man which Impressionism unsettled by destroying symmetry. Man had believed that he summarized in himself every natural law and felt himself to be a model of reality, and yet he now discovered himself to be superfluous in an environment of acting forces. No longer was the world a theater but chaos. This was the end of painting as microworlds contained in a setting. Reality escaped everywhere, and future painters would attempt to establish the effect of this flight and disorder which became more and more unrestrained.

Japan has a dominant influence on Whistler.

WHISTLER, passionately enamored of the Japanese style, integrated into his compositions formal solutions inspired by the perspective audacity of Japanese prints. In "Caprice in Purple and Gold No. 2" he organized within his studio a play of glowing colors in which the fictitious space of the screen and the real space which the model occupies interrelate. The same preference was applied to his landscapes. He imposed on his view of the Thames the distortions of upward glance borrowed from Hokusai and Hiroshige (*right*). The reference to Japan is stressed by the silhouette of the hunchbacked boatman. Suspended in the upper part of the painting, the roadway of the bridge is nothing more than a diagram. A few silhouettes in the fog disturb the linear outline.

Born in Lowell, Massachusetts, Whistler went to Paris in 1855 to study painting. There he met Degas and Henri Fantin-Latour in Gleyre's studio. Until 1865, he was influenced by Courbet. That year, under the stimulation of Japanese prints, he revolted against Courbet's militant realism and turned to a more decorative and artificial art. In 1867 he wrote to Fantin-Latour, "Courbet and his influence have been disgusting (*sic*). . . . This damned realism, immediately appealing to my painter's vanity and mocking every tradition, shouted to me with the assurance of ignorance, 'Long live nature!' Ah! my friend, why was I not a pupil of Ingres."

James Abbott McNeill Whistler (1834–1903). "Caprice in Purple and Gold No. 2: The Golden Screen." 1864. Oil on wood. 19.9 x 26.5 inches.

James Abbott McNeill Whistler. "Nocturne in Blue and Gold: Old Battersea Bridge." 1865. Oil. 25.7 x 19.5 inches.

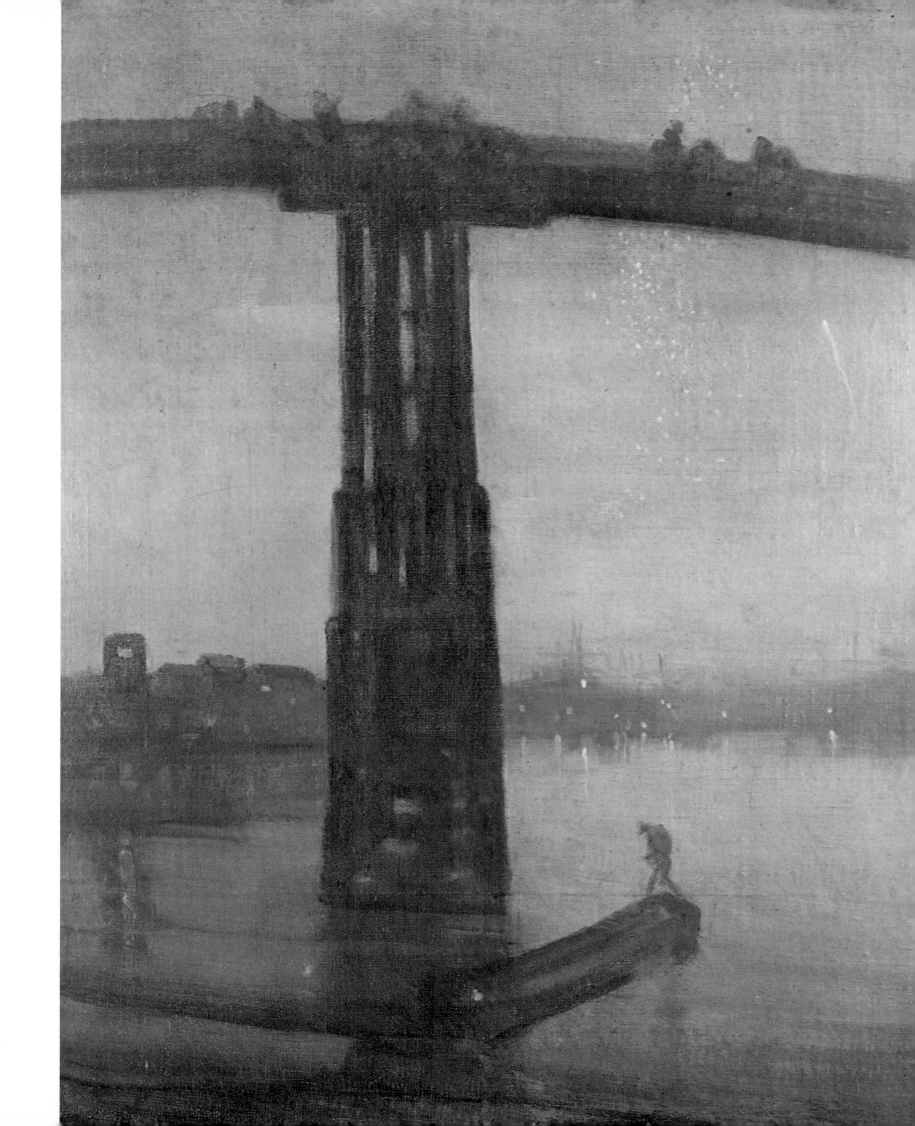

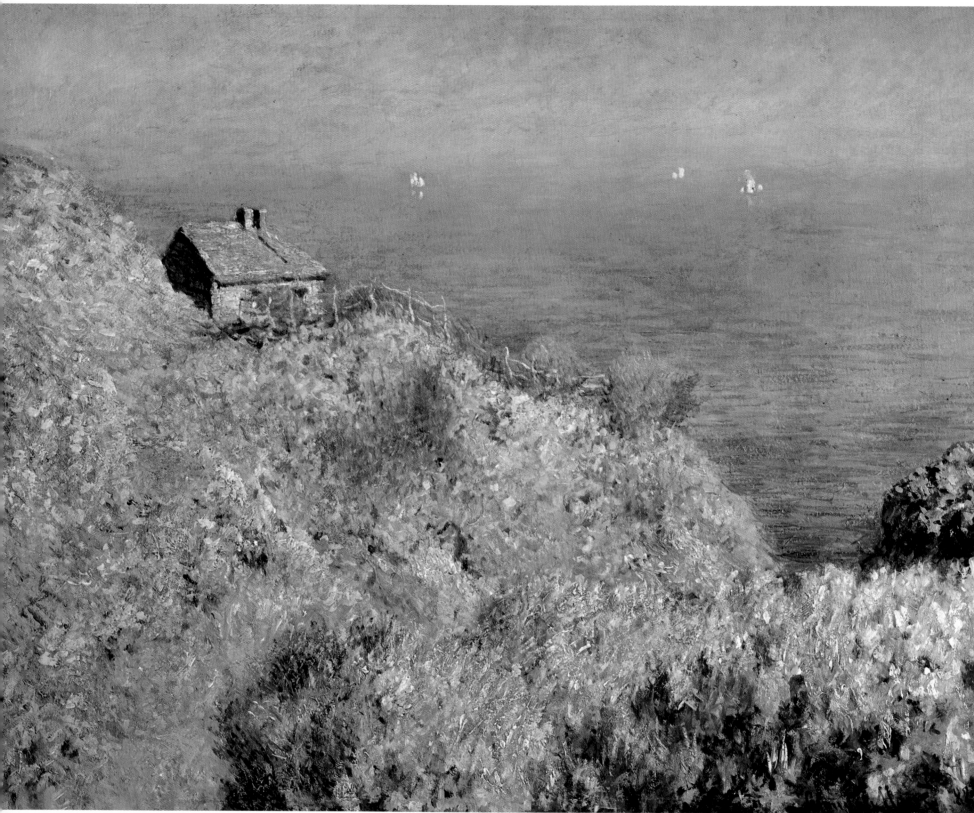

Claude Monet (1840–1926). ''The Customhouse Officer's Cabin at Varengeville.'' 1882. Oil. 23.4 x 30 inches.

THE RELATIONSHIP of filled and empty spaces, taken for granted in classical painting, was questioned by the Impressionists, who refused to regard nature as a balanced composition, a symmetrical scene designed to please the human eye. The world is chaos, matter imposing itself brutally without considering our visual habits or our corporal scale. In 1882 Monet, while traveling in Normandy, his favorite part of France (he had spent his childhood in Le Havre), did not hesitate to "decenter" his landscapes in a brutal manner. The edge of a cliff (*right*) timidly invades the lower left portion of the canvas. The slope of grass scarcely seems to be more concrete than the waves below.

Monet dramatized his painting at left by opposing the strong diagonal of the foreground to the horizontal of the waves in the distance blending with the sky. Fifteen years separate these two paintings of a small cabin at Varengeville. In 1882 Monet rented the Villa Juliette at Pourville, the starting point of his visits to the surrounding area. In 1897 he returned to linger over the same sites, as though he wanted to develop to a greater degree his analysis of a complex landscape rich in unusual vantage points.

Monet introduced large areas of space into his compositions.

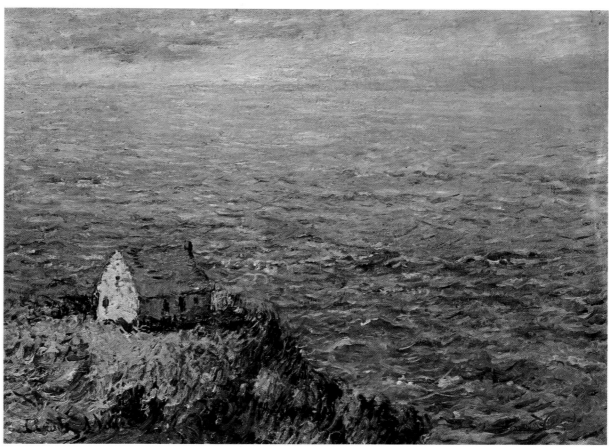

Claude Monet. "The Customhouse Officer's Cabin." 1897. Oil. 25.35 x 37.05 inches.

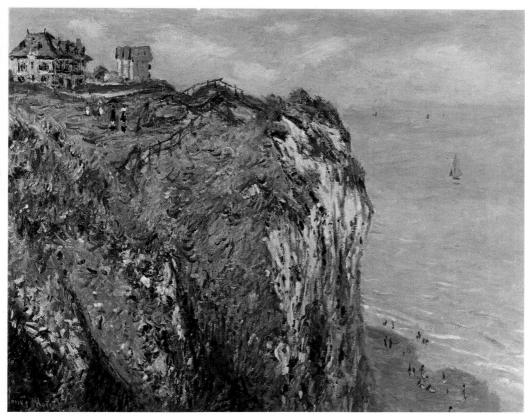

Claude Monet. "Cliff Near Dieppe." 1882. Oil. 25.7 x 32 inches.

With his eccentric viewpoints Degas gave
the human body a new interpretation.

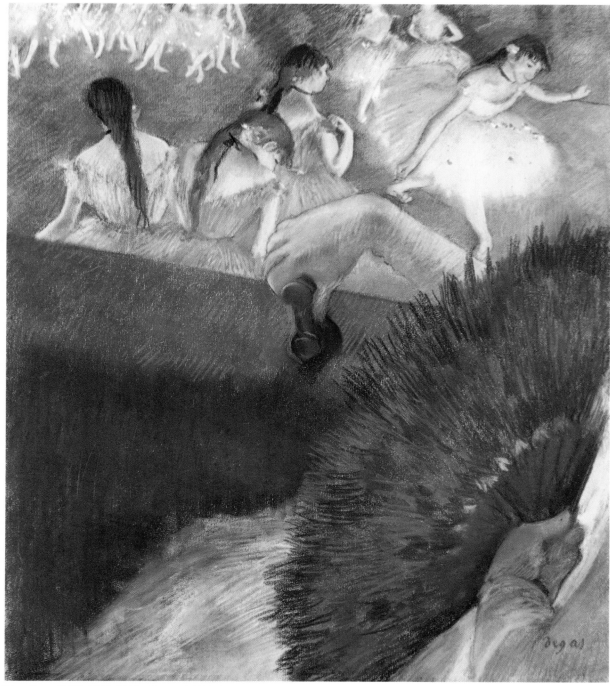

Edgar Degas (1834–1917). "At the Theater." 1880. Pastel. 21.45 x 18.7 inches.

DEGAS IN "At the Theater" diverts our gaze from the stage to fix our attention on the details in the foreground: a fan, a pair of opera glasses, the ledge of the box, a hand. In the painting equal importance is given to the event—the ballet—and to the nonevent. Degas here demonstrates a deliberate vision which levels everything, refusing to give value to one aspect of reality at the expense of another. Degas wishes simply to be an eye. He sees merely forms and colors assembled in a kaleidoscope. He shows what can be seen from the far end of an opera box at a certain moment. His subject is this half-closed space. As early as 1869 Degas fled open-air painting and deliberately shut himself up in artifical atmospheres such as the café, the theater, the opera house, and cabarets. To Pissarro and his friends, he said, "You need a natural life, I an artificial one."

To break our visual habits, Degas grasped the world from the most surprising angles. With a painting like "Miss Lola" we can measure the extraordinary transformation of pictorial conceptions which occurred in the last quarter of the nineteenth century. The arbitrary compositional imbalance, the strange upward view of the subject, the distance of the painter from the figure, as though he were using a telephoto lens, all make this painting a veritable exploit.

Degas would sketch the model on the spot, then paint the canvas in his studio, professing that "painting is a cold fever" in which the impression ought to be counterbalanced by careful work. "Never was an art less spontaneous than my own," he was to say. "What I do is the result of thought and the study of the great masters. Inspiration, spontaneity, temperament, I know nothing about these. . . . A painting is something which requires as much trickery and vice as the perpetration of a crime: paint false and add a natural accent."

Miss Lola is portrayed at the culminating point of her act, hanging by her teeth to a rope which links her to the ceiling of the Fernando Circus, the future Médrano Circus, at 63 Boulevard Rochechouart. Degas had a passion for everything that required training and effort. He often seized his figures, ballet dancers, jockeys, acrobats, in the tension of an act in progress. In 1888 it was Toulouse-Lautrec's turn to visit the Fernando Circus.

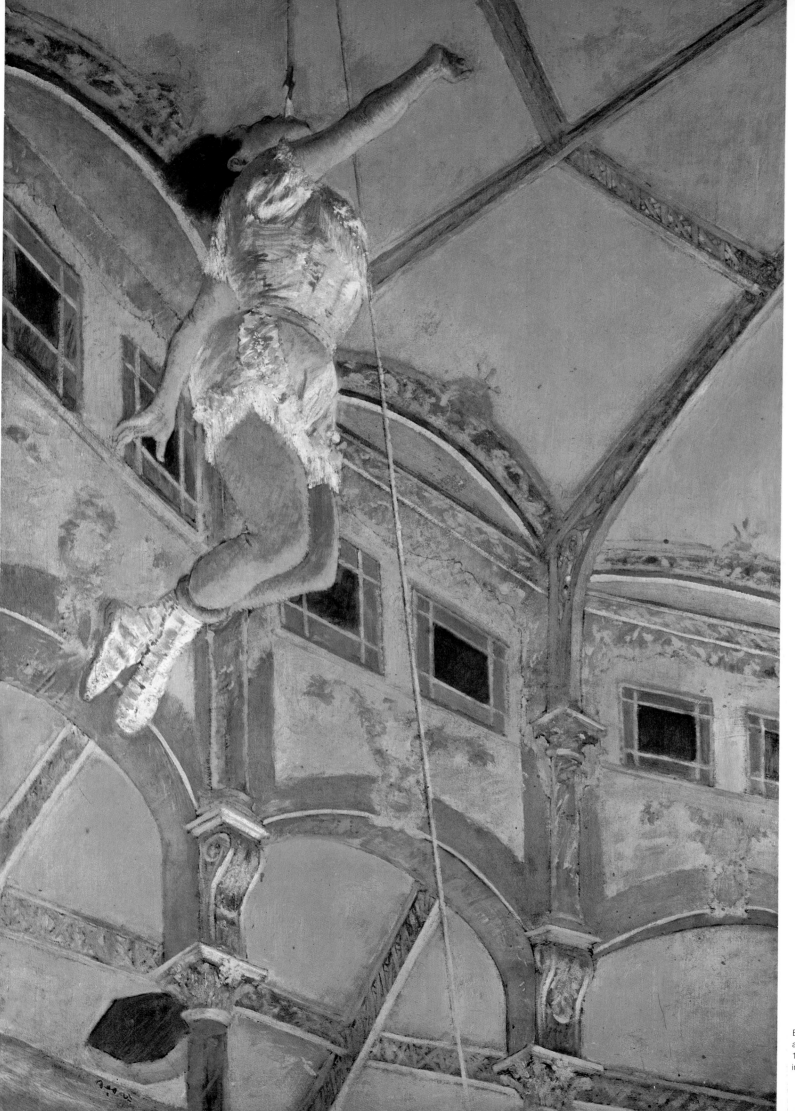

Edgar Degas. "Miss Lola at the Fernando Circus." 1879. Oil. 41 x 27.7 inches.

The artist submitted soft female features to cruel theatrical lighting.

1. Edgar Degas (1834–1917). ''At the Café des Ambassadeurs.'' About 1875. Pastel. 14 x 10.9 inches.
2. Henri Toulouse-Lautrec (1864-1901). *En Cabinet particulier.* 1899. Oil. 21.45 x 17.5 inches.
3. Edgar Degas. ''Singer with a Glove.'' 1878. Pastel. 20.7 x 16 inches.

DRAMATIC LIGHTING gave Toulouse-Lautrec's demimondaines a hallucinating unreality. The artist painted this portrait of a prostitute (*opposite*) in 1899, the very year he was interned for two months at the Folie St.-James. He died two years later. The artist, whose figures, said Gustave Moreau, "were painted entirely in absinthe," had boundless admiration for Degas. "Once after a joyful evening," related John Rewald, "Toulouse-Lautrec brought a group of friends at dawn to the home of an art collector, Mademoiselle Dihau, who after some hesitation received them in her modest apartment. Toulouse-Lautrec led his companions to Degas' canvases and ordered them to kneel before them in homage to the venerated master."

THE UNUSUAL success of Degas' canvases devoted to low-class concert halls and to the theater stems from his use of light, which cuts the faces in two, as only Goya and Daumier had dared to do (Degas owned 1,800 lithographs by Daumier). "After doing portraits seen from above," he wrote, "I will do them from below. Seated close to someone and looking at him or her from below, I will see the head surrounded by crystal."

In this close-up (*right*), which reveals even the singer's mouth, we can admire the frank colors and sudden suspension of the glove, the heavy dark tone that gives the canvas its tension. "Queens are done from a distance and without makeup," said Degas, who here deliberately portrays a music hall queen as anything but sacred. Draner, a caricaturist of the period, made a rather poor gag of this. He published a drawing with the following caption. "An unparalleled buy at 7.50 francs a pair! What an excellent sign for a glove business!"

In the *"Café des Ambassadeurs"* (*left*), the artist used the same lighting effect. The hazy foreground and the red dress lead the eye directly to the singer standing close to the double bass player, a subject later treated by Toulouse-Lautrec. "To produce good fruit," said Degas, "you have to become an espalier and remain there all your life, arms outstretched, mouth open to assimilate what happens, what is around you, and to live from it."

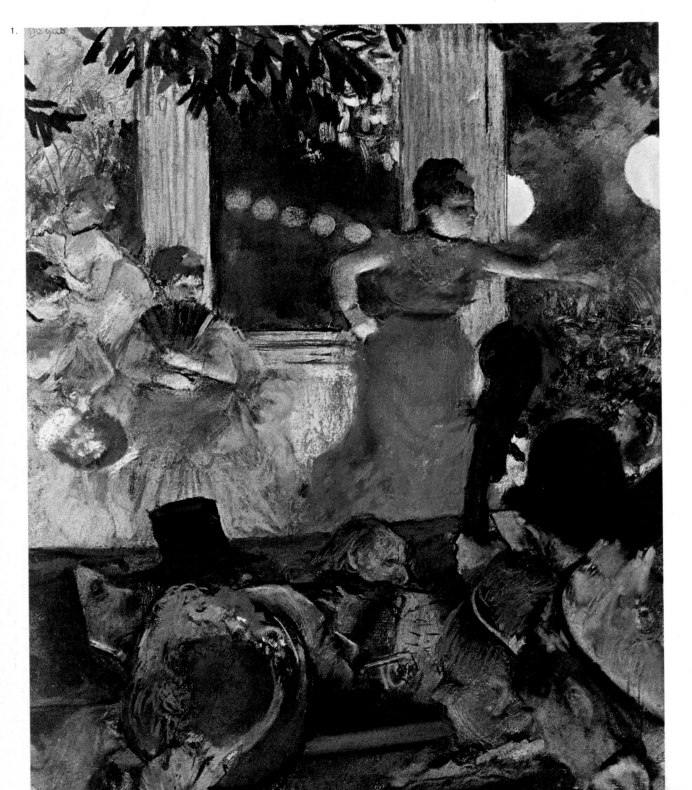

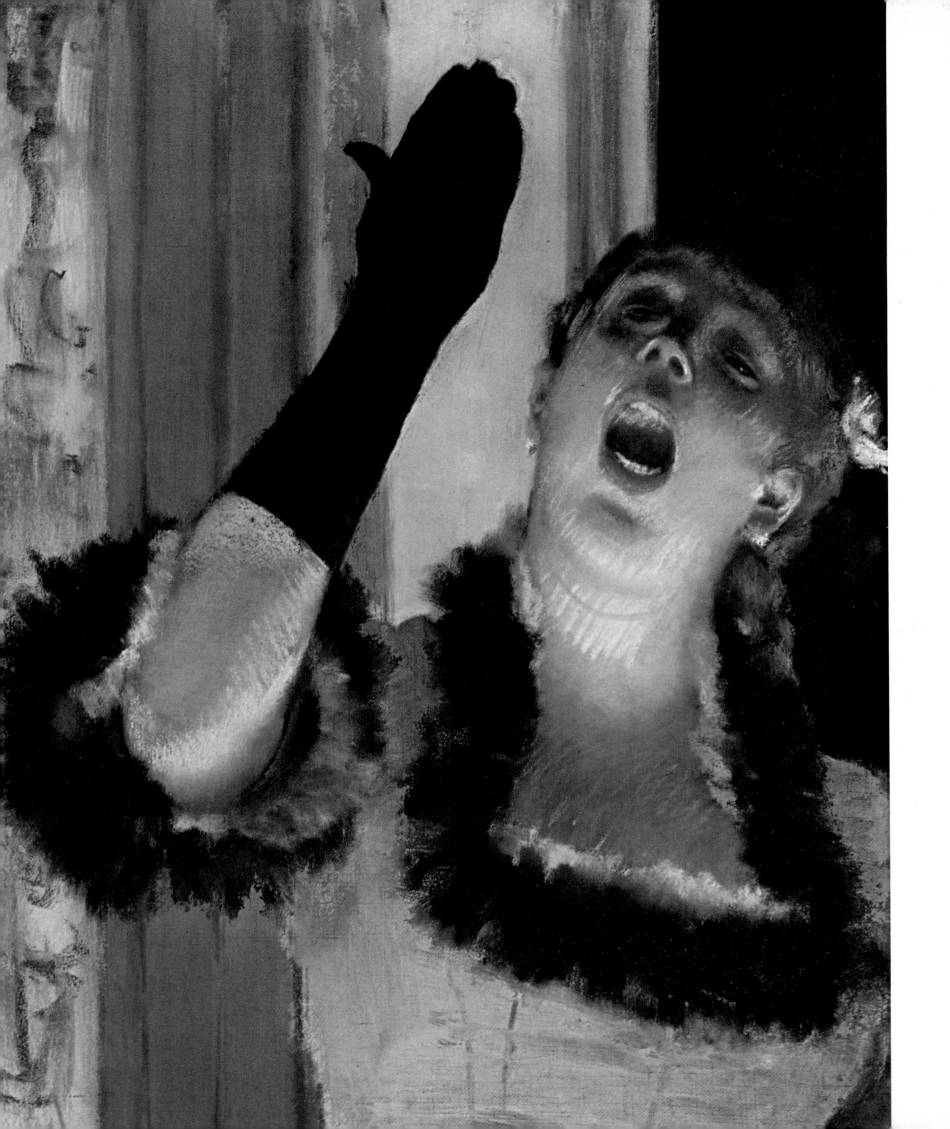

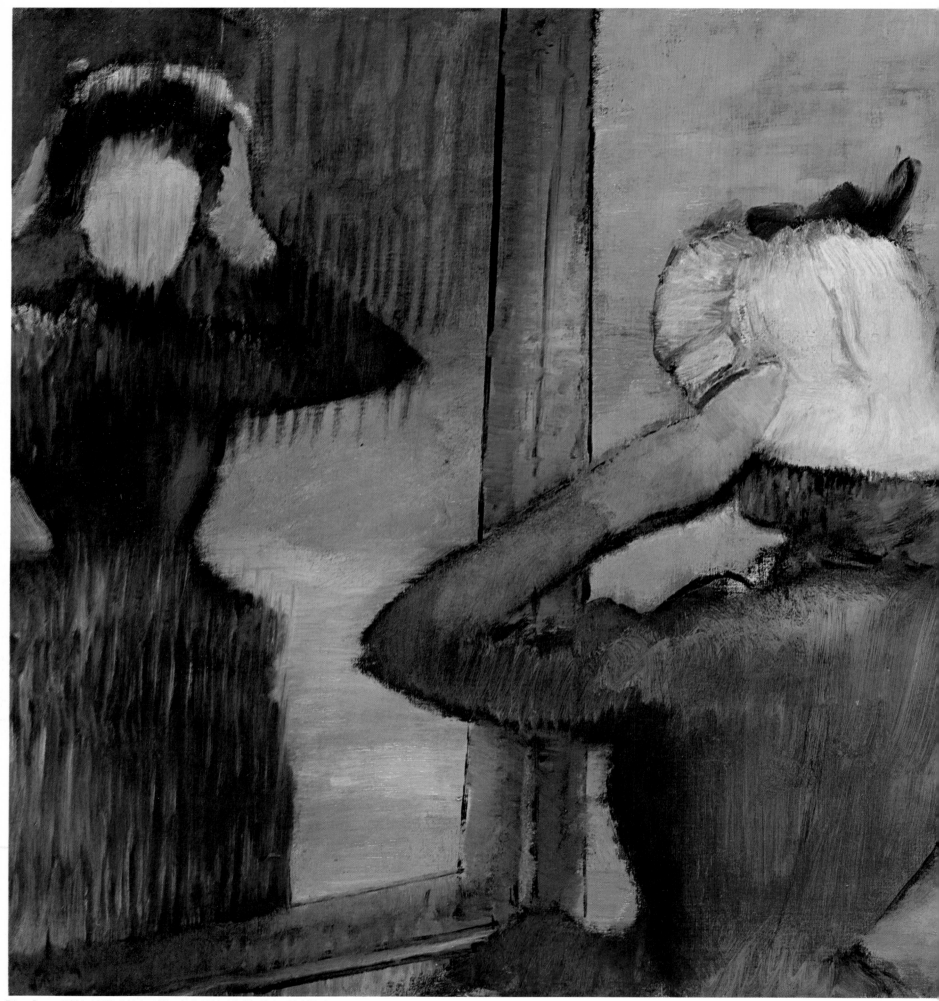

Edgar Degas (1834–1917). "At the Milliner's." 1882–85. Oil. 19.1 x 29.25 inches.

By skillful use of mirrors, Degas revealed his subject at two different angles.

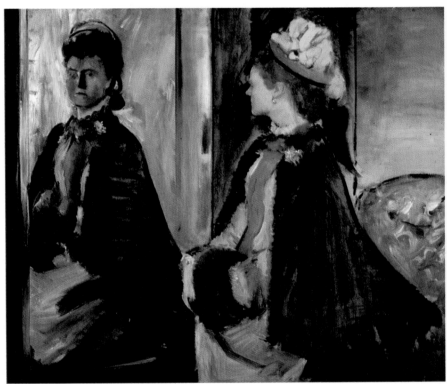

Edgar Degas. ''Portrait of Madame Jeantaud.'' About 1874. Oil. 27.3 x 32.8 inches.

GOING FROM precision to allusion, Degas in a few years made decisive progress. In the two paintings reproduced on these pages theme and composition are almost identical. The mirror occupies a similar surface and serves the same purpose in the dual figure of the model. Yet in the work of 1882 (*left*) the artist brings us closer to the subject and emphasizes tactile values. He treats the scene chiefly by large synthetic planes, boldly dismissing detail and anecdote.

He achieves a simplified image and allows us to project our own preference on the woman's empty face, a method Matisse was to use. "It is fine to copy what you see," wrote Degas, "but even better is to draw only what struck you, that is, the essential. Here your memories and fantasies are freed from nature's tyranny."

This multiplication of the figure by the use of a mirror had already been done by such painters as Van Eyck,

Velázquez, Vermeer, and Ingres, and it was soon to become one of Bonnard's favorite themes. It revealed the artist's determination to surround the subject from several points of view, a modern preoccupation which was to be developed by Cubism with its successive approaches to the same object. On the right, the milliner's outstretched hand shows Degas' bold asymmetry.

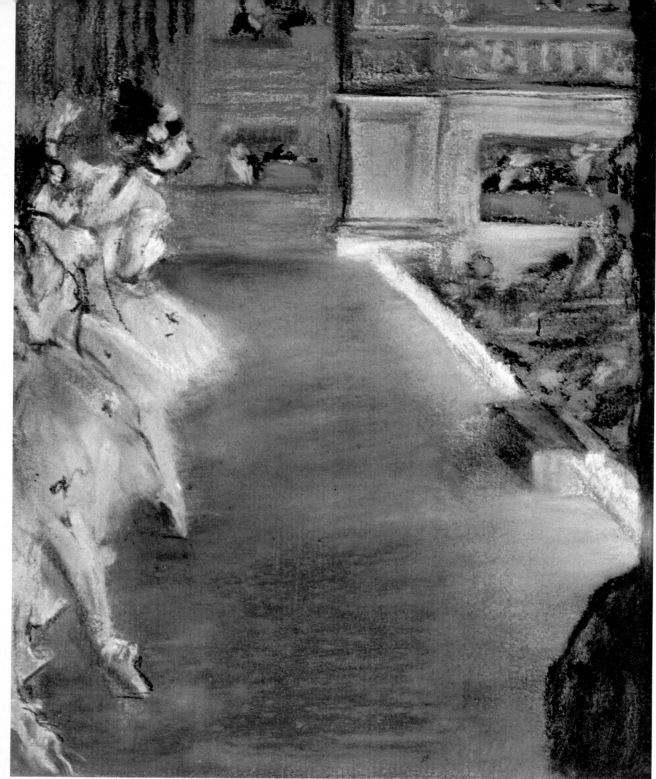

Edgar Degas (1834–1917). "Ballet Dancers at the Old Opera House." 1877. Pastel. 7.8 x 6.2 inches.

The composition is balanced on the large empty area which occupies the center of the picture.

HOLES OF empty space invaded the picture. With Degas the floor often became the essential part of the composition. In "Ballet Dancers at the Old Opera House," the stage dominates the rest of the picture. Figures are relegated to edges and the ballet dancers, the "monkey girls," as Edmond de Goncourt described them, continue their "graceful twisting and turning" around the large free space which Degas has deliberately left empty.

No sooner had he arrived in Paris in 1886 than Van Gogh (*right*) began to utilize openings in the heart of his compositions. However, he treated the problem in his own rugged and deliberate manner. "I am now trying to exaggerate the essential," he stated, "to leave the commonplace deliberately vague." The terrace of the Moulin de la Galette (*right*) is treated in large visible brushstrokes. The panorama is reduced almost to a *grisaille* without outline. The strolling figures are spots. This allusive style reveals a surprising freedom in an artist who, a year earlier at Nuenen, was still painting his "potato eaters" in dark tones. Once in Paris he immediately became extremely bold.

Vincent van Gogh (1853–90). "Montmartre." 1886. Oil. 17.5 x 12.9 inches.

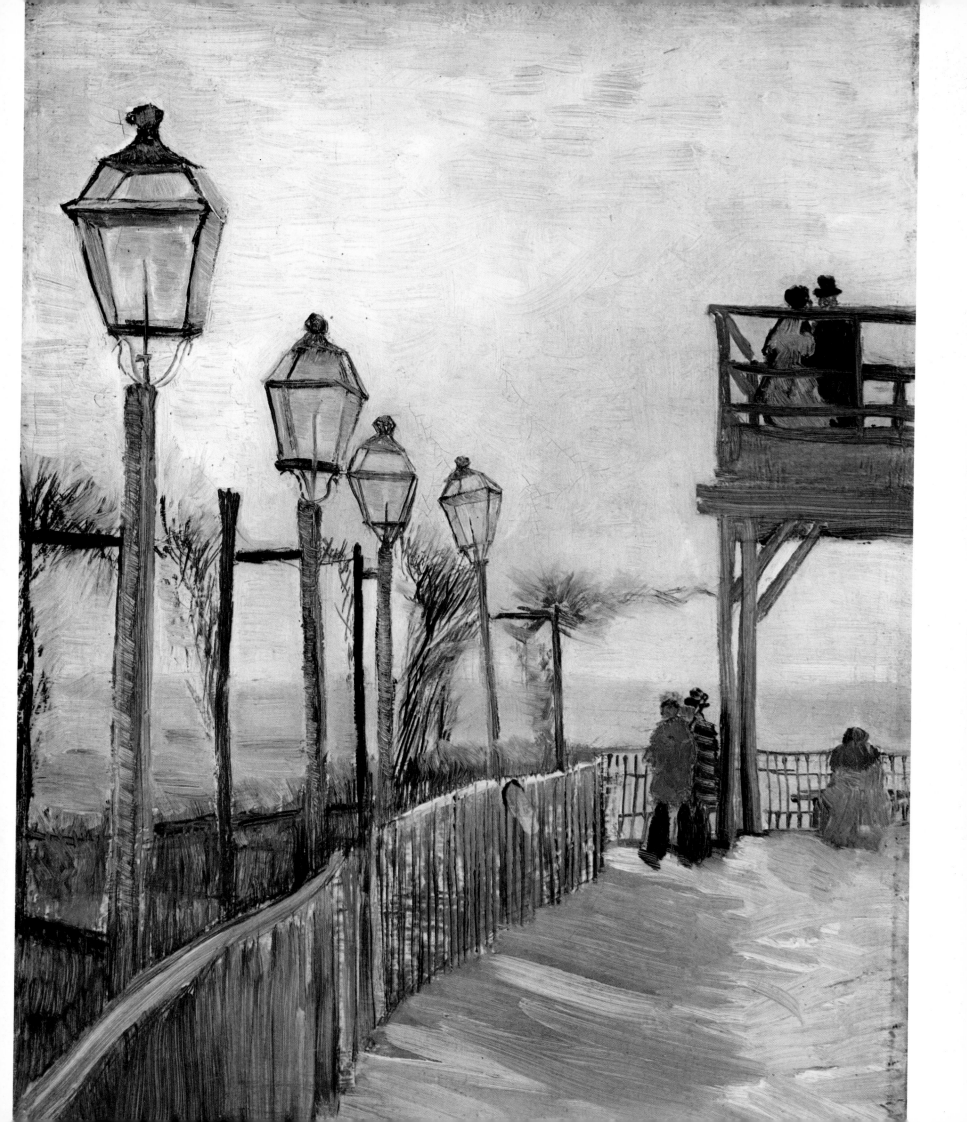

Edgar Degas (1834–1917). "Reclining Nude." 1883–85. Pastel. 12.9 x 16.4 inches.

Degas takes the viewer into the model's "territory."

DEGAS IN "Reclining Nude" has diminished the distance between his model and the viewer. The proximity, the disturbing warm colors, the haziness, the unusual position viewed from above, all enable him to enter the model's "territory." In 1886 the critic Félix Fénéon spoke of the "stifled, seemingly latent effect . . . the reddish mop of hair, the purplish wet linen . . . all used as a pretext. It is in the obscure rooms of furnished hotels . . . that these rich-patina bodies, these bodies much the worse for dissipation having given birth, and having suffered from illness disrobe themselves or stretch their limbs."

Beginning in 1890 Degas worked almost exclusively in pastel often mixed with gouache and water. This quick method, which lessened eyestrain, combined in the same movement both drawing and color. He even used a division of tones, following a technique which he—admirer and pupil of Ingres—had long condemned.

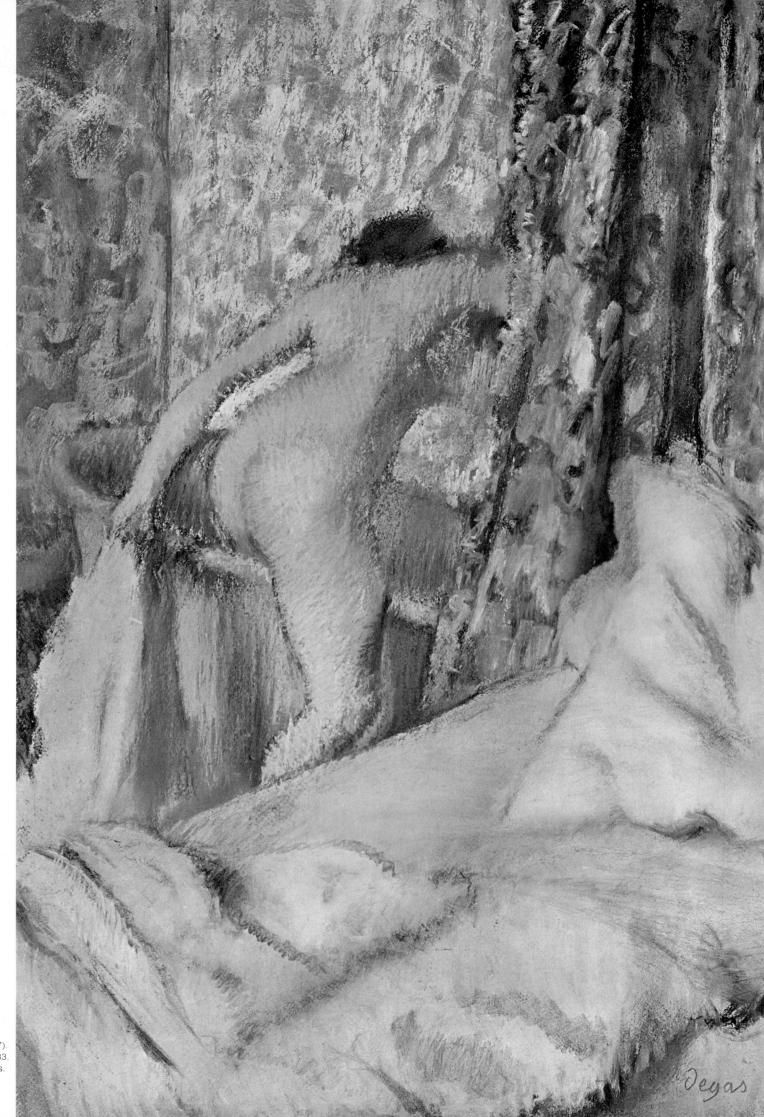

Edgar Degas (1834–1917).
"The Morning Bath." 1883.
Pastel. 27.3 x 16.8 inches.

THE TWO paintings on these pages are characterized by a closed-in space and an off-center axis of vision. The diagonal lines of an intermediary zone in the foreground lead into the compositions. Degas (*left*) admirably combined in his pastel colors of a narrow chromatic range. The woman stepping into the tub receives green from the wall and blue from the curtain.

Degas excelled in these alcove scenes which express his delight in indoor painting—as well as his misanthropy. This man, who on seeing a winter scene by Monet pretended to raise his collar, had a reputation for sarcasm and a mean spirit. Manet said to Berthe Morisot, "He's anything but natural. He is incapable of loving a woman, to tell her so, to do anything." Paul Valéry described him as "a great arguer and a terrible reasoner, particularly excitable if it were a question of politics or drawing. He never gave in, would at once burst out in a strong voice, use the harshest words, cut you off just like that!" Thadée Natanson related: "Degas would become so excited with a critic as to forbid him angrily to use the word 'blue' which belonged solely to painters, the writer being allowed to use only abstract words." In 1883, the year Degas painted "The Morning Bath" (*left*), he confessed, "I was, or seemed to be, hard with everyone because of a kind of training for brutality which stemmed from my doubt and ill-humor. I felt so badly made, so poorly tooled, so soft, while all the time it seemed to me that my artistic *calculations* were so correct. I was sulky with everyone and with myself."

Van Gogh (*above*) here adopted a similar attitude and treated his still life by emphasizing the plunging view. The size of the statuette is indicated by the two books. Their choice is significant, for the authors, Guy de Maupassant and the Goncourt brothers, were members of the literary movement of naturalism in which the former Borinage preacher recognized himself. "It has since seemed to me," he wrote to Emile Bernard, "that in our dirty painting profession, we have the greatest need of people with a workman's hand and stomach, tastes more natural, temperaments more loving and charitable than the decadent and dead Parisian man about town."

The painter adopts compositional devices to lead the eye into the painting.

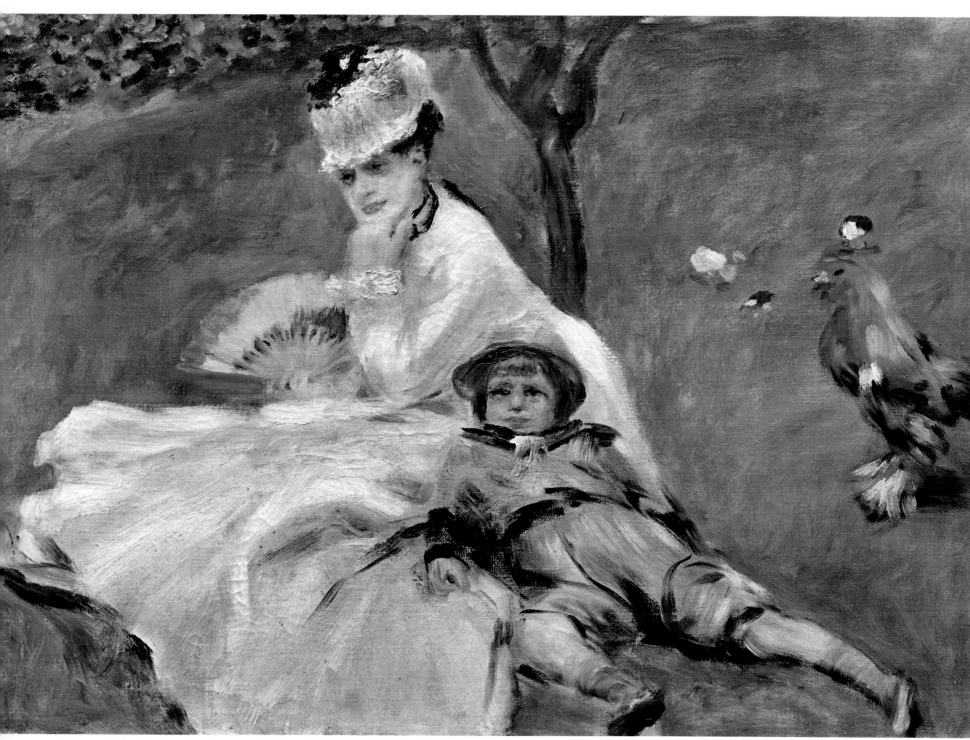

Pierre-Auguste Renoir (1841–1919). ''Madame Monet and Her Son in Their Garden at Argenteuil.'' 1874. Oil. 19.5 x 26.5 inches.

The artist seats his figures, dominates
them and heaps them on the ground and
on the floor.

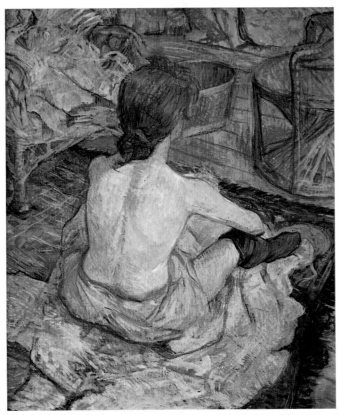

Henri de Toulouse-Lautrec (1864–1901). *"La Toilette."* 1896. Oil. 26.1 x 21
inches.

ALTHOUGH BRUEGEL had painted
beggars and sleeping peasants, the close,
casual pose is uncommon in the history
of Western art. The Impressionists,
however, often turned to the theme,
using a plunging perspective favored by
the Japanese in their domestic scenes.
In the three paintings reproduced here,
the point of view is that of a standing
person close to the seated model. The
prosaic quality of the bodies, heaped
and made heavy by the plunging view,
is in contrast to the more slender, aerial
vision which predominated from the
eighteenth century down to the time of
Delacroix. All idealism is dismissed in
these pictures. In his "Two Bathers"
Degas even brutally cuts off part of the
human body in order to capture the
instantaneousness of his glance.

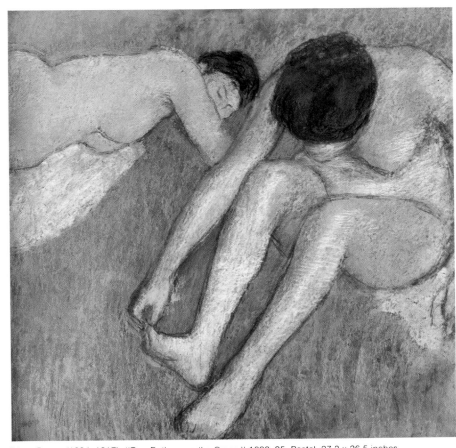

Edgar Degas (1834–1917). "Two Bathers on the Grass." 1890–95. Pastel. 27.3 x 26.5 inches.

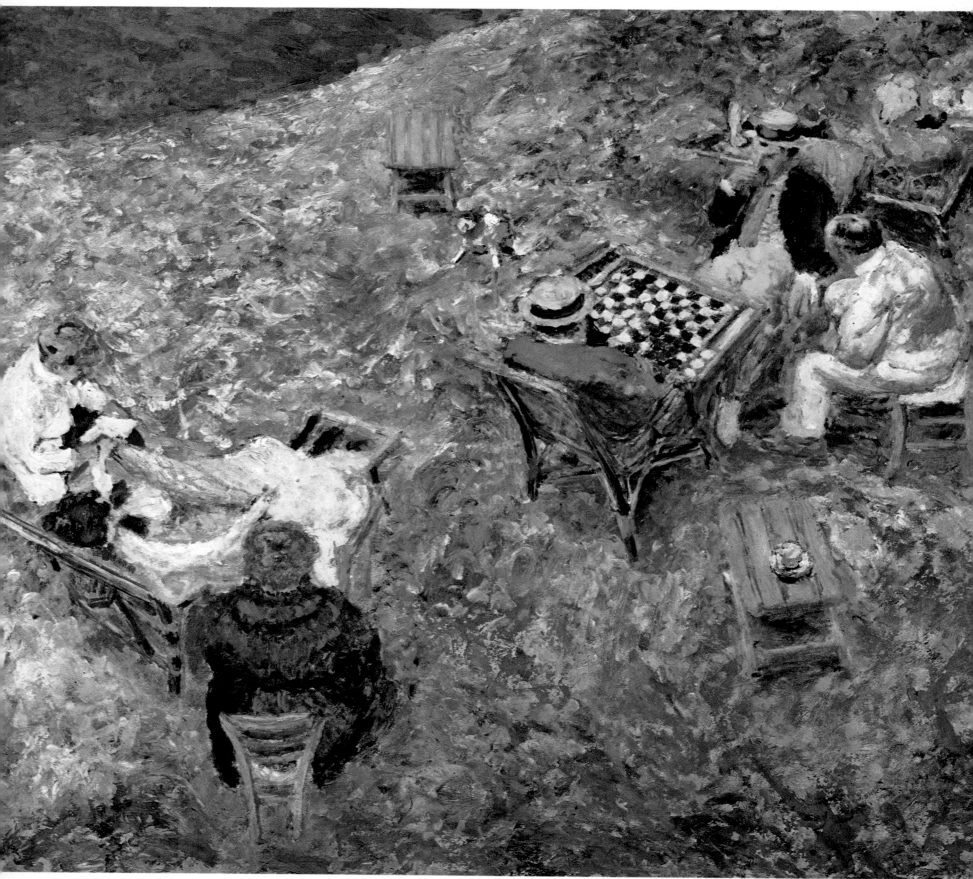

Edouard Vuillard (1868–1940). ''The Game of Checkers at Amfreville.'' 1906. Oil. 29.6 x 42.9 inches.

From his window the artist records the chaos of the world and renounces the reassuring hierarchies of classical perspective.

VIEWED FROM A window, the world reveals unusual aspects which the Impressionists and their successors were to exploit. For Vuillard (*left*) it was a matter of strict obedience to the visual sensation. He gave an account of what he saw and refused to allow the logic of perspective to dictate the slightest correction. A window corner in the lower right section of the composition emphasizes a subjective feeling. Alongside the painter, we bend over and dominate the Amfreville garden where Tristan Bernard, a humorous novelist and dramatist (center), is playing checkers with one of his friends.

Although Gustave Caillebotte's point of view (*below*) is less audacious and more respectful of traditional perspective, nevertheless it reveals the importance of the city in the history of Impressionism. With its streets too wide for the traffic of the period (at the far end we see Garnier's Opera House finished four years earlier), Baron Haussmann's Paris imposes itself like a stony landscape, orderly and rectangular, having nothing in common with the haphazardness and fantasies of rural architecture. The numbers of stories in the apartment buildings emphasize the altitude and the artist's point of view.

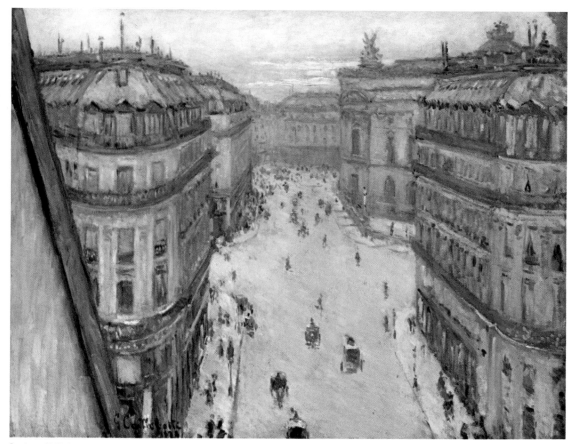

Gustave Caillebotte (1848–94). "Rue Halévy." 1878. Oil. 23.4 x 28.5 inches.

Claude Monet (1840–1926). *"Les Galettes."* 1882. Oil. 25.35 x 31.6 inches.

Monet and Gauguin in their paintings
place the viewer above the subject.

THE ARTIST in the paintings shown here treats the table surface as though he were bent over it. Whereas the Dutch still life generally gave the feeling of a whole carefully arranged composition spread out *facing* the spectator, Impressionism often favored a partial view and used the sectional field of vision. The table is seen close and occupies almost the entire painting, the circumference for the most part hidden from view. The effect is heightened by the overhead view, which, as Charles Sterling remarked in respect to Monet's "*Galettes*" (*left*), "places us in sudden and intimate contact with the white tablecloth, the cakes, the wine carafe . . . as though we were sucked up by the subject."

Gauguin (*above right*) deliberately disturbs the perspective by maintaining a vertical background (the fireplace) in opposition to the truncated ellipse of the table. In his "*Fête Gloanec*" (*below*), rich in color, the composition is tightly fitted. In 1891 Emile Aurier, the best critic of Synthetism, noted, "Gauguin is above all a decorator. His compositions are crowded into the restricted field of the canvases. One is often tempted to take them for sections of huge frescoes, and almost always they seem to be on the point of bursting from the setting which unduly limits them."

Paul Gauguin (1848–1903). ''Flowers and a Bowl of Fruit.'' 1894. Oil. 16.8 x 24.6 inches.

Paul Gauguin. "*Fête Gloanec*." 1888. Oil. 14.8 x 20.7 inches.

DEGAS'S COMPOSITIONS foreshadow twentieth-century architecture with its free-flowing space. In "Ballet Dancers Climbing a Flight of Stairs" the studio and the staircase with their figures are treated as an entity in which the surfaces follow one another. The lateral axis of the viewpoint helps to join a close space and a receding one. This is a subjective space emphasizing what is seen of it by a young ballet dancer for whom the floor is essential.

A straight line dissects each of the two works reproduced on these pages. In the first case it is the vertical wall; in the second, "The Tub," it is a horizontal table (though the line, because of the viewpoint, is vertical). The painter uses the same device to link each composition, one seen from above eye level and the other from below.

Degas emphasized outline. He said to the painter Walter Sickert, "I have always tried to force my colleagues to see fresh combinations in the path of drawing, which I consider more fruitful than that of color. But they refused to listen to me and followed the opposite direction." To Ludovic Halévy's mother, Degas said, "Louise, I should like to do your portrait, you are extremely drawn."

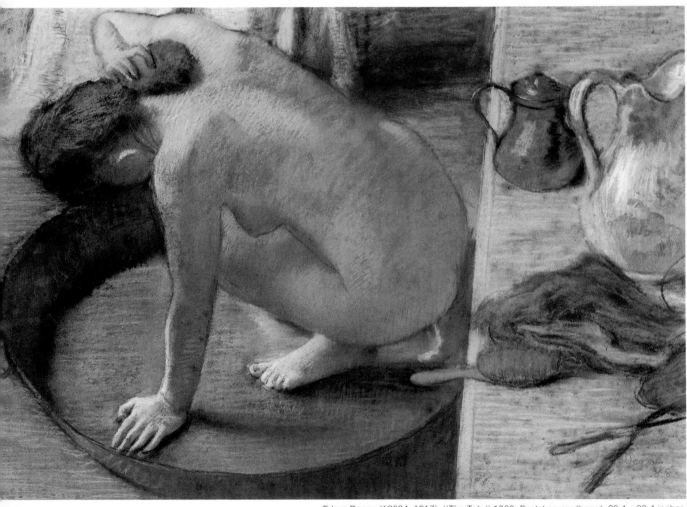

Edgar Degas (18834–1917). "The Tub." 1886. Pastel on cardboard. 23.4 x 32.4 inches.

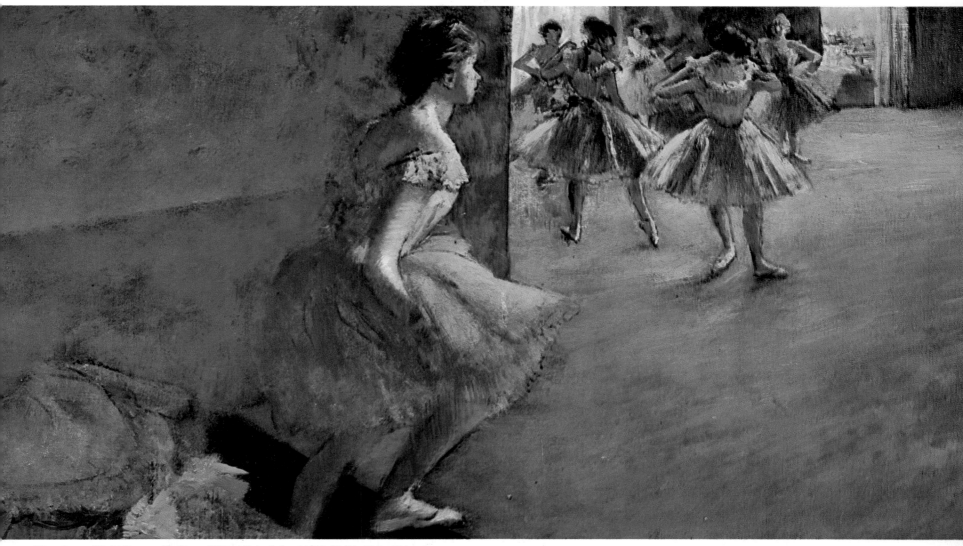

Edgar Degas. "Ballet Dancers Climbing a Flight of Stairs." About 1886–90. Oil. 15.2 x 35.1 inches.

Degas combined dissimilar spaces in the same composition, just as we experience them in life.

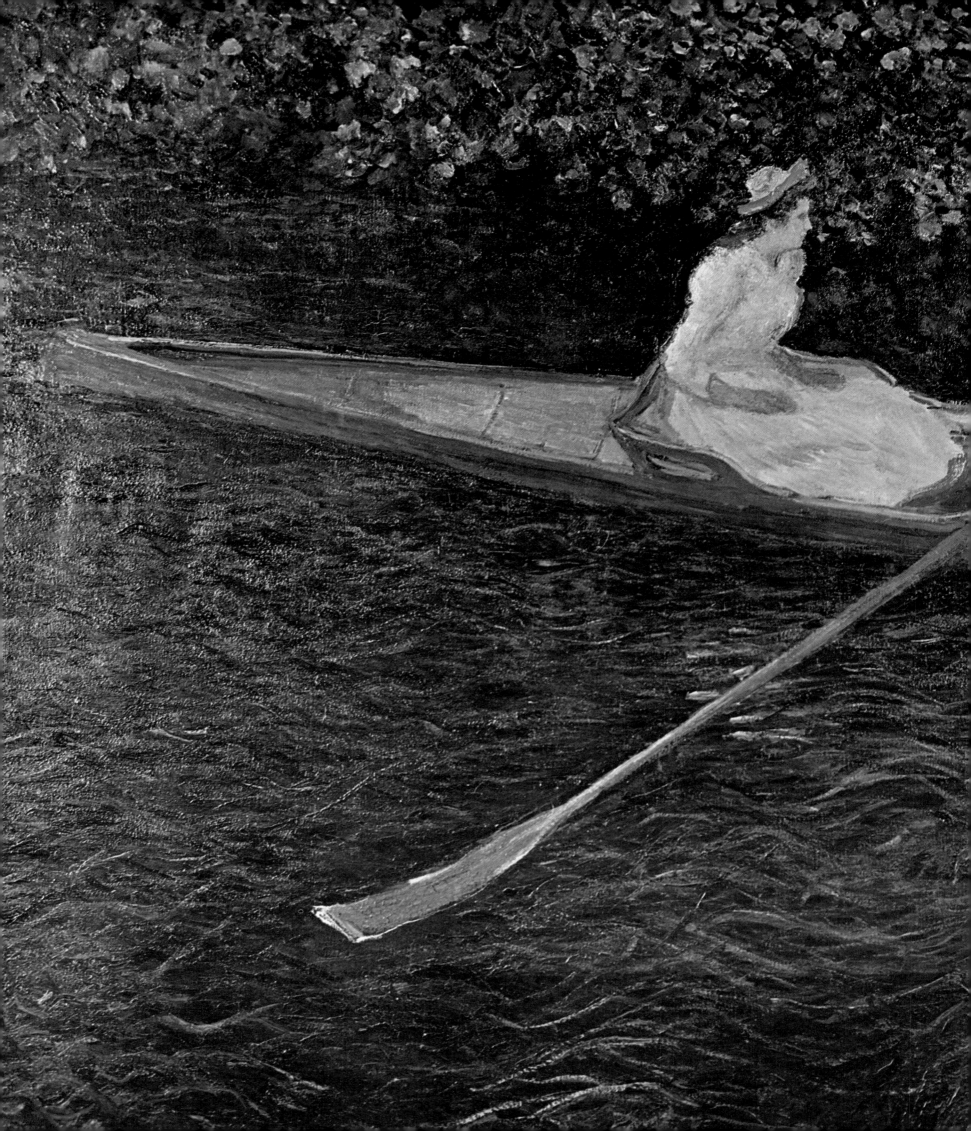

Monet carried compositional innovations to an extreme.

TERMINATED AS though with an ax, these compositions by Monet (the paintings are seen here in full) show the extreme freedom achieved by the artist. **"Portraits of young girls in the flower of youth, delightful and fleeting glimpses,"** to quote Gustave Geffroy, these paintings represent, sometimes in the shade, sometimes in full sunlight, Blanche and Suzanne Hoschedé boating on the Epte, the river of Giverny, in Normandy, where Monet had settled down three years earlier with his second wife Alice Hoschedé. "I have taken up things impossible to do: water with grass undulating at the bottom. It is wonderful to see, but one can go crazy wishing to do this thing," wrote the artist with regard to the large transparent sheet of water which occupies two-thirds of the painting on the left. A fragmentary vision, it leaves the spectator to continue the subject beyond the frame.

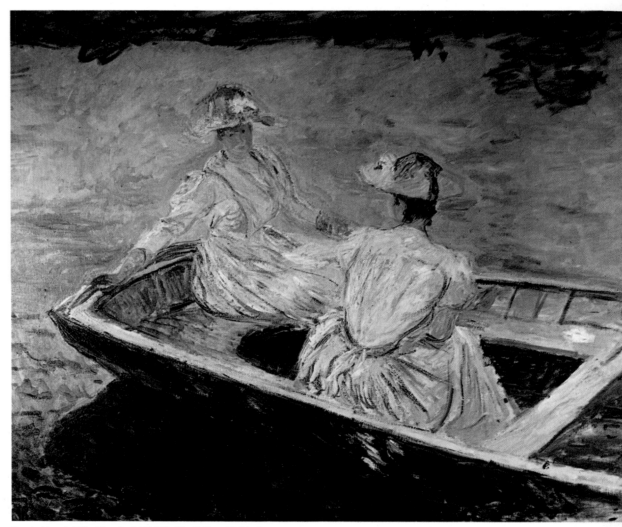

Claude Monet. "The Blue Bark." 1886. Oil. 42.9 × 50.7 inches.

Claude Monet (1840–1926). "Boating on the Epte." About 1887. Oil. 52.3 × 56.9 inches.

The artist made use of geometry and perspective in attaining the effects he sought.

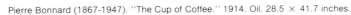
Pierre Bonnard (1867-1947). "The Cup of Coffee." 1914. Oil. 28.5 × 41.7 inches.

THE PAINTER'S EYE obeys the injunctions of color. Since the red tablecloth was a striking element of his decor, Bonnard gave it priority in his painting. "The Cup of Coffee" reveals his preoccupations in 1914. After the fascinating discovery in 1910 of the South of France and its light, beginning in 1913 he felt the need to reconstruct his compositions and to give them a geometrical basis. Bonnard refused to paint according to a preestablished size. He attached to the wall a canvas which he had deliberately chosen as being too large and then arranged the interior with the freedom of a photographer

making prints from a portion of his negative.

BY DISTORTING the perspective, Van Gogh gave his "visionary snapshots" a dramatic, almost disturbing force. The torsion of the drawing board, the absence of shadows, the disproportion between the near and the far, precipitate the glance toward the large pitcher, which seems stuck, lopsided, between the edge of the table and the wall.

84

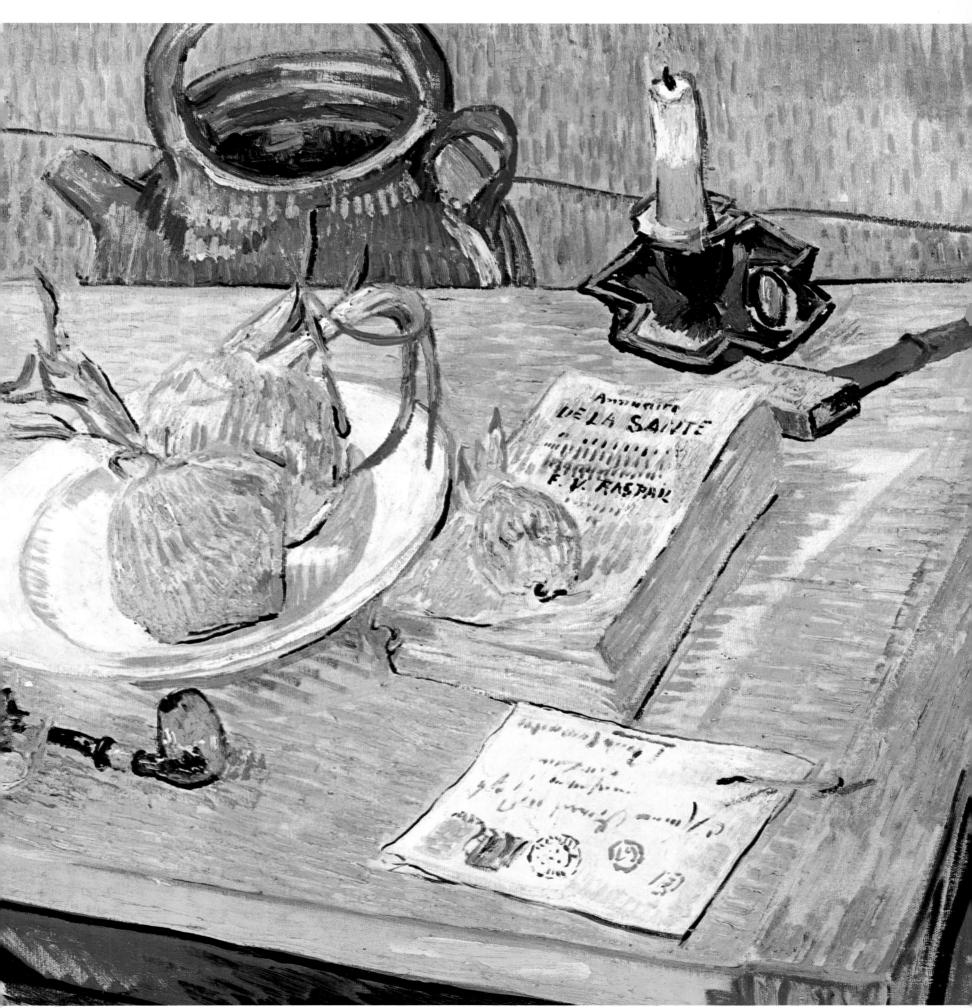

Vincent van Gogh (1853–1890). ''Still Life. Drawing Board with Onions.'' January, 1889. Oil. 19.5 × 25 inches.

Imperious ellipses harmonized a space in which
the human figure is gradually minimized.

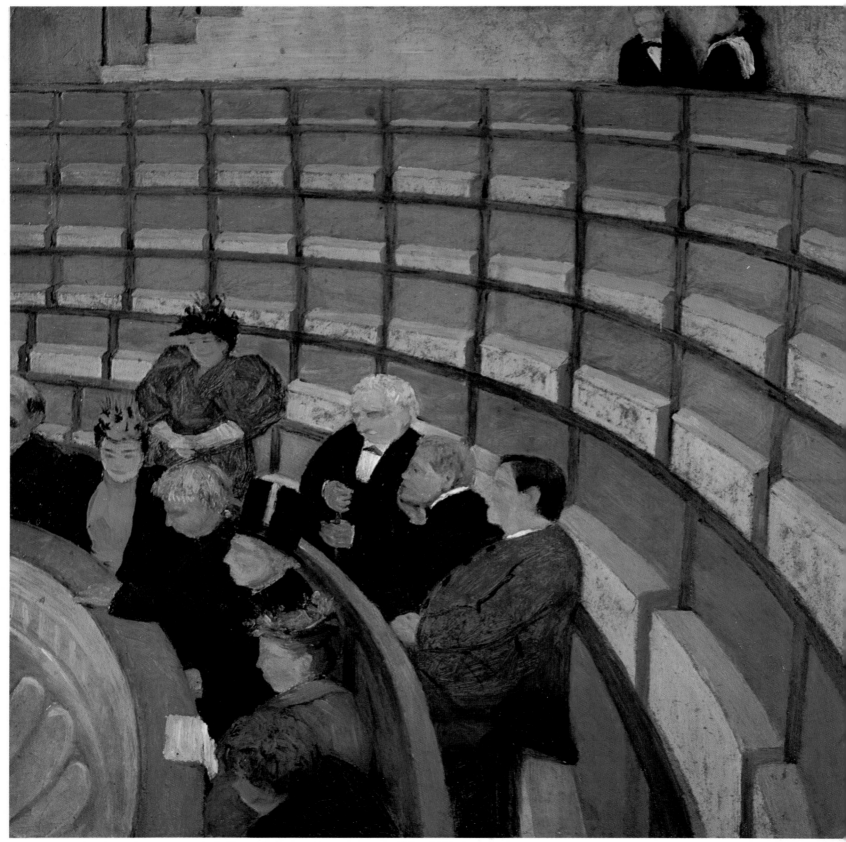

Félix Vallotton (1865–1925). ''Third Gallery of the Théâtre du Châtelet.'' 1895. Parquet wood. 19.5 × 24.2 inches.

ALLOTTON 95

Giacomo Balla (1871–1958). "The Staircase of Good-byes." 1908. Oil. 40.6 × 41 inches.

WITH THEIR truncated curves, with their figures which dwindle in spaces too large for them, Vallotton and Balla reveal the freedom acquired by the painters in their description of reality at the end of the Impressionist revolution. In the paintings here the empty space is more important than the object, and it is the ellipse, short and compact with Vallotton, drawn out with Balla, which forms the central theme. Born in Lausanne, Switzerland, Vallotton was a member of the Nabis group with whom he exhibited in 1893. In his "Third Gallery of the Théâtre du Châtelet," we again find something of the admiration he felt for the poetic rusticity of Henri Rousseau. In 1891 he wrote in the *Journal Suisse* that "the Douanier overwhelms all" and that "he is the alpha and the omega of painting."

BORN IN TURIN, Balla, who taught Boccioni and Severini, was the most passionate spirit of Futurism. His "Staircase of Good-byes," painted two years before the movement's beginnings, is a vertiginous spiral, a bottomless chasm in which ethereal, smiling creatures are disappearing. Thanks to the radical quality of the perspective which summons to mind photography and the cinema, the Italian painter gave a symbolic dimension to his painting.

Objects and
The disparate

environment interpenetrate. components of reality merge in light.

Diego Velásquez. "The Infanta Margarita." 1654.
Velásquez's fluidity fascinated the Impressionists. For Manet he was the "painters' painter."

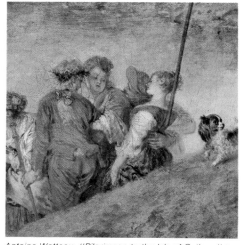

Antoine Watteau. "Pilgrimage to the Isle of Cythera" (detail). 1717.
Monet admitted that he idolized Watteau. He considered him the first great painter of the ephemeral.

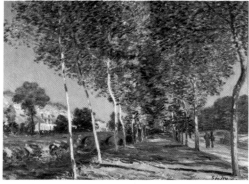

Alfred Sisley. "Promenade." 1890.
Forms are broken down, light pulverizes the masses, trees become a single, indistinct, and changing entity.

In half a century, Impressionism went imperceptibly from softening of the outline to the almost complete pulverization of the object. Since Monet with his "Water Lilies" took this tendency to its logical conclusion, he dominates this later development.

Traditional painting considers each object an independent entity, a static construction different in essence from the objects surrounding it. The world is an accumulation of autonomous substances placed side by side. "Not only does Descartes believe in the existence of absolute elements in the world," states Gaston Bachelard, "but he believes also that these absolute elements are known in their totality and directly. . . . The evidence here is complete precisely because the simple elements are indivisible." To express this segregation of substances, the painter depicts forms with closed outlines.

This conception, however, has been questioned since the Renaissance—through Velásquez, Claude Lorrain, Rembrandt, Watteau, Turner—by the growing role of light in art. The study of energy and the increasingly attentive observation of the dissolving role of solar rays disturbed faith in a system founded on the compact realities of matter. Impressionism was born when the idea was imposed on psychology that the visible world is not only composed of solids but is also bathed in an undulating field. With painters the concrete henceforth gave way to the fluctuating, the permanent to the . ethereal.

This feeling was revealed in the early landscapes of a Monet or a Sisley. For years they painted branches of trees which rise, quivering, mirrored in light, diluted in the transparency of a morning sun (*left*). Certainly it is important here to avoid an oversimplified explanation which sees in Impressionism a direct consequence of the discovery of nature. Contrary to common belief, Monet did not leave his home one day to find the countryside "fresher" than the studio and set to work on the spot. This is to confuse causes and consequences. It is quite true that the Impressionists were open-air fanatics. The critic Gustave Geffroy, who was Monet's friend, describes him "out of doors, always walking, constantly in search of nature, in the North, in the South of France, in Holland, in England, in the countryside of meadows and orchards, in spring, in winter, facing the sea of Normandy and of Brittany. . . . He is in a hurry to cross the countryside to the place where he began his canvas. He wonders if he is going to rediscover exactly the same combination of light, shade, reflections, water, and sky that he experienced so intensely the day before."

Certain technical innovations occurred just at the proper moment to simplify these ambulations. The invention of the zinc tube lightened the artist's load of small paint pots and simplified the mixing of colors. "It was the colors in tubes, easy to carry," Renoir stated later, "that enabled us to paint completely from nature." All these good reasons, however, would not have sufficed to launch a new art. The discovery of the open air merely hastened a method which became part of the aesthetic and scientific evolution of the period. Vermeer, as René Huyghe has shown, painted his "View of Delft" from a window. Nevertheless he did not produce an Impressionist picture, whereas Manet's pictures of flowers, painted in the studio, are Impressionist. Delving into the constantly changing sight of nature, Monet, Sisley, Pissarro, and Cézanne went to seek what they wanted: material untiringly transformed and renewed by the changing rays of the sun. Nature therefore favored and

Jan Vermeer. "View of Delft." 1658–60.
It is not the out of doors which makes Impressionism but Impressionism which makes the out of doors.

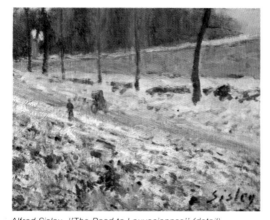

Alfred Sisley. "The Road to Louveciennes" (detail). 1877–78.
The study of snow strengthened the Impressionists' intuition that a shadow is not black but obeys the laws of reflection.

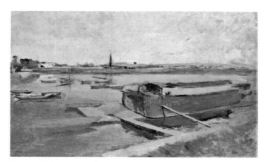

Ernest Meissonier. "Banks of the Seine at Poissy." 1889
During quiet moments, the painter of "Les Cuirassiers" became a minor Impressionist. This sketch, made from his window, shows how far the principles of the new school penetrated even among the most stubborn champions of academic work.

intensified a preexisting intuition. They were interested in the sky, in the reflections in water, in moving foliage, in anything that had no arrested form, in anything that changed visually in the light.

"Since the Renaissance [and until Manet]," observes E. H. Gombrich, "the most famous artists continued to perfect their means of expressing the visible world, but not one of them seriously doubted the idea that each object in nature possessed its well defined and constant forms which merely had to be transposed into the painting." Now, the Impressionists, analyzing the play of solar rays, observed that these by no means absorbed themselves into the object but reflected on what surrounded it. A white leaf has the color of the red alongside. As Félix Fénéon was to write, "The objects, all bound up with one another, without chromatic autonomy, share their neighbors' *moeurs lumineuses.*"

If, however, the chromatic waves rule out the outlines, at the same time they color the shadows. The black shadow is an artifice, a school proposition developed in the darkness of the studios. The Academy believed it could simplify and wished to impose the habit of bitumen, "shadowy sauces," which in no way reflect natural phenomena. As early as 1859, when he was eighteen years of age, Monet on a visit to the Salon studied Troyon's paintings and in a letter to Boudin stated: "There are some I find somewhat too black in the shadows. When you go and see, you can tell me if I am right." Another ten years were necessary to rid his palette entirely of blackish tones. The methodical study of snowscapes (*left*) was to enable the Impressionist to demonstrate clearly that even an immaculate surface obeys the laws of reflected color.

From the moment the shadows were tinted, a new conception of the pictorial surface came into being. No longer was the shadow a depth but a spot. It lost its neutrality, came to the foreground of the canvas, imposed itself as a strong note. The moment the Impressionists dematerialized volume, they materialized empty space. The painting became less and less a subject outlined on a background and more and more a flattening organization of color. As we shall see, it was Cézanne who took this experiment to its conclusion.

We are well aware of the support received by the Impressionists from such members of the Naturalistic French school of literature as Emile Zola and Louis-Emile-Edmond Duranty, followed by their increasing hostility as the style became more vigorous. "Well, really!" exclaimed Zola in 1896, "is it for this that I fought? For this light painting, for these spots, for these reflections, for this decomposition of light? God, was I mad? But it is ugly, it horrifies me! Ah! Vanity of discussion, uselessness of formulas and schools!" The author of the Rougon-Macquart series, who showed himself perspicacious in the 1860's, adopted a stricter attitude to realism the more he advanced in his own literary production. As early as 1879 he condemned as inadequate the technique of the Impressionists. His desire was for a documentary art in which the period would appear with "its costumes and its *moeurs.*" So long as Monet and his friends appeared to stick to a kind of modern reporting, he supported them and called them *actualistes.* However, as Pierre Francastel writes, when this "documentary" developed, when it took the realistic vision to the extreme, "the analysis of the methods of perception," Zola protested. He saw merely an arbitrary *tachisme,* a "madness." Less and less did he admit that a painting can express the raw experience of the optical sensation in its instantaneous confrontation with the visible. Now, this is precisely the final aim of the principal Impressionists,

Frans Hals. "Portrait of the Minister Langelius." About 1660.
His conception of allusive and "moving" form had a lasting influence on Manet, who in 1872 discovered him during a trip to Holland.

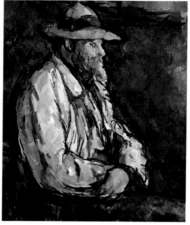

Paul Cézanne. "Portrait of Vallier." 1906.
In his groping search of the model, Cézanne refused to close the form. He obeyed Baudelaire's principle: "A work done is not necessarily a finished work, and a finished work not necessarily a work done."

El Greco. "The Vision of Saint John." About 1610.
El Greco offered a style in which figures and decor were of the same texture; Cézanne was to remember this.

namely, to free the mind of all memory, of all visual culture, of all preconceived knowledge of nature in order to seize the latter merely as a play of spots floating in space. "The artist," explained Cézanne, "is merely a receptacle of sensations, a brain, a registering device. . . . Why, of course, a good device, fragile, complicated chiefly in relation to others. But if it intervenes, if this puny thing dares to meddle deliberately with what it must express, politeness infiltrates. The work is inferior." Monet especially was "an eye," a "savage" eye which would remain faithful to the end of the pure sensation. In 1889 he explained to an American painter that he would have liked to have been born blind, then suddenly receive the gift of sight. Thus he would have distributed his colors not knowing the identity of the objects spread out before him. In 1920, then eighty, when in the urban or country landscapes, he saw merely imprecise colors crossed by luminous dots. This is what he painted (*right page*) without ever trying to reconstruct and to complete his subject by adding what he *knew*.

This logic of the perceived conditioned all Impressionism. To it we owe the haziness, the unfinished appearance, which characterize, for example, certain paintings by Renoir (page 101). Our optical nerve cannot accommodate itself simultaneously to the near and far, to what faces us and what is sideways. Renoir detailed his foregrounds and rendered indistinct his backgrounds. Only classical painting, believing it could dominate the totality of nature, pierce all its obscurities, thought it had the right to "give a clear image" of the foreground and the background.

Another consequence of the modern perception was *movement*. To a friend who asked him why, in his portraits, the hands always appeared unfinished, Manet replied, "because the hands are not a dry outline in nature, they move" (p.108). Thirty years later Pissarro was to offer the same advice to a young painter. "It is useless to tighten the form which can do without it. Precise, dry drawing detracts from the impression of the whole and destroys every sensation. Do not define the outline of things."

The unfinished was also the technical means of expressing the ephemeral. Impressionism is the art of metamorphoses. No longer did one paint a landscape but the action of the clouds, of the wind, of the rain on trees and on fields. Paintings were entitled "Morning Effect", "Fog Pierced by a Ray of Sunshine," "Nocturne in Blue."

Contemporaries regarded as clumsy, amateurish, or childish the Impressionist depictions of the transitory. "There is a moment of the world which passes," explained Cézanne, "one must paint it in its reality." To which Merleau-Ponty adds: "Cézanne does not wish to separate the things which appear to our eye and their fleeting manner of appearance." This resulted in the development of the series—the logical consequence of an aesthetic of the ephemeral. Before Monet were Pierre-Henri de Valenciennes and Johan Jongkind, but Monet pushed the formula to its conclusion. Each poplar (page 254), each haystack (pages 134–35), each cathedral (pages 136–37) is a fraction of one and the same investigation. Each canvas refers to all the others and reads as the unfinished section of a speech on the unfinished. Of Monet's Cathedrals Clemenceau, who was an occasional art critic, observed: "The immutability of the subject brings out more strongly the mobility of the light." No longer was the object of the painting the huge, secular Gothic façade but the undulating play which constantly dressed and undressed it.

Claude Monet. "View of London at Night." After 1900.
The aging Monet describes London as a quivering of light. He tries to find a manner of expressing a world which is merely energy.

Jésus Rafaël Soto. "Pénétrable." 1969.
With his "Pénétrables," Soto did Monets in space. No longer is the spectator *opposite* the painting but plunged *within;* his entire body takes part in its aesthetic process.

Jackson Pollock. "Convergence." 1947–50.
Modern art was to remember the lesson of the late Monet: more form, more composition. Here the painting is merely an accumulation of lines covering the entire surface.

Jean-Baptiste Carpeaux. "Descent from the Cross." About 1865.
Nineteenth-century sculpture followed the same movement as Impressionist painting. Daumier, Carpeaux, Rodin, Rosso created hollow volumes with light infiltrating to break the clean-cut outlines.

By emphasizing radiance, Impressionism took the drama out of painting. We cease to find, as with the Romantics, striking action and unusual figures. Absent also are dramatic moments—the one depicted is as worthy as all others. The painter's eye is dispassionate, attaching no more importance to a human silhouette than to that of a tree. Immobile with Monet, suspended in their movement with Degas, petrified in their humble task with Van Gogh, human beings sink into the general texture of the work (page 119). At most they are a vibration among many others. If we reconstruct them, it is thanks to the spontaneous visual coherence of the human eye which constantly tends to identify and to personalize the confused heap of forms presented to it. In a vertical line we distinguish a silhouette. Monet solicits the spectator's participation to give meaning to his spots, just as his friend Mallarmé in successive strokes created in words the adumbrated equivalent of the object which he allows us to name.

The second result of Impressionism was a generalized merging of objects in the undulatory radiation. Beginning with a flecking and a jumbling of outlines, the painters intuitively arrived at insights of contemporary physics. They perceived that there are no compact, static objects on one side and the luminous energy which animates them on the other. Matter is energy, energy is matter. As the physicist Bachelard explained, "We must first break with our concept of *rest:* In microphysics it is absurd to assume matter at rest since it exists for us merely as energy and sends its message only through radiation." Cézanne wanted to "marry the curves of women to the shoulders of hills." "All beings and things are nothing more than a bit of stored-up and organized solar energy, a souvenir of the sun, a bit of phosphorus which burns in the membranes of the world." He invented an art of interpenetration (pages 112–15 and 266–69), an art in which the powers of nature mingle with a molecular chaos, and animal, vegetable, and mineral appear to be of the same structure.

In his final large surfaces ("Water Lilies," page 141) Monet surrounds the spectator with a hazy mist in which every object disappears and the law of gravity is disregarded. Vaporous, ductile substances, lighter or heavier than air, float in a limitless depth. Whereas Sisley and Pissarro preserved a spatial distribution stemming from the Renaissance and limited themselves to the softening of outlines, Monet required from the spectator a new attitude. He demanded that from the perception of a painting or sculpture there follow an apprehension of an entity which envelops us. The work was no longer received by the eye but with the entire body. Perception required that we mobilize our entire nervous system.

Simultaneously a new conception of art appeared. The traditional canons of balance, beauty, composition, became less important. Henceforth the work represented a phenomenon of nature and made visible a part of reality. Lost in the endless environment which encloses us—constantly increased and upset by scientific research—the artist disengages sensible truths which are his manner of reading physical reality and expressing its essential laws. In his own way, he attempts to take into account intuitively the time-space continuum which encompasses us. Impressionism organized the grandiose stage setting of the ephemeral. It made us comprehend to perfection a dominant phenomenon of nature and offered an example of the words of the philosopher Ernest Renan: "Everything is ephemeral and the ephemeral is often divine."

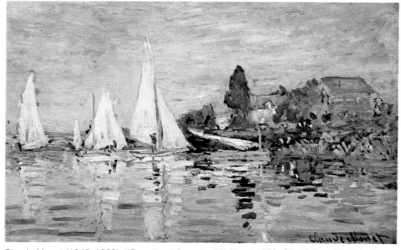

In a series of passionate observations, Monet established a dialogue of water and light. In his early paintings he outlined the program of an entire life.

Claude Monet (1840–1926). "Regatta at Argenteuil." About 1872. Oil. 18.7 × 29.25 inches.
Claude Monet. "Regatta at Argenteuil." Detail.

Claude Monet. "Impression, Sunrise." 1872. Oil. 18.3 × 25 inches.

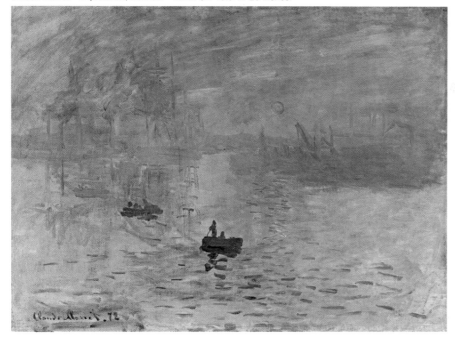

OBSERVING ON the surface of the Seine the transformation of reflections into myriads of dancing spots, Monet found the occasion to express his conception of a fluid world in which movement and light constantly question outline. As early as 1868 Zola had noted, "With him water is lively, deep, true everywhere. It chops around the barks with greenish islets broken up by white glimmers. It extends in glaucous pools suddenly swept by a gust of wind, it increases the size of the masts which it reflects by breaking up their image, it has pallid and dull shades which come to light quite distinctly." The conception is as yet timid in *"La Grenouillière"* (*below*). The black residue deprives the water surface of its transparency and the bottom with its foliage remains intact. However as early **as about 1872, some three years later,** following his stay in London where he studied Turner and Constable, Monet took a bold step. He juxtaposed on the canvas, in his "Regatta at Argenteuil," in the name of realism, large accents of pure divided tones (*left*). In his rough brushstrokes he would never go further. "Impression, Sunrise" (*above*), painted in 1872 in Le Havre, in a more fluid manner, was destined to give its name to the movement. Renoir's brother, who was in charge of the catalogue of the Exhibition of 1874, deplored the monotony of the titles. To which Monet retorted, "Put *Impression.*" Derisively quoted by the critic Louis Leroy, this title ultimately gave the name Impressionist to the entire group of painters.

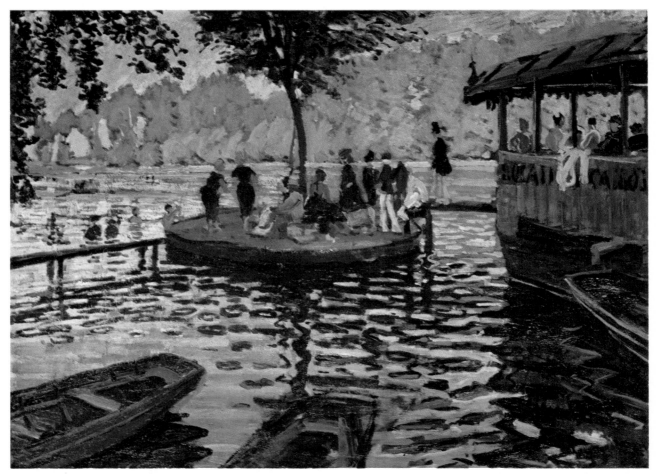

Claude Monet. *"La Grenouillière."* 1869. Oil. 28.9 × 39.8 inches.

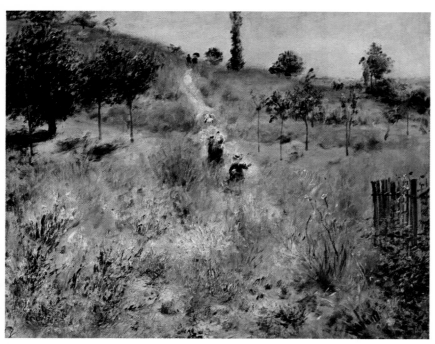

Pierre-Auguste Renoir (1841–1919). "Road Through High Grass." 1876–78. Oil. 23.4 × 28.9 inches.

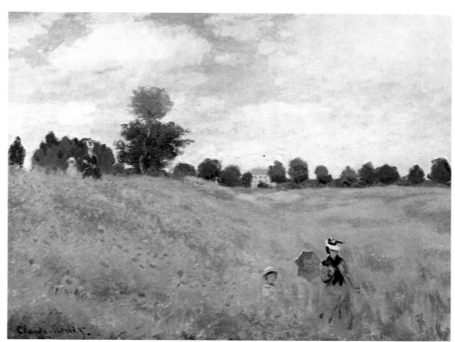

Claude Monet (1840–1926). "A Field of Poppies." 1873. Oil. 19.5 × 25.35 inches

A SPLASH OF red spots in a haze of greenery, this is how Monet saw a bit of countryside. He made no attempt to render the detailed form of a poppy but offered his first impression, the instantaneous effect on the retina. This silhouette of a faceless woman (*right*) reveals how far painters have come since the time of Watteau (page 90). As diaphanous as were the latter's women of Cythera, they nevertheless retained an outline and distinctive features. To quote Gustave Geffroy, Monet's friend and critic, "Here human beings pass as glimmers and a glimpse of everything is had through the transparent atmosphere. . . . Everything is illuminated and quivers under the waves of light propagated in space."

IN THE CENTER of the painting by Renoir (*above*), who was under the influence of Monet when he painted it, the role of the shadow is that of a heavy accent to heighten the raw greens. The manner in which the trees are painted recalls Valenciennes' technique (page 32). "Methods and techniques, however, are not taught," said Renoir. "One learns them oneself by searching. Nothing should be painted in a similar manner. Some things in a canvas gain by being sketched and left to imagination. It is a matter of feeling."

Claude Monet. "A Field of Poppies." Detail.

In the random sowing of the red spots of Monet's poppies
is seen the first delight of light painting.

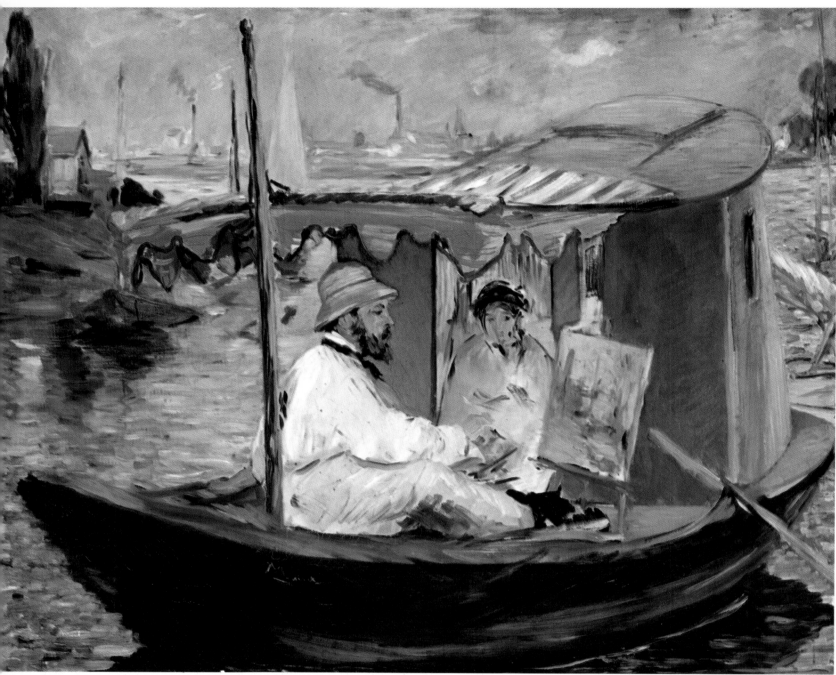

Edouard Manet (1832–83). "Claude Monet in His Studio Boat." 1874. Oil. 32 × 41 inches.

THESE TWO paintings by Manet of Monet allow us to see the artist at work. Following the example set by the landscape painter Charles-François Daubigny and his *Bottin,* Monet had purchased an old boat which enabled him to observe the play of light on water at close hand. In this floating studio he could sleep and even make a trip. In fact, he once took his entire family as far as Rouen. Both paintings **reveal the canvas shelter which offered** protection to the painter and his wife from the sun.

The year 1874 marked the rapprochement of the two men. "You are the Raphael of water," said Manet. Influenced by his pupil, Berthe Morisot, he let himself be led to the open air and joined the Impressionists who were painting on the spot. He rediscovered the charm of lively light, a presentiment of which he had had as early as 1869 (page 192). It was during this period that the painter of the scandalous "Olympia" proved generous to his young artist-friend who found himself in serious financial difficulty. On June 28, 1873, Monet himself described his plight as "more and more difficult. Since the day before yesterday not a *sou* and no more credit from the butcher or the baker. Although I have faith in the future, you can see that the present is rather painful. . . . Could you not send me by return máil a twenty-franc note?"

Converted to the freedom of out-of-door painting, Manet
portrayed Monet in his nautical "studio"—close to nature.

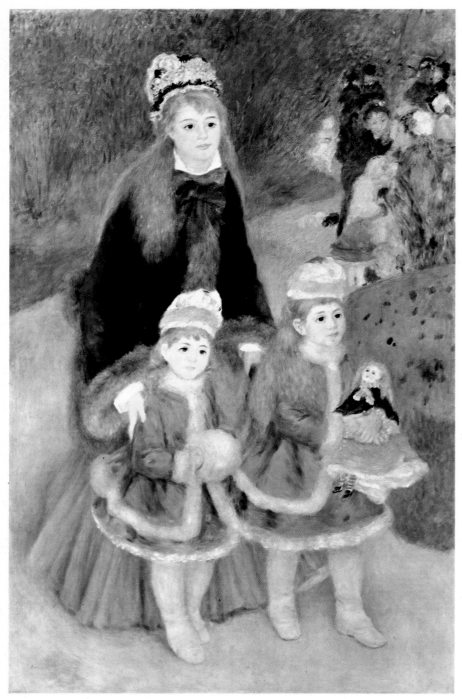

Pierre-Auguste Renoir (1841–1919). *"La Promenade."* 1874–75. Oil. 67 × 42.1 inches.

Renoir gradually blended his figures into a hazy reality without outline.

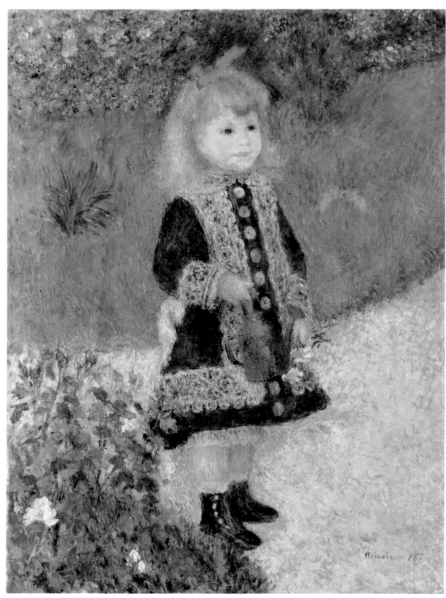

Pierre-Auguste Renoir. "Girl with a Watering Can." 1876. Oil on canvas. 39.37 × 28.5 inches.

To INTEGRATE his figures into their setting, Renoir sought his way. In *"La Promenade"* (*left*), there is extensive modeling and the faces are clearly designed, the charm of the painting stemming from the physiognomical identity.

In "Girl with a Watering Can" painted two years later, the outlines gain in fluidity, the clothing tones vibrate. No longer does the girl stand out in the foreground. She and the background merge into the same light. The third dimension is minimized. In "Her First Evening Out"—the bold composition suggests Degas' influence—the foreground is clear and the background indistinct. Renoir sought here to obey a law of vision which forbids us to accommodate simultaneously different distances. Whereas classical painters were content in general to suggest distance by *sfumato* (a light haze to express atmosphere), Renoir chose a more radical method and one more faithful to what he effectively perceived with his eye on his young and delightful spectator. He breaks up the masses, eliminates all precise outline and the public becomes an indistinct *mêlée*. In so doing, he **replaces studio convention by what he** has learned from physical experiment.

Pierre-Auguste Renoir. "Her First Evening Out." 1876. Oil. 25.35 × 19.5 inches.

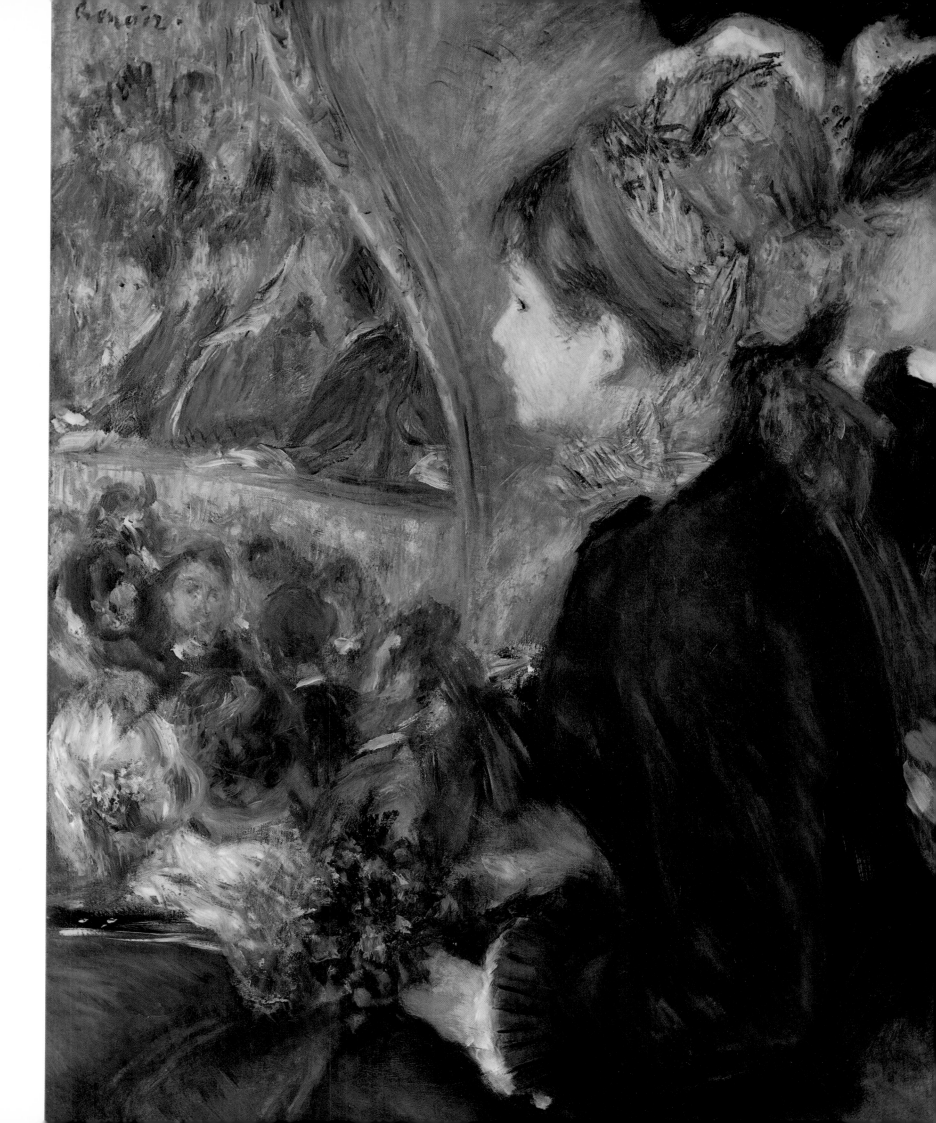

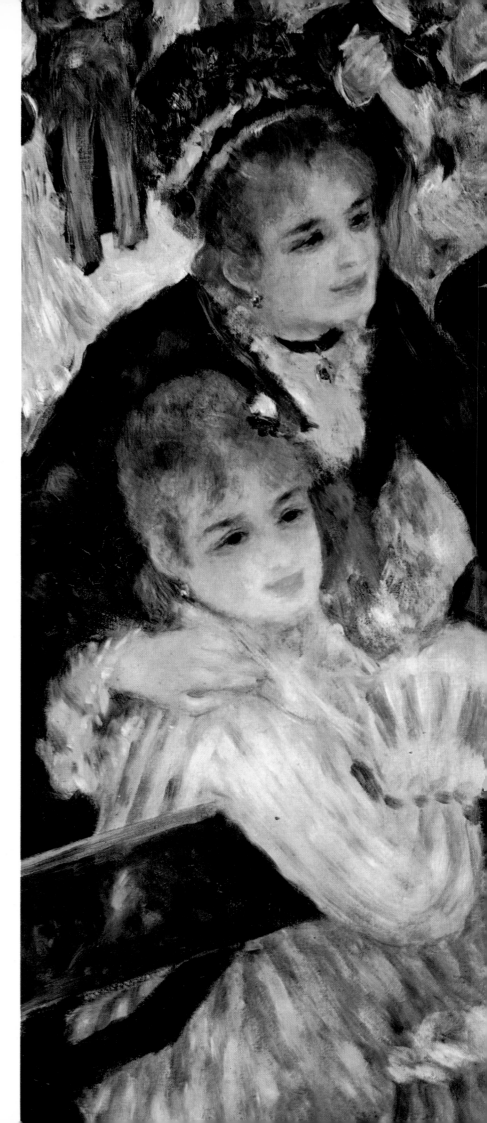

Solar rays pulverize the *grisettes'* dresses and change them into luminous matter.

THE "ARBOR," now in the Pushkin Museum, Moscow, is a feast of light. The large light area of the dress, on the left, does not disturb the balance of this work, which is bathed in palpitating summer light. "Without the slightest compositional artifice or *trompe-l'oeil* effect," wrote the curator Charles Sterling, "Renoir takes us into the very core of the scene. We are invaded and, as it were, absorbed by the radiation of his painting. . . . Apart from Delacroix this is the most saturated and densest painting in modern times." Renoir, who detested *misérabilisme* (a term coined from Victor Hugo's massive novel *Les Misérables,* which is replete with social and humanitarian themes), stated, "Zola thought he had portrayed the people by saying that they smell. For me a painting should be something pleasant, joyful, and attractive, even pretty. . . . There are sufficient bothersome things in life so that we need not create others." In his early days he studied in the studio of Charles Gleyre, a free and easy institution headed by this mediocre Swiss painter. To Renoir he observed, on one occasion, "One should not paint for amusement" which called forth the retort, "If it didn't amuse me, I shouldn't paint."

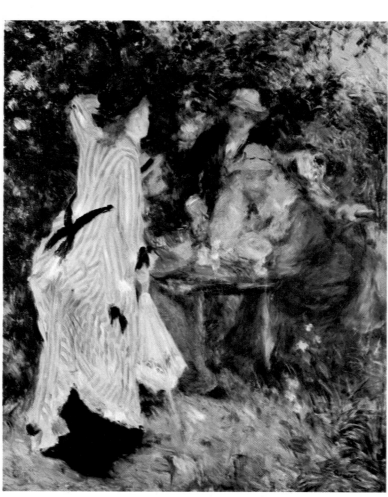

Pierre-Auguste Renoir (1841–1919). "The Arbor." 1876. Oil. 31.6 × 25.35 inches.

BEHIND THE enchantment of Renoir's Montmartre paintings lies a virtuoso demonstration of the possibilities of animating a subject by the use of light. Thanks to the pretext of branches of trees with their arbitrary screen of colored spots, Renoir pulverizes the forms and changes the young women's dresses into a shimmer of formless matter. Closed outline is effaced by the thread of solar rays which treat with equal freedom the stony ground and the rumpled texture. To quote Gustave Geffroy, "Woman, the modern goddess, in silk, satin, and curves, dressed and ribboned in every color," is queen of the Moulin de la Galette, the popular dance hall of the working-class families of the district. Here Renoir was perfectly at home. After selling a painting, he settled down close by, at No. 78 Rue Cortot, so that he could work more easily on the spot. Georges Rivière, Renoir's and Cézanne's faithful friend, relates how "we carried this canvas ["*Le Moulin de la Galette*"] every day from the Rue Cortot to the Moulin, for the painting was done entirely on the spot and not without some difficulty."

Renoir devoted his mornings to "*Le Moulin de la Galette*" and his afternoons to "The Swing." Both canvases were the result of the same inspiration which proved the most fortunate in the painter's entire career.

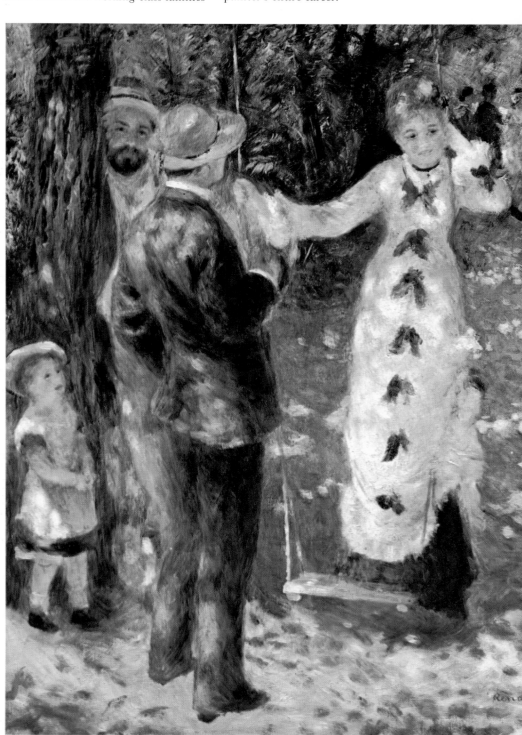

Pierre-Auguste Renoir. "The Swing." 1876. Oil. 35.9 × 28.5 inches.

Pierre-Auguste Renoir (1841–1919). "*Le Moulin de la Galette*" (detail). 1876. 51.5 × 68.6 inches. 103

Claude Monet. "Turkeys." Detail.

THE ENTIRE canvas is covered with a lively, nervous, rhythmic brushstroke. In this inextricable skein of pigment applied to the surface, Monet constructs volumes which become logical only as the spectator takes a few backward steps. Each color is the result of numerous series of approximations. In contrast to a Courbet, who painted a landscape out of doors and its figures in the studio, Monet executed the entire canvas on the spot, in the same luminous atmosphere. Gustave Geffroy, who on many occasions watched him at work, relates how "he weighed the matter in his eye, coordinated in his precise mind the multiple phenomena of form, color, and light which constantly change the distances, the densities, the surfaces, and the expressions." The large decorative canvas entitled "Turkeys," with its animals seemingly thrown in haphazardly, like so many white spots, was shown at the third Impressionist exhibition in 1877 and poorly received by the critics. That same autumn Monet urged the collector Victor Chocquet, "Would you kindly take one or two badly painted pictures which you may have at a price you name: fifty francs, forty francs, whatever you can, for I can no longer wait."

In a skillful chaos, Monet's rhythmic brushstroke blends every color in the prism.

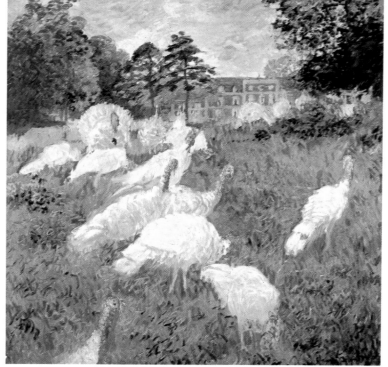

Claude Monet (1840–1926). "Turkeys." 1877. Oil. 68.3 × 67.5 inches.

Claude Mo
"Turkeys."
Detail.

The enchantment of the prosaic enthralled Monet. Relentless in his interpretations of the Paris railroad station St.-Lazare, he gave the steam jets an airy and countrylike interpretation.

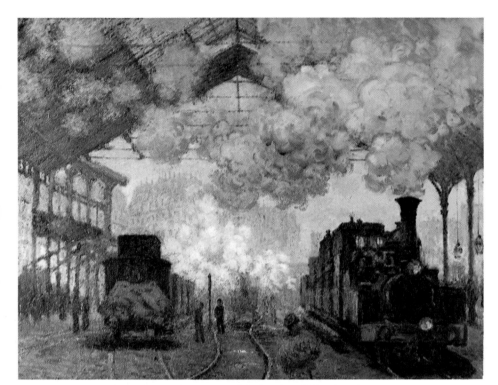

Claude Monet (1840–1926). *"La Gare St.-Lazare."* 1877. Oil. 32 × 39.8 inches.

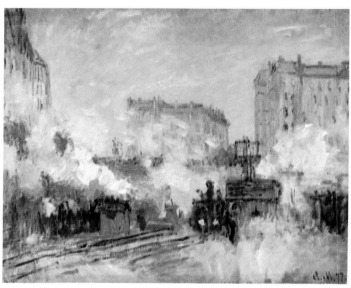

Claude Monet. *"La Gare St.-Lazare."* Oil. 23.4 × 27.3 inches.

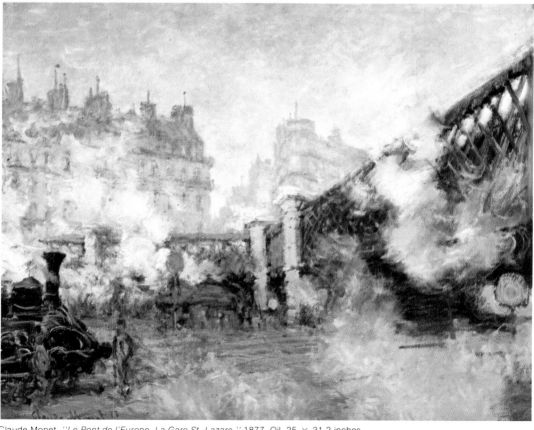

Claude Monet. *"Le Pont de l'Europe. La Gare St.-Lazare."* 1877. Oil. 25 × 31.2 inches.

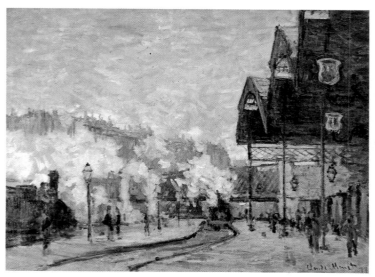

SMOKE, MORE diffuse and fleeting than water, fascinated Monet. He discovered beneath the huge panes of St.-Lazare a constant mobility in the clouds of smoke from the locomotives. With Monet there was no "message" when he chose a site as prosaic and utilitarian as this. Nor were there any social intentions. He dealt chiefly with plastic problems: the relationship of the permanent dark masses of the locomotive to the ephemeral light clouds of the steam jets. Yet in these images we feel the sensibility of a country man, as though Monet attempted to insert his colors into the drab world of the machine and to combat the cloud of soot on the point of invading Paris.

"In 1877," notes the art critic Lionello Venturi, "the locomotive still stirred up enthusiasm as a miracle of science. Monet wanted to reveal that even a black machine and a mass of black panes could be depicted by blue, that the dirty gray of the ground could be seen as green, and that the smoke itself could become light."

Claude Monet. *"La Gare St.-Lazare."* 1877. Oil. 23.4 × 31.2 inches.

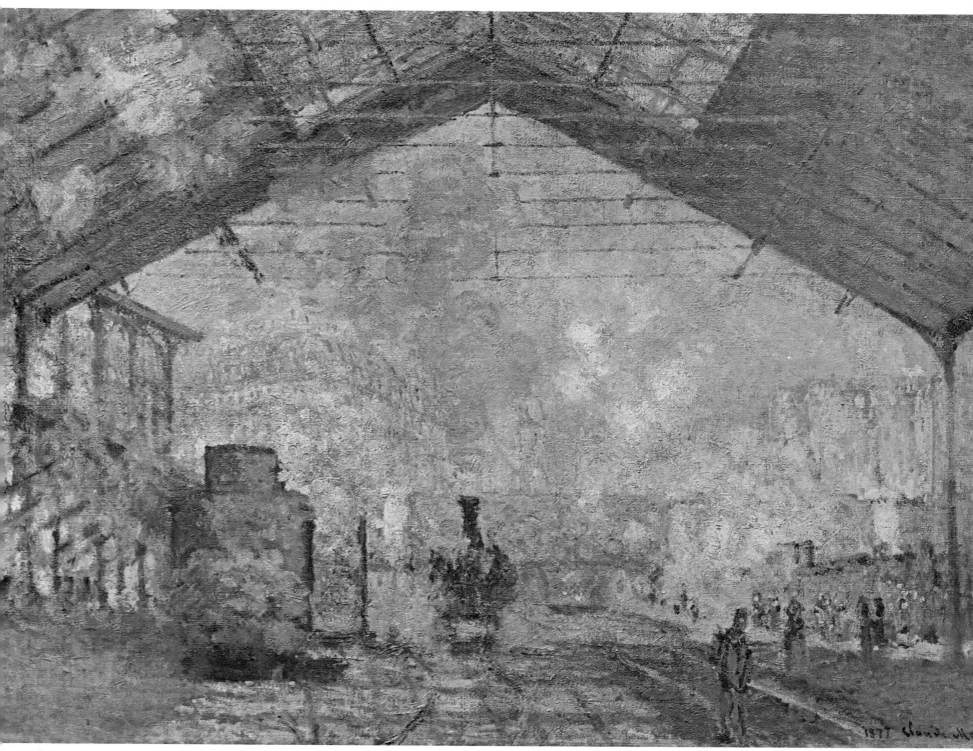

Claude Monet. *"La Gare St.-Lazare."* 1877. Oil. 29.25 × 39.8 inches.

In Manet movement is a significant quality. He attempted to catch the restlessness of everyday gestures.

Edouard Manet (1832–83)."Lady Dressed in a Riding Habit." 1882. Oil. 28.9 × 20.3 inches (**detail opposite**).

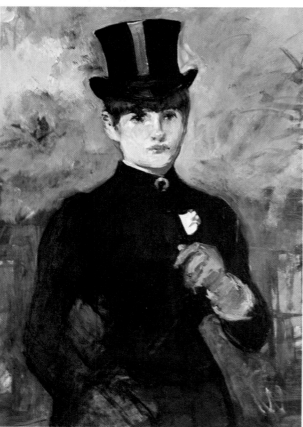

"LIVELY, PROFOUND, sharp, haunted by black," such were Mallarmé's terms to qualify the art of Manet, who had oriented his entire Impressionist production toward seizing the immediate gesture. He wanted to create the feeling of an improvisation, of a hastily caught silhouette "thrown" onto the canvas. "There is but one real thing," he explained to his friend Antonin Proust, "to put down at once what you see. When it's done, it's done. When it's not, one begins all over again. Everything is there, the rest is a joke." He did not rework a painting which came off badly but cleaned the canvas and started from zero. He did four portraits of Mademoiselle Henriette Chabot, the daughter of a bookdealer on the Rue de Moscou. He worked relentlessly on her riding habit, as he intended to present the picture to the Salon of 1883. "This 'Lady Dressed in a Riding Habit,'" wrote Jacques-Emile Blanche, "I saw Manet rub it out,

scrape the top hat, redraw it so that it would 'stick' to the hair." Manet, however, did not live to be present at the Salon of 1883. A sick man, he was confined to bed. Gangrene set into his left leg and it was amputated. On his deathbed, he was obsessed by the hostility of the academic painter Alexandre Cabanel. "He is in good health," moaned Manet, who died on April 30. Degas admitted that "Manet was greater than we think." His "Self-Portrait" shows him, in 1879, palette and brushes in hand (reversed by the mirror) about to paint the splendid yellow of his jacket.

In the two paintings shown on this page, the hands are treated with unusual freedom. Manet owed this to his discovery of Frans Hals (during a trip to Holland in 1872) whom he soon surpassed in representing the allusive and the unfinished. "Hands," he said, "are not drawn dry in nature. They move."

Edouard Manet. "Self-Portrait with a Palette." 1879. Oil on canvas. 32.4 × 26.1 inches.

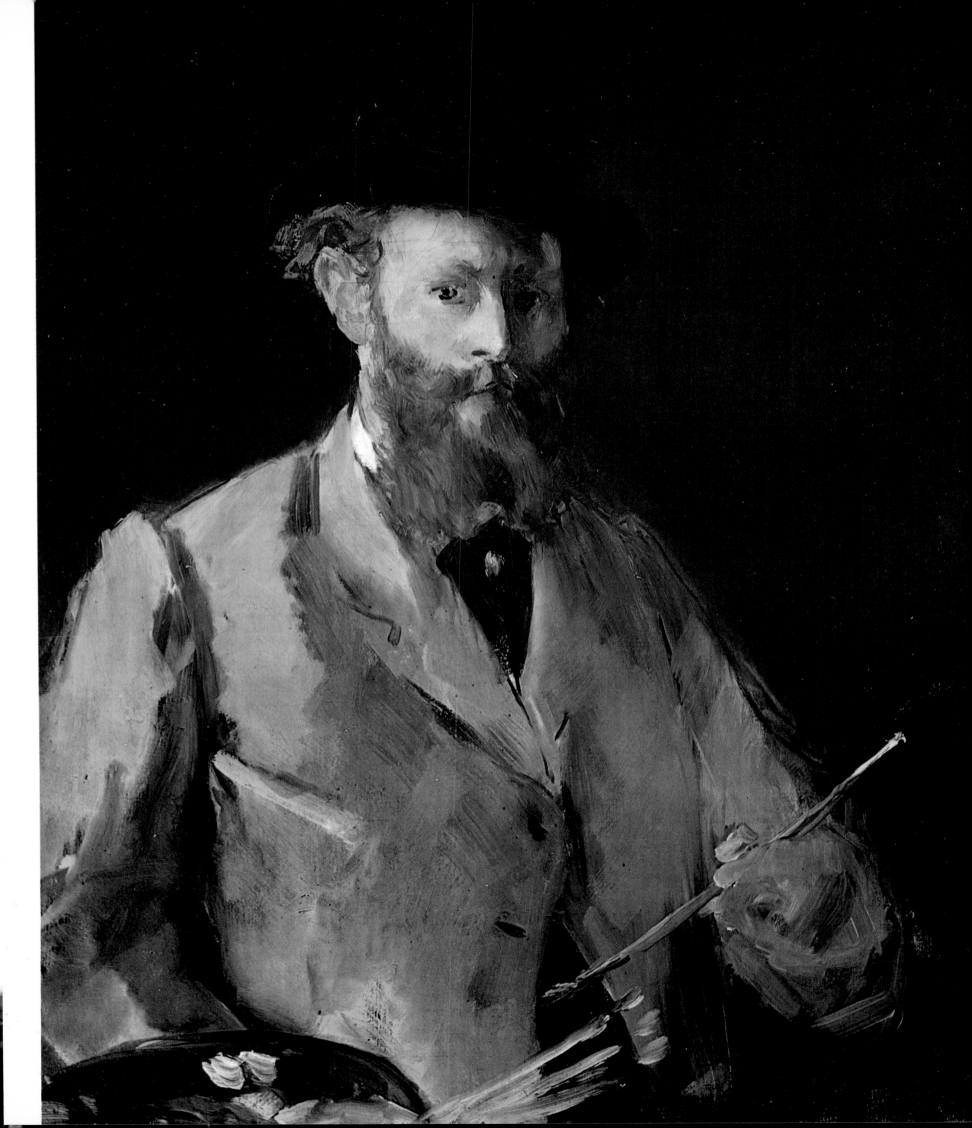

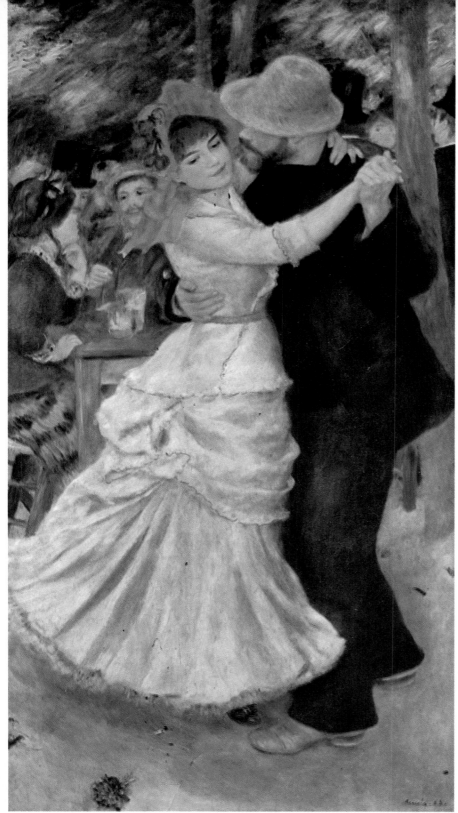

Pierre-Auguste Renoir (1841–1919). "Dance at Bougival." 1883. Oil on canvas. 70.6 × 37.4 inches.

This is the typical Impressionist *fête*. From a tavern on the banks of the Seine, Renoir created an image of happiness.

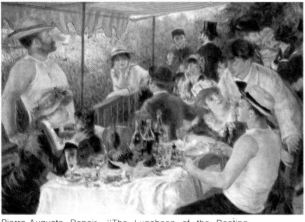

Pierre-Auguste Renoir. "The Luncheon of the Boating Party." 1881. Oil. 50.7 × 67.9 inches (Detail, left page).

"RENOIR is perhaps the only painter," said Octave Mirbeau, "who never produced a sad painting." "The Luncheon of the Boating Party" brilliantly ends the first Impressionist period of the painter who, in 1883, was about to enter a phase influenced by Ingres. The picture represents a group of friends, in a joyful and relaxed mood, around the table of La Mère Fournaise, a kind of pleasure garden with music and dancing on the banks of the Seine. In the background, behind the figures, we glimpse pleasure boats. In the foreground, playing with a dog, in the midst of other "boating Mona Lisas," is the girl Aline Charigot, who soon married the painter. In the delightful "Dance at Bougival," painted two years later, we feel Renoir's hesitation between a stronger, more linear, more modeled style and the vibrating manner which triumphed in his *"Le Moulin de la Galette."* Henceforth the dominant note was no longer blue but red.

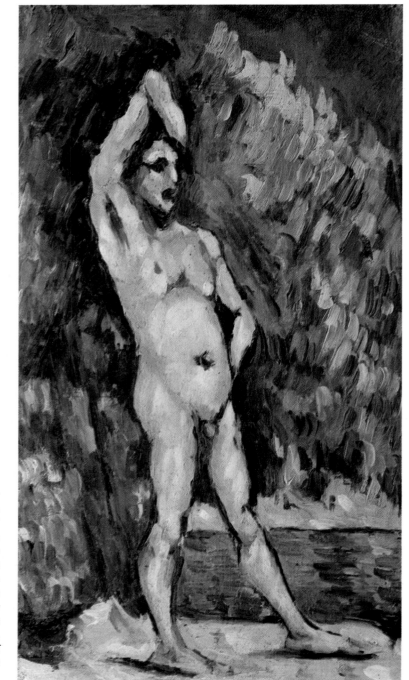

Paul Cézanne (1839–1906). "Standing Nude." 1875–77. Oil. 21 × 17.5 inches.

CÉZANNE USED the same thick brush-stroke to express the landscape and the figures which are submerged in it. "For an Impressionist to paint from nature is not to paint the subject but to 'realize' sensations," explained the artist who sought to mingle on the canvas every element of nature. As he observed the countryside, the master of Aix with prophetic sensibility discerned, beneath the surface appearance, the great molecular chaos which blends in a larger order the vegetal, the animal, and the mineral. "My eyes are so stuck to the point of view that I am looking at," he said, "that I believe they are going to bleed."

In the "Standing Nude" Cézanne satisfied the nostalgia of his youth and of his friendship with Emile Zola, the period when both boys, who were fond of bathing, swam nude in the Arc, a small river which winds its way south of Aix. "What I would like—rotten fate that separates us—is to see you succeed," wrote the future artist in 1858 to his former fellow-student who had left to complete his studies in Paris, where he was to become the most famous writer of his time.

Cézanne wanted "to marry the curves of women's bodies to the shoulders of the hills." In a single heavily loaded brushstroke he achieved a fusion in which all nature became one.

112

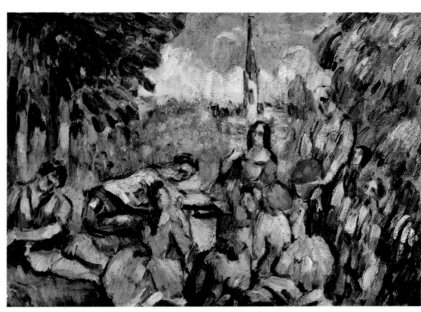

Paul Cézanne. "Luncheon on the Grass." About 1873–75. Oil. 8.2 × 10.1 inches (Detail, on the right).

Cézanne's monumental bathers take their architectural power from the structure of nature.

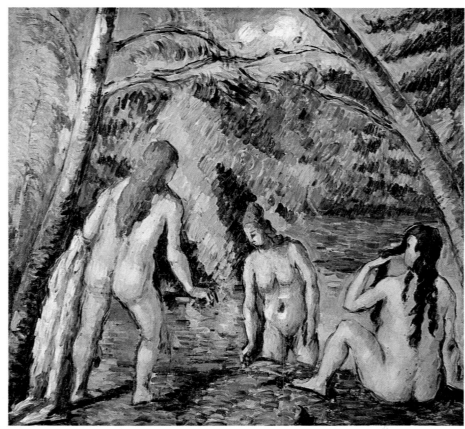

Paul Cézanne (1839–1906). "Three Bathers." 1879–82. Oil. 22.6 × 21 inches.

"To do Poussin again from nature and to make of Impressionism something solid and durable, like the art of the museums," such was Cézanne's ambition. In the works shown here bathers participate in the most secret movements of creation. As Maurice Merleau-Ponty explained, "Cézanne wanted to paint this primordial world and that is why his pictures create the impression of nature at its origin." Fernand Léger stated, "Without Cézanne, I often wonder what present-day painting would be. For a long period I worked with his *oeuvre*. It never left me. Of my exploring and discovering it there is no end. Cézanne taught me to love forms and volumes and he made me concentrate on drawing. I had a presentiment then that this drawing should be rigid and not at all sentimental."

Cézanne was intimidated by women, as is evident in his youthful works. "I paint still life," he told Renoir. "Female models frighten me. The hussies are always in the act of observing you so as to seize the moment when you are offguard. One must be constantly on the defensive and the subject disappears." In 1890 the Paris art dealer Julien Tanguy sold his Cézannes at a fixed price—100 francs for the large canvases and forty for the small ones.

Paul Cézanne. "Five Bathers." 1885-87. Oil. 25.35 x 25.35 inches.

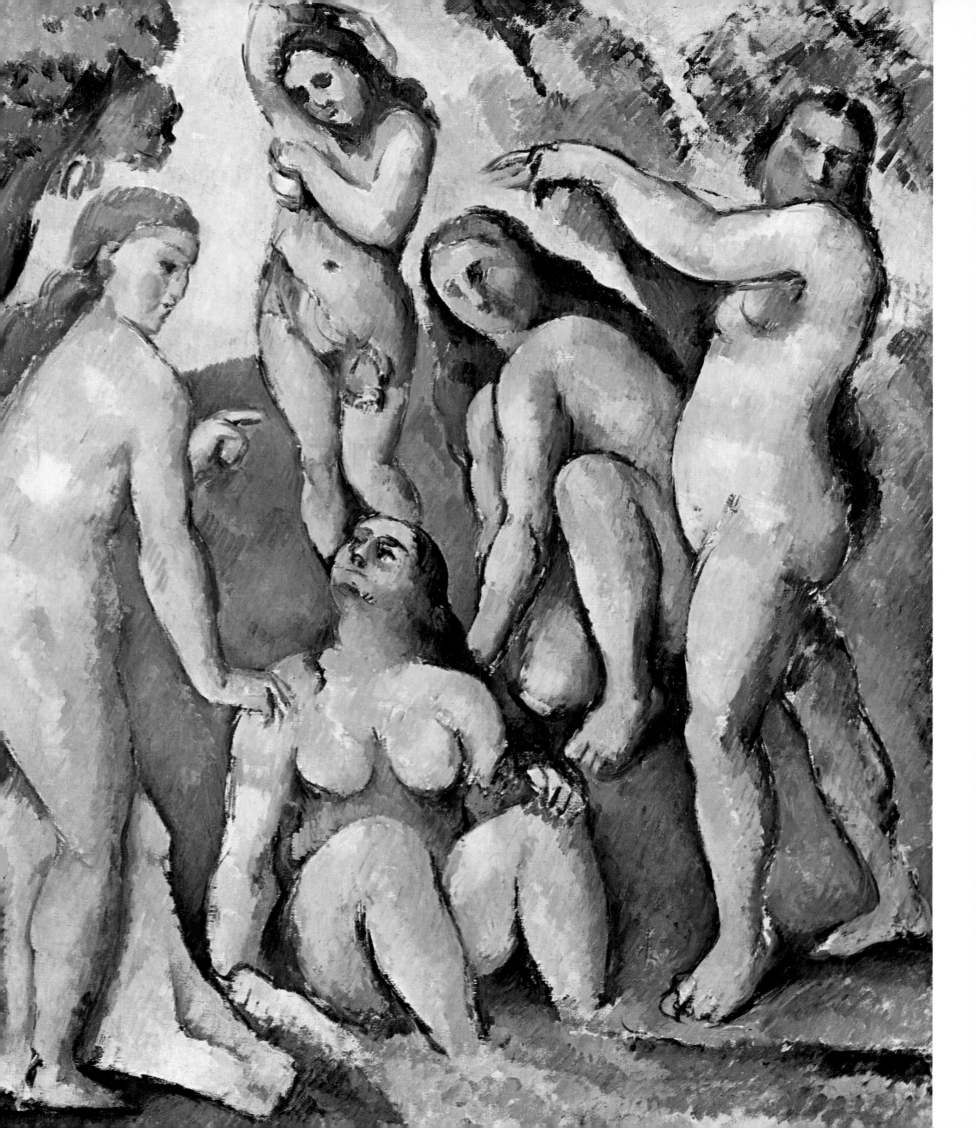

At the bedside of his dead wife, Monet drew the most heartrendering tones from the Impressionist palette.

AFTER THE DEATH of his first wife, less than thirty years of age, Monet reacted as a painter. He gained insight that day into the profound meaning of his own research and the reason for his relentlessness in describing the ephemeral character of things and beings. To his friend Georges Clemenceau he later admitted, "Finding myself at the bedside of a dead woman who had been very dear to me and who was always very dear, to my surprise I kept staring at the tragic temple while mechanically looking for the sequence, the appropriation of the color degradation which death had just left on the motionless face. Blue, yellow, gray tones, and goodness knows what else. That is what I had come to. . . . The organic automatism trembled at first from the shock of the color, and in spite of myself the reflexes committed me into an operation of unconsciousness in which the daily course of my life resumed its flow, like an animal turning round his millstone."

Camille Monet's life had been nothing more than a long struggle against poverty. In 1878 Monet wrote to Zola, "We don't have a *sou* in the house, today nothing to boil the pot. With all that my wife in ill-health and in need of much care, for perhaps you are aware that she happily gave birth to a superb baby boy. Would you lend me two or three louis [twenty-franc pieces], or even one?" A year later, Camille dead, he begged a friend "to withdraw from the municipal credit office the medallion whose pawn ticket I am sending you. It is the only souvenir my wife was able to keep and before I leave I should like to place it on her neck."

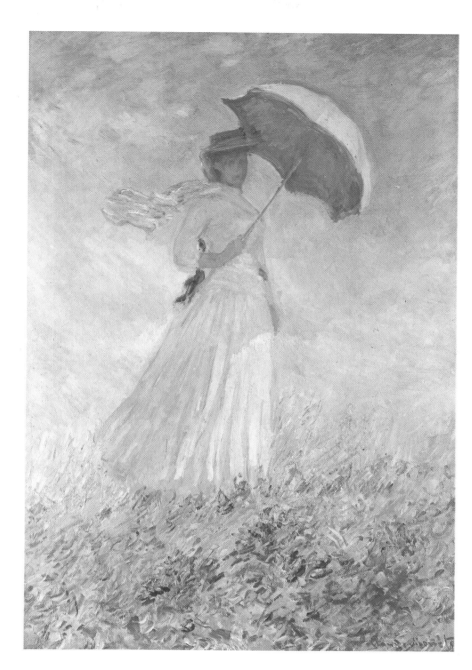

TRANSPORTED BY the light, Monet painted his stepdaughter Suzanne Hoschedé. He had caught a glimpse of her walking on a slope, at the far end of "the island of nettles," a meadow which marked the farthermost point of his Giverny property. "Swept away by the splendid subject," related Jean-Pierre Hoschedé, "forgetting how tired the model was, he would not allow her to rest and Suzanne, not daring to move, fainted—much to Monet's great **despair.**" His **"Lady with a Parasol" is** the triumph of a "painting of air," miraculously transparent and subtle. With Monet, beings and things acquired a vaporous and immaterial texture. The point of view, as though the spectator were indeed below, gives the feeling of accompanying the model in her metamorphosis as she rises toward the airy region. As Gustave Geffroy explained, "Monet clothes these figures of ethereal and harmonious girls in willowy ascensions, in the golden sun and march of the clouds. The novelty here is a kind of evaporation of things, a disappearance of outline, a delightful contact of surface with atmosphere."

Claude Monet (1840–1926). "Camille Monet on Her Deathbed." 1879. Oil. 35.1 × 26.5 inches.

Claude Monet. "Lady with a Parasol." 1886. Oil. 51.5 × 34.3 inches.

With the same peaceful caress the wind envelops flowerbeds and women's dresses.

In the painting at right Alice Hoschedé, Monet's second wife, is fitted, as it were, into the curve of the tree next to her and is an integral part of the garden at Giverny. As a refined pantheist, the artist treated his figures as the components of a huge cosmic totality. To quote Pierre Francastel, "Man here is nothing but a fleeting and secondary place between displacing forces." The best description of Monet's flying brushstroke was given by Octave Mirbeau in 1912. "One would think the hand abandons itself to follow light. It renounced the effort of seizing it. It glides over the canvas like light over things. The careful movement which, piece by piece, created the atmosphere [in the previous periods] gives way to a more subtle movement which imitates and obeys it. Claude Monet no longer seizes light with the joy of conquest of one who, having reached his prey, clenches it to himself. He expresses it in the same manner as the most intelligent ballet dancer expresses a feeling."

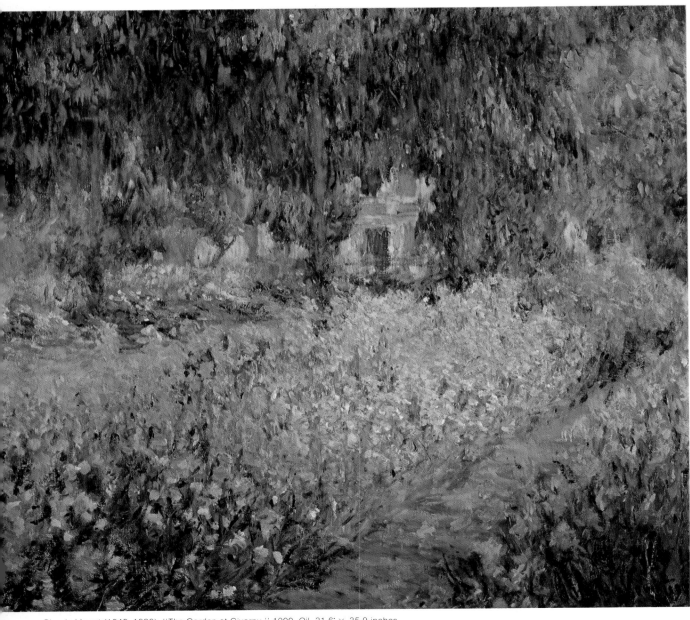

Claude Monet (1840–1926). "The Garden at Giverny." 1900. Oil. 31.6" × 35.9 inches.

Claude Monet. "Alice Hoschedé in the Garden." 1881. Oil. 31.2 × 25.35 inches.

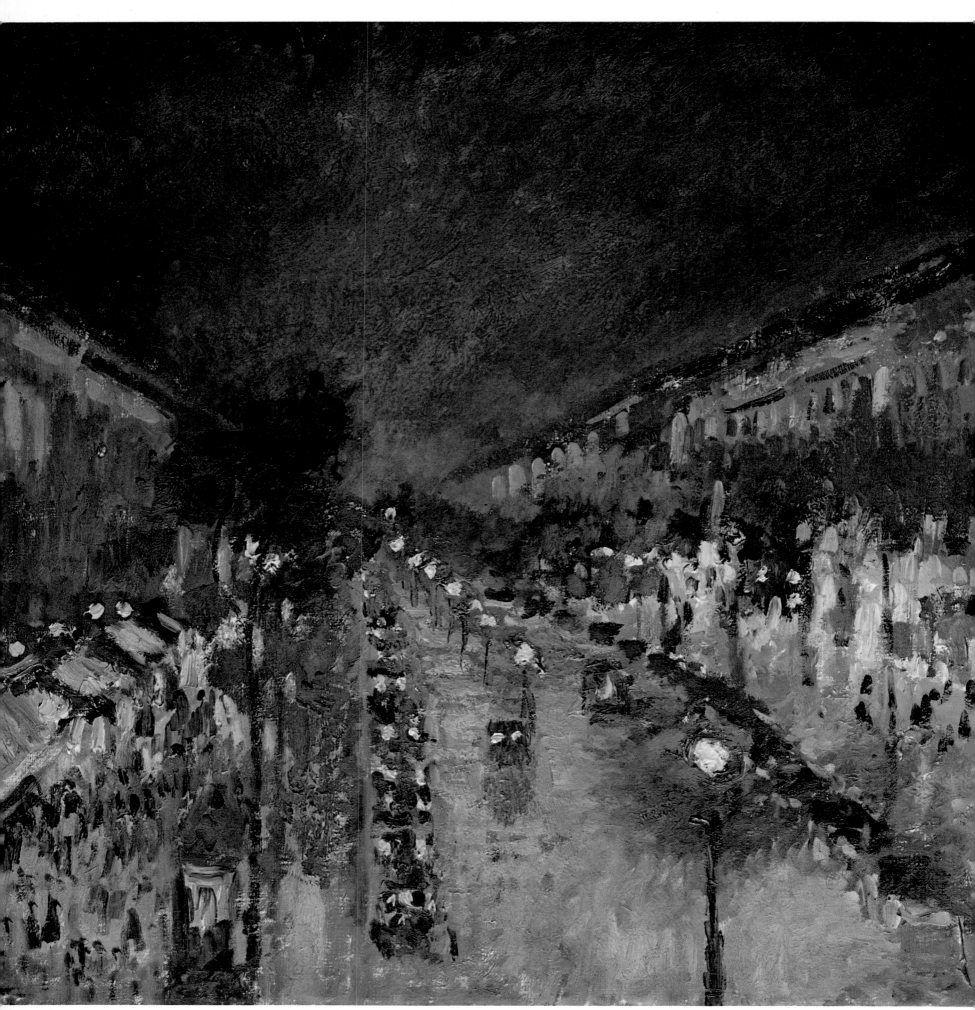

Camille Pissarro (1831–1903). "Boulevard Montmartre, Night Effect." 1897. Oil. 21 × 25.35 inches.

Painters cast a summarizing glance at Baron Haussmann's new Paris.

THE MAGIC OF Paris passionately inspired the Impressionists, who produced many paintings of such quarters as that around the Opéra and of the Grands Boulevards. Placing their easels at a hotel window overlooking the new avenues designed by Haussmann, they captured the enchantment of nocturnal illumination and the peaceful charm of the middle class strolling by. As Renoir would paint, his brother would stop the passersby to ask them the time, thus enabling the painter rapidly to catch their silhouette. In the urban setting the Impressionists behaved no differently than in the country; they refused the deceiving outline and sought to paint only the momentary view. Gustave Geffroy,

Monet's friend, expressed an idea which defined them all when he stated, "It is a question of houses in groups, crossing carriages, moving pedestrians. One has no time to see a man, a carriage, and the painter who lingers over detail will fail to catch the confusion of movements and the multiple spots which form the whole. Claude Monet by no means fell into such error, his canvas is alive, agitated by the Paris which inspired it."

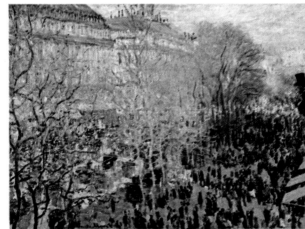

Claude Monet (1840–1926). *"Boulevard des Capucines."* 1873. Oil. 23.8 × 31.2 inches.

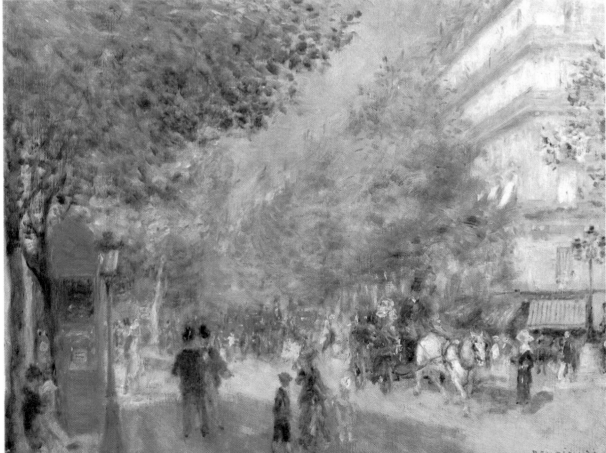

Pierre-Auguste Renoir (1841–1919). *"Les Grands Boulevards."* 1875. Oil. 19.5 × 23.8 inches.

Renoir's women like fruit—tender, pulpy, languid. . .

THE CRISIS which Renoir underwent in the years 1881–90 is evident by a comparison of these three paintings. Analyzing his production, he was overcome by doubt. "It was like a break in my work. I had gone to the very end of Impressionism and I came to the conclusion that I knew neither how to paint nor how to draw. In short, I was at a dead end." For a solution he went to Italy to study the great painters. "I went to see the Raphaels in Rome," he wrote to the art dealer Paul Durand-Ruel on November 21, 1881. "It's handsome painting and I should have seen it sooner. It's full of knowledge and wisdom. Unlike me, he makes no attempt to seek impossible things. Nevertheless it's handsome. In oil painting I prefer Ingres. But there's a wonderful simplicity and grandeur in the frescoes." This marked the beginning of Renoir's so-called Ingres period. Jealous of Degas' design, he disciplined himself, worked at his drawing and tried pencil. The outline became more defined, the figures emerging from the background (*left*). As the years passed his work gradually began to resemble the precise draftsmanship of Boucher, who was among the painters he had constantly

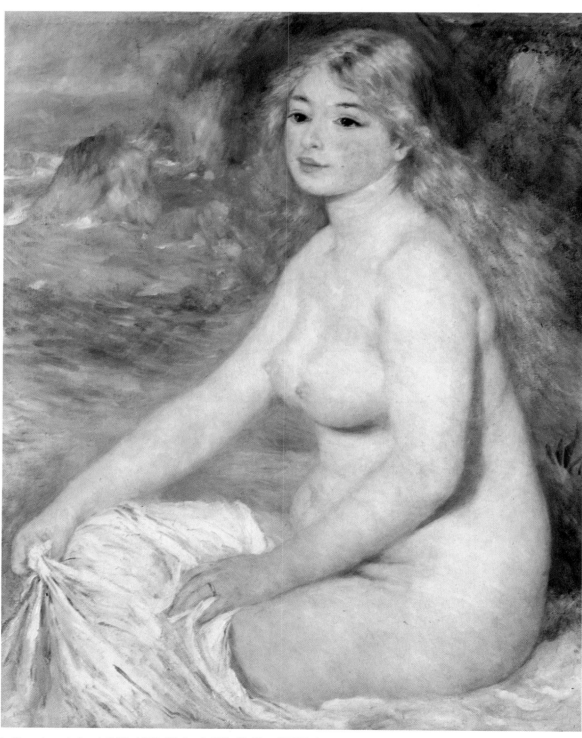

1.

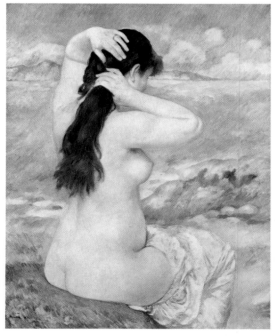

2.

admired. He wanted to be traditional and developed a veritable hatred of Impressionism. In 1885 he said, "I have returned to sweet and light old painting so that it may no longer leave me. . . . This is nothing new, for it follows eighteenth-century painting." Renoir, however, soon realized his error and despite the success gained from his new style (definitely effective as a result of the important exhibition of his work at the Galerie Durand-Ruel in 1892, one canvas of which was purchased by the State), he entered a fresh crisis. This resulted in his large "Bathers," voluptuous and lyrical, pulpy and tender (right page) as though to mark the painter's reconciliation with nature. Renoir detached himself from restricted realism and his canvases became a song of participation and adherence to nature and the joy of living symbolized by his women like fruit.

1. Pierre-Auguste Renoir (1841–1919). "Bather." 1881. Oil. 32 × 25.35 inches.
2. Pierre-Auguste Renoir, "Girl Combing Her Hair." 1885. Oil. 35.9 × 28.5 inches.
3. Pierre-Auguste Renoir. "Blond Bather." 1905. Oil. 35.9 × 28.5 inches.

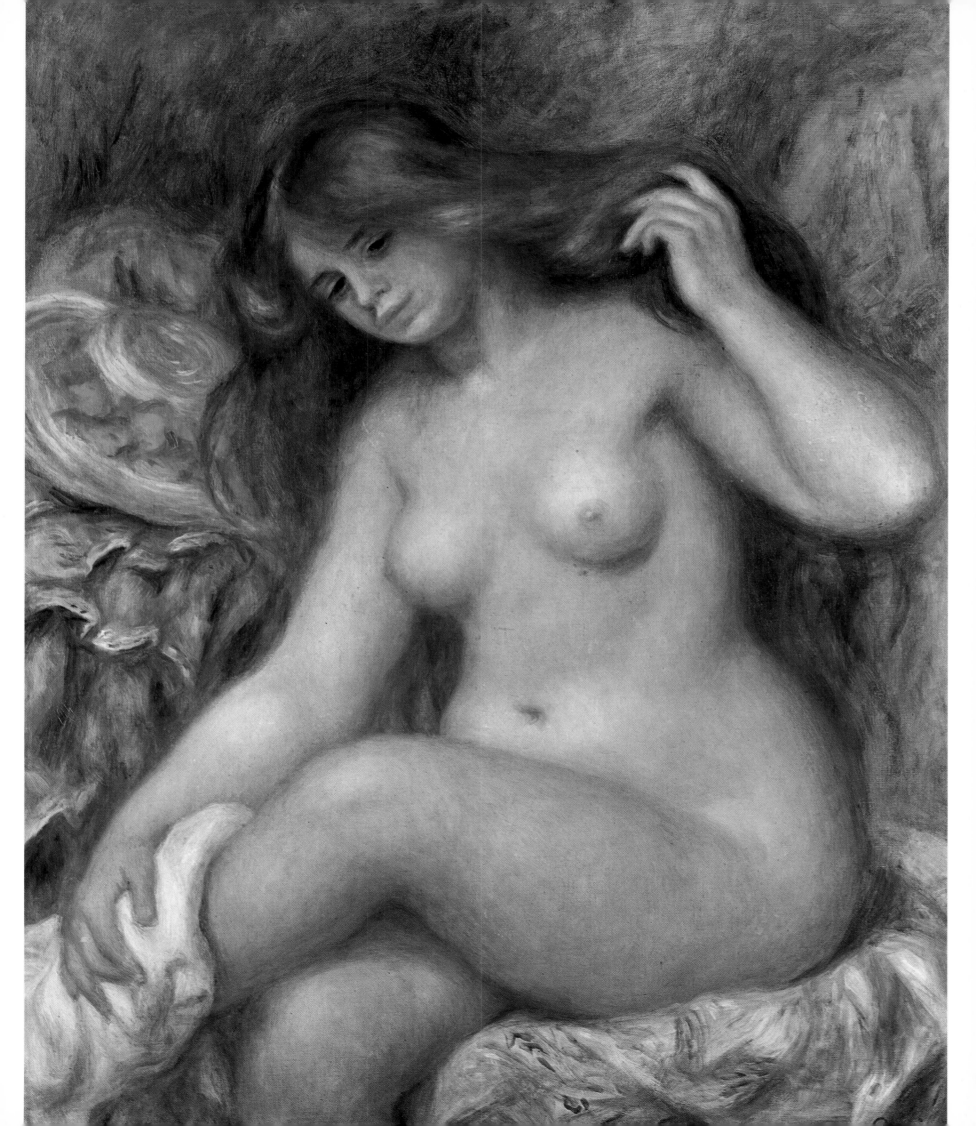

Pierre Auguste Renoir (1841–1919).
"Nude with a Hat." 1910. Oil. 25.7 × 21.8 inches.

Pierre-Auguste Renoir.
"Sleeping Bather." 1897. Oil. 31.6 × 25.35 inches.

. . offer to the
sun of the South of
France the bloom of
their succulent flesh.

RENOIR'S OLD AGE was a constant homage
to the female figure. "A woman's breast,"
he said, "is round and warm. If God had
not created her neck, I doubt if I would
have become a painter." Psychology is
absent in the savory forms from his late
pictures. In Ingres' *"La Source"* Renoir
admired "that head which is not thinking
at all." In 1908 he stated to an American
painter, "I treat my subject as I wish,
then I begin to paint it as a child would.
I want a red to be sonorous and resound
like a bell. If it is not, I add more reds
and other colors until I achieve it. I am
no more clever than that. I have neither
rules nor methods. . . . I look at a nude
and see myriads of infinitely small tones.
I must find those that will make the flesh
on my canvas alive and vibrate." During
this period he constantly suffered from
rheumatism. Painting with the brushes
strapped to his paralyzed fingers, he tire-
lessly continued to work. In 1912, seven
years before his death, Paul Durand-
Ruel paid a visit to him at Cagnes and
found him "in the same sad state but
with that astonishing forceful character
which never left him. He can neither
walk nor rise from his wheelchair. Two
persons are required to carry him every-
where. What torture! And with all that
the same good disposition and the same
happiness when he can paint.'

Pierre-Auguste Renoir. "Ode to Flowers." Between 1903 and
1909. Oil. 17.9 × 14 inches.

Pierre-Auguste Renoir.
"Bather Seated on a Rock." 1892. Oil. 31.6 ×
25.35 inches.

Pierre-Auguste Renoir.
"Bather Seated on a Rock." Detail.

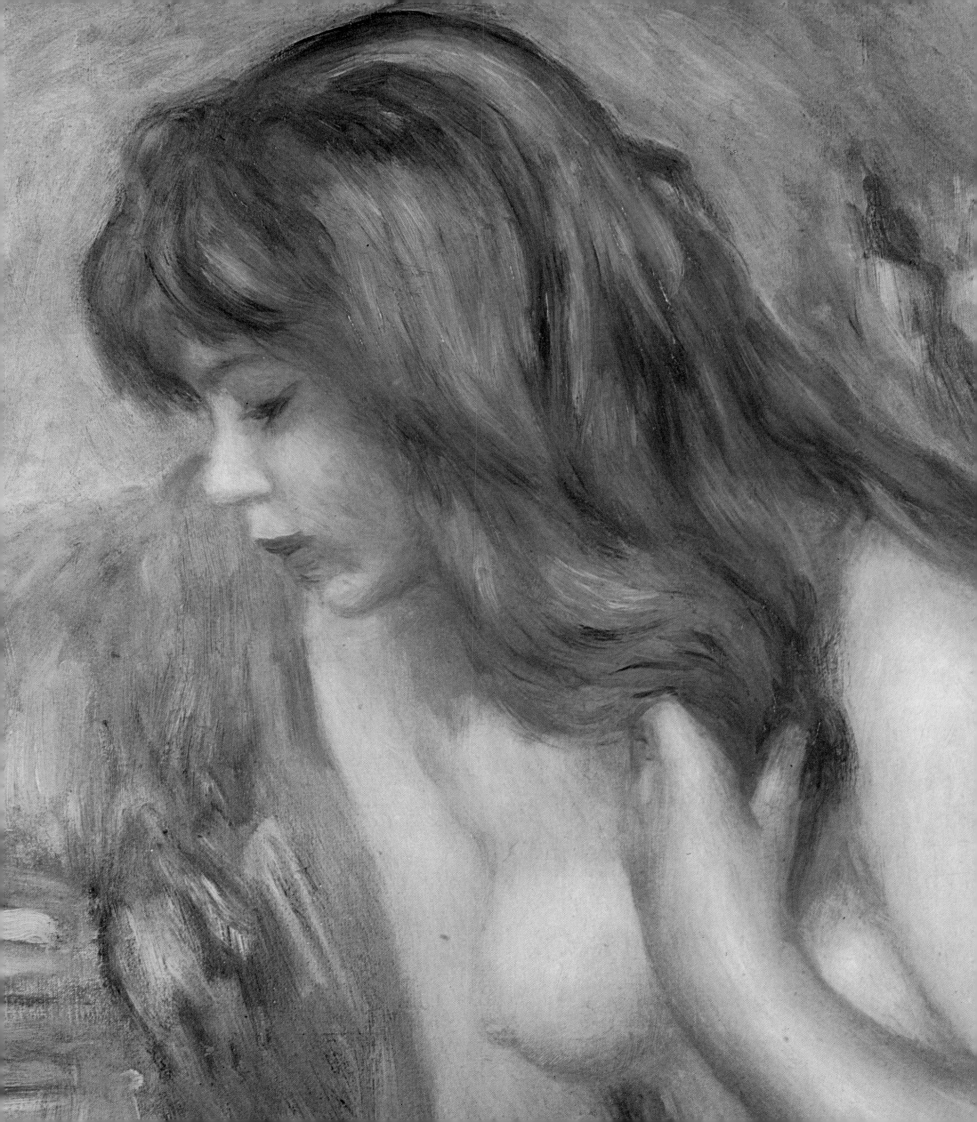

Vincent van Gogh. "Self-Portrait". St.-Rémy. 1889. Oil. 20.3 × 17.5 inches.

Behind a fixed, hallucinating stare Van Gogh brooded over "the terrible human passions."

THIS HAUNTING FACE, which seems burned into the canvas and fixed there by the very viscosity of the pigments, is that observed by Van Gogh in his mirror. Since Rembrandt no one had gone so far in such a scrupulous and pitiless self-analysis. Marked by an agitated existence full of disappointment and failure, Van Gogh struggled against the rising tide of attacks of epilepsy which caused his death in 1890. In a letter dating from 1886, the same year as the portrait (left), his brother Théo wrote to one of their sisters, "It is as though there were two persons in him, the one marvelously gifted, delicate and tender, the other selfish and hard-hearted. Each is evident in turn. Thus he can speak first

one way, then another, and this with arguments which are sometimes for, sometimes against the same thing. It is quite sad that he is his own enemy."

Three years separate the portrait painted in the town of St.-Rémy (right) from that of 1886. On May 8, 1889, he was admitted to the St.-Rémy hospital as a voluntary patient. Director Peyron interviewed him and entered in the register that the patient "suffers from fits which last from fifteen days to a month. During these fits the patient is victim to terrifying terrors and on several occasions has attempted to poison himself either by swallowing paint which he uses to produce his pictures, or by swallowing paraffin oil which he took from the boy

while he was filling his lamps. The last fit he had broke out after a trip he had made to Arles and it lasted about two months. During the intervals between fits the patient is perfectly quiet and paints ardently." It was during one of these peaceful moments that Van Gogh painted the self-portrait of 1889. The artist appears to be worn out, prostrated, vanquished by the permanent threat of his illness. He portrays his angular face surrounded by radiating, colored nimbuses. Although the man is ill, the artist is more powerful than ever. He has fully achieved his ambition "to paint portraits which a century later will appear as ghosts."

Vincent van Gogh (1853–90). "Self-Portrait." 1886. Oil. 17.9 × 14.8 inches.

Nature convulses.
Forms swell and crackle.
Trees twist like flames. . . .

Vincent van Gogh (1853–90). ''The Park of the Insane Asylum, St.-Rémy.'' October, 1889. Oil. 28.5 × 35.9 inches.

In Van Gogh's convulsed landscapes, the chaos of nature is rendered by a visionary eye. The trees appear to be the figures of a wild dance, as though they incarnate the artist's torments, his difficulty in escaping anguish. In the sole article written about him before his death and pub-

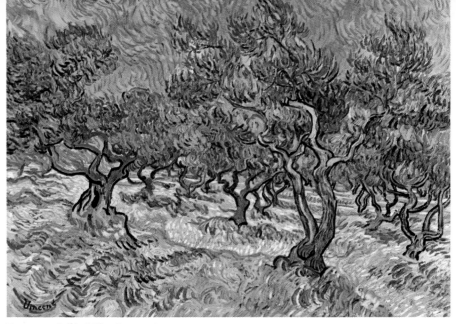

Vincent van Gogh. "Olive Grove at St.-Rémy." November, 1889. Oil. 28.1 × 35.9 inches.

Vincent van Gogh. "Dr. Gachet's Garden". May, 1890. Oil. 28.5 × 20.3 inches.

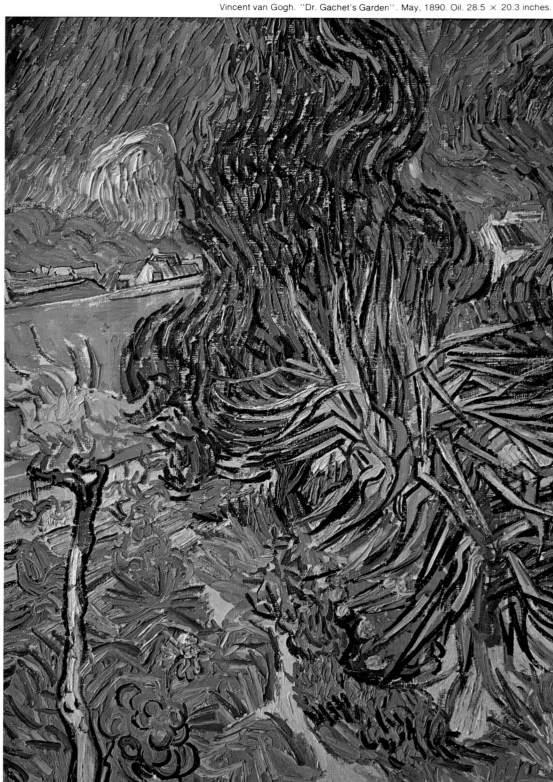

lished in the January, 1890, issue of the avant-garde magazine, *Mercure de France,* a young critic named G.-Albert Aurier mentioned "trees twisted like giants in battle . . . the tragic swirling of their green manes . . . their sap warm as blood." He also spoke of "a strange nature both real and almost supernatural, a nature in which everything, beings and things, lights and shades, lights and forms, forms and colors, rises up in wrathful determination to hurl its essence and its proper song in the most intense and most savage tone."

Less than a month after his arrival at St.-Rémy, Van Gogh was authorized to work in the garden and in the immediate surroundings, accompanied by a guardian. He painted the olive groves (*above*), the buildings of the asylum, the white benches enclosed by wild grass (*left*). Here and there is the frail silhouette of a patient. "There is a fine understanding among us," wrote Van Gogh. "If someone falls into a fit, the others hòld him and intervene so that he does nothing wrong. The same for those who habitually become angry; old habitués of the menagerie run forward and separate the fighters, if there is a fight."

In May, 1890, at Dr. Paul Gachet's in Auvers, he painted the same twisting, tormented vegetation. Van Gogh, who committed suicide in late July, said to those who attempted to save him, "It's useless. Sadness lasts an entire life." The picture on the right was painted from a window and depicts the doctor's private garden. The principal mass in the foreground (the sinuous yew tree in the center and the yucca with its pointed leaves) seems pierced by the aggressive perpendicular of the red roof. The abrupt composition is disconcerting because of the acrobatic frankness of its choice.

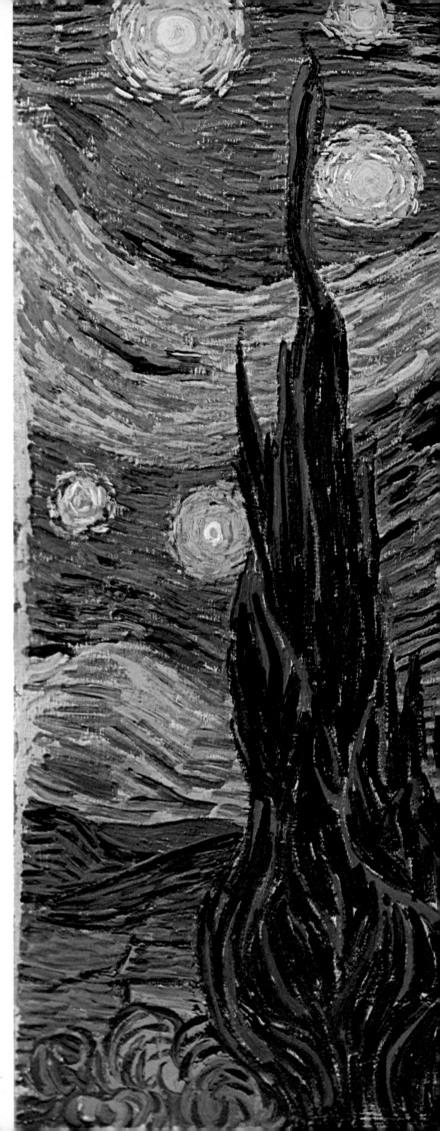

. . . everything swirls. Nebulae
are unfurled at night in St.-Rémy,
the tortured gyration of nature gone mad.

AN END-OF-THE-WORLD cataclysm in vades Van Gogh's "Starry Night," one of apocalypse filled with melting aerolites and comets adrift. One has the impression that the artist has expelled his inner conflict onto a canvas. Everything here is brewed in a huge cosmic fusion, as in the nebulae painted by William Blake. The sole exception is the village in the foreground with its architectural elements.

While giving free rein to his wild imagination, Van Gogh recalled his childhood and youth. In his article written in 1890 G.-Albert Aurier spoke of "a kind of drunken giant, better able to move mountains than to handle bibelots, an ebullient brain which irresistibly pours its lava into all the ravines of art." To which Van Gogh replied several months after painting "Starry Night," ". . . the emotions which seize me when I am confronted with nature sometimes produce fainting spells, and then the result is a fortnight during which I am incapable of working." On the left of the composition the dark mass of the cypress tree rises to the sky. "I have always been preoccupied by cypresses," wrote Van Gogh in June, 1889. "Their lines and proportions are as handsome as an Egyptian obelisk. And the dark green has such a distinguished quality. It is the dark note in a sunny landscape, but it is one of the most interesting dark notes, the most difficult to hit just right, that I can imagine."

Vincent van Gogh (1853–90). "Starry Night." 1889. Oil. 28.9 × 35.9 inches.

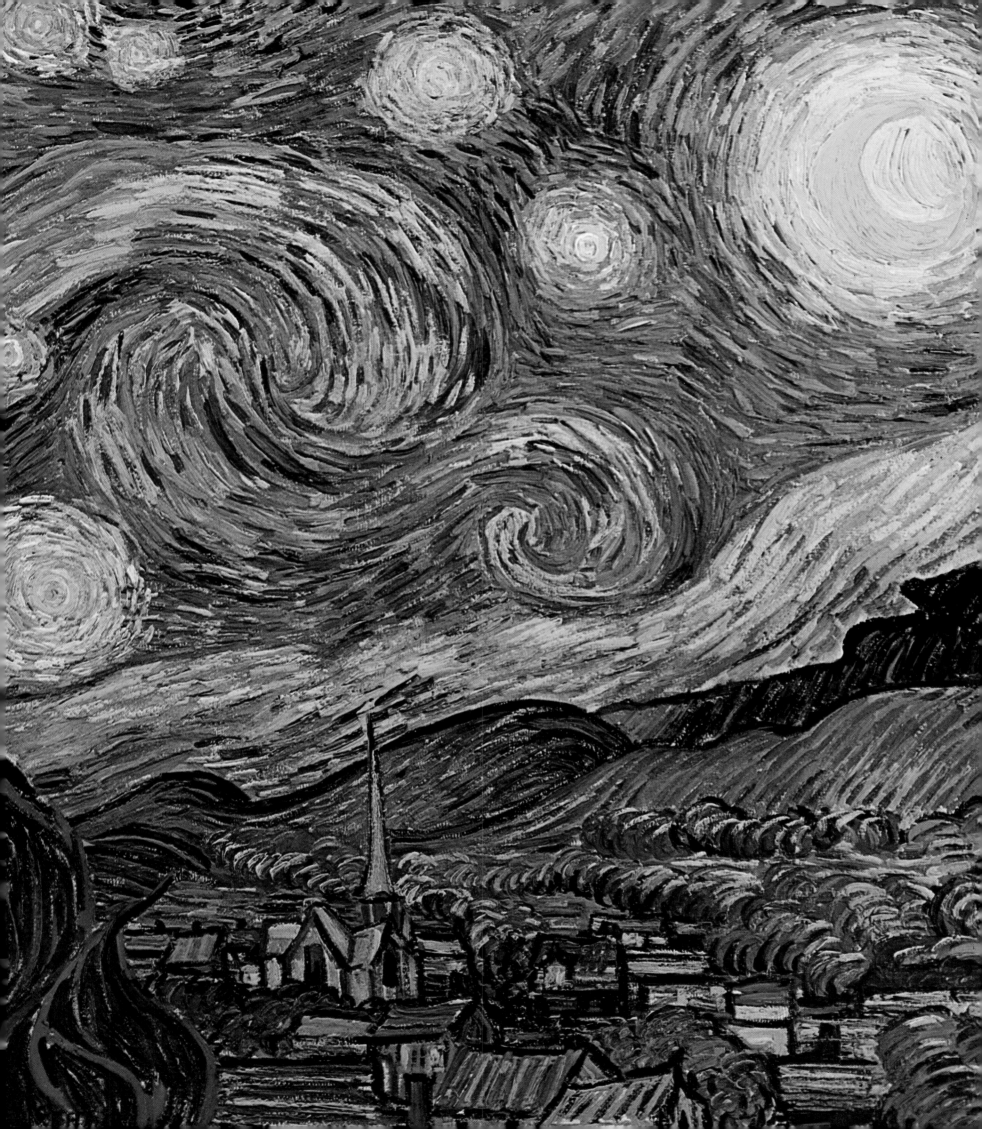

The lines wind and contort.
An earthquake seems to shake the most ordinary sights.

Vincent van Gogh (1853–90). "The Ravine." October, 1889. Oil. 28.5 × 35.9 inches.

Vincent van Gogh. "Road at Auvers." December, 1889. Oil. 19.5 × 27.7 inches.

VAN GOGH REVEALS the strangeness of daily life in the smile of two children and in the most familiar sights of the countryside. A seismic upheaval seems to disturb the surface of his canvases, as though the image, seized by vibrations, were about to disintegrate. In the three paintings shown here, the same trembling agitates the houses and the road, the girls' dresses, and their clasped hands.

The two landscapes, painted at an interval of two months, resemble each other. In both cases, a sinuous curve cuts the painting from top to bottom and from right to left, and a central vanishing line stops on the vertical of an upraised background. In "Road at Auvers" a group of houses obstructs the horizon; in "The Ravine" it is a mountainous wall. "The closer the rocks approach the foreground," noted Lionello Venturi in reference to "The Ravine," "the more their view becomes tormented, reaching the point of terror and the demoniac in the arch formed by the erosion of the torrent." In a letter to Emile Bernard

written during the first half of October, 1889, Van Gogh stated, "I am working on a big canvas of a ravine, a subject very much like that study of yours with a yellow tree which I still have: two masses of extremely solid rock between which flows a thin stream of water, and at the end of the ravine a third mountain which blocks it. Such subjects have a fine melancholy, and moreover it's fun working in very wild places where one has to wedge the easel in between the stones to prevent everything from being blown by the wind."

Vincent van Gogh. "Two Children." 1890.
Oil. 19.9 × 17.9 inches.

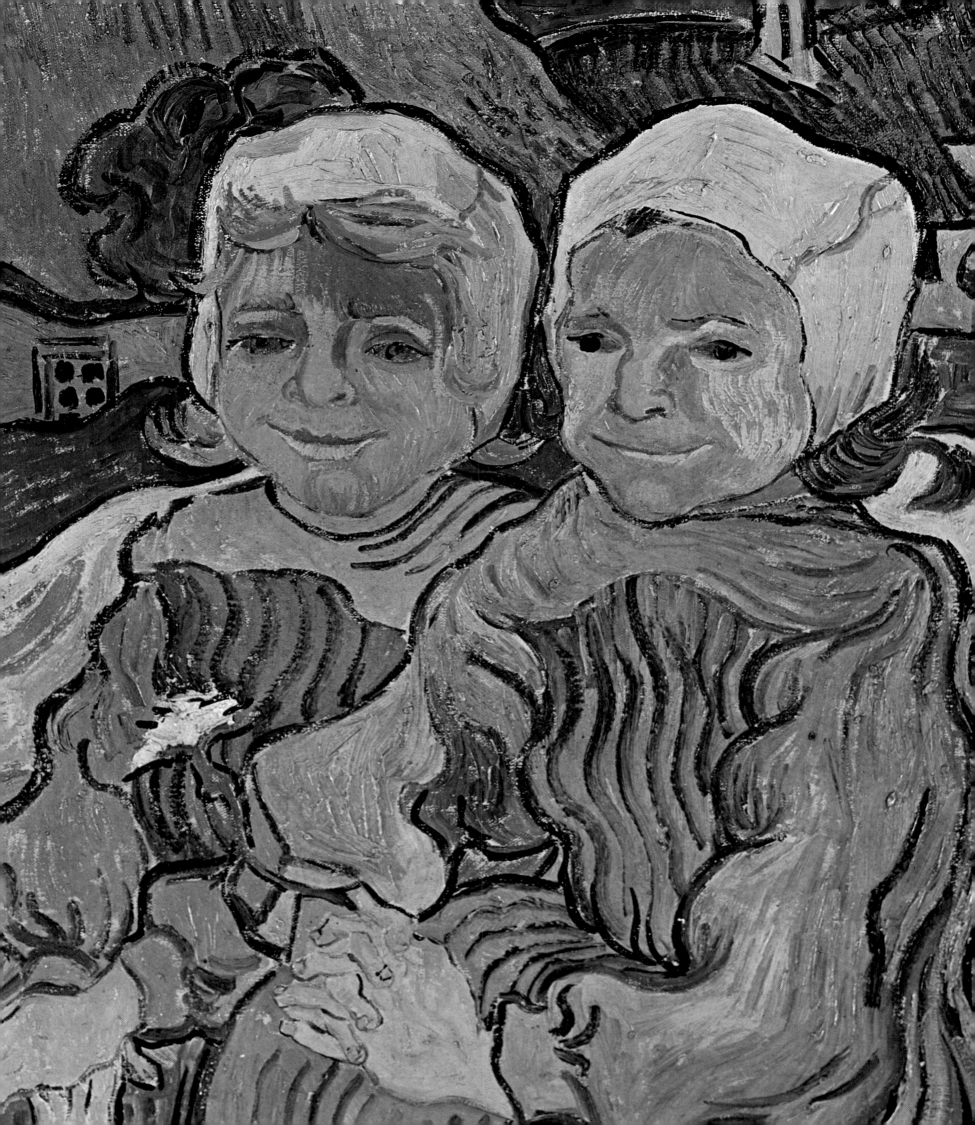

A COSMIC HALO impregnates the haystacks, as though Monet had seized, beyond his subject, the immense and majestic harmony of nature. "He gives the sensation of the fleeting instant, which has just come to life, dies and will not return—and, at the same time, by the density, the weight, the force which comes from within without, in every one of his canvases he evokes the curve of the horizon, the roundness of the globe, the course of the earth in space," wrote Gustave Geffroy who, in his preface to the exhibition of 1891, gives us firsthand evidence of Monet. "There he is, a few steps from his peaceful home, from his garden ablaze with flowers. There he is stopping on the road on a late summer's evening, glancing at the field with its haystacks. . . . He remained at the edge of this field that day and returned the following day and the day after, and every day until autumn, during the entire season and at the beginning of winter. If the haystacks had not been removed he would have been able to continue, go there during the entire year, renew the seasons, reveal the infinite changes of time on the eternal phase of nature."

The exhibition, which included fifteen canvases, had cost Monet much effort. The painter thought at first that two paintings would suffice, the one in dull weather, the other in sunshine, to express his impression of the subject. But new effects continued to appear to him. "I am grinding a great deal," he wrote on October 7, 1890, "stubbornly insisting on striving for a series of different effects, but at this season of the year the sun sets so quickly that I cannot follow it. . . . It is deplorable how slowly I am working. . . . The further I go, the more I see how hard I must work to render what I am trying for, that 'instantaneousness,' above all the outer surface, the same light spread everywhere, and more than ever the things which come easily disgust me." On seeing one of these haystacks a young jurist, Wassili Kandinsky, decided to devote himself to painting.

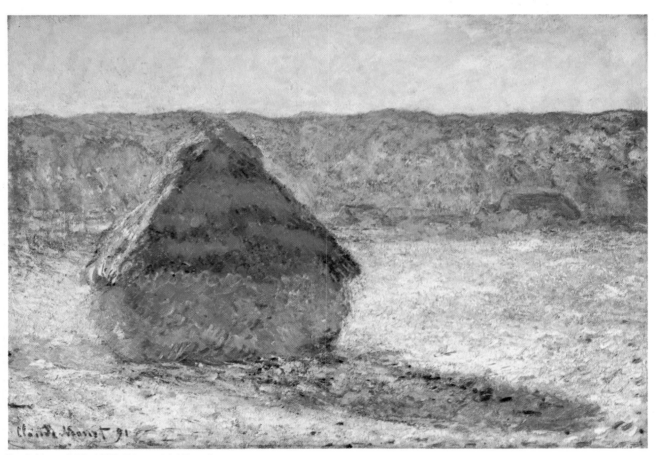

Claude Monet (1841–1926). "Haystack in Winter." 1891. Oil. 25.7 × 35.1 inches.

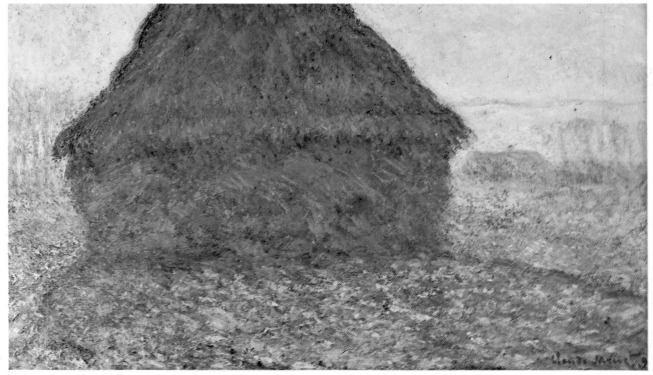

Claude Monet. "Haystack." 1891. Oil. 23.4 × 39.37 inches.

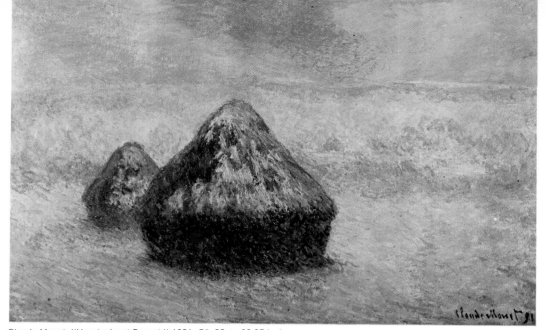

In the metamorphoses of a haystack Monet captures the passing of hours and seasons, tuning in on the great terrestial harmonies.

Claude Monet. "Haystacks at Sunset." 1891. Oil. 25 × 39.37 inches.

Claude Monet. "Haystacks at Sunset, near Giverny." 1891. Oil. 29.25 × 36.7 inches.

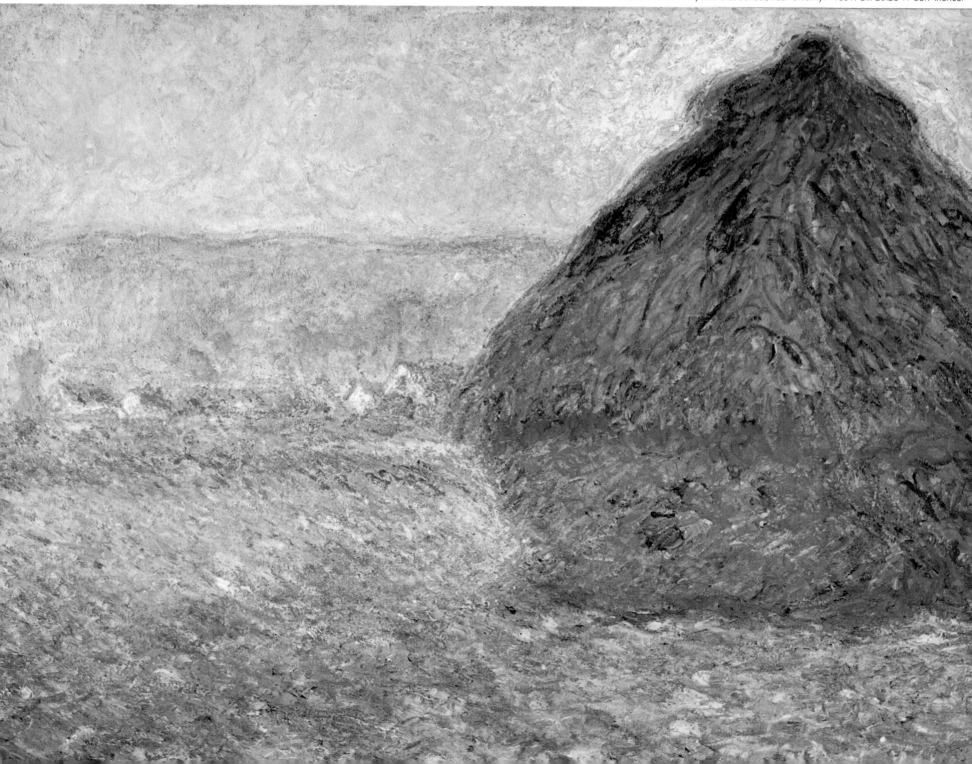

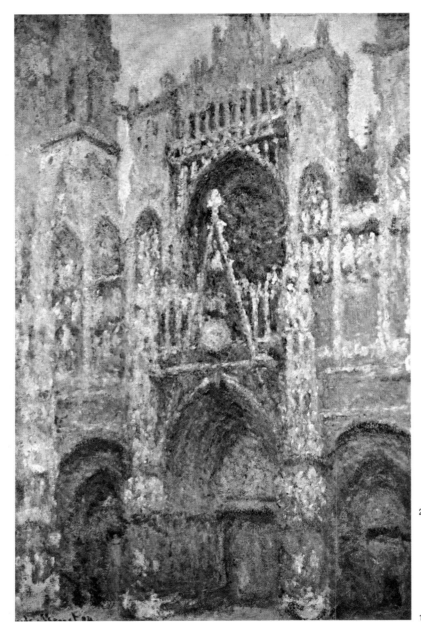

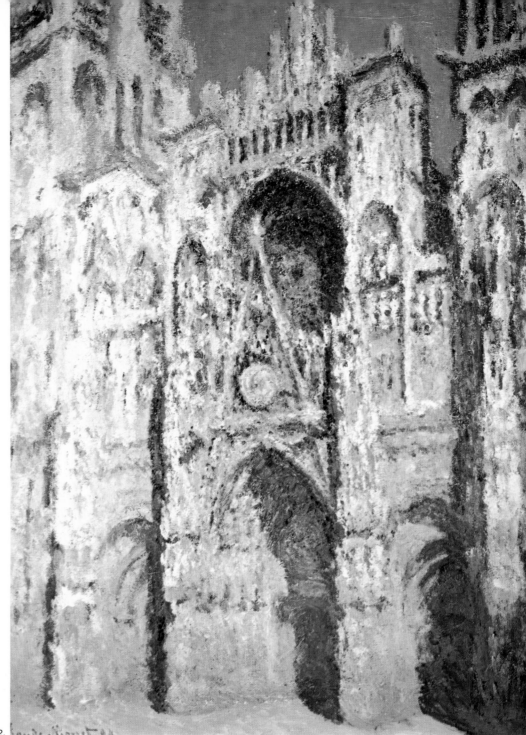

Fascinated, Monet observes on the façade of a cathedral the quality of the light.

MONET ATTACKED a Gothic cathedral, which could hardly be more dense, compact, and permanent, with his "light" painting. He rented a room in Rouen on the Place de Rouen, above the shop Au Caprice, set up several easels before the window, and there spent long months, studying the façade, going from one easel to another according to the hour of the day. He left Rouen with a series of twenty canvases, twenty "impressions," all different and which as a whole form a veritable manifesto of the ephemeral. "His painting," noted Germain Bazin, "becomes a kind of cement, as though to imitate the very material of old stone." Monet himself explained, "For me the subject is insignificant. What I wish to reproduce is what is between the subject and myself."

Exhibited in 1895 at the Galerie Durand-Ruel the Cathedral series created a sensation. "I am quite carried away by this unusual mastery," wrote Camille Pissarro. "Cézanne whom I met yesterday at Durand's very much agrees with me that it is a deliberate work, long considered, pursuing the fleeting nuance of effects which I see achieved by no other artist."

Georges Clemenceau, an occasional art critic, stated in *La Justice,* "Each fresh moment of each changing day forms in the moving light a new state of the object which has never been and will no longer exist. . . . The stone itself lives, we feel it moving from the life which precedes it into the life to follow. . . . In its depths, in its projections, in its strong recesses, or in its lively arches, the wave of the immense solar tide, rushing forward from infinite space, breaks in luminous waves, striking the stone with the entire light of the prism or. . . ."

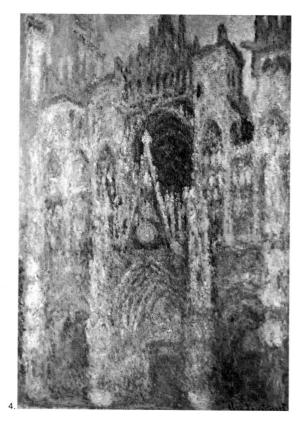

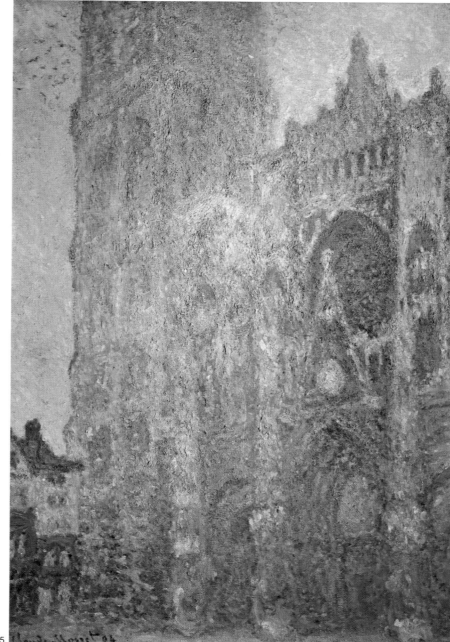

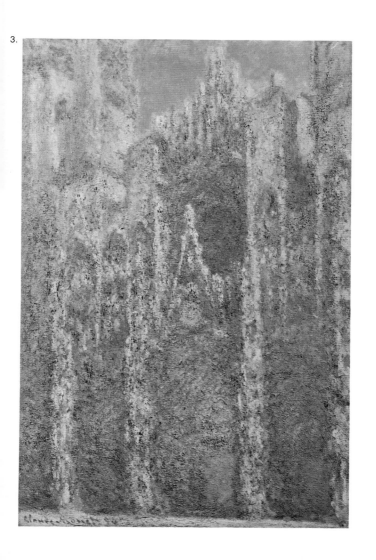

4.

3.

5. Claude Monet 94

1. Claude Monet (1840–1926). ''Rouen Cathedral. The Portal, Morning Sunshine. Harmony in Blue.''
1894. Oil. 35.5 × 24.6 inches.
2. Claude Monet. ''Rouen Cathedral. The Portal and the Albane Tower. Full Sunlight. Harmony in Blue
and Gold.'' 1894. Oil. 42.1 × 28.5 inches.
3. Claude Monet. ''Rouen Cathedral, Sunset,'' 1894. Oil. 39.4 × 25.35 inches.
4. Claude Monet. ''Rouen Cathedral. The Portal in Bleak Weather.'' 1894. Oil. 39.4 × 25.35 inches.
5. Claude Monet. ''Rouen Cathedral. The Portal and the Albane Tower. Morning Effect. Harmony in
White.'' 1894. Oil. 41.7 × 28.5 inches.

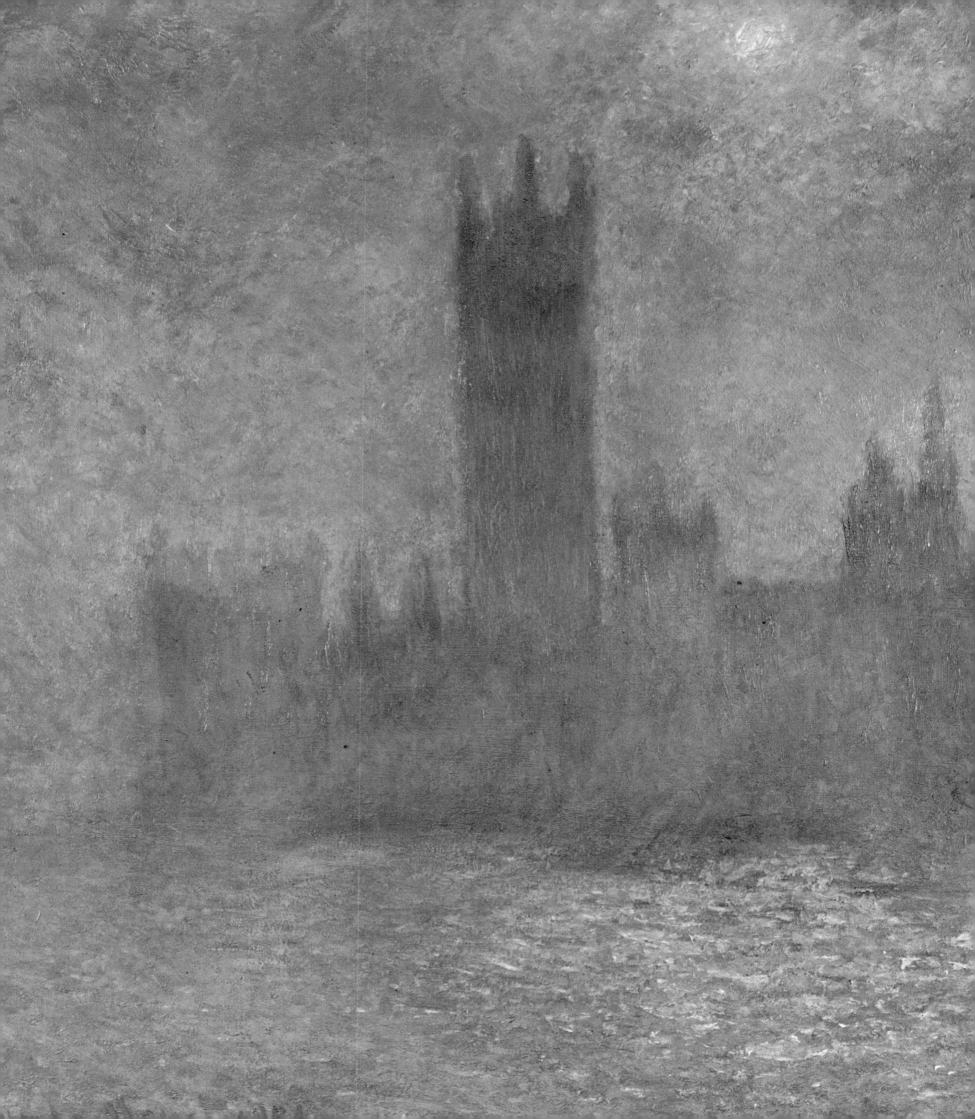

The artist scrutinizes Gothic palaces drowned in city fog.
The subject is faintly seen in the distance, at the point
of evanescence.

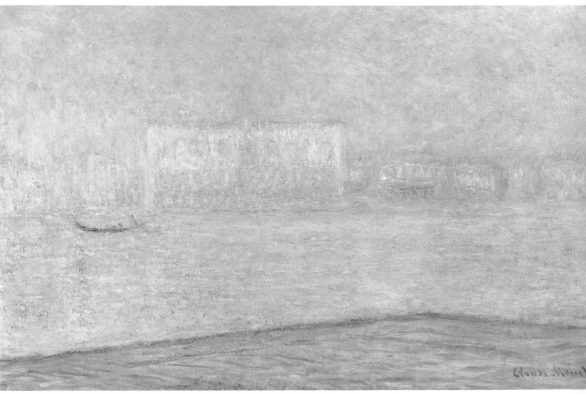

Claude Monet. "The Doges' Palace Seen from San Giorgio." 1908. Oil. 25.35 × 39.37 inches.

MONET IN HIS old age created in his paintings a ghostlike reality. In London he was fascinated by the neo-Gothic architecture of the Houses of Parliament, the silhouette drowned in fog. Here again, the critic Gustave Geffroy had the privilege of watching Monet at work on the banks of the Thames. "He accumulated the brushstrokes, as one can see in his canvases, he accumulated them with prodigious certainty, knowing exactly to which phenomena of light they corresponded. From time to time he would stop, saying, 'The sun has gone down.' . . . It was a grand sight, solemn and gloomy, an abyss from which a murmur came. One had the feeling that everything was about to evaporate, disappear in a colorless obscurity.

"Suddenly Claude Monet would seize

his palette and brushes. 'The sun is out again,' he said. At this moment he was the sole person aware of this. Hard as we looked, we still saw nothing but heavy gray space, somewhat indistinct, the bridges as though hanging in the air, the smoke soon disappearing, and close to the riverbank a few surging waves of the Thames. We tried to catch a better glimpse, to penetrate this mystery and in fact we finally saw some distant and mysterious glimmer which appeared to be trying to penetrate this motionless world."

MONET WAS EXALTED by Venice, the predestined city of Impressionism, where water, sky, and stone constantly merge. He was sixty-nine when he first visited the city. "How unfortunate not to have come here when I was younger! When I was so bold! Oh, well. . . .

Nevertheless I am spending some delightful moments here, almost forgetting I am an old man!"

He devoted to the city of St. Mark twenty-nine paintings which were exhibited at the Galerie Bernheim. Three days after the opening, Paul Signac wrote to him, "On seeing your paintings entitled 'Venice,' the splendid interpretation of these subjects so familiar to me, my feeling was as complete and as strong as the one I had, about 1879, on seeing your 'Modern Life,' your 'Railroad Stations,' your 'Streets Decked with Flags' and which decided my career." Contrary to Manet (page 193), Monet seems to remain at a distance from the magical city. He represents the Doges' Palace from far off, half-vanished, suspended in time, like a vestige of its ancient splendor.

Claude Monet (1840–1926). "The Houses of Parliament. Effect of Sunlight in the Fog." 1904. Oil. 31.6 × 35.9 inches.

At the close of his life Monet, grasping for the immaterial, produced an art without form or depth at the verge of abstraction. For twenty years, working on large canvases, he relentlessly painted the most vaporous clouds and the most ephemeral unions of sky and water. This atmosphere no longer draws attention to a specific object but by means of impregnation penetrates sensibility.

The first series of "Water Lilies," a total of twenty-five canvases, was exhibited at the Galerie Durand-Ruel in 1900. This was followed nine years later by a second series of forty-eight canvases. "These landscapes of water and reflection have become an obsession," wrote Monet on August 11, 1908. "This is beyond the strength of an old man, and yet I want to express what I feel. I have destroyed some of the canvases. I begin once again. . . . I hope something will come of all this effort."

Monet organized his property at Giverny as though it were a huge painting. Thanks to a small army of gardeners, he diverted a river, planted exotic flowers, weeping willows, bamboo trees, and rhododendrons. He seeded the pond and added enclosures with white chickens, ducks, and pheasants. Nature, recomposed by the artist, began to resemble his art. "My finest masterpiece," he later said, "is my garden."

At the age of eighty-two Monet discovered that he had a cataract and was forced to consider a delicate operation to which he resigned himself only on the insistence of his friend Georges Clemenceau. This was followed by a difficult reapprenticeship. The artist had to use many pairs of glasses before feeling again in full possession of his visual capacity. "The Japanese Footbridge" (*below*) dates from 1922 and was painted during the worst moment of this crisis. The picturesque bridge, above the Giverny pond, was part of the landscape which Monet saw daily. From this structure decorated with wisteria he studied and laid out his garden. Instead of representing what he knew from experience of such a subject, the artist preferred what his sickly eyes saw. The result was a strange agglomeration of color which some later abstract painters—Jackson Pollock for example—regarded as a source of inspiration.

The "Sistine Chapel" of Impressionism, the end of an evolution begun almost sixty years earlier, the group of "Water Lilies" in the Musée de l'Orangerie, Paris, is Monet's apotheosis. Nineteen panels each measuring about 6½ × 11½ feet are juxtaposed in two rooms, whose arrangement the painter himself made. To quote Gustave Geffroy, "The ensemble represents a stroll round the pond and should be placed below the walls of the exhibition room to be seen from above by the spectator, exactly as the water surface and the setting of the river bank is actually seen. That the site and arrangement, if not oval or circular, at least be rounded at both extreme ends, is the sole condition of Monet's constantly increased bequest to the State." In the artist's mind it was very much a question of an *environnement* and it was thus that he presented the "Water Lilies" to his friends. "In the huge studio which the painter had built

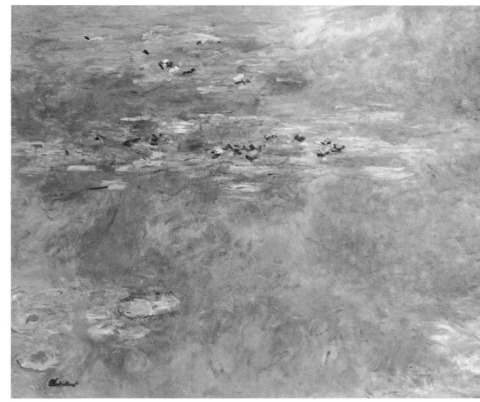

Claude Monet (1840–1926). "Yellow Nirvana." Oil. 51.1 × 78.5 inches.

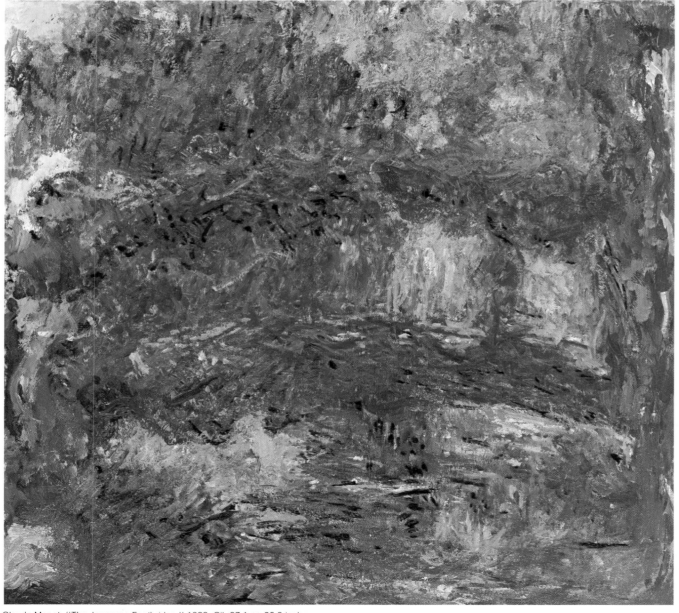

Claude Monet. "The Japanese Footbridge." 1922. Oil. 37.1 × 36.3 inches.

Water, earth, and light coalesced into an inseparable whole on the Giverny pond, which inspired the work of Monet's final years. His "Water Lilies" opened the path to abstract painting.

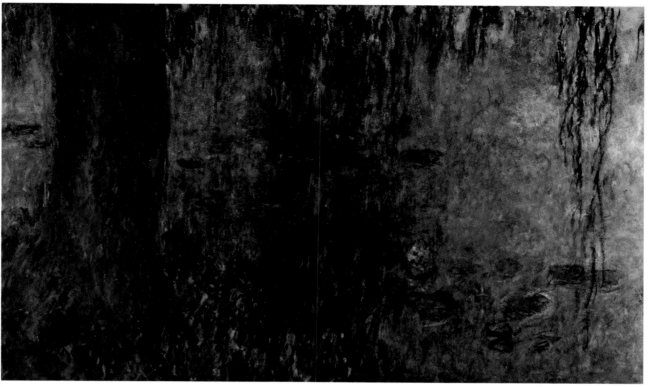

Claude Monet. "Water Lilies. The Two Weeping Willows. Morning, left section." 1922. Oil. 77.2 × 66.3 inches.

Claude Monet. "Water Lilies, Sunset." 1914–18. Oil. 6.4 × 19.5 feet. Detail on the following double page.

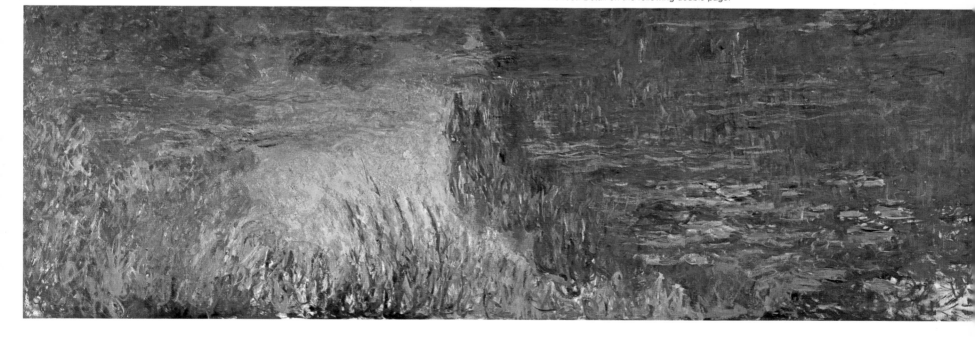

for them at the far end of the garden," related Thadée Natanson, "he and his daughter-in-law made us sit down and, carrying the canvases which rose to the height of a man—as they are now seen in the museum—shifting them, turning them upside down, they finally surrounded us, first in one circle of panels, then in another, the two of them measuring almost the length of the two rooms in the Musée de l'Orangerie. Monet, who had never seen them in place, already had the arrangement to precision."

The visitor finds himself surrounded by the infinite play of the "impressions" of every color, as though drowned in the silence of a mysterious, limitless depth. Here and there emerge a few more concrete forms, like weeping willows (*above*). In most of the panels, however, not a single precise object is evident. A detail of "Sunset" is shown on the following double page.

Color acquires
its independence.

From the time of David until today, color has developed along three main paths. First, it was used by the academics to indicate the nature of the represented object according to a traditional code that stems from the Renaissance.

Second, through Romanticism, then Impressionism, it freed itself from this documentary conception and assumed a validity of its own. This change called into question a fundamental concept of the classical studios. According to this concept, every object had a constant hue: A tree was green, an apple red, a bowl brown, flesh pale pink, and so forth. In the nineteenth century, painters became aware of the fact that an essential part of the effect of color is produced by atmospheric conditions and that pigments are tributaries of the light which falls on them. The open air confirmed this: An apple is not red but may have several colors according to the density and frequency of the waves of light which it receives. The static, material components of color (pigment) gave way to its dynamic, variable, and ephemeral components. Corroborating the conclusions of contemporary science and technology, the artist emphasized the variability of color.

Gustave Courbet. "Still Life." 1871.
Courbet's conception of color was classic. Each object has its specific hue, and its reflection does not encroach upon the other objects.

The prism which decomposes light into a multicolored spectrum without the aid of a single pigment reinforced this intuition. The art of the twentieth century in the wake of Impressionism and Cubism, notably the Bauhaus, was to produce numerous works which used light by means of mobile projection. This, then, is the third stage of color: We see the waves in effect before our eyes at the very moment we are looking at them. We are contemplating the phenomenon itself as it happens and no longer assessing it through the static mediation of a painting.

Georges Vantongerloo. "Composition with Light Refraction." 1958.
Certain twentieth-century artists used the prism to create by diffraction pigmentless color.

As early as the Romantic period the painter freed himself from the restraint of local color and affirmed his taste for, and great pleasure in, pure color. Color was the cursed child of classicism. Uncontrolled, it was thought suspect. "On reading what Ingres, Gleyre, Gérôme, and other great nineteenth-century masters had written on color," noted Kenneth Clark, "one might suppose that they were talking about a particularly unspeakable and dangerous form of vice." From Ingres came a heartfelt cry which said much on the attitude of official art, "Enough of blazing color, it is antihistorical." Opposed to the Academy were the painters who discovered that color was a feast for the eye and soul, a sensual reality, valid in itself, without reference to any aesthetic or intellectual system. The physicist Eugène Chevreul had already observed, "The eye takes an indisputable pleasure in seeing colors regardless of any drawing and of all other qualities of the object in which they are presented." Delacroix stated, "Color has a much more mysterious and perhaps more powerful force. It acts, so to speak, despite us." (June 6, 1851). Charles Baudelaire shared the same feeling, for he said, "Seen at too great a distance to analyze or even to comprehend the subject, one of Delacroix's pictures has already produced a rich, happy, or melancholy impression on the soul. It is as if this work, like a sorcerer or a hypnotist, could project its thoughts from a distance. . . . It seems as if this color thinks by itself independently of the subjects which it clothes." (1865).

Claude Monet. "Terrace at St.-Andresse."
(detail). 1886–67.
The Impressionist artist discovered that color is a pleasure.

It is this voluptuousness of color which we see in the first works of Manet (page 151) and in those in which the new landscape painters used accents of scarlet to make their canvases sing (page 152). Restraint had disappeared. The first Impressionist generation wanted to paint what it saw, even if its account of reality was the antithesis of the traditional one, since it was based on the painter's subjective experience. The second generation, that of Gauguin, Van Gogh, Bernard, wanted to go further. It claimed "the right to try everything."

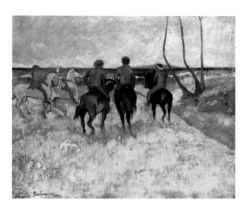

Paul Gauguin. "Riders on the Beach." 1902.
Gauguin refuses to yield to the spectator's habits. His colors tend to the arbitrary and he paints the beaches pink.

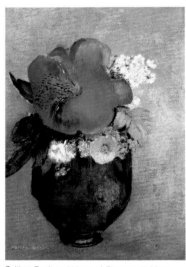

Odilon Redon. "Vase of Flowers." After 1890.
Redon's reds transcend realism. Opulent and mysterious they are the artist's dream instruments.

Already Baudelaire had stated, "I should like red-colored fields and blue-painted trees. Nature has no imagination." His wish was to be granted (page 162). Gauguin pushed the abandonment of local color and rejected "the hindrance of verisimilitude." Monet might have said, "I observed that this haystack is purple at dusk so I paint it purple." Gauguin and his friends affirmed, "It matters little whether the haystack is yellow or purple, we shall paint it red if we wish." Having abandoned local color, within a few years painting passed to subjective color. Next came nonfigurative color which no longer considered our empirical experience of the world which surrounds us. Henceforth the painters' recurring theme was to be the working independence of color.

For Gauguin it was the "passionate equivalent of a sensation." He explained this in an interview. "Through the arrangement of lines and colors, with the pretext of any subject borrowed from life or nature, I obtain symphonies of harmony which represent abolutely nothing real in the popular sense of the term, directly express absolutely nothing, but which make one think, just as music makes one think without recourse to ideas or images, just by the mysterious affinities between our brains and certain arrangements of color and lines." What is emerging here for the first time during the years 1885–90 is the principle of abstraction. Gauguin stigmatized "the abominable mistake of naturalism" and denounced the first Impressionist generation "which saw nothing but matter through a brainless eye" and which looked "all about the eye and not at.the mysterious center of thought." To his pupil Emile Schuffenecker, he gave the following advice, "Do not paint too closely from nature. Art is an abstraction. Take it out of nature by dreaming in its presence and think more of the resulting creation. It is the sole means of rising to God by creating, as our Divine Master does." To paint from memory is to retain only the essential. Gauguin in Pont-Aven and Le Pouldu constructed compositions of large flat areas and bright colors. It was a matter of breaking all relationship "between modeling and this blasted nature," as he explained. There was a simultaneous movement toward the symbolic and the emotional. On the one hand, as the art critic G.-Albert Aurier pointed out, "Each detail is in reality a partial symbol, more often than not useless for the complete signification of the object." As a result, there was simplification and anecdotes were dismissed. Perspective (page 170) or shadows (pages 158–59) and gradation from one tone to another (pages 160–61) were eliminated or treated in a new way. The painting read like a stained-glass window. On the other hand, there was emphasis: The artist had the right to distort, to exaggerate, to emphasize by a dissonant tone (pages 178–79).

One would think this the antithesis of realism, a hundred miles from what Redon had called, "The rather low-vaulted edifice of Impressionism." Artists thought they had created a play of colors which referred only to one another. The painting became a "thing in itself." Actually realism was attained by other means. Certainly what the revolution of Synthetism, as Gauguin's style has been called, and its abstract extensions into the art of the twentieth century revealed were the limits of an art based on the perception of the immediate. Monet was already aware of the weakness of his tools for seizing the passing moment, for nature moved too quickly. He would even have his hair cut while working on the subject in order not to lose a moment's observation. "There are never three successive favorable days," he wrote in 1884, "with the result that I must make continuous changes as everything is growing and becoming green . . . and this river which is low, rises again, is green one day, then yellow, is dry now and tomorrow will be a torrent after the frightful rain which is falling this very

Maurice Denis. "Sun Spots on the Terrace." 1890.
Gauguin's pupil, Maurice Denis, summarized in a
famous sentence the painter's rights to absolute
freedom. "A painting," he said, "is essentially a plane
surface covered with colors arranged in a certain
order."

Jean Delville. "Orpheus." 1893.
Symbolism took painters astray on the path of a *fin de siècle*
literature.

Kees Van Dongen. "Liverpool Nightclub." About
1907.
In the early twentieth century artists thoroughly
exploited the color discoveries made by Vincent van
Gogh and Paul Gauguin.

Henri Matisse. "The Black Door." 1942.
For Matisse "color acts on feeling like a resonant note
when a gong is struck."

minute. . . ." What he wanted was to "slow down" the landscape and to submit the transformations to the slowness of his brush. A friend once saw him ask some astonished peasants if they would be so kind as to rip away the yellow shoots from a tree which was changing quicker than his picture.

The idea that one can reveal the truth with the methods of classical Impressionism may be questioned in two ways. First, the tools were felt to be inadequate; second, reality was greater than what one saw. It was not spread out, decoded, like a panorama, before the retina, this last being anything but a sensitized plate to record the totality of the view. Our eye is but a narrow window which selects an infinitely small section of the undulating field, absorbing somehow or other the few stimuli which are perceptible in the immensity of the continuum.

Unable to seize the complexity of nature, the artist thought it was possible for him to move back from the outer world to the inner one and propose solutions based on color harmonies further and further removed from all figurative representation. The organization of these abstract schemes, however, led in turn to a question which had its place in a larger investigation of reality: What effect (psychological and physiological) did a certain group of colors have on the human organism? No longer was the problem a triangular one (the landscape, the painter who interprets it, and the spectator who analyzes this interpretation); it had become a confrontation between the painting and the spectator. Color is not an abstraction but an energy, a quantifiable radiation which has a certain effect on our senses. An entire part of modern art was to apply itself to establishing laws of this dialogue.

Prior to this there were several false departures, the first of which was illustrated by Maurice Denis' famous sentence in 1890, "Remember that a painting—before becoming a war horse, a nude woman, or any sort of anecdote—is essentially a plane surface covered with colors arranged in a certain order." By his expression, "in a certain order," Denis confirmed Gauguin's discovery only to orient him in the direction of decorative art. Denis could well see the interest in an abstraction which allowed the painter complete freedom to place on the canvas the tone desired, no longer having to consider the constraint of verisimilitude. What exactly he was looking for, however, was the harmony and balance of forms which were the goals of classicism, formulae for a static and immutable conception of reality.

Using pure color as a pretext, painters resurrected the aesthetics of the well-composed canvas nourished on traditional values: All contradictions were resolved and canceled out, a pattern which reproduced none of the tensions and questions of life. It was anything but chance which soon led Maurice Denis to proclaim that "a painting should decorate" and Bernard as early as 1892 to say that "we must return to the primitive painters." Theirs was a regressive form of painting which sought to ignore the achievements of the first generation of Impressionists and its inquiry into the instability of nature, believing it was going beyond Monet but which actually was to lose itself in the meanderings of a primitivism and of a prerenascent mysticism.

The second false path was Symbolism, that hypertrophy of the ego, that dreamy narcissism which gratified the majority of the new generation. Its program consisted of a panic-stricken flight from an insufferable and trivial existence, an escape to spiritual opiums, unexplored regions as yet untouched by a vicious and corrupt civilization. Introspection became generalized. The complexities of the soul were examined. As the poet Gustave Kahn explained, "The essential goal of our art is to objectivize the subject (exteriorization of the

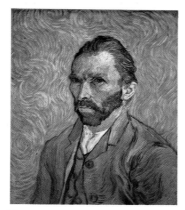

Vincent van Gogh. "Self-Portrait." 1889.
The background color influences our conception of the painter.

Fernand Léger. "The Tugboat Bridge." 1920.
According to Léger, "Color is a vital element, as essential as water and fire. A red, a blue, are equivalent to a steak."

Maurice de Vlaminck. "Portrait of Derain." 1905.
Vlaminck pushed Van Gogh's conceptions to the very limit. The face is a red spot sculptured in the impasto. The artist has created a brutal presence.

Robert Delaunay. "Circular Forms, Sun No. 2." 1912–13.
Delaunay offers a dynamic vision and draws us into the gyration of his "simultaneous contrasts."

idea) instead of subjectivising the object (nature seen through a *temperáment*)."

Beyond hese false paths a fresh conception of color prevailed. In a relentless but all-too-short attempt, Van Gogh opened perspectives which were to influence Fauvism and Expressionism. "Instead of trying to render what I have before my eyes," wrote the artist in 1888, "I use color in a more arbitrary manner to express myself strongly." But with him this arbitrariness was in the service of a *psychological* conception of color used to express "the terrible human passions." The background became an essential component of the character portrayed. We absorb simultaneously the hatched face of *La Segatori* and the yellow, shadowless flat area against which it stands out. It is this yellow which qualifies her (page 156). Speaking of a portrait, the artist explained, "Behind the head, instead of painting the ordinary wall of the cheap apartment, I paint infinity, I do a simple blue background, the richest, the most intense that I can produce, and by this simple combination the blond head, illuminated against this rich blue background, acquires a mysterious effect, like a star in the deep blue sky."

For Van Gogh, color beyond all descriptive and figurative conception of the object, conditions our psyche. A certain amount of green or red creates melancholy, anguish, gaiety. This led, in September, 1888, to his remark, "To express the love of two lovers by a marriage of two complementaries, their mixture and their oppositions, the mysterious vibrations of similar tones. To express the thought of a forehead by the radiance of a light tone on a dark one. To express hope by a star. The ardor of a being by the radiance of a sunset. This is anything but a realistic illusion, but is it not something which truly exists?"

This was the path followed by Matisse in his "Dance" and "Music," by the abstract Kandinsky of the 1910's, and by their successors. Meanwhile in the course of years it became evident that it was impossible to codify the psychological effect produced by color and that the impressions that each painter considered in all good faith objective were in truth subjective.

What remains true, what Pierre Francastel has precisely pointed out, is that color, employed for itself, reveals a new space independent of the perspective space imposed by Renaissance artists. "Van Gogh discovered the autonomous spatial quality of colors in their pure state," wrote Francastel. "No one before his time had understood that a pure color signified in itself a certain notion of proximity or distance. . . . A complex space can be constructed merely by the juxtaposition of colored spots." This was an essential discovery. Colors "breathe." On the canvas they can retreat or advance. The artist organizes his surface with living matter which has its reactions, its sympathies, and its antipathies, which retreats and advances according to the space given it and to what surrounds it.

Among the contemporary artists, it was Delaunay who pushed this vitalist conception to its furthest limit. With his "circular forms" he developed from 1912–13 a visual dynamic which agitates and takes our eye from curve to curve through the canvas. A painting has become a field of expansion for our optic muscle: Henceforth the subject was this *physical* event of the eye which literally experiences the movement by its displacements. As Delaunay himself explained, "Color is form and subject. It is color itself which by its play, its sensibility, its harmonies, its contrasts, forms the framework of the rhythmic development." Color has acquired independence.

Edouard Manet. *"Lola de Valence."* Detail.

Voluptuous pure color surrounds an academic arm.

Edouard Manet (1832–83).
"Lola de Valence." 1862. Oil. 48.4 × 35.9 inches.

MANET'S ART reflected his pleasure in color. In *"Lola de Valence"* there is a brutal contrast between the smooth, blended texture of the arm, reminiscent of Courbet's ivory nudes, and the lively spotted skirt in which the vivacious virtuosity of the artist gave free rein to the sensuality of reds and yellows. The influence of Goya's portraits of actresses is felt in this canvas. Manet had discovered Spanish art in Louis-Philippe's splendid collection in the Louvre. Later, in 1865, when he paid a visit to the Prado, it was Velásquez who chiefly impressed him. The year 1862 saw the arrival in Paris of a troupe of dancers from Madrid; their brilliant and highly colored

costumes aroused Manet's enthusiasm. When not performing, they spent the day posing for him in his friend Steven's studio, near the Théâtre de l'Hippodrome. This resulted in the sixteen "Spanish" paintings which were exhibited March 1, 1863, at the Galerie Martinet only to be deplorably received. Writing in *La Gazette des beaux-arts,* Paul Mantz stated, "This art may be very loyal, but it is unhealthy and by no means leads us to plead Monsieur Manet's case before the exhibition jury." Another newspaper, full of sarcasm, called the painter "Don Manet y Courbetos y Zurbaran de Los Batignolles."

Edouard Manet. *"Lola de Valence."* Detail.

The pigment in slabs or in heaps springs from
the canvas and imposes its radiating presence.

Claude Monet (1840–1926). "Jean Monet on His Wooden Horse." 1872. Oil. 23 × 28.5 inches.

THE PIGMENT PROJECTS from the background and seems to exude from the canvas either in the form of luminous large slabs or as small heaps of strongly radiating pigment.

In the flowers which occupy the background of the composition above, behind the wooden horse, Monet plays with the pigmentary layers and gives to certain details a relief which is related to that of the real object. As John Rewald noted, "He sought to reproduce the material and at the same time the vibration of light." This method was to shock some of the painter's companions, including Pissarro, who was to condemn him in a letter to his son Lucien in which he mentions "the summary execution of certain Monets. . . . The impasto is so heavy that an artificial light is added to that of the canvas. You have no idea how I dislike this."

This detail of "Luncheon on the Grass" (*right*) is along with another detail the sole trace of a huge project which Monet undertook at the age of twenty-five to compete with Manet on his own ground and at once find a foremost place for himself. The canvas was to measure some 16 × 19 feet, more than that of Courbet's "The Studio." It represented a dozen persons picnicking in a glade in Fontainebleau. Left as security to a landlord to whom the artist owed rent he was unable to pay, the canvas was found utterly ruined by dampness, only two sections of which Monet managed to save.

Claude Monet. "Luncheon on the Grass" (detail, left part). 1865–66. Oil. 164.6 × 58.9 inches.

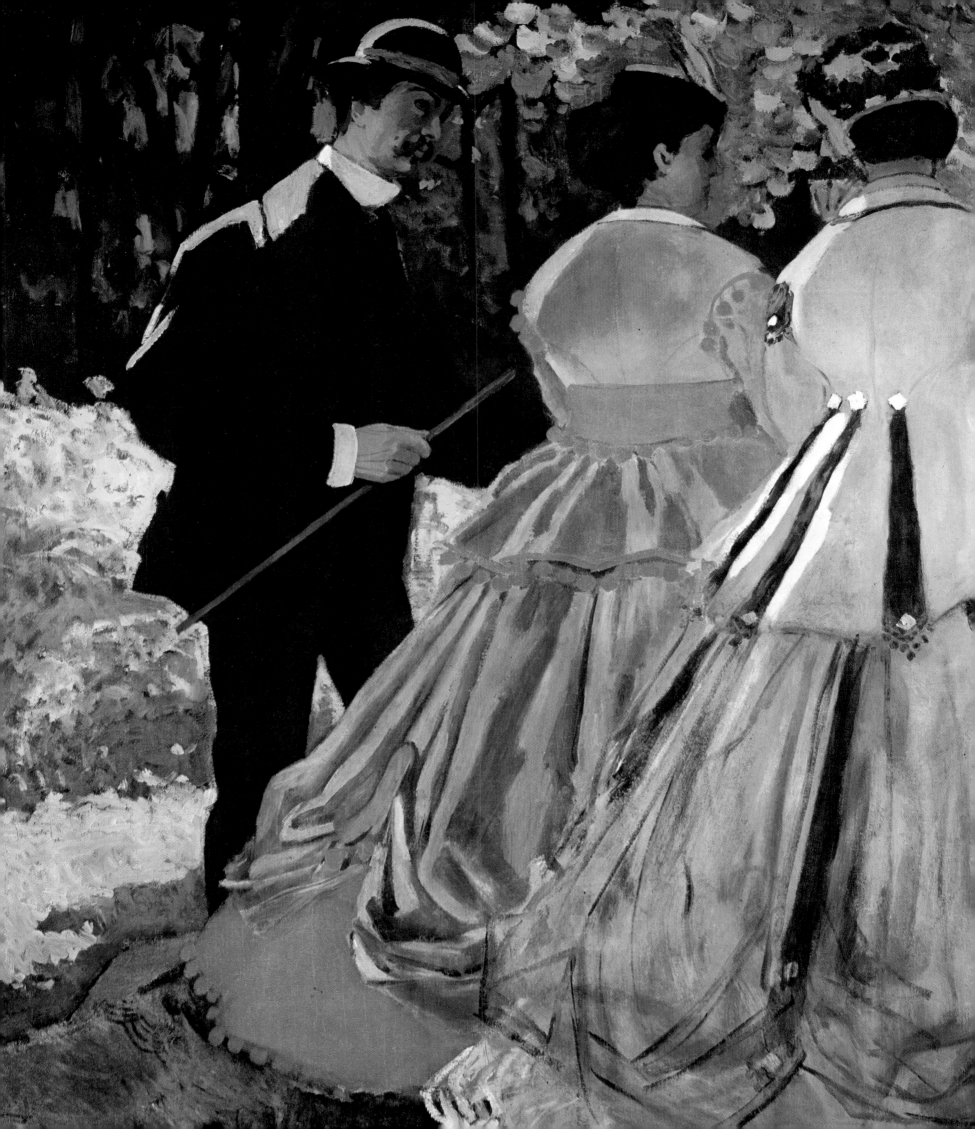

Vincent van Gogh (1853–90). "Fourteenth of July in Paris." 1886–87. Oil. 17.2 × 15.2 inches.

THE PALPITATION of flags is the painter's pretext to design on the canvas a series of lively and unmixed colors. Monet (*right*), on the occasion of the Universal Exposition of 1878, represented a street off Les Halles in Paris. He marvelously expresses the airy, fresh aspect of national emblems caught up in wind and light. Passersby are treated as lively dark spots in the dark street passage. At the far end of the street, a ray of sunshine heightens the tone of the oblique spots created by the painter's brushstrokes.

Eight years after Monet, Van Gogh (*left*) in turn took up the theme of flags. He minimizes the perspective effect and the use of vanishing points, letting the color itself create space. "No one before him," wrote Pierre Francastel, "had yet understood that a pure tone alone signifies in itself a certain notion of proximity or distance. . . . One can construct a complex space merely by the juxtaposition of colored spots." Van Gogh himself said, "I am trying to express the hopelessly rapid passing of things in modern life." Never was he to go so far as in this violent and powerful canvas. In no way does it yield to the Fauve landscapes which Derain or Vlaminck were to exhibit twenty years later.

The oblique liveliness of flags transforms the streets of Paris into multicolor lacework.

Claude Monet (1840–1926). "Rue Montorgueil." 1878. Oil. 24.2 × 12.9 inches.

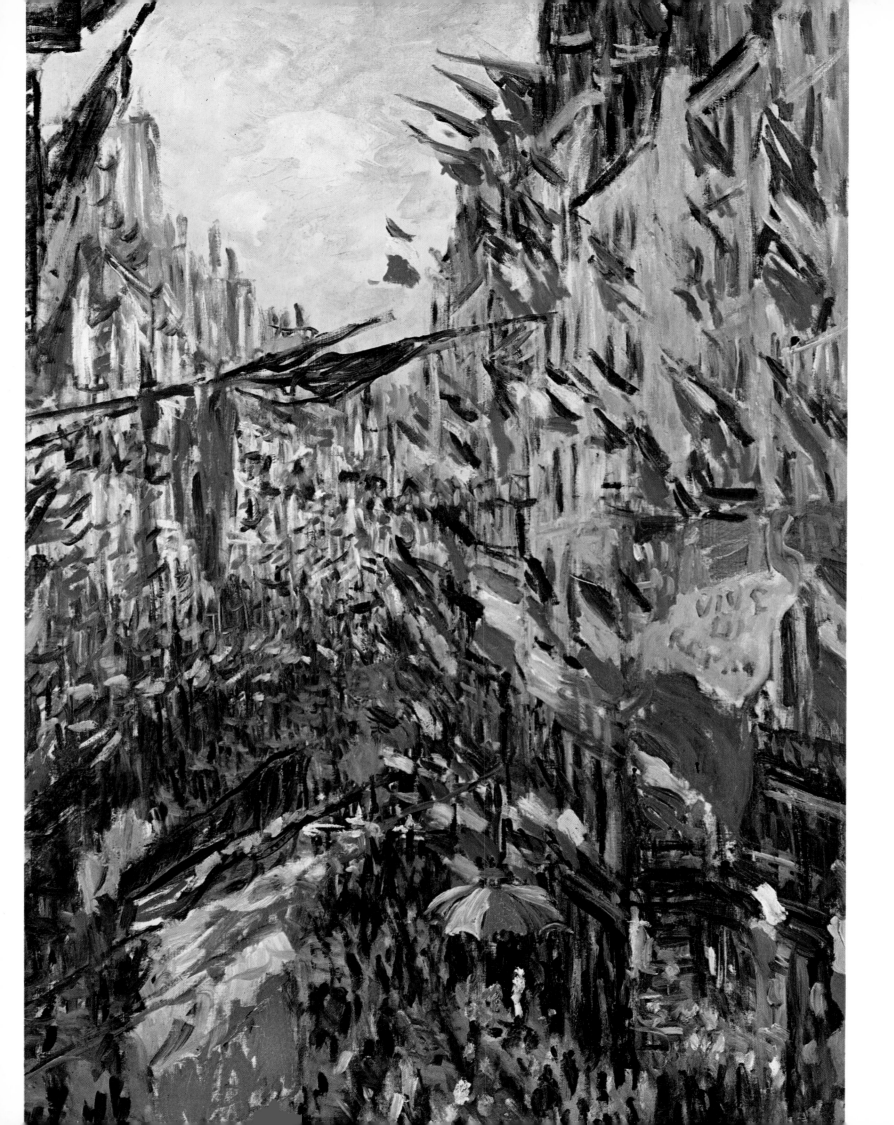

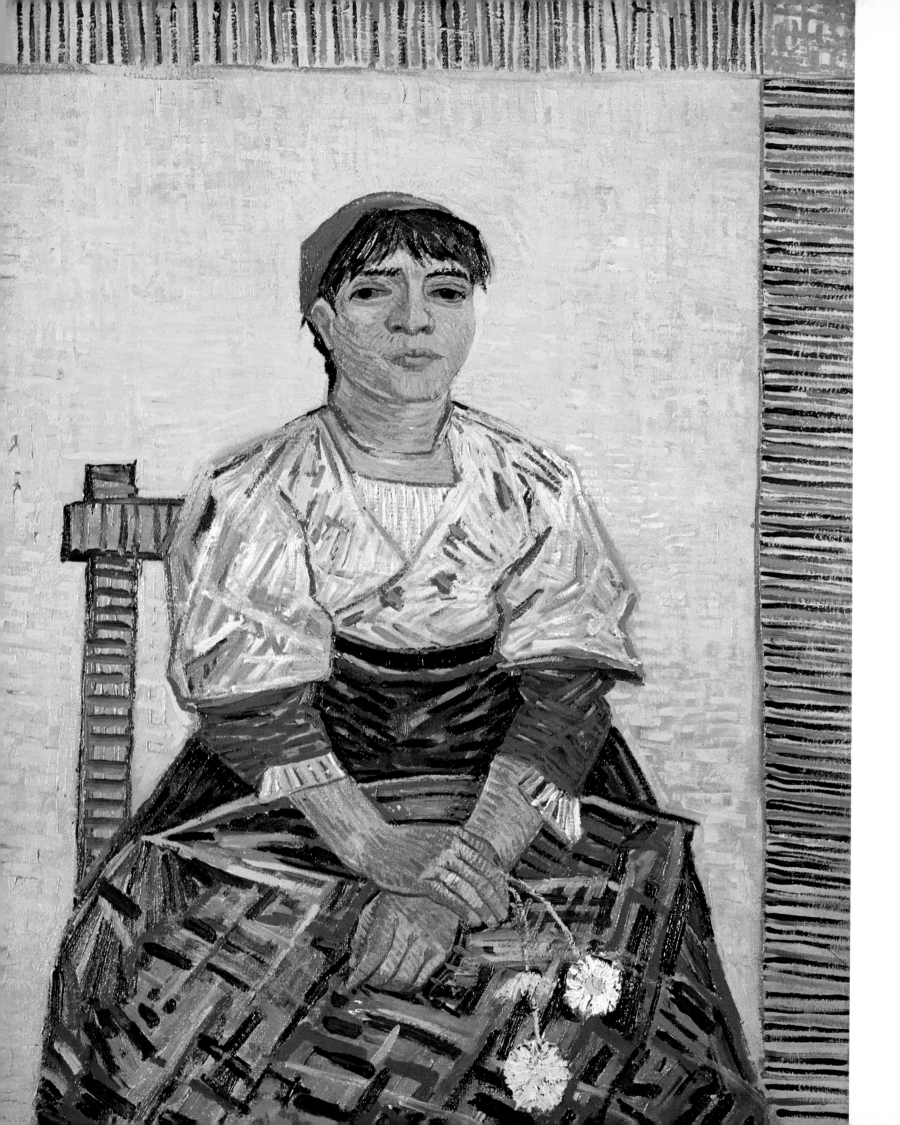

The harsh tones of a wild color scheme upset the French tradition of an art emphasizing light and shade.

IN HIS LARGE unified flat areas, Van Gogh was directed by a quantitative conception of color. The artist, who was to say, "I have sought to paint with red and green the terrible human passions," sought to create shock by using intense tones which have a direct impact on our emotions. As a result, the representational image was simplified. He was not concerned with rendering the instantaneous or atmospheric reality. Depth was not emphasized. The spot alone should "speak" and by its striking effect have a suggestive power.

For *La Segatori's* clothing *(left),* Van Gogh, who knew very little about the techniques developed by the Neo-Impressionists, used a division of tones and, carried away in the act, revealed the entire excess of his character. This canvas, with the design off-center because of a crudely placed fringe that is repeated rather weakly in the back of the chair, shows in the foreground a large lattice of hatchwork, a veritable array of colored lines. Far from hiding his brushstrokes, the artist emphasized them. It is a manner of increasing their physical presence on the canvas. Nevertheless what is revealed here is the future of an entire current of painting, for color was soon to express merely itself, its power to act physically on the spectator's retina. Van Gogh announces abstract painting by Kandinsky and Mondrian. Agostina Segatori, more familiarly know as *La Segatori,* had in her youth served as a model for Corot, and when Van Gogh painted her portrait she owned the café Le Tambourin in the Boulevard de Clichy in Paris. Van Gogh may well have been her lover. It was here that he organized an exhibition of works by Anquetin, Bernard, Lautrec, and himself. It is not clear whether they were hung in hopes of a sale or were gifts to the woman. He got into a fight with someone in the café who may have been jealous of his attentions to *La Segatori,* and thereafter she broke with him. In the upshot he appears not to have been able to retrieve his paintings which seem to have been sold as waste canvas.

Vincent van Gogh. "An Italian (La Segatori)." Detail.

Vincent van Gogh (1853–90). "An Italian (La Segatori)." 1887. Oil. 31.6 × 23.4 inches.

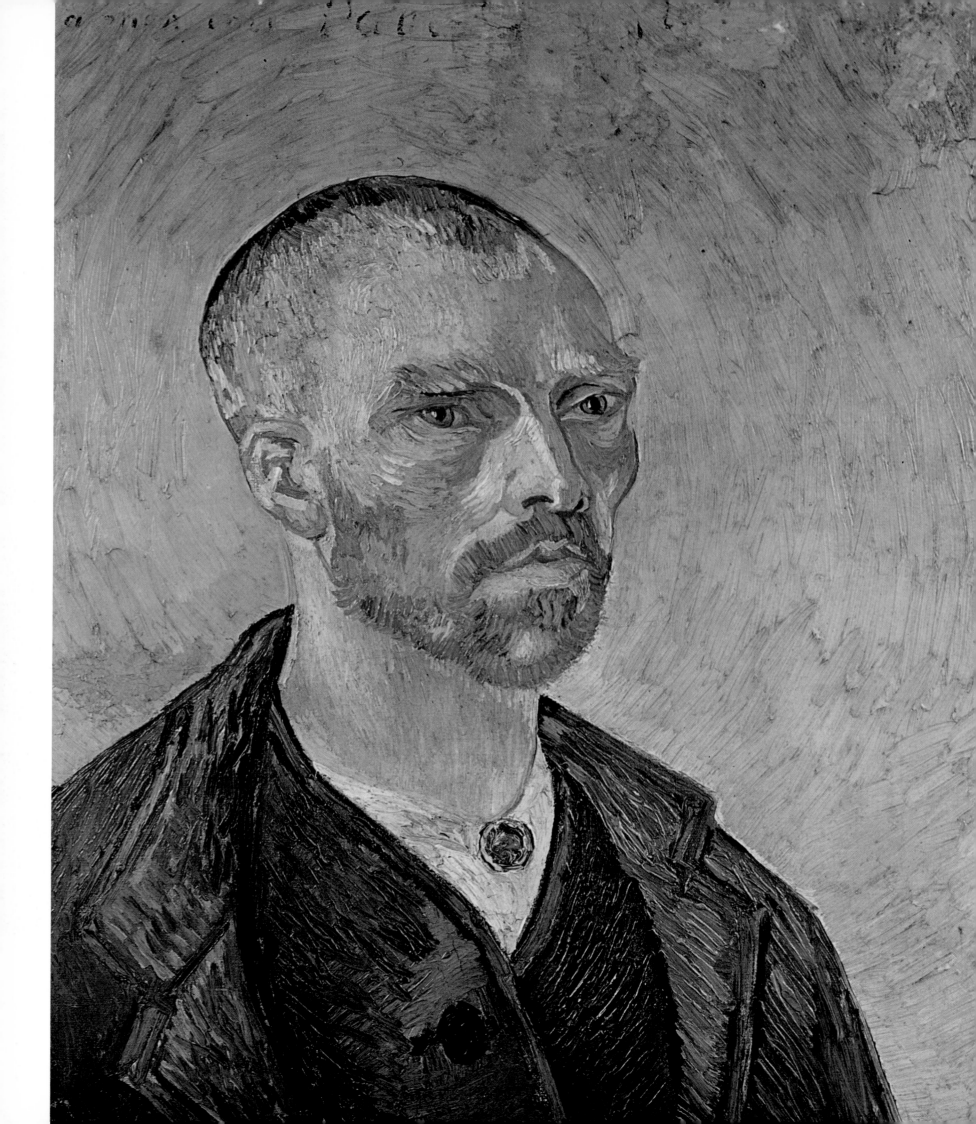

Vincent van Gogh (1853–90). "Self-Portrait with Shaven Head." 1888. Oil. 24.2 × 20.3 inches.

These three faces set against a colored background inaugurated the period of the accursed painters.

THE STRIKING POWER of these three faces is heightened by the colored background against which they stand out. Vincent van Gogh, Emile Bernard, and Paul Gauguin all believed in the importance of color to express the state of mind of the model represented. Speaking of his self-portrait Van Gogh wrote to his brother Théo, "The whole thing is centered against pale Veronese (no yellow). The clothing is that brown jacket with a blue border although I exaggerated the brown to purple and the width of the blue edges. The head is modeled in light impasto against the light background almost without shadows. Only I *slightly* slanted the eyes in the Japanese fashion."

Gauguin, describing his own self-portrait, explained, "I believed it to be one of my best things: it is so abstract that it is absolutely incomprehensible. At first glance the head of a bandit, a Jean Valjean (from *Les Misérables*) personifying also an Impressionist painter who has fallen into disrepute and is always wearing a chain for the world. The drawing is quite special, complete abstraction. The eyes, the mouth, the nose are like the flowers of a Persian tapestry personifying also the symbolic side. The color is far from nature; imagine a vague recollection of pottery twisted by a high fire!"

In all three cases, the concern for immediate realism is abandoned in favor of an inner fidelity. For several months the history of modern painting coincided with these three artists. Gauguin first met Van Gogh in November, 1886, then Bernard two

years later at Pont-Aven, in Brittany. Their feverish exchange of daily letters reveals the break of classic Impressionism in favor of a greater and more brutal vision of realism. On Van Gogh's initiative these three self-portraits were dedicated and exchanged as tokens of friendship. He was then living in Arles and hoping for a "school of the South." In June, 1888, he wrote to Emile Bernard, one of the younger painters who had befriended him in Paris, "My dear comrade Bernard, more and more it seems to me that the pictures which must be made, so that painting should be wholly itself, and should be raised to the heights equivalent to the serene summits which the Greek sculptors, the German musicians, the writers of French novels reached, are beyond the powers of an isolated individual; so they will probably be created by groups of men combining to execute an idea held in common."

Gauguin later joined Van Gogh in Arles, where their meeting ended in conflict and tragedy. It was during this period that Gauguin wrote to Bernard, "In general we scarcely agree, especially on painting. He admires Daumier, Daubigny, Ziem, and the great Théodore Rousseau, all persons I cannot bear. And on the other hand, he detests Raphael, Ingres, Degas, all persons I admire. My reply is, 'You are right, corporal!' " As for Van Gogh, he explained to his brother Théo, "We are in the presence of a pure being with wild instincts. With Gauguin blood and sex are more important than ambition."

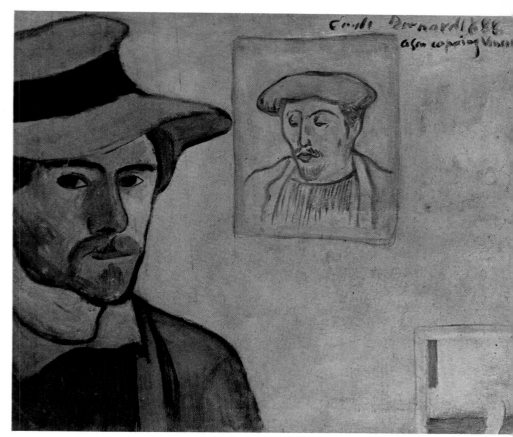

Emile Bernard (1868–1941). "Self-Portrait Dedicated to Van Gogh." 1888. Oil. 17.9 × 21.45 inches.

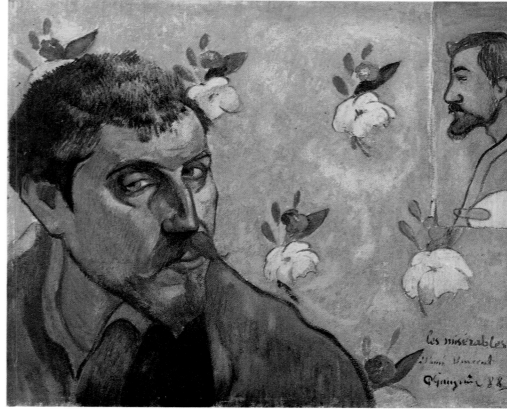

Paul Gauguin (1848–1903). "Self-Portrait. Les Misérables." 1888. Oil. 17.5 × 21.45 inches.

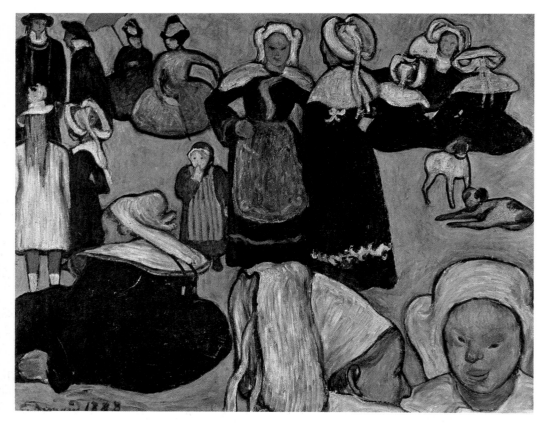

Emile Bernard (1868–1941). "Breton Women in the Meadow." 1888. Oil. 28.9 × 35.9 inches.

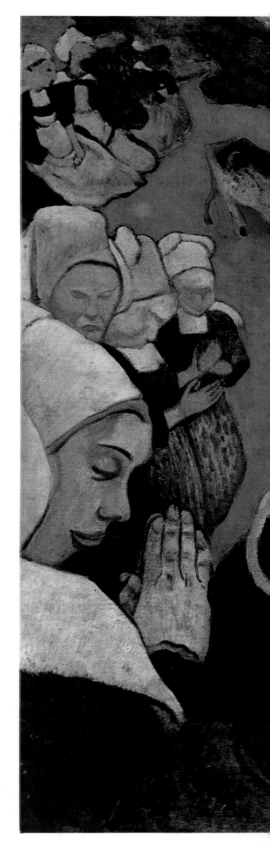

SYNTHETISM, LED by Paul Gauguin, originated at Pont-Aven, in Brittany, where he had met a brilliant twenty-year-old painter named Emile Bernard who together with another young painter, Anquetin, had developed a simplified style inspired by Japanese art. "The first, Monsieur Bernard," remarked the critic Félix Fénéon, "painted topsy-turvy Breton women in saturated colors, delimited by a kind of mesh drawing and enveloped in a setting without atmosphere or value." Actually Bernard's "Breton Women in the Meadow" (*above*), with its strong play of headdresses, preceded Gauguin's "The Vision After the Sermon" (*right*). Gauguin was to develop Bernard's style to a striking degree. "Today Monsieur Emile Bernard is perhaps Gauguin's pupil," wrote Félix Fénéon, "but it appears that it was he who had initiated Gauguin."

"The Vision After the Sermon" was Gauguin's first masterpiece. In Paris the canvas created a sensation among young painters and Bernard himself was subjugated. He wrote to Van Gogh full of veneration for Gauguin's talent, stating that he considered him such a great artist that he was quite frightened and found that by comparison his own work was bad. The women kneeling in "The Vision After the Sermon" are contemplating an apparition resulting from the Sunday sermon which they had just heard in church. Thus the canvas has the juxtaposition of an imaginary scene and a real one. In a letter to Van Gogh Gauguin said, "I believe I have attained in these figures a great rustic and *superstitious* simplicity. It is all very severe. . . . For me in this painting the landscape and the struggle

exist only in the imagination of those praying as a result of the sermon. That is why there is a contrast between the natural people and the struggle in this landscape—unnatural and out of proportion."

The Oriental inspiration here is strong, chiefly in the shape of the tree trunk and in the antirealistic character of the red field. In her book on Gauguin, Françoise Cachin points out "the obvious Japanese quality of the composition: the angular tree in the center and the treatment of the theme of Jacob and the angel which appears to have been borrowed directly from a group of wrestlers drawn by Hokusai. Moreover the angel's legs have muscles low on the ankle which is characteristic of Sumo wrestlers."

Gauguin remembered Bernard's lesson. To express the dream of pious women, he painted a Breton meadow in untrue tones.

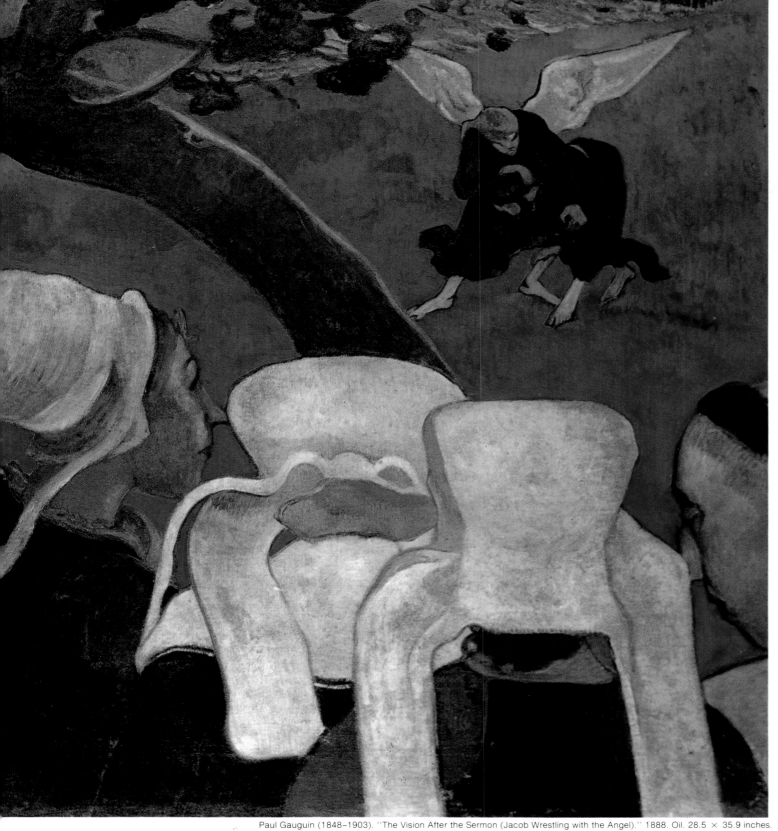

Paul Gauguin (1848–1903). "The Vision After the Sermon (Jacob Wrestling with the Angel)." 1888. Oil. 28.5 × 35.9 inches.

Bernard reinvents the harmonic
scale of nature. He drowns his black
outlined silhouettes in the red wheat.

BERNARD'S BEST canvas dates from 1888. At the age of twenty, the artist had already exchanged works with Van Gogh, had had controversial discussions with Signac, and studied and collected Japanese prints. Toulouse-Lautrec had painted his portrait. He was sure of himself and bursting with fresh ideas. "Black Wheat" (*right*) is an exceptional product of this youthful fearlessness; the colors are deliberately forced. The overall reddish tone, the cutting up of the face in the foreground, the harmonious division of white spots without outline, all reveal the young man's astonishing authority. After inspiring Gauguin, his elder by twenty years, he paradoxically succumbed to the latter's strong personality. As early as 1891 both men strongly disputed, for both claimed to have invented Synthetism. When in February of that same year, Gauguin organized a public auction to finance his trip to Tahiti,

several articles were printed naming him leader of the new school, with no mention of Bernard. This angered Bernard, and out of hostility for Gauguin, he gradually withdrew from a style which he had helped create. In 1893 he visited Italy, studied the Renaissance painters, and deliberately turned to the past. Bogged down in a mysticism which kept his feelings increasingly in check (he was a member of the Catholic Order of the Rosicrucian Brotherhood of the magus Péladan), he lost all plastic qualities in his compositions. "I intoxicated myself with incense, organ music, prayer, ancient stained glass, and hieratic tapestry," he later explained in reference to this period, "and I returned to past centuries, increasingly isolating myself from those around me whose business preoccupations only inspired me with disgust. I gradually became a man of the Middle Ages."

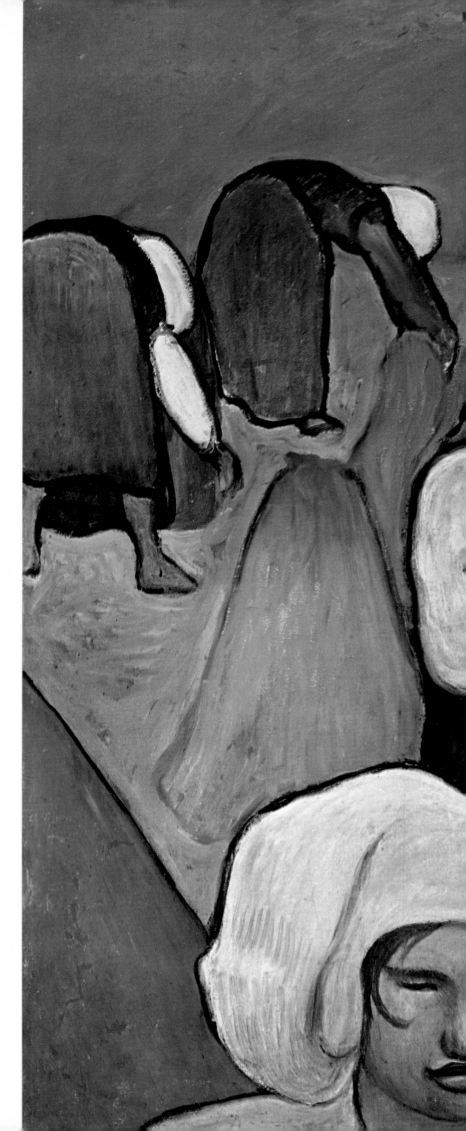

162

Emile Bernard (1868-1941). "Black Wheat."
1888. Oil 28.5 × 35.1 inches.

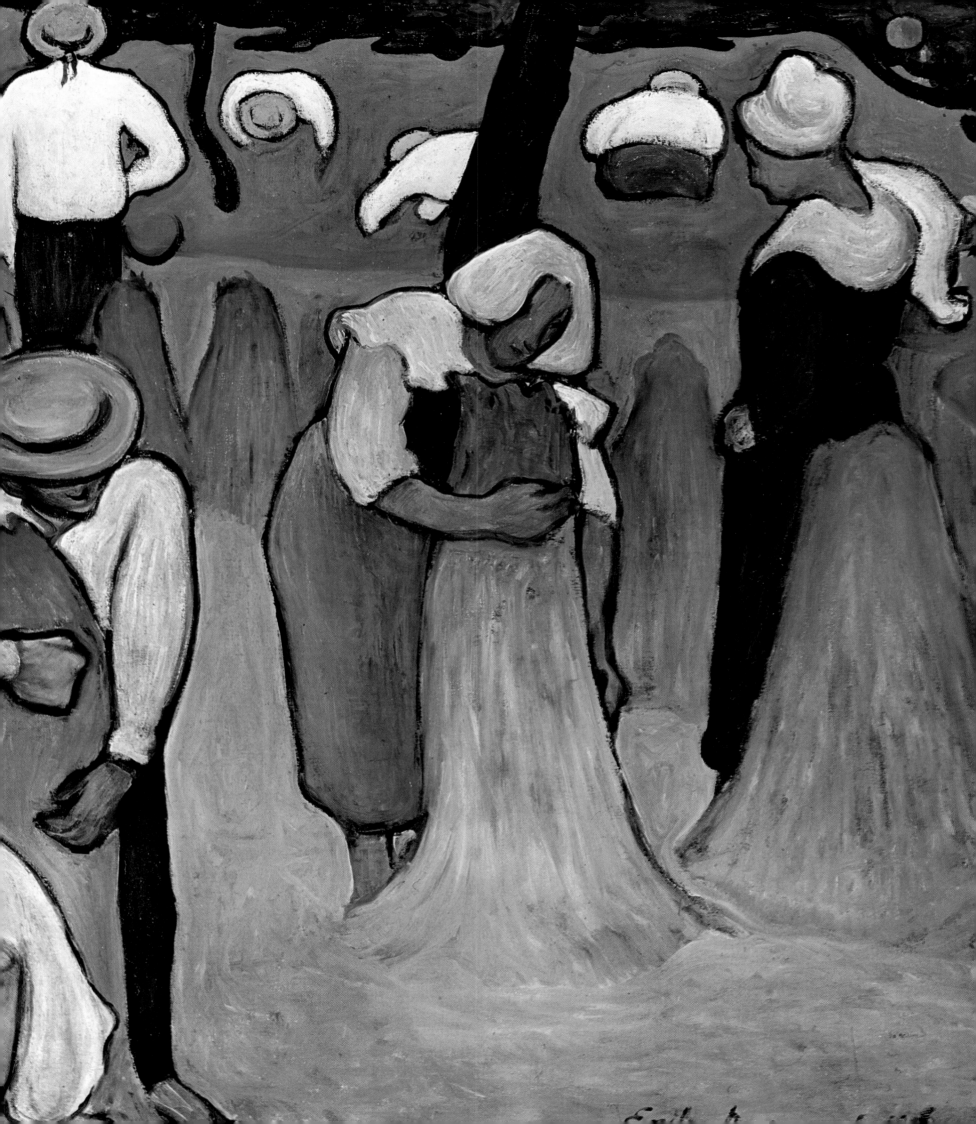

The stubborn affirmation of a new painting is revealed
in this simplified, synthetized face, like the blaze of a
stained-glass window.

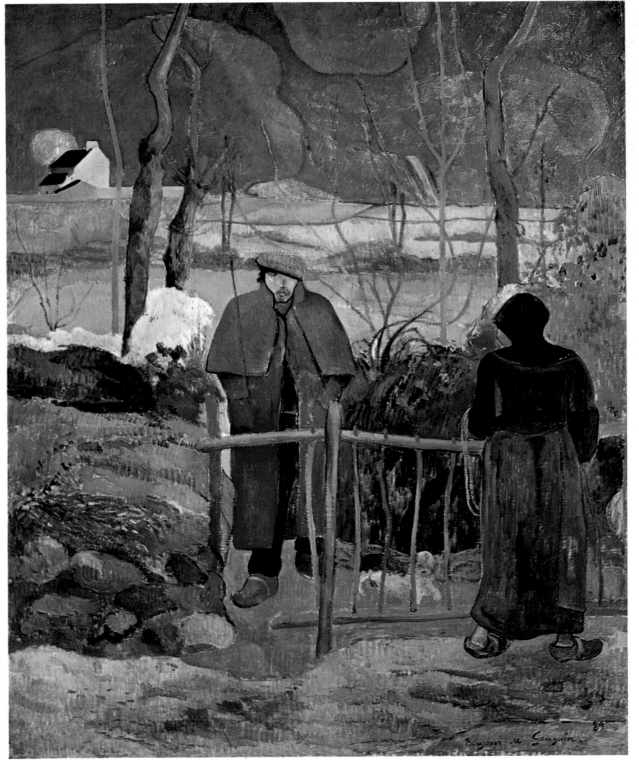

Paul Gauguin (1848–1903). *"Bonjour, Monsieur Gauguin."* 1889. Oil. 44.5 × 35.9 inches.

Paul Gauguin. *"Bonjour, Monsieur Gauguin."* Detail.

GAUGUIN'S FACE with virtually no modeling, outlined in black, like a piece of stained glass, expresses the arbitrary quality of a synthetic painting. Félix Fénéon mentions "the mysterious, hostile, crude aspect" of the canvases dating from about 1889 and calls attention to "an opulent and heavy color which takes pride in itself cheerlessly without having the slightest effect on the neighboring colors." Gauguin had settled down in northern France at Pont-Aven, then at Le Pouldu in order to find in the Celtic soul an atmosphere of anticlassical archaicism. "I love Brittany," he wrote. "Here I find a wild and primitive quality. When my wooden shoes clatter on the granite ground, I hear the muted, dull, and powerful sound which I am seeking in painting." At Le Pouldu he fell into a frenzy of creative work and painted the walls, the shutters, the doors, executed bas-reliefs, busts, did pottery, motifs for dishes and fans. In late 1889 while visiting the region, André Gide chanced to enter an inn where Gauguin and his friends were staying. "I had the impression that this was nothing but childish scribbling, but the tones were so lively, so special, so joyful that I no longer thought of leaving. . . . There were three of them who soon arrived with paint box and easel. . . . They were all barefoot, splendidly untidy with fine voices, During the entire evening I remained breathless, taking in every word that said, tormented by the wish to speak to them, to know them and to tell the big fellow with a clear look that what he was singing at the top of his voice and what the other took up like a chorus was not by Massenet, as they believed, but by Bizet."

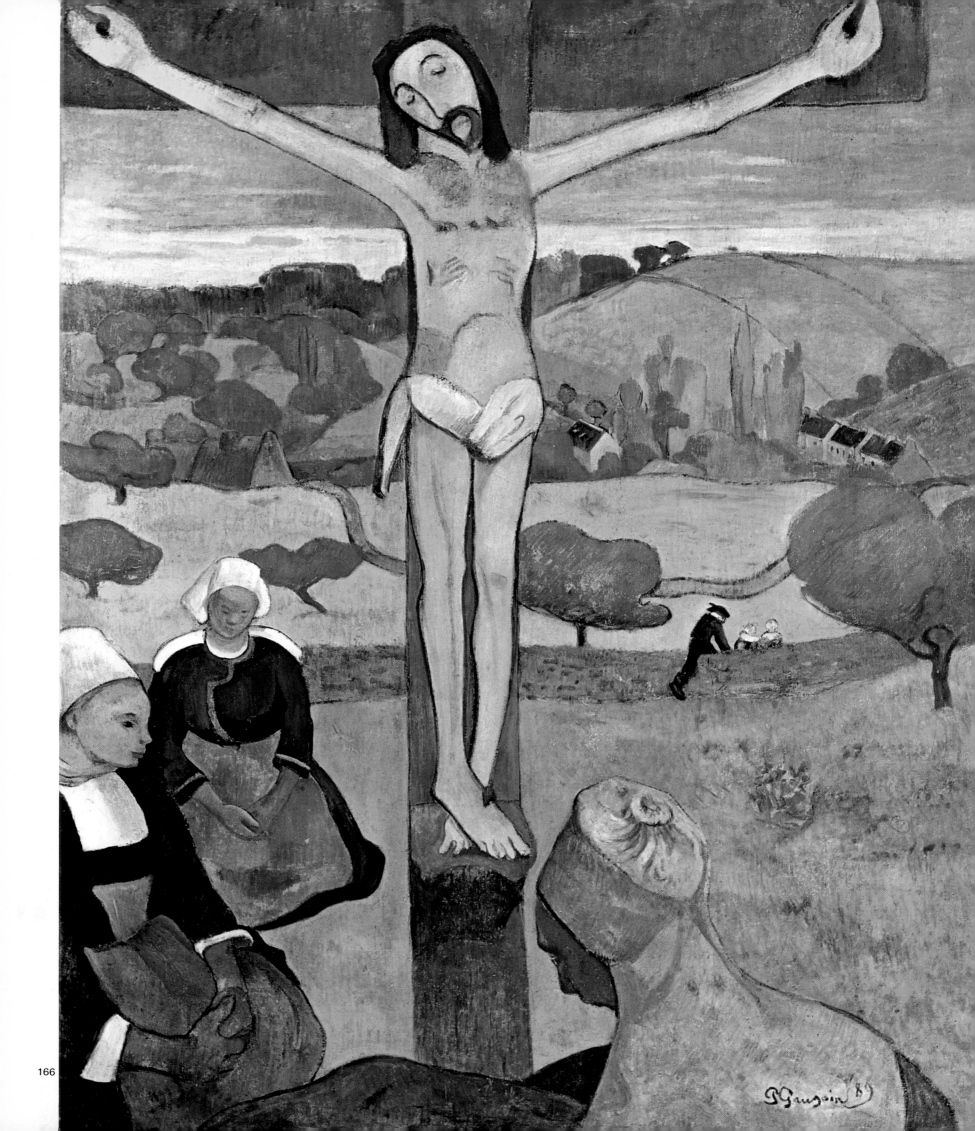

166

The rustic stiffness of Breton religious sculptures offers
Gauguin a lesson in restraint and power.

GAUGUIN FOUND what he called "the rustic grandeur and superstitious simplicity" of his religious masterpieces in the stiff, intense sculptures of the Breton countryside. Inspired by a polychrome wooden crucifix of the ancient chapel of Trémalo, near Pont-Aven, his "Yellow Christ" at once impresses us for its unusual fresh tones and the linear simplicity of the figure of Christ. The work recalls the powerful schematic designs of Eastern Christian art.

The same hieratic quality is evident in "The Green Christ" (*right*) inspired by the countless calvaries which bordered the country roads. The novelist Maurice Barrès, noting his impressions of Brittany in 1886, wrote, "On an evening when the sky is of such a soft green color, one must love these nameless chapels, these gray, poor stones." Gauguin expresses this very melancholy in his Christian representations in which the background, as in Bruegel's paintings, is filled with scenes from nature and everyday life all indifferent to the tragic scene. This melancholy appears in the letters written about 1889. "Of all my efforts this year," he wrote to Emile Bernard, "there remains only the roar of Paris which discourages me here to the point where I no longer dare to paint; I take my old body for a stroll in the north wind of Le Pouldu. . . . The soul, however, is absent and looks sadly at the gaping hole before its eyes. . . . Let them take a careful look at my latest painting (granted they have a heart for such things) and they will see what resigned suffering is. Is a human cry nothing at all?"

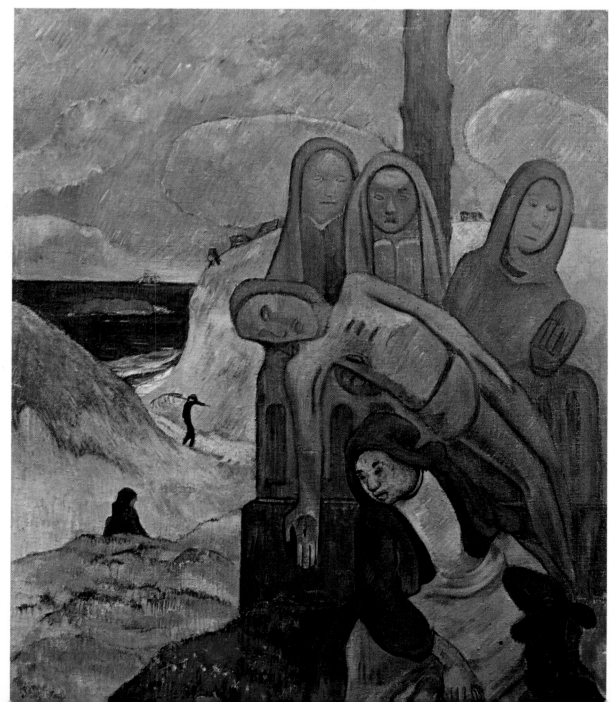

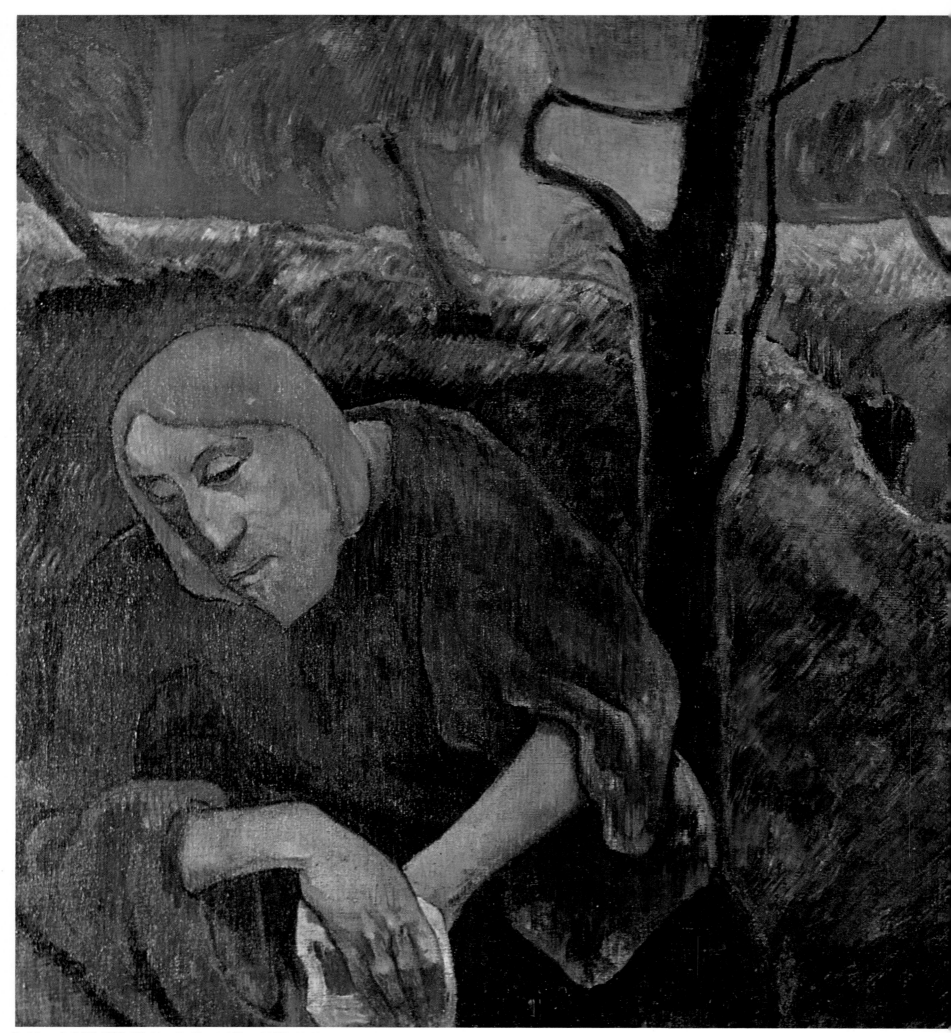

Paul Gauguin (1848–1903). ''Christ on the Mount of Olives.'' 1889. Oil. 28.5 × 35.9 inches.

Gauguin, using a single spot of color,
dramatizes his composition and swings it
to the left.

A COMPOSITION swung to the left,
pivoted entirely on the sharp note of red
hair, an almost filmlike projection of
the figure of Christ, were the dramatic
means Gauguin employed to isolate the
principal figure of Christ praying in the
garden of Gethsemane on the Mount of
Olives. This religious imagery reflects
the influence of Emile Bernard and his
strong mystical convictions. Yet at the
same time Gauguin portrays his own
features in those of Christ, identifying
himself with the Messiah and his
Calvary. With a naïveté which is not
without cunning or brutality, he sees
himself as the misunderstood messenger
of a new school, betrayed by his own
and rejected by all. His sole hope is in
a new life in the tropics. Writing to his
wife in February, 1890, he said, "Oh,
may the day come (and perhaps soon)
when I can escape to the woods of an
island in the South Seas, live there in
ecstasy, calm, and art. Surrounded by a
new family, far from the European
struggle for money, there in Tahiti, on
quiet tropical nights, I shall be able to
listen to the soft murmuring music of
the movements of my heart in amorous
harmony with the mysterious beings
around me. Free at last, with no
concern for money, I shall be able to
love, sing, and die."

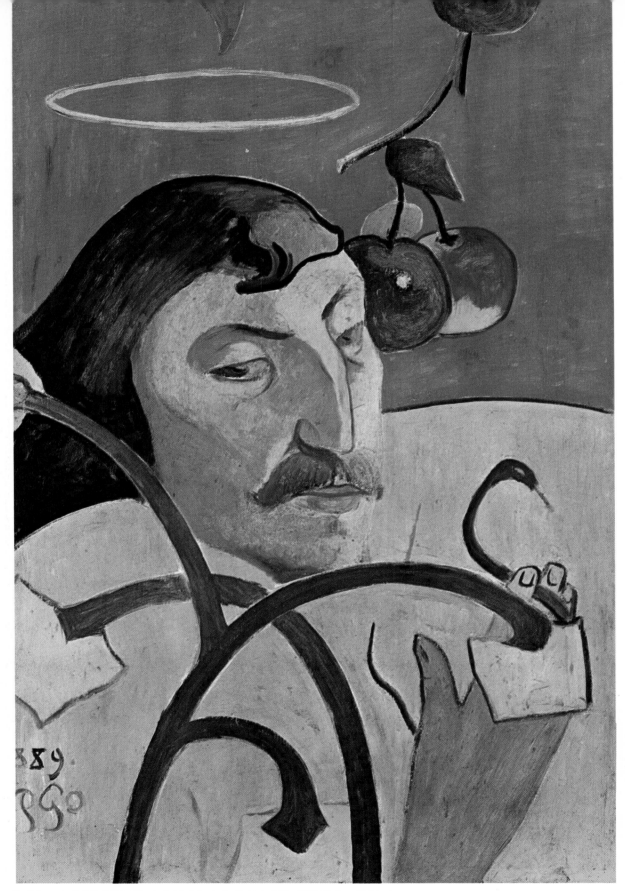

THE ARABESQUE which invades Gauguin's paintings announces Art Nouveau. Nature is but a pretext, the emphasis being on the purely decorative value of the interlacing pattern. The man who, according to the poet Guillaume Apollinaire, "will return to the limits of humanity to seize the divine purity of art," is the ancestor of the so-called Noodle Style. Referring to "*Fatata te Miti*" (*right*), Françoise Cachin mentions "an astonishing foreground which resembles a modern Liberty [Art Nouveau] style fabric in mauve, orange, and yellow." In this painting there is a striking conflict between the flat areas and the modeled relief of the female back. Gauguin constantly goes from a research of expressive volume to a taste for abstract, sinuous decoration. As early as 1889 in his self-portrait (*left*)—with halo, stylized flowers, and sexual allusions—he enjoyed painting a network of twisting and turning lines. "Be wary of modeling," he advised his pupils. "The simple stained-glass window which attracts the eye by its division of color and form, this is still best. . . . One bit of advice, don't copy nature too much. Art is an abstraction." Below is a "synthetic" signature formed by the letters "P. GO" for "Gauguin."

In the heart of the tropics, the artist remained in close contact with the most distant cultures—Egypt, Java, Japan, Greece. In his art he examined them all. Thus the movement of "Man with Ax" (*below*) was inspired by a figure of a horseman on the frieze of the Parthenon.

Paul Gauguin (1848–1903). "Symbolist Self-Portrait with Halo." Oil. 1889. 31.2 × 20.3 inches.

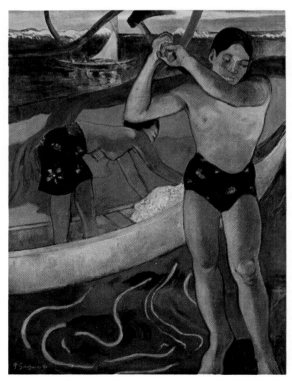

Paul Gauguin. "Man with Ax." 1891. Oil. 35.9 × 27.3 inches.

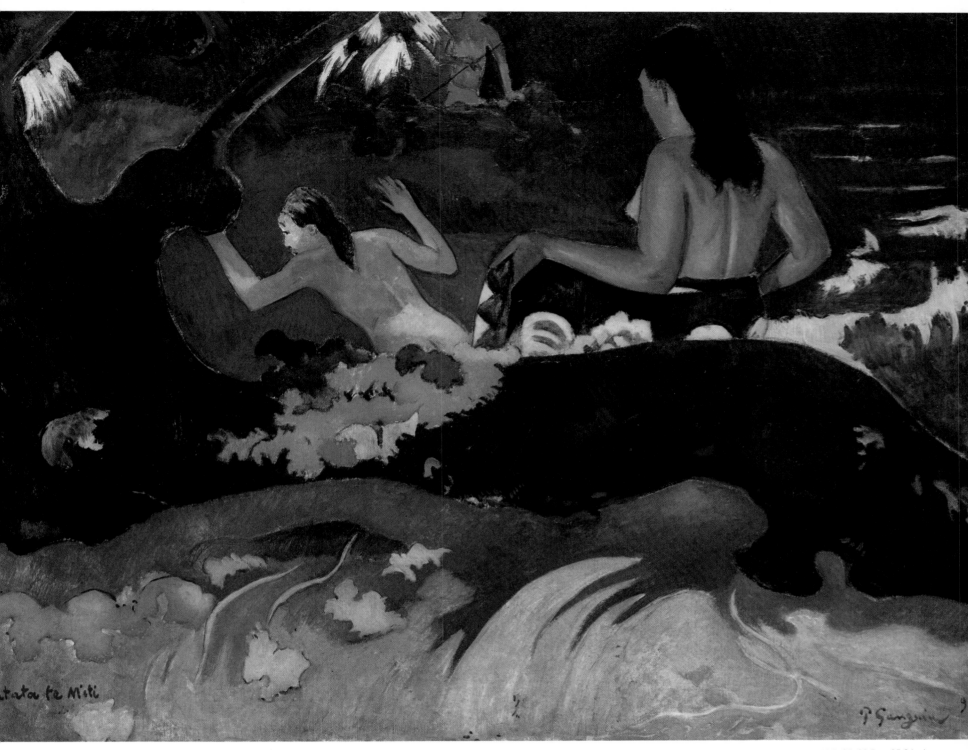

Paul Gauguin. "*Fatata te Miti* (On the Beach)." 1892. Oil. 26.5 × 35.9 inches.

The early beginnings of Art Nouveau are revealed in these light curves.

WHITE, ITS NUANCES, its depth, its relationship with light and the bluish tones of shadows—all were constantly studied with passionate interest by the Impressionists. On these pages are four examples. As early as 1864 Whistler (*right*) painted the delicate white dress worn by Jo Heffernan, his favorite model, and for ten years the center of his life. (Courbet admired her rich red hair and painted her portrait which he entitled *"La Belle Irlandaise."*) The white has a mysterious quality which Whistler uses to give a tender and melancholic graceful accent.

Gauguin, on the other hand (*right, above*), uses white as a spot of chalk to highlight his composition. The painting, inspired by a photograph, is languid and serene. The rounded mass of the shoulders and of the body contrast with the vertical plane of the garment which recalls certain tablecloths painted by Cézanne.

Manet, who said, "the chief person in a painting is light," succeeded in his "Nana" (*right, below*) in creating a splendid genre painting harmonized around a transparent, crunchy slip. The model was a young actress who, according to her reputation, was anything but wild. To create the aspect of a boudoir, Manet installed in his studio a Louis XV console and other pieces of furniture. He could paint, and wanted to paint, only what he saw. The half-cut figure on the right emphasizes the rather saucy scene. In 1876 Nana appeared as a minor character in one of Zola's serialized stories. In 1877 Manet painted this "portrait," the model standing stiff, with a furtive and charming look, as though photographed.

Renoir (*far right*) painted Lise Tréhot, who was his mistress for eight years. It was a question of trying to portray a figure in the open air and to submit a large white area to the changing play of natural light. Although this first attempt announces the masterpieces of Renoir's Montmartre period (pages 102–3), it lacks freedom. The mass is compact and the spots of light remain imperceptible. At the age of twenty-six, however, Renoir was already a master with a certain reputation. "Lise with a Parasol," accepted for the Salon of 1868, was deliberately hung in a poor place. The critic Castagnary, a champion of realism, defended Renoir. "Poor young man! He has submitted a painting which I shall not say good but interesting in every respect. . . . The ground is soft, the tree cottonous, yet the figure was modeled in half tones with much skill and, in any case, this was a bold attempt."

In observing the immaculate dresses worn by their models, painters gave white the prestige of a color.

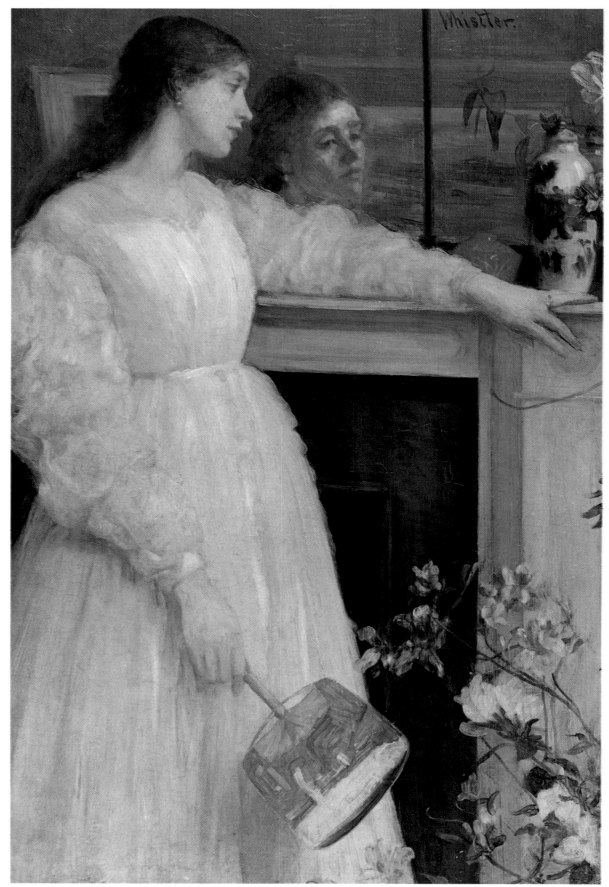

James Abbott McNeill Whistler (1834–1903). "Symphony in White. No. 2: The Little White Girl." 1864. Oil. 29.6 × 19.9 inches.

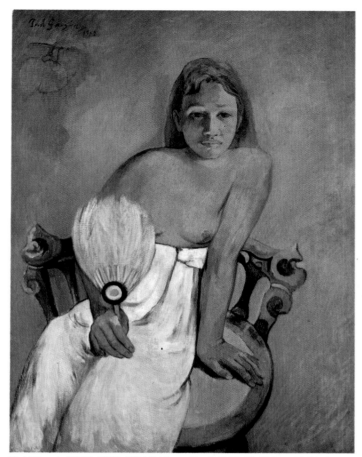

Paul Gauguin (1848–1903). ''Girl Holding a Fan.'' 1902. Oil. 35.5 × 28.5 inches.

Edouard Manet (1832–83). ''Nana.'' Oil. 58.5 × 45.2 inches.

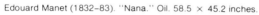

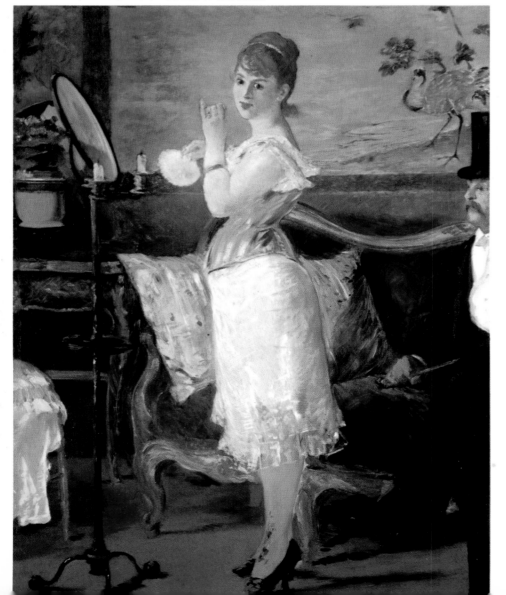

Pierre-Auguste Renoir (1841–1919). ''Lise with a Parasol.'' 1867. Oil. 71.4 × 46.4 inches.

The light of women's bodies illuminates Degas' confined atmosphere.

As VIOLENT AS a flame, a woman's form in "After the Bath" casts a colorless streak on the canvas in an unreal, dense, and red atmosphere (*right*). Never did Degas go so far in the striking effect and artifice of color as in this work painted when he was sixty-two. The body, treated in large and precise forms, is divided into light and dark areas. We must admire the artist's sensitive dexterity in separating the shadowed from the lighted zone.

As Degas' sight weakened, his palette became stronger. In 1891 he wrote to a friend, "This winter I see worse than ever. I do not even read a few lines in the newspaper. Zoé, my maid, reads it to me at lunch."

The same chromatic audacity is evident in *"La Toilette"* (*below*) with its monochrome tones heightened by a sudden red spot. In both canvases the figures are caught in a moment of tension, for Degas enjoyed giving a dramatic note to something which is really peaceful. Interpreted by the artist, the motions of performing the toilet acquire a kind of convulsive violence engaging the entire body.

While painting these pictures, the aging Degas was withdrawing more and more into himself. His letters are filled with bitter remarks against those who, despite his wishes, wanted to exhibit his work. Almost blind, unable either to paint or to enjoy his collection of works by Ingres, Delacroix, Cézanne, Gauguin, he began to wander in the streets of Paris. He died in 1917 during World War I. On learning of this, Renoir wrote, "How fortunate for him. . . . To live as he was, any death imaginable is better."

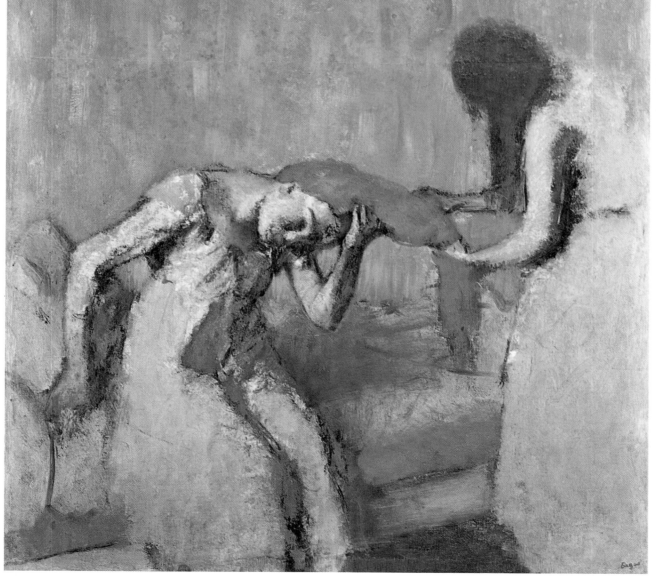

Edgar Degas (1834–1917). *"La Toilette."* 1892–95. Oil and pastel. 32 × 33.9 inches.

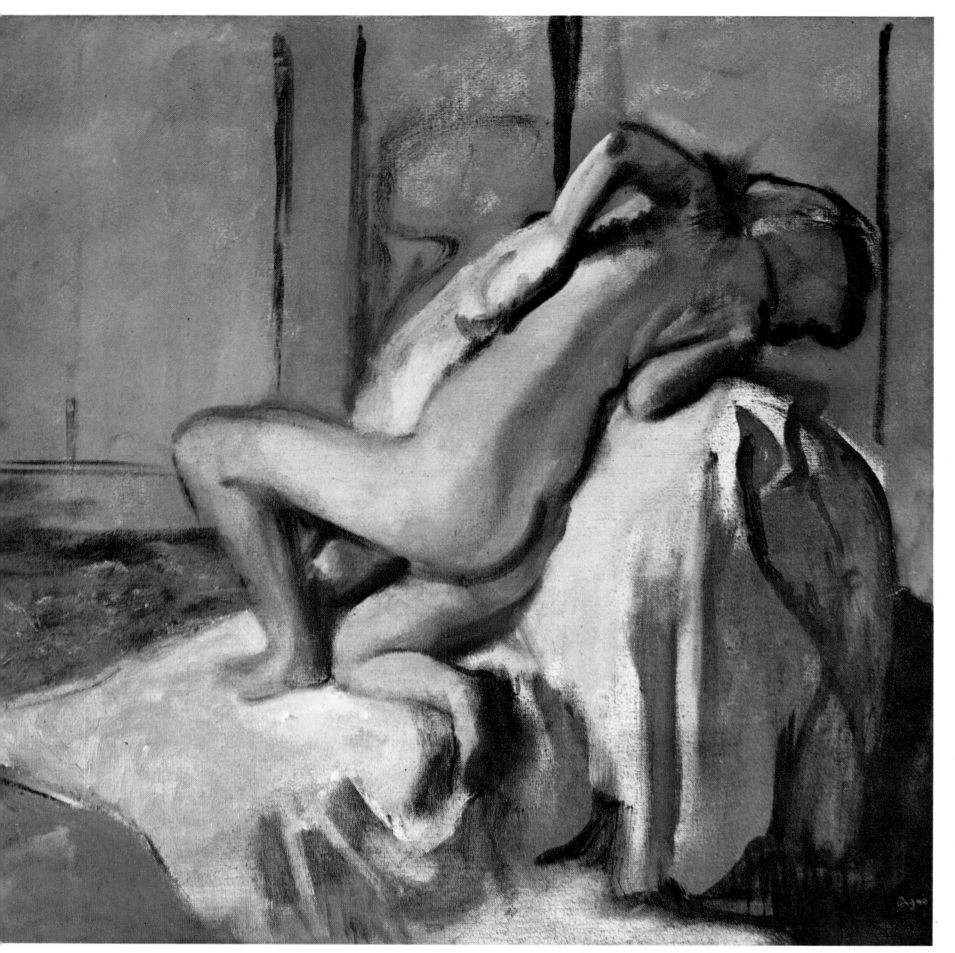

Edgar Degas. ''After the Bath. Woman Drying Herself.'' 1896. Oil. 34.7 × 45.2 inches.

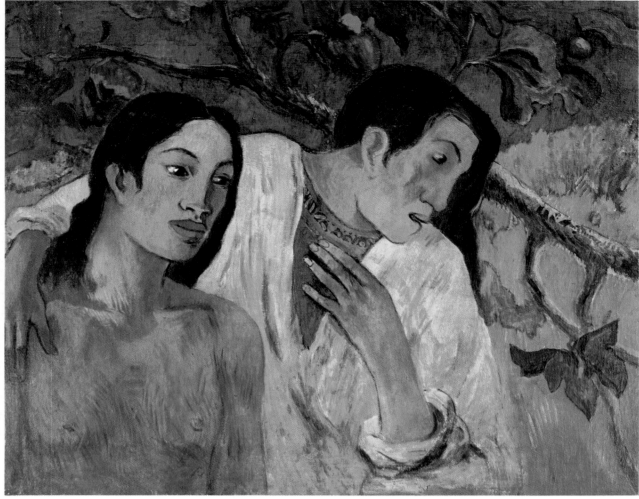

Paul Gauguin (1848–1903). "The Lovers." 1902. Oil. 28.1 × 35.9 inches.

GAUGUIN MINIMIZED color contrasts, for he detested exaggerated and gaudy striking effects. He combined his colors in a subtle manner, and if he turned to the excitement of complementaries, they were generally used in large masses. To quote Félix Fénéon, "Monsieur Gauguin's tones are scarcely distinct from one another. This explains that muted harmony in his canvases."

"The Lovers" (*above*) was painted in 1902, a few months before Gauguin's death following his flight from Tahiti to final exile in the Marquesas Islands.

Here the yellow and ochre tones are associated with the dark blue sky to create an intimate atmosphere heightened even further by the absence of vanishing lines. The branch of the tree crosses the scene as though to remind us of his "Jacob Wrestling with the Angel" (page 161). "Any distant perspective," explained Gauguin, "would prove meaningless. Wishing to suggest a luxuriant and disorderly nature, a tropical sun embracing everything around it, I really had to give these figures a setting which

agreed." In "Still Life with Ham" (*right*) he audaciously emphasized the wallpaper which covers the background. This large yellow plane which advances toward us has such a warm presence that in contrast the table and the ham appear almost abstract. Gauguin refused to distinguish form and color. "Can you really make me believe," he wrote in 1890, "that drawing does not stem from color and vice versa? As proof, I can reduce or enlarge the same drawing according to the color with which I shall fill it."

The painter juxtaposes close tones. Peaceful and warm, his yellows and beiges produce the effect of an echo.

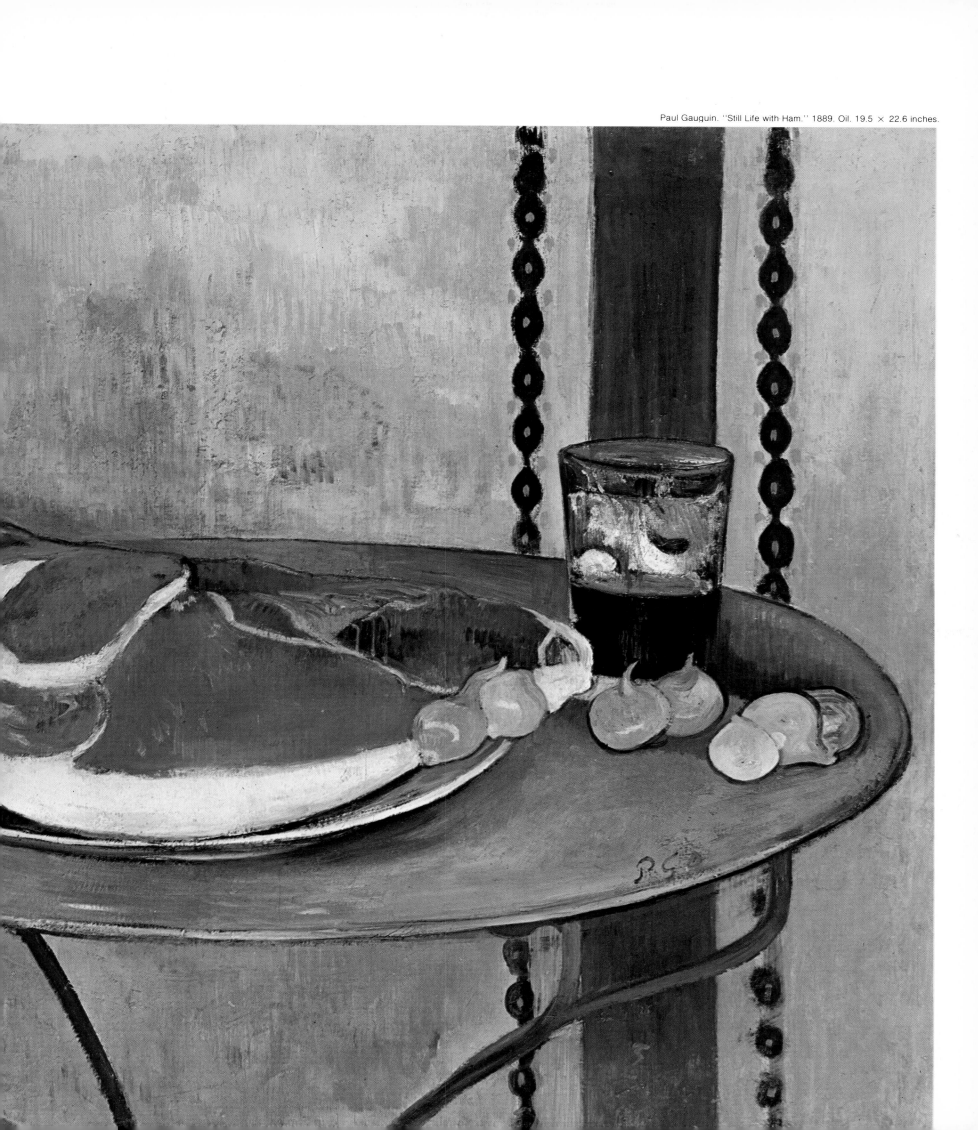

Paul Gauguin. "Still Life with Ham." 1889. Oil. 19.5 × 22.6 inches.

THE FREEDOM which bursts forth in the Gauguin paintings shown here is found elsewhere only in Matisse, the Matisse who painted "Music" and "Dance" twenty years after Gauguin. Gauguin designs his large pink flat areas with disregard for the conventions of realism. What counts for him is the psychological impact of a color which, associated with these exotic nudes, evokes with unparalleled freshness the feeling of Eden. With his *"Eh quoi, es-tu jalouse?"* (*below*) Gauguin met the challenge of achieving a harmony between the modeling of the bodies and the almost abstract interlacing of a landscape without shadow or depth. "The arabesque which organizes the whole," wrote Charles Sterling, "is one of splendid firmness and fantasy. In the most unexpected manner, it unites the massive relief of the bodies and the purely decorative background. Yet, at the same time, Gauguin surpasses himself in evoking the liveliness, the youthful firmness, and the subtle

heaviness of the bodies which ripen and stretch out in the sunshine like plants." Gauguin seems to have mentioned this painting in a letter in 1892. "I recently painted a nude *de chic*, two women on a shore, I believe it to be the best thing I have done to date."

Painted in Paris between two stays in Tahiti, *"Annah la Javanaise* (*right*) is a powerful front-view work and of an unbelievable chromatic boldness. This is especially striking when we remember the colors used in official art during the Third Republic. Gauguin moved into an apartment in Paris where he held soirées, including music and dancing; his new mistress was a dark-skinned half-caste girl, part Malay and part Indian, named Annah. To keep Annah amused he bought her a pet monkey. "Those who reproach me," he wrote in 1891, "have absolutely no idea what exists in an artist's nature. And why wish to impose on us duties similar to theirs? We do not impose ours on them."

Gauguin's large pink flat areas open the way to the chromatic audacity of Fauvism.

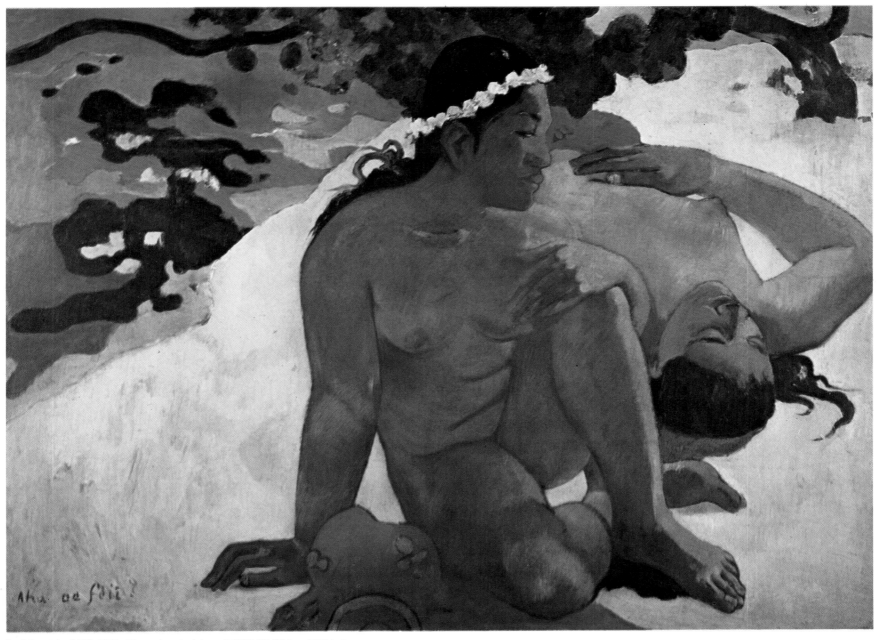

Paul Gauguin (1848-1903). *Eh quoi, es-tu jalouse?* 1892. Oil. 26 5 × 35 9 inches.

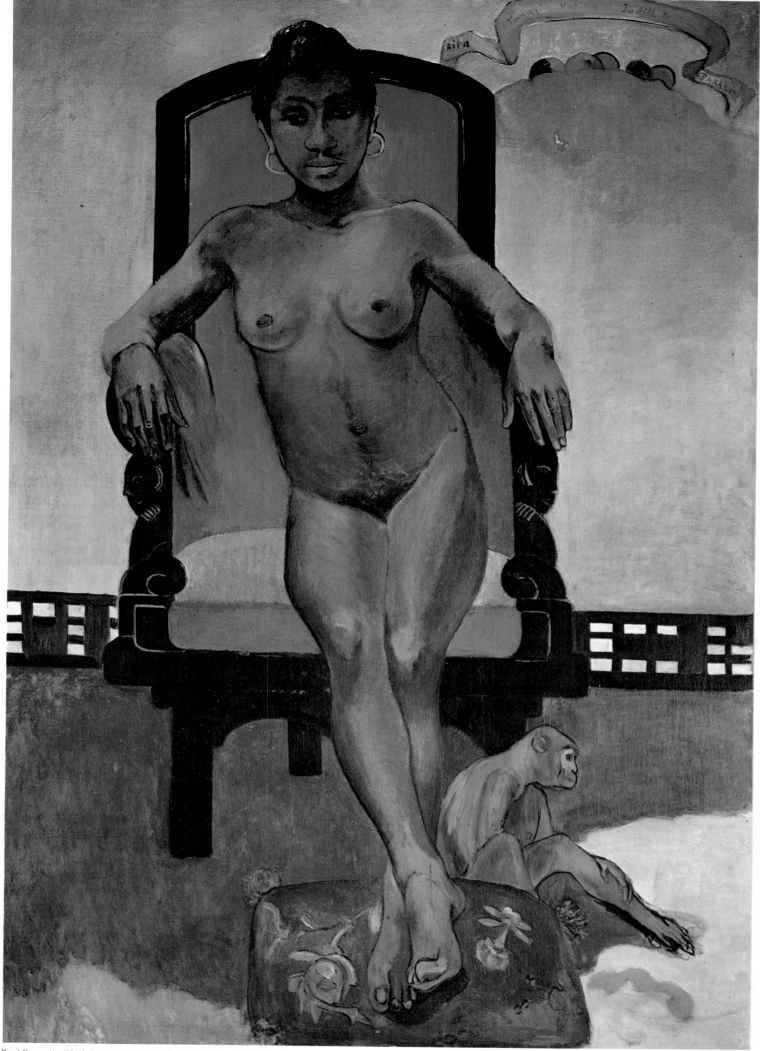

Paul Gauguin. *"Anniah la Javanaise."* 1893. Oil. 45.2 × 31.6 inches.

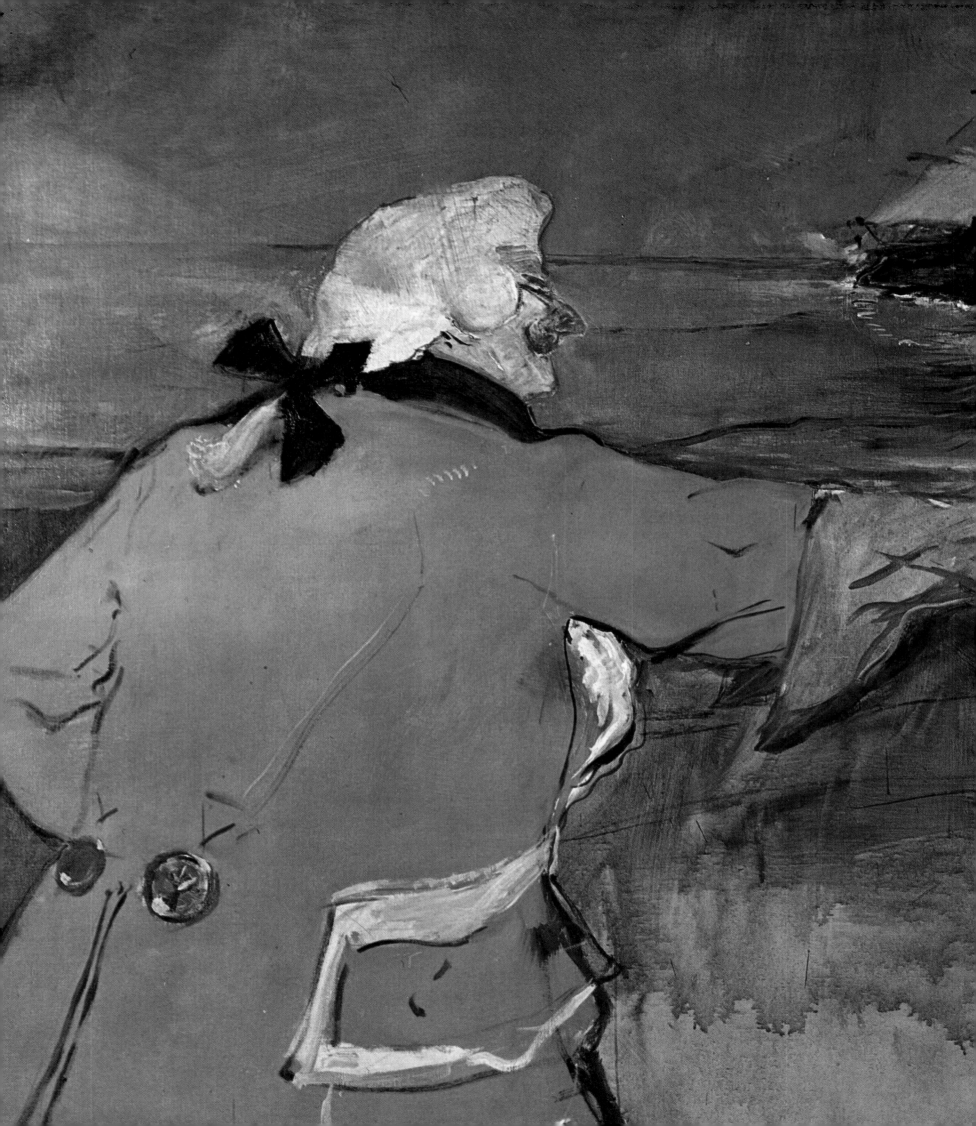

Using a strong red, Toulouse-Lautrec changes a conventional painting into a piece of bravura.

Toulouse-Lautrec's consummate layout art was dictated by the poster. The large flat areas can be read at a glance. In 1899 he spent three months in a clinic recovering from an attack of delirium tremens and was released not without difficulty three months later. Painting less and less, he spent the winter of 1900–1 in Bordeaux. A lifetime lover of the theater, he became an enthusiastic admirer of Isidore de Lara's *Messalina,* which inspired six paintings, including the large oil at right. He redid the setting after his own fashion and using a brilliant accent gave the figure of Messalina an impressive dramatic presence.

After his recovery he resumed his old life, but in 1901 he broke down completely and was taken to his mother's country house, the Château de Malromé, where he died. His last painting represents, in profile, an old family friend, Paul Viaud, dressed as a British admiral. As Lionello Venturi noted, "The profile plays an extremely important role in Toulouse-Lautrec's style. It enables him to emphasize line and to render the *'canaille'* side of the image." In this masterpiece, one of the many the artist painted, nothing offers the slightest suspicion of his decrepitude. The canvas is unfinished for he died before completing it, on September 9, 1901, at the age of thirty-seven.

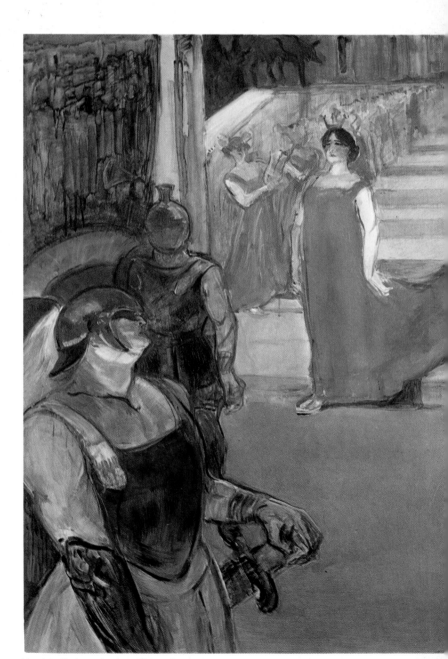

Henri de Toulouse-Lautrec. "Messalina." 1900. Oil. 39.4 × 28.1 inches.

Henri de Toulouse-Lautrec (1864–1901). "Admiral Viaud." Summer, 1901. Oil. 53.8 × 60.1 inches.

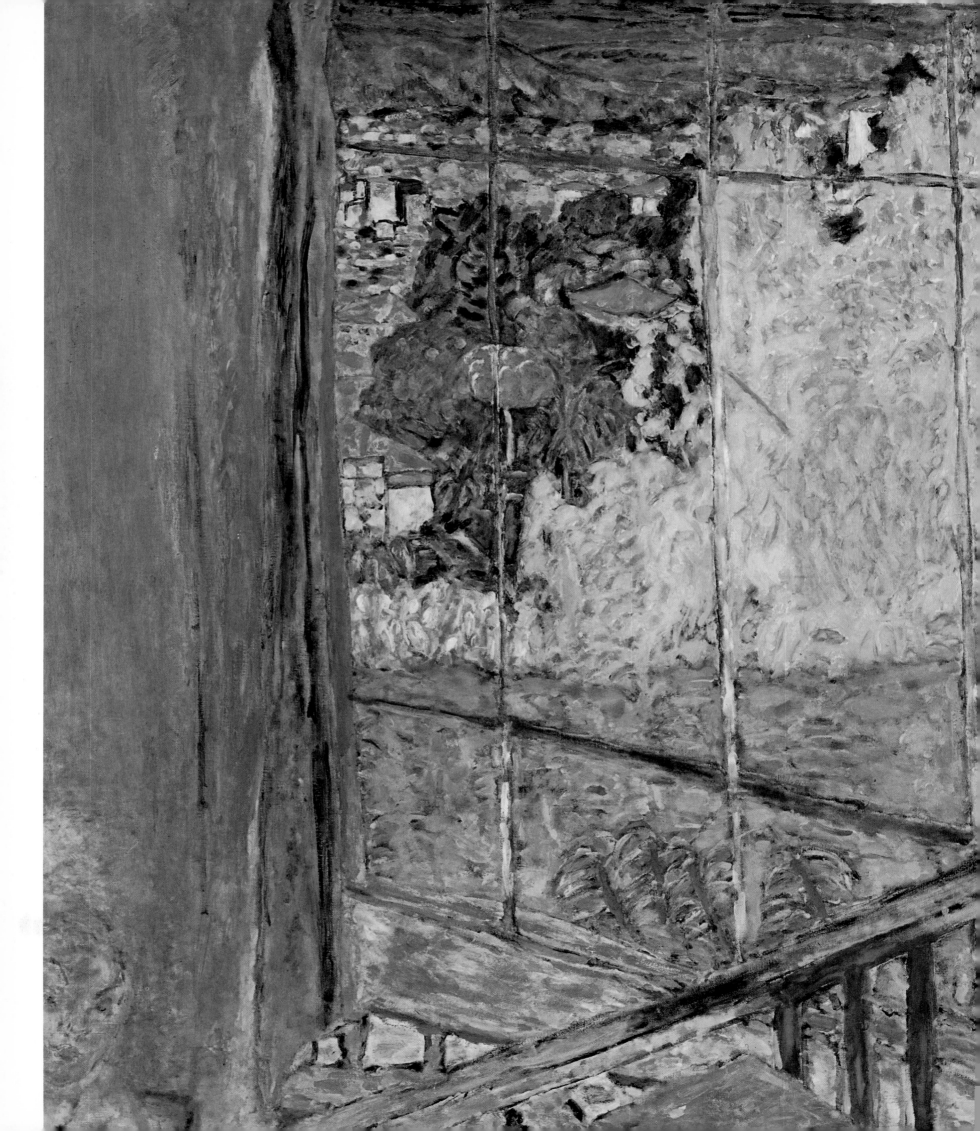

With Bonnard the visible world becomes a haze of warm, fruity colors saturated with sunshine.

THE SENSUAL COLOR of Bonnard has been likened to a pantheistic hymn to the sun. "His objects," noted Charles Sterling, "seem penetrated by its rays and heat." The sun appears to melt his fruit and leave merely a colored essence of its flesh and taste, filling the interiors where it is found with a delightful essence." This conception of radiating color takes Bonnard to the edge of abstract art. In fact, little is needed for the large landscape, "The Studio" (left), with its frontal view of the large glass panes, to become a nonfigurative work. "But art," said Bonnard, "can never dispense with nature." He stops before the formless. The important series of Bathtubs caused him utmost labor. For he had to struggle a great deal to obtain these powdery haloes of pigments floating in space (right), these imponderable clouds which link the amazing variety of tones. "Never again will I commit myself to such a difficult subject," said the painter. "I fail to bring out what I want. I have been at it for six months and I have to work for several months more." Bonnard devoted countless paintings to the intimacy of everyday life. "If he could do without a studio and be satisfied for his wife and himself with a bedroom and a dining room," wrote Thadée Natanson, "they would never do without a bathroom and which finally, often at great expense, they had installed in what was little more than a shanty. The whole world will know what things the painter has seen between the bathtub and the sink."

Pierre Bonnard. "Nude in a Bathtub." 1938–41. Oil. 47.6 × 60.8 inches.

Pierre Bonnard (1867–1947). "Woman with a Striped Tablecloth." About 1921. Oil. 23.4 × 30 inches.

Pierre Bonnard. "The Studio." 1928–46. Oil. 49.9 × 49.9 inches.

Heavy with a yellow truer than nature, Bonnard's sea re-creates the tepid weight of vacation hours.

IN THIS PAINTING of St.-Tropez, Bonnard took the art of chromatic equivalences to the extreme limit. At the expense of any verisimilitude, he paints the sea and sky a strong yellow. As Thadée Natanson noted, "The mature Bonnard deeply admired Mallarmé and in his old age read and reread his work, verse by verse, line by line." Here, after his own fashion, the painter uses the poet's methods. He gives us no local color but, by a play of approximations, re-creates a special atmosphere, gathering a series of "sonorities" which make his landscape appear true and more "experienced" than any postcard. These dense colors, this solar atmosphere, this sea of strong yellow with its reflections of red clouds, evoke for the spectator the tepid weight of summer hours, the insidious saturation of the skin, the languor of intemporal holidays.

Pierre Bonnard (1867–1947). "The Bay of St.-Tropez." 1937. Oil. 16 × 26.5 inches.

ensemble of forms balanced but a section of

The work is not an
within the canvas
nature which extends
beyond the setting.

Jean Dubreuil. La Perspective practique. 1642.
In the seventeenth century the Academy imposed on artists an official model for rendering the illusion of space—monocular perspective, invented two centuries earlier in Florence. Spatial conceptions solidified into studio formulas which in the nineteenth century related less and less to technical, scientific, and artistic ideas.

During four centuries, in reducing the diversity of nature to the two dimensions of his canvas, the artist had to submit to a unitary screen, a regulating outline—the perspective of the Renaissance—to which each detail of the work was submitted. To quote Maurice Merleau-Ponty, "Painting was a metamorphosis of the world perceived in a peremptory and rational universe." Reducible to measurable quantities, reality was organized according to a pattern which was the same for all transposed space. A numerical relationship unified the disparate components of nature.

In the fifteenth century a prodigious effort of collective intelligence was necessary to submit the infinite variety of the visible world to a prescribed graphic process. This effort, however, had its other side. "It indicated," said Merleau-Ponty, "how far the man who painted the landscape and the one who looked at the painting were superior to the world, as they dominate it and take it in with a glance." Perspective is the visual expression of the anthropocentric rationalism of Western societies with their roots in the Greco-Roman tradition.

This conception of an order transcending natural chaos is found uncompromised in Western painting. Certainly it was frequently shaken. With Venetian painters, Rembrandt, Watteau, the scheme lost its clarity, the outlines were cut off, drowned in the haze of light (see Chapter IV). Others went in the opposite direction, that is, *trompe-l'oeil* (illusion). With them emphasis was on modeling resulting in illusionism, falsifying the arrangement of the projected space by an excess of precision. With Chirico, Magritte, and other painters, Surrealism took up this formula. Generally speaking, however, the system invented during the Renaissance "held" for four centuries until it was destroyed by the Impressionists.

The Renaissance system postulates that one can combine in one space objects which the eye often distinguishes separately and perceives successively. Its outline supposes that one can arrange in a restricted setting—the painting—an entire series of perceptions, often very divergent. The "wild" appeal of stimuli should be controlled, negotiated, reinserted within the regulating scheme at the cost of compromise and arbitration. "Composition is the introduction of intellectual order in the chaos of sensations," wrote Elie Faure. In his *La Prose du monde* Maurice Merleau-Ponty has splendidly analyzed the mutilating character of Renaissance space in relation to the tumultuous flux of sensation we have as we look at nature. "Whereas I had experienced a world of teeming, exclusive things," he wrote, "each commanding our vision and which could only be grasped by a temporal distance in which every gain is at the same time a loss, the world crystallized into an orderly perspective. . . . The entire image is in the past, in a distant mode or in one of eternity, everything takes on an air of decency and discretion, things do not summon me and I am not compromised by them." As an example, he takes two entirely different objects, the sun and a coin, both impossible to perceive simultaneously in nature. "I had to set my eyes on one of them, and the other appeared to me as though in a margin, a large-object-seen-from-afar [the sun] and a small-object-closely-studied [the coin], the one incommensurable with the other and as though existing in another universe.

"When we attempt to establish in the same canvas two such distant worlds," he continues, "we must arbitrate their conflict . . . place on paper a series of local visions . . . construct a representation in which each [visible thing] ceases

to require entire vision for itself, makes concessions to the others, and agrees to occupy on the paper no more space than that left by them."

The French Academy increased this order. In his *Life of Claude Monet* Gustave Geffroy notes, "There was the education in Rome [the French Academy founded in 1666 to which the most successful students could be sent for further training], the reign of David and his pupils. A landscape was then a background of hills, a duo of trees, a silvery stream, all serving as accessories to a holy scene or one from Greek or Roman history."

The conventional art which triumphed at the Salon under the Second Empire and the Third Republic, barring the way to Impressionism, caricatured the formal logic of the Renaissance. It denatured both the luminism of the Venetian painters, Rembrandt, and Watteau and the constructive arabesque inherited from Raphael, who harmonized his designs according to imperious rhythms which subordinated the anecdote—a lesson which Ingres and Seurat were not to forget when they painted their early canvases. For Raphael and his followers painting was above all the subtle organization of an equilibrium, of a play of curves, its strength stemming from this abstract unity. Nineteenth-century bourgeois art, however, failed to retain even the logic of classical painting. It was interested in the accumulation of substances, in the detail of material values. What it wanted was the palpable and the concrete, and it aspired to quantity, to rendering exploits in a desire for an art which was not ambiguous, a form of painting as precise as photography, with the canvases revealing the artist's effort. In 1879 the critic Bergerat, mentioning a military scene by Edouard Detaille, wrote, "There are almost two hundred soldiers in this picture and the most distant one as well as the closest retains his character. I love this art which is so French in the spirit of its touch, precision never evading the issue."

To all this must be added the doubts of a generation which had become aware of the great scientific changes of its time. The unknown increased the more it was explored. It was a lie to pretend to describe the world on the canvas as though in complete obedience to a logic whose key lay in the painter's hand. Darwin in his *Origin of Species* (1859) questioned the idea that man was a privileged creation and the image of God. Non-Euclidian geometry, the advent of the machine, microphysics, electromechanics, astronomy, radioactivity, all shook the certainty of the nineteenth century of a unitary and simplified representation of reality. Henceforth nothing was certain, not even our senses. "Man will soon perceive," wrote Pierre Francastel, "that his eye in which he had such confidence is incapable of revealing to him in a natural way the position of a horse's members as it gallops. The grand mysteries of nature have at once ceased to be ensembles and distances to become the detail closest to us."

Faced by this imperfection of our senses, by the immense universe described by scientists, the artist was overcome by a feeling of modesty. No longer did he claim that he could read into the depth of things or make a complete inventory of the physical world. He offered neither a microcosm nor a plausible summary of the natural world but, quite the contrary, a close-up, a detail of nature which he relentlessly studied in order to extract the greatest possible truth although fully aware that this truth is a relative, fluctuating one and in the final analysis difficult to verify. He tightened his subject, narrowed his ambition: He showed a limited *space* and a limited *time,* a detail and a movement. "You

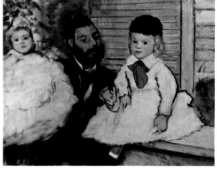

Edgar Degas. "Viscount Lepic and His Daughters." About 1871.
The artist reduces his ambitions. No longer does he pretend to offer the whole truth about a person but merely to describe a moment of his existence. The off-center composition emphasizes this feeling of transience.

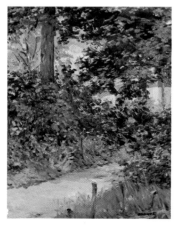

Edouard Manet. "Path in the Rueil Gardens." 1882.
No longer is nature seized as a whole but as a detail. Nor is it presented as something clear, orderly, and legible, but as something chaotic and involved, obviously extending beyond the canvas.

Claude Monet. "Torrent of the Little Creuse at Fresselines." 1889.
The artist shows us a close-up view of the river rather than the river itself. He analyzes the dividing line between earth and water.

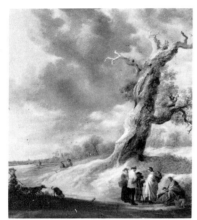

Jan van Goyen. "The Oak Struck by Lightning." 1638.
When Van Goyen wants to stress the subject (the oak in the foreground), he isolates it against the background of nature. Van Gogh (page 210) avoids such a panoramic vision.

Claude Monet. "The Rock." 1889.
The mountain is conceived as matter rather than as landscape.

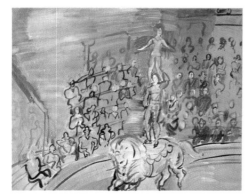

Raoul Dufy. "Acrobats on a Circus Horse." 1934.
The colors float independent of the outline. Depth is treated freely, according to the artist's whim.

will guess the season, the hour, and the wind!" exclaimed the astonished Baudelaire on seeing a seascape by Boudin, who in fact entitled one of his paintings, "October 8, Noon, Northwest Wind." Gustave Geffroy moreover described Monet as a tireless, careful, and passionate researcher. "He succeeds in analyzing the ever-changing color, constantly moving, of the running water in rivers and as it rushes and foams at the foot of rocks and cliffs. He shows this color made of its basic state, of that of the sky and of the reflections of objects. He studies the terrains, the fall of dunes, the flanks of cliffs after the manner of a geologist, and at the point of his brush he illuminates stones, ore, lodes. He takes into account action from without. He paints grass dried by the wind and soaked by rain; he reproduces the wet rocks revealed at low tide on which the waves have left a heap of marine plants."

Henceforth the painter offers to show us the world as a series of details, and each detail as a world in itself. To quote Pierre Francastel, "No longer does the artist offer the art patron the sight of part of the earth to be dominated; the world of contemporary artists is a universe filled with fearful secrets which lie outside ancient measures of dimensions and values. . . . The essential is the close vision of the world, that is, an inquisitive vision no longer satisfied with overall sensations. The cubic vision of the Renaissance was chiefly a vision removed from the world. The modern vision is one spread out in the discovery of a secret in the detail. . . . The closest is the most mysterious."

We merely have to compare a tree trunk by Van Gogh (page 210) with one by Van Goyen (*left*) or a rocky projection by Monet (*left*) with any seventeenth-century landscape to see how much the Impressionist vision narrows its search. The objects are suddenly offered in close view. They are thrust upon the observer like some zoom effect or like the sea when it invades an entire window. Better still, as in assemblages, the artist succeeds in juxtaposing scenes which are part of different spaces. He cuts up his surface after the fashion of a stained-glass window (page 213). Various actions are depicted in one composition (page 212). The artist superimposes a real scene on a mythical one (page 161). In short, he questions the concept of unitary space.

This development has had significant consequences for twentieth-century painting. Thus Fernand Léger combines in a painting a wedding detail and reminiscences of the Norman landscape, what he sees and what lingers in his memory. Marc Chagall associates his memories of Vitebsk, Russia, with images of the Eiffel Tower. Dufy spreads his "stenography" over many square yards obeying no spatial hierarchy (*left*). Braque and Picasso show *simultaneously* what we would see successively if we went around an object, which is "rapidly shot," so to speak, from top to bottom, from within and without, front view and profile, from all sides at the same time. The totality of these observations is presented synthetically on the same surface and combined with others which concern the setting, the atmosphere, or which can be drawn from the past.

This is the twentieth century. But compare Cézanne's still lifes with those by Dutch painters. Meyer Schapiro has noted that in the still life the objects are smaller than ourselves and within reach. They owe their existence and their situation to human will and intervention. Made and used by man, they communicate to us man's feeling of power over things. Now, Cézanne makes an uneasy field of this painting of appropriation. With him, things overflow and leave the setting. They stretch out and distort themselves. The most familiar

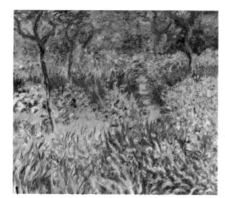

Jan Vermeer. "The Music Lesson." 1660.
The setting cuts the objects in two. Our imagination completes them.

Claude Monet. "The Garden of Iris, Giverny." 1900.
The painting seems to be a section of a larger canvas, for no composition is evident.

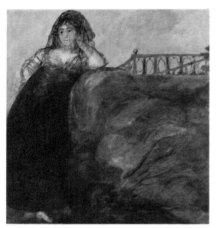

Francisco Goya. "Una Manola." 1819–23.
The strange huge volume which occupies the center and which offsets the figure to the left is felt as being the far end of a much greater volume.

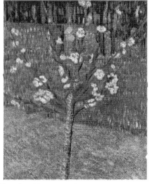

Vincent van Gogh. "Tree in Blossom." 1888.
The artist expresses the instantaneous aspect of vision.

objects escape us. All Impressionist painting takes part in what Heinrich Wölffln called "open form," which he had already discovered in Northern landscape painters. In his *Fundamental Principles of the History of Art* he states, "In the seventeenth century the contents were freed from the servitude of the setting. Nothing must allow the spectator to suppose that the composition was conceived specifically to enter into the setting of the painting. Although some sort of hidden coincidence is naturally present and effective, the whole must appear as a section of the visible world cut out haphazardly."

This divorce between the physical setting of the painting and the scene inscribed was to be taken to a conclusion by the Impressionists. The image became foreign to its setting. This is what Félix Fénéon expressed in 1889 when he wrote, "A landscape by M. Monet never entirely develops a theme of nature and seems to be one of some twenty rectangles which one would cut out from a panoramic canvas one hundred square meters in length." In one of those concise sentences whose secret was entirely his own, Cézanne summarized the problem perfectly. Referring to classical painters he wrote to Emile Bernard, "They made a painting and we are attempting a section of nature."

A "section of nature," a detail of the world seized almost haphazardly: We are no longer in the presence of a decor distributed on the canvas according to human logic. To organize herself nature has no need of men. We are offered a small anarchic, discontinued section. A vague path enters a thicket enclosed by heavy vegetation. And we have the feeling that it will continue beyond the limits of the setting into limitless space.

Modern art was gradually to develop this conception of the setting as a transition between what the artist explicitly represents and what he suggests in the logical extension of the painted surface. Already with Vermeer the subject was brutally cut off (*left*) allowing us to add the missing portrait section or part of the table. As for Goya, he decenters his point of view (*left*) and fills his picture with a heavy volume which we notice is merely the end of a much greater volume. Although these artists were rather removed from classical composition, nevertheless they did not entirely eliminate it. These truncated forms still maintain an equilibrium. For Bonnard in the twentieth century (page 219) it was no longer the same, and this was to hold true also for Kandinsky, Van Doesburg, and Franz Kline. With these painters the dynamics are shifted beyond the setting, as though the pictures were nothing more than a base of departure for the expression of a form. Or the entire surface is covered. This is the so-called total field painting dear to such American painters as Jackson Pollock, Mark Tobey, Sam Francis, to name a few.

As the image increases and detail invades and covers the canvas, the spectator no longer experiences the physical and psychic distance which kept him far from the painting. The taste for close-up and for tactile values stimulates in the visitor a response. He approaches and becomes an integral part of the work, engaging several of his senses simultaneously. The twentieth century from this heritage was to witness the creation of strange propositions, such as manipulatable and transformable art objects. One of these insists that the spectator abandon passivity while facing a canvas, which changes when he goes from one viewpoint to another. Such concepts seem situated light-years from Monet and Cézanne. In the course of almost a century of upheavals, by paths which were often devious, they are nevertheless their inheritors.

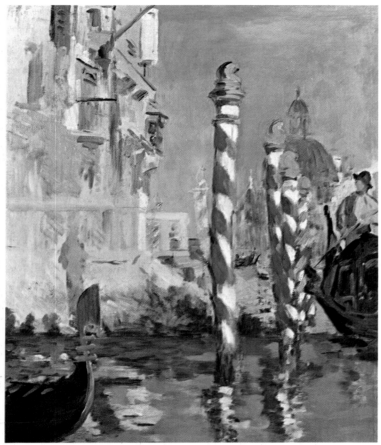

Edouard Manet (1832–83). "Departure of the Folkstone Steamer." 1869. Oil. 23.4 × 28.5 inches.

Manet carves his landscape from life. His viewpoint and composition echo the instantaneousness of vision.

Edouard Manet. "The Grand Canal in Venice." 1875. Oil. 22.2 × 18.7 inches.

As early as 1869 Manet had a presentiment of the freedom of Impressionism. This was the year in which he painted a crowd of vacationers on the quay observed from the second-story window of his hotel. What impresses us is first the allusive touch, the sketchy style—what the novelist Joris Karl Huysmans called "a concise but tipsy drawing"—which mingles and assigns equal importance to all the figures. "Manet was perhaps the first to feel intuitively that the quick displacements because of the use of steam and the swarming mass of the crowd necessitated a change of artistic vision in the direction of abbreviation," wrote Charles Sterling. Another novelty was the composition. The artist by no means sought to balance his picture, nor even to give a plausible version of the steamer. He carved spontaneously from life the scene before his eyes and it mattered little if the subject extended beyond the edge of the canvas. We are not in the presence of a seascape, an enlarged vision of nature, but in that of a precise and limited episode which the

artist encloses in a pictorial photo. The same spontaneity, the same dazzling light, the same freshness are seen in the view of the Grand Canal which Manet painted in September, 1875, at the water level during a short visit to Venice with his wife and the British painter James Tissot. (*above*). In the meantime he had gone to Argenteuil to observe Monet working out of doors (pages 98–99) which hastened his evolution. In the "Grand Canal" the viewpoint takes us literally into the subject. We are no longer *opposite* things, but we take part in them. Such conceptions were poorly understood by his contemporaries. In 1868 Zola wrote, "When they see the name of Manet they try to bubble over with laughter. The canvases, however, are there, light and luminous, and seem to look at them with a serious and proud air. And away they go, ill at ease, no longer knowing what to think, moved despite themselves by the severe voice of talent, prepared for the admiration of the coming years."

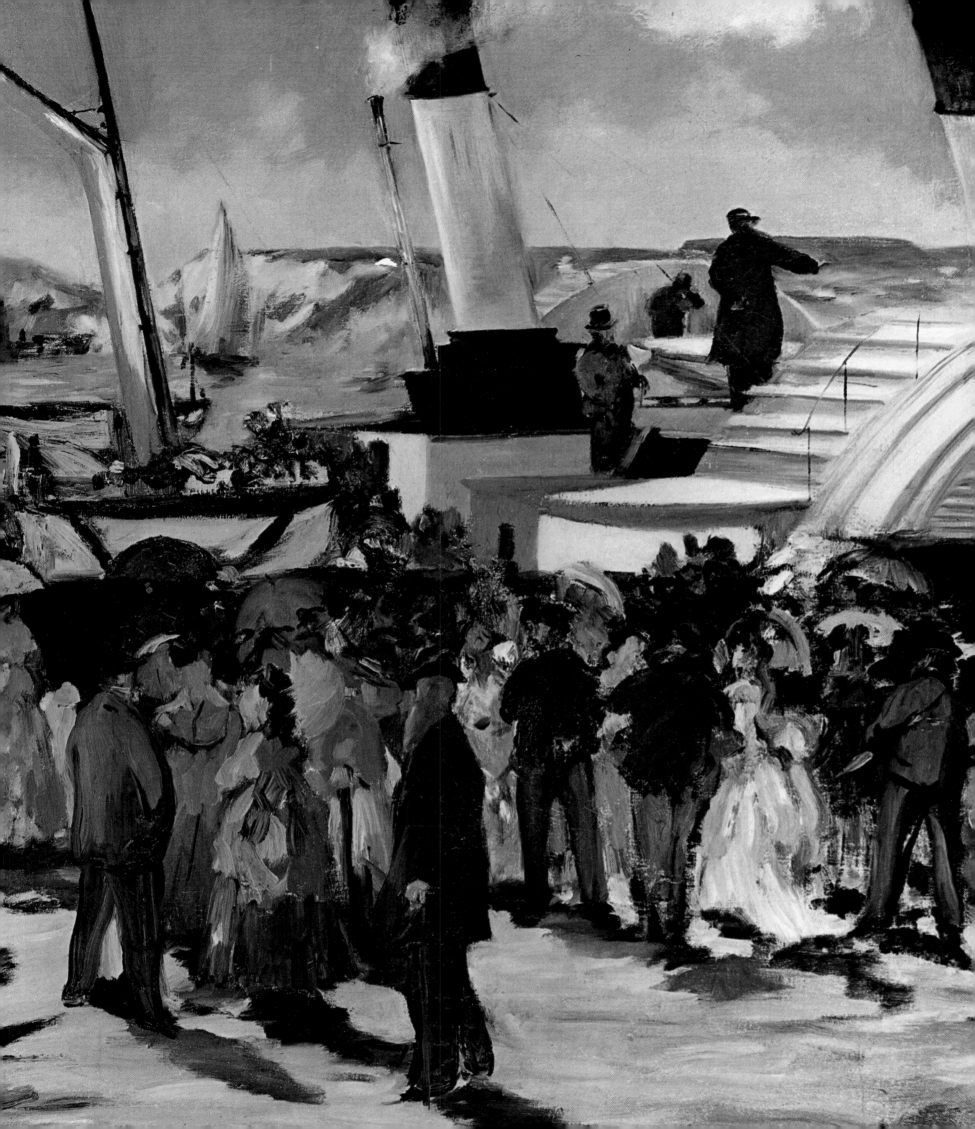

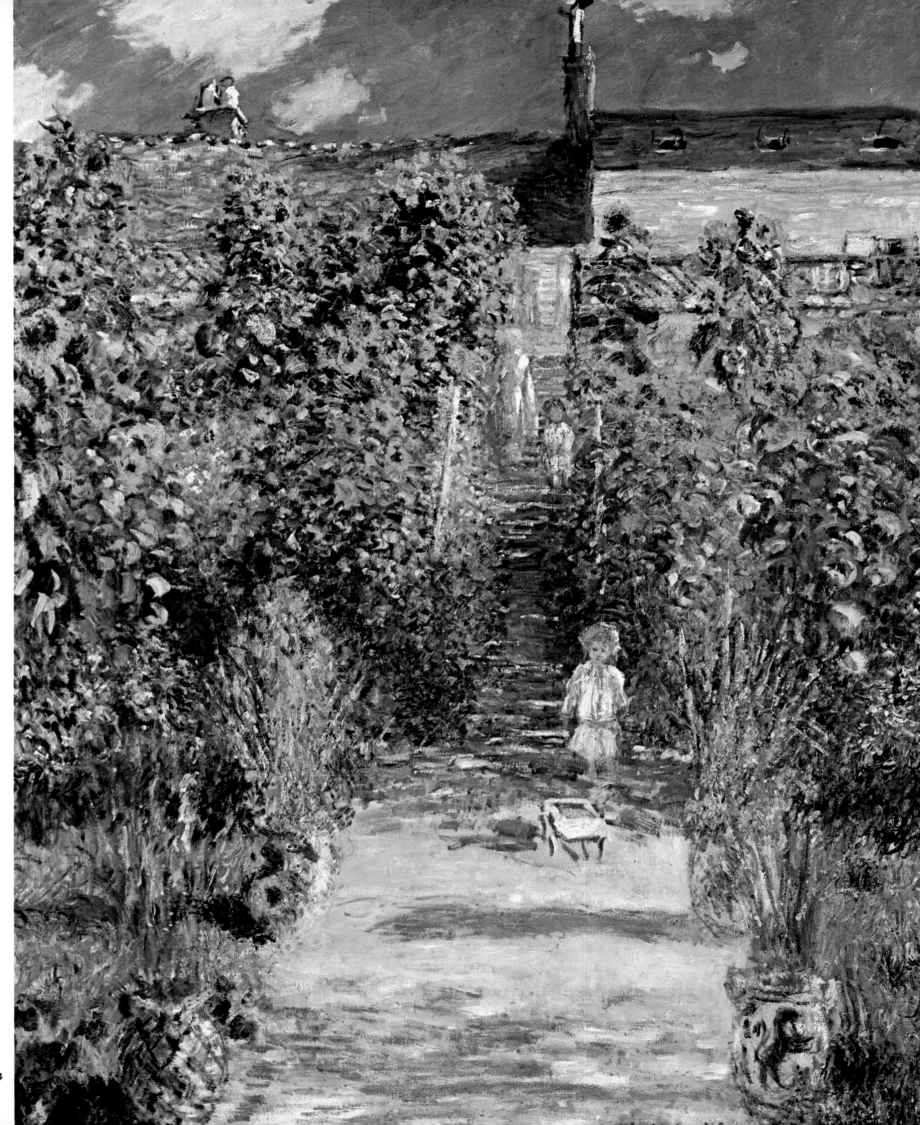

Monet opens a deep space, leading the eye to the heart of the canvas.

THE SAME COMPOSITIONAL device of an opening in the heart of the canvas hollows out these two compositions by Monet, the one painted five years after the other. In both cases, the artist seems to advance between a figurative curtain to penetrate—and at the same time to plunge us—into the scene he is painting. A central axis, an almost symmetrical arrangement of the planes around an empty space, such regularity was not frequent in Impressionist works. They would create a monotony if, as in these two canvases, there had not been a bold contrast between the vertical front plane and the deep recession of space. Rebellious to any academic teaching (he left the Gleyre studio almost the day he had enrolled in 1863), Monet arranged his masses with unprecedented freedom. He believed only what his eye saw and refused lessons from the past. During the period of these pictures he suffered poverty and was highly discouraged. On April 3, 1876, the influential art critic, Albert Wolff, wrote in *Le Figaro*, deriding the artist's work, "five or six lunatics, including a woman, a group of unhappy souls mad with ambition exhibited at the Galerie Durand-Ruel. There are people who burst out laughing on seeing such things. As for me, it wrings my heart. These so-called artists call themselves Intransigents, Impressionists, they take canvases, color, and brushes, haphazardly throw a few tones on the surface and sign the whole. . . . A frightful spectacle of human vanity lost to the point of madness." In 1878 twelve works by Monet were sold at the Hoschedé auction and failed to fetch more than the average price of 184 francs.

Claude Monet. "Corner of an Apartment." 1875. Oil. 31.2 × 23.4 inches.

Claude Monet (1840–1926). "The Artist's Garden at Vétheuil." 1880. Oil. 59.7 × 47.6 inches.

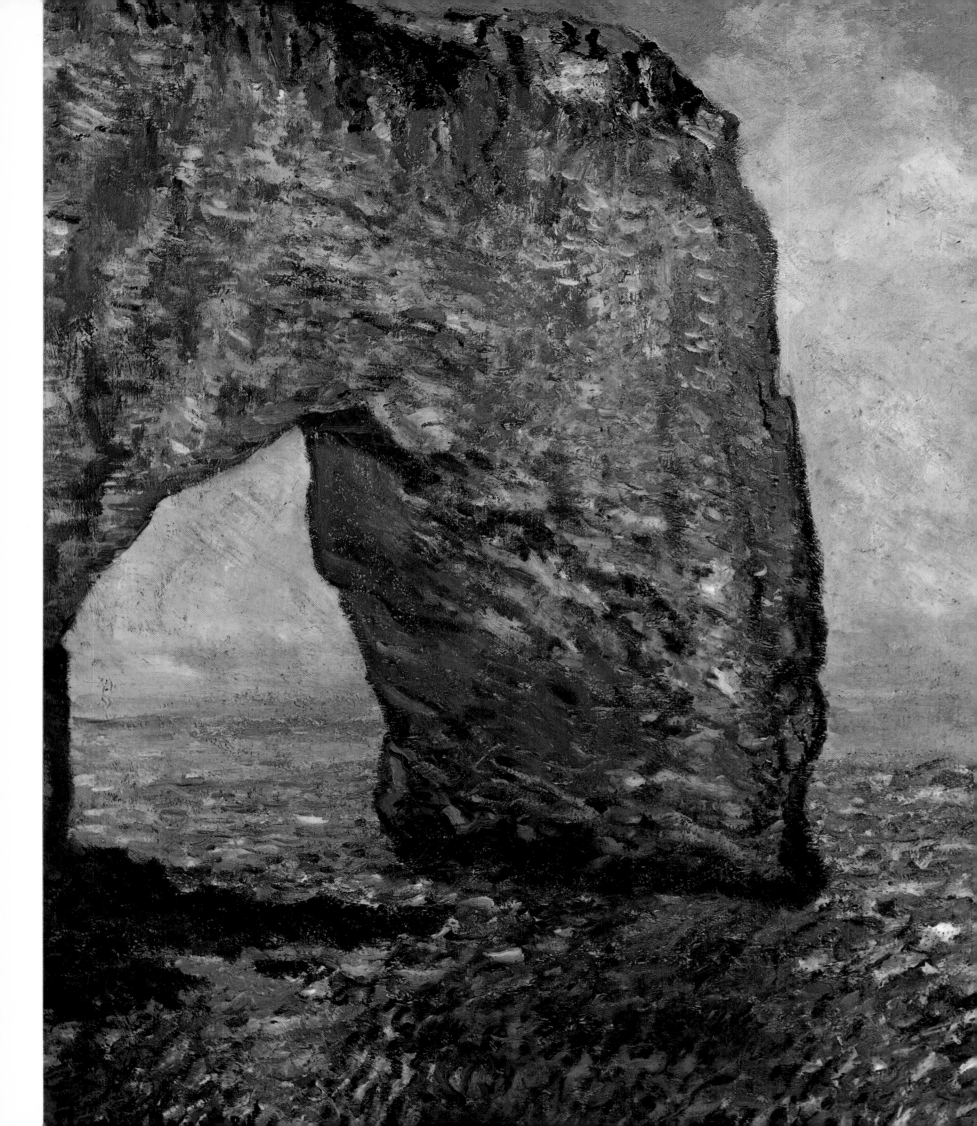

Monet approaches from a distance and plants his easel before the subject.

Claude Monet. "The Hollow Needle at Etretat." 1883. Oil. 23.4 × 31.2 inches.

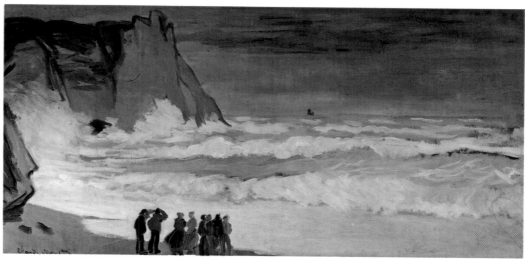

Claude Monet. "High Sea at Etretat." About 1873. Oil. 25.7 × 51.1 inches.

FROM THE PANORAMA to the close-up, Monet marked his determination to tighten nature as close as possible. The first works at Etretat were those of large views of the sea and the coast, often with human silhouettes painted against the light. Mentioning the painting of 1873 (*right, center*) Gustave Geffroy speaks of "the tiny group of spectators, so well seen, in their anxiety and powerlessness in the presence of a low sky, of black rocks, and of an angry sea unfurling its strong waves against the puny figures, so small before the high billows and the furious gallop of the sea."

Monet, however, was dissatisfied with this large and distant vision. To quote Félix Fénéon, "In 1886 he descended to the very foot of the steep ramparts with its granite flying buttresses jutting out like horns. He planted his easel quite close to the rock and painted this massive paw (*left*) planted in the sea

which invades almost the entire canvas where it radiates with a strange presence." "One can say of Monet," wrote Octave Mirbeau in 1887, "that he has veritably invented the sea, for he is the only person to have thus understood it and rendered its smell with its changing effects, its huge harmonies, its movements, its constantly renewed infinite reflections." Gustave Geffroy relates the following confession by Monet; "When I die, I should like to be buried in a buoy." To which the critic added, "He rather liked this idea. He laughed at the thought of being forever enclosed in this sort of invulnerable cork dancing among the waves, braving the storms, softly at rest during quiet moments when the sea is calm, under the light of the sun. There was nothing morbid in this evocation, for it seemed to him the logical conclusion of his love for the sea."

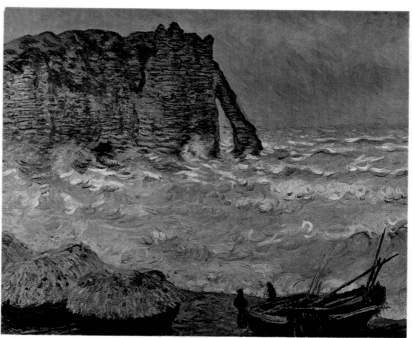

Claude Monet. "Cliff at Etretat." About 1883. Oil. 31.6 × 39.4 inches.

Claude Monet (1840–1926). "Etretat." 1886. Oil. 31.6 × 25.35 inches.

197

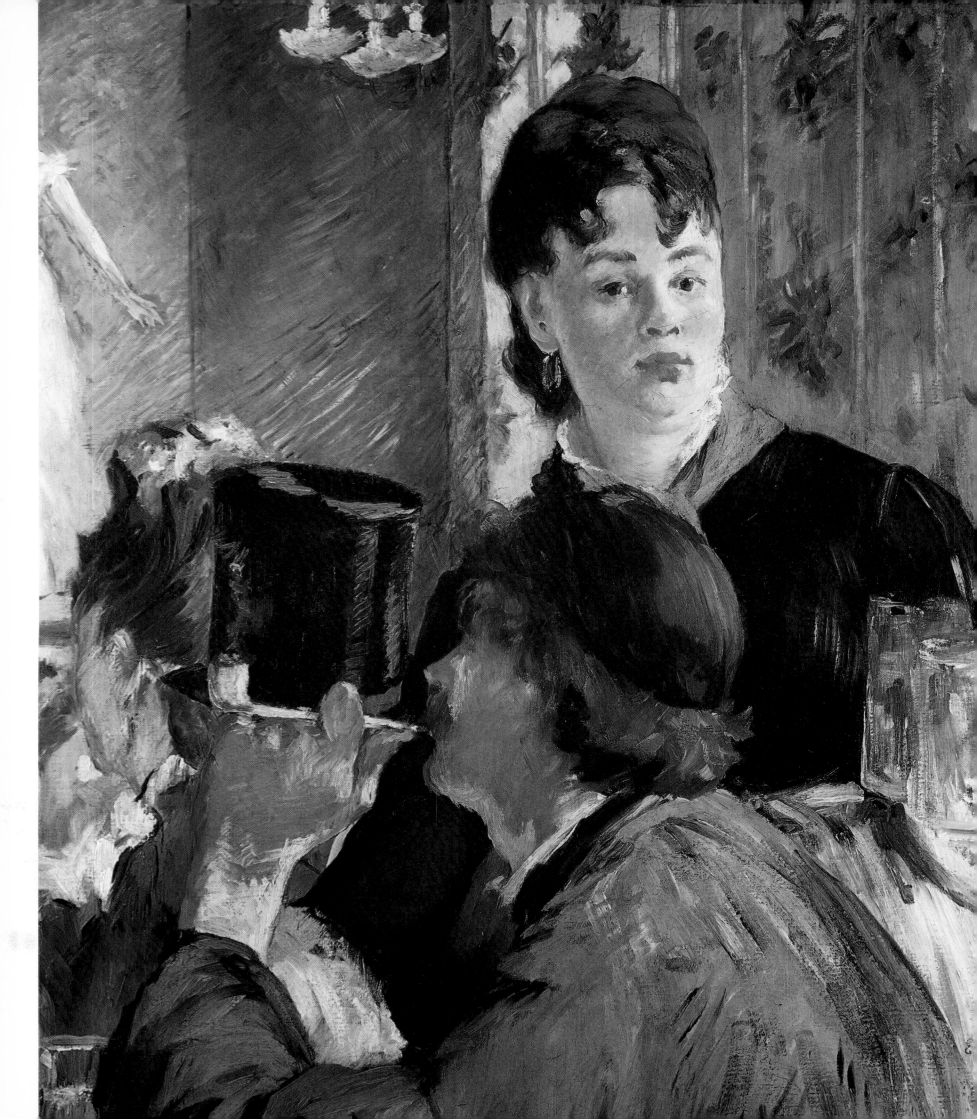

In a series of "flashes" the artist catches the fleeting and simple charm of the café.

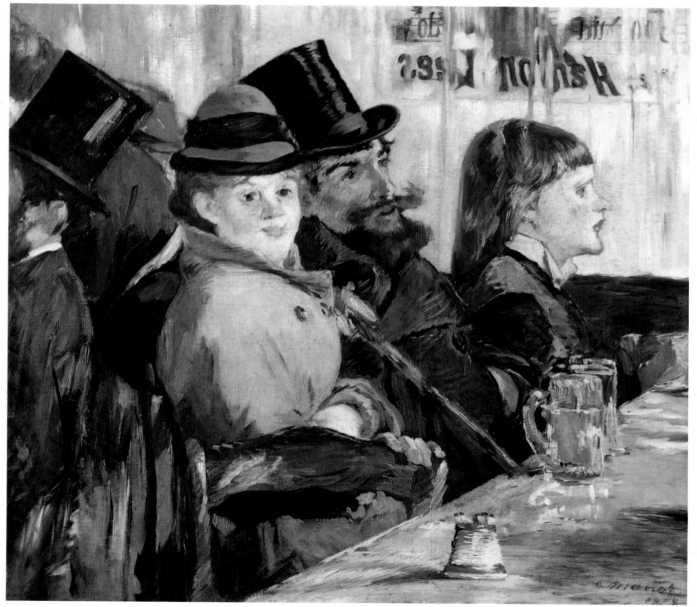

Edouard Vuillard (1868–1940). "Café in the Bois de Boulogne." About 1893. 13.65 × 15.2 inches.

THIS TAVERN IN the Bois de Boulogne (*above*) was painted by Vuillard in his brilliantly elliptical style of simplified color which changes the figures into spots, removes all relief from them, and sets them deep into the interior space. A charming decor, with its ghost of Odette de Crécy (one of the characters in Proust's great work, *A la recherche du temps perdu,*) pursued by Swann in the Proustian atmosphere of the avenue in the Bois, is captured with freshness and simplicity.

THE CROWDING EFFECT in the cafés imposes on the customers a fragmentary vision of all the liveliness around them. Like Vuillard years later, Manet wanted to express in a close, quick image this feeling of confusion and disorder. The passing waitress, the couple we surprise drinking beer, are the components of a kaleidoscope, each facet of which is offered separately.

The cafés of Paris played an essential role in the battle of Impressionism which was the victory of the restaurant over the Academy. The Rue des Martyrs, behind the church of Notre-Dame-de-Lorette, was the meeting place of the realists who gathered around Edmond Duranty and Gustave Courbet. In the Café Guerbois Manet attracted a circle. La Nouvelle Athènes, Le Père Lathuile, the Brasserie de Reichshoffen, and other such places—each was a center for the chattering and bohemian world of painters, critics, poets, *grisettes,* and models who never ceased arguing their ideas and explaining themselves.

Edouard Manet (1832–83). "At the Café." 1878. Oil. 30 × 32.4 inches.

Edouard Manet. *"La Serveuse de bocks."* 1878–79. Oil. 30 × 25.35 inches.

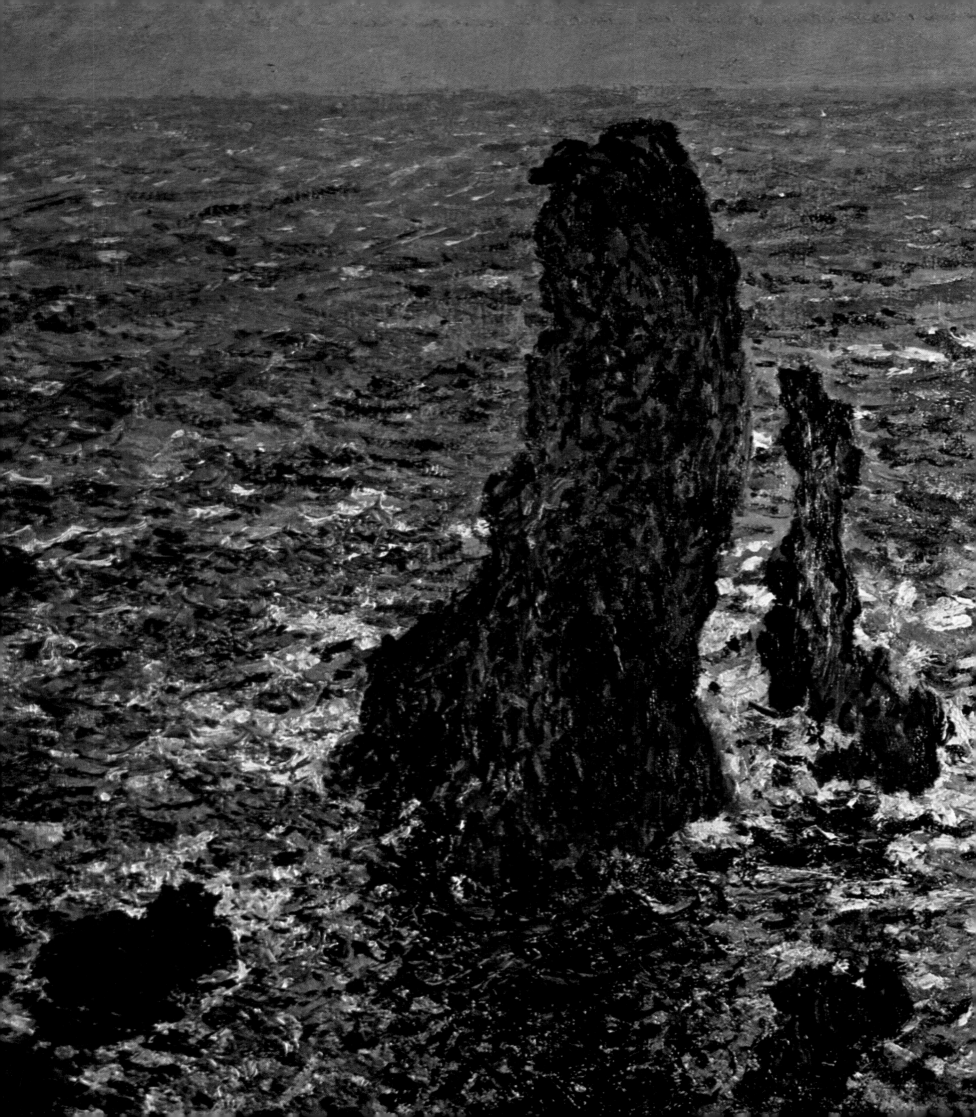

Claude Monet (1840–1926). "Rocks of Belle-Ile." 1886. Oil. 25.35 × 31.2 inches.

From the infinite sea the painter cuts off a small section of vibrating surface.

Edouard Manet (1832–83). "Rochefort's Escape." 1881. Oil. 55.8 × 43.5 inches.

WITH THE EXCEPTION of a small streak of sky, the sea occupies the whole canvas. Moving, heavy, opaque, it captivated the Impressionists who devoted countless careful and documentary studies to the subject. Gustave Geffroy mentioned Monet relentlessly working at Belle-Ile, an island off Nantes, "in wind and rain, dressed like the men along the coast, wearing boots, covered with heavy sweaters and wrapped in an oilskin with hood. The wind is often so strong that it tears the palette and brushes from his hands. His easel is anchored by cord and stones. Nevertheless the painter keeps working and goes about the study as though in battle."

Edouard Manet, the unsuccessful candidate to the naval school, set sail for Brazil but was back home in June, 1849, with little taste for the sailor's life, though his passion for the sea seldom left him. It served as pretext for battle scenes and was the subject of numerous canvases. The escape of an ardent foe of Louis-Philippe and sympathizer with the Commune, imprisoned in New Caledonia, is treated by Manet with the scrupulousness of a historian. In 1880 he wrote to Mallarmé, "Yesterday I saw Rochefort. Their craft was a whaler. The color was dark gray. Six persons, two oars." He had the same scrupulousness when rendering his vision of the sea, a huge glaucous surface with its flourishes of foam.

201

Vincent van Gogh (1853–90). "Sunflowers." 1887. Oil. 23.4 × 39.4 inches.

With their precision of outline and their vitality, Van Gogh's sunflowers turn their strange heads, whose centers protrude like the eyes of so many insects, toward the spectator.

VAN GOGH'S SUNFLOWERS have a strange, almost morbid, life. They are larger than nature, their background is eliminated, and their nuances of color range from yellow to brown. This painting has such aggressive power and expressive violence that we suspect some sort of human torment in the twisted branches and flowers.

Painted in Paris during the summer of 1887, this work represents a transition between the severe, dense canvases made at Nuenen, Holland ("Still Life with Nests," "Still Life with a Bible") and the series devoted to sunflowers painted at Arles. "In life and painting, I can easily do without God," wrote Van Gogh, "but ill as I am, I cannot do without something greater than myself, which is my life: the power of creation."

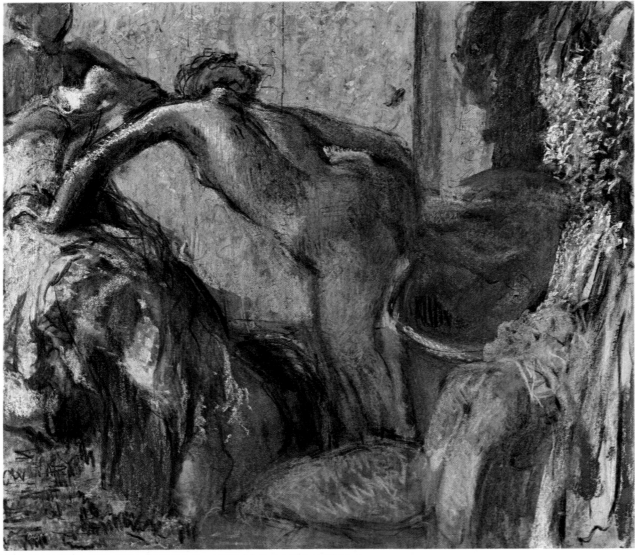

DEGAS GOES AROUND the model and from his series of observations offers a kind of obsessive reporting on women during intimate moments. In 1888 Félix Fénéon wrote, "Monsieur Degas pursues the female body with an old animosity which is like a grievance; he dishonors it with animal analogies." For Degas, a bitter and passionate spectator, it was a matter of bringing forth the most secret truth of everyday gestures, even at the risk of appearing indiscreet. Referring to one of his pastels, he explained, "this is the human beast busy with itself. The nude until now had always been presented in attitudes which suppose the presence of a public. My women are simple, honest people interested in nothing else but their physical occupation. . . . It is as though you were peering through the keyhole." His was a careful research, a strange, daily conversation with the young women who posed before the frowning look of an old misanthrope. As one of the women explained, "He would sometimes eat lunch in the studio on his newspaper, on the corner of a stand filled with drawings, chiefly by Ingres." Such was the scrupulous behavior of this introvert who poorly understood men like Gauguin. Writing to Emile Schuffenecker in May, 1886, Gauguin stated, "As for Degas, I have scarcely anything to do with him. I am not going to spend my life twiddling my thumbs during five sittings from a model. Considering the cost of butter, it is too expensive!"

Edgar Degas (1834–1917). "After the Bath." About 1895–98. Pastel. 29.6 × 32.4 inches.

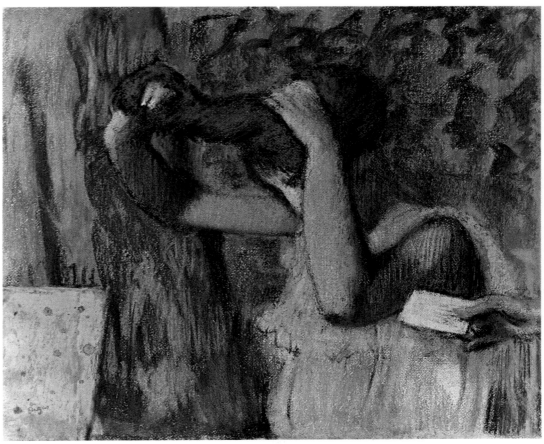

Edgar Degas. "The Letter." 1888–92. Pastel. 19.5 × 23 inches.

Degas wanted to be "the portraitist of the human beast." By a series of approaches. . . .

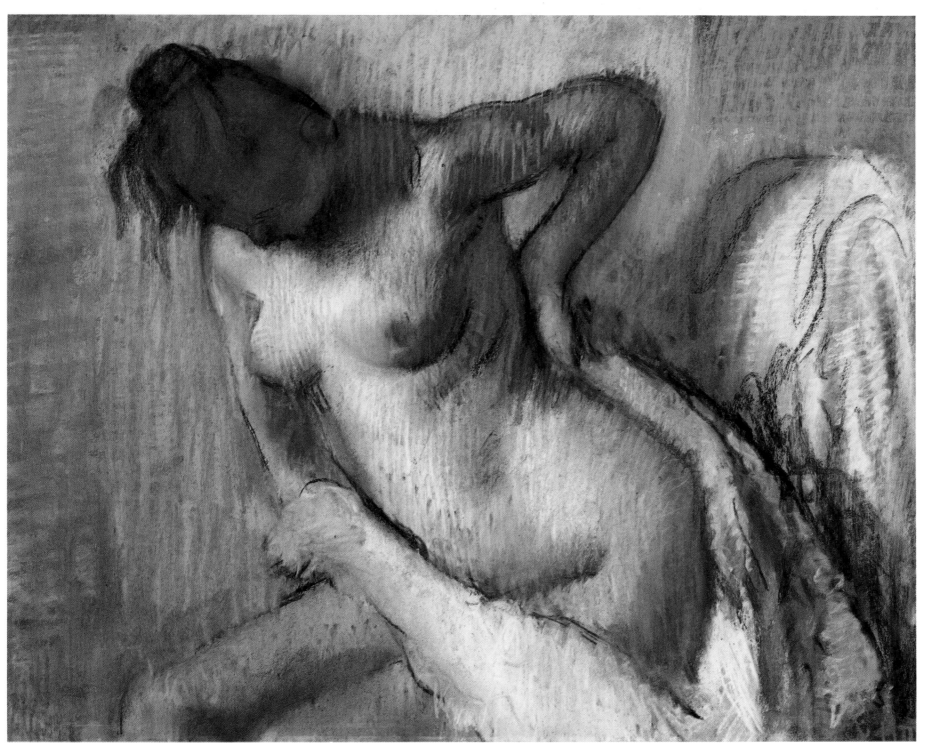

Edgar Degas. "Woman Drying Herself." 1886. Pastel. 21.45 × 27.7 inches.

Edgar Degas (1834–1917). "Before the Mirror." About 1889. Pastel. 19.1 × 25 inches.

. . . he reveals the intimacy of a neck and the silky quality of a woman's hair.

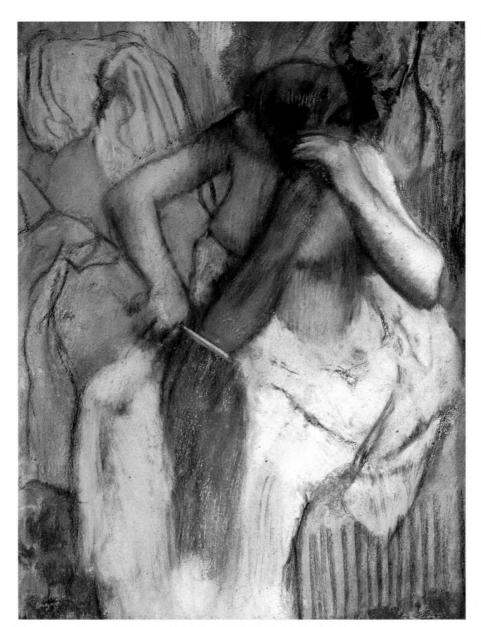

Edgar Degas. "Woman Combing Her Hair." About 1887–90. Pastel. 32 × 20.3 inches.

DESPITE HIMSELF, Degas lets a bit of crisp tenderness show as he arranges the light on a frail neck or a soft arm. These delicate notations were rather new considering the bold, close view and the tension of the figures who, as always with Degas, are seized in the precarious balance of the effort they are making. Poking fun at Monet and his followers, Degas said, "Don't speak to me of those old fellows who are crowding the fields with their easels." For Mallarmé he added, "The false is art. The study of nature is insignificant. Painting is an art of convention; it is much better to learn how to draw from Holbein." As early as 1888 Félix Fénéon revealed Degas' antispontaneous aspect. "He does not copy from nature: On the same subject he accumulates a host of sketches which become the source of the irrefragable truth of his work; no painting has less evoked the painful image of the 'model' who 'poses.'"

207

In Van Gogh's visionary eye, trees become bars and the forest a prison.

ARBITRARILY ELIMINATING the horizontal aspect of his landscape, Van Gogh brutally breaks the harmony of nature. And he transforms the traditional concept of the tree. No longer is the forest a cathedral, a slender vault, but a prison. The artist dismisses the logical response to the landscape and retains merely what corresponds to his obsessions. Here, where we see a forest interior, he sees an accumulation of bars which separate a couple from the rest of mankind, just as the tight grill of his cell window separates him from the living. As for these ectoplasmic beings who wander among the trees, half effaced somewhat like Giacometti's figures, Van Gogh indicates to us chiefly the *distance,* all that separates them and all that separates us from them. This is a painting by a sick man. The artist is struggling against the illness which gradually gains the upper hand over him. "Every day I take the remedy which the incomparable Dickens prescribed against suicide," wrote Van Gogh in April, 1889. "This consisted of a glass of wine, a piece of bread and cheese, and a pipe of tobacco." After reading the sole—enthusiastic—article on him written during his lifetime, he begged his brother Théo, "Please inform Monsieur Aurier not to write further articles on my painting, tell him firmly that first of all, he is wrong about me, and secondly, that I am too filled with sorrow to give way to publicity. Painting pictures distracts me, but if I hear mention of this, it makes me more sorrowful than he imagines."

Vincent van Gogh (1853–90). "Forest Interior." 1890. Oil. 19.5 × 39.4 inches.

Van Gogh observes the cracked pattern of tree bark and seeks to penetrate the secret vitality of nature.

John Constable (1776–1837). "Study of a Tree and Trunk." 1821–22. Oil on paper. 9.8 × 11.7 inches.

By SEEING THE most ordinary aspects of nature with the careful study of a botanist and the exaggeration of a distorted view, Van Gogh gives objects a hallucinating character. This greatly cracked, divided tree trunk appears to be alive with an opaque, secret, and threatening life. Realistic excess was to end in Surrealism. Painted by the artist two months before his tragic suicide, the work may bear comparison with an amazing sketch by Constable made seventy years earlier in the English countryside. The point of view, the section of the trunk, the divisional brushstroke, all are prophetic in this study which was not discovered until the close of the nineteenth century when the public, trained in fact by Impressionism, was capable of understanding its beautiful quality. We feel the difference between an idyllic vision of nature and Van Gogh's tragic vision of life.

Vincent van Gogh (1853–90). "Grass in a Park." May, 1890. Oil. 28.1 × 35.1 inches.

The artist attacks the unitary concept of space that had prevailed since the Renaissance.

THE FIGURES IN Gauguin's famous large composition (*below*) appear to float, and only with the greatest difficulty can we imagine their speaking to one another, for each is contained within his own space shut off from the others. Whether standing, seated, or reclining, they are separated by invisible partitions. As in medieval art, the painter does not hesitate to juxtapose, within his rectangle, unusual scenes which fail to obey the same spatial logic. "Where do we come from? Who are we? Where are we going?" was executed by Gauguin at the worst moment of his depressive period when he contemplated committing suicide. In a final effort, he attempted a kind of metaphysical testament in which he poses after his own fashion the question of human destiny. Most of the themes were borrowed from earlier paintings, and Puvis de Chavannes' influence is quite evident in the arrangement. "Not only does this canvas surpass in value all the others, but I shall never do a better nor a similar one," wrote Gauguin to Daniel de Monfreid. "Before dying I put into it all my energy, such painful passion under the circumstances and such a clear vision without correction that haste disappeared and it was life that came forth. . . . I worked on the canvas night and day for an entire month with incredible fever. . . . Despite the tonal passages, the landscape aspect is constantly blue and Veronese green from one end to the other. All the nude figures stand out in strong orange."

Whereas in the large Tahitian composition there is implicit separation between the unusual spaces, in *"La Belle Angèle"* (*right page*) Gauguin uses an effective cut-out surface. A circle isolates the portrait from the rest of the canvas. "Gauguin has sent me a few new canvases," Théo van Gogh reported to his brother Vincent in September, 1889. Among these was, to quote Théo, ". . . a portrait arranged on the canvas like the big heads in Japanese prints. . . . This expression of the head and the position [of the model] are very well achieved. The woman somewhat resembles a young cow, but there is something so fresh and also so full of rustic flavor that it is very pleasant to behold." The "young cow" was Madame Sartre, wife of the future mayor of Pont-Aven who was horrified at the thought of receiving it.

Picasso, at the age of twenty, painted a Mannerist version of dual space (*opposite right*) based on El Greco's famous "Burial of the Count of Orgaz." This was destined to honor the suicide, out of love, of his comrade, the Catalan painter Casagemas, in the winter of 1901. While the body remains on the ground, the sky reveals—twelve years before the first Chagalls—the free flight of the reconciled lovers. This painting with its juxtaposition of imaginary and real space reflects two painters who had inspired Picasso, El Greco and Cézanne.

Pablo Picasso (born 1881). "The Burial of Casagemas." 1901. Oil. 58.5 × 35.1 inches.

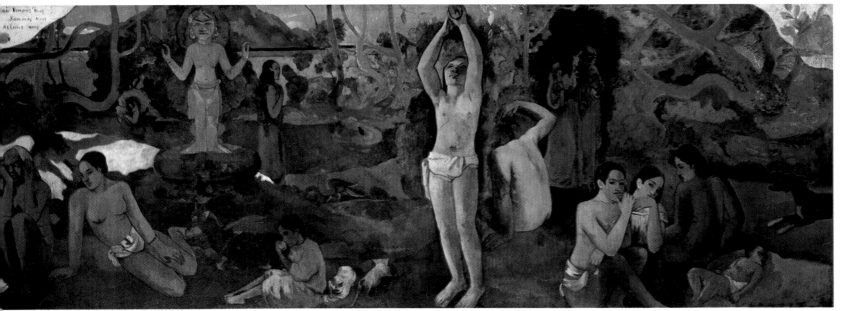

Paul Gauguin (1848–1903). "Where do we come from? Who are we? Where are we going?" 1897. Oil. 53.8 × 147 inches.

The artist rediscovers medieval narrative liberties by placing different spaces side by side in the same composition.

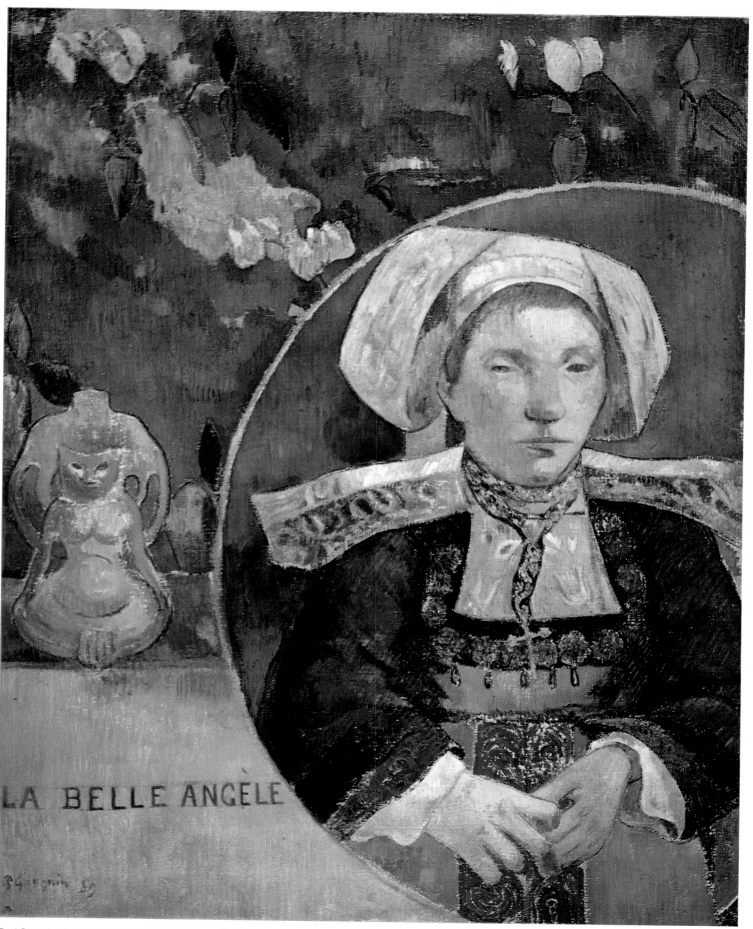

Paul Gauguin. *"La Belle Angèle."* 1889. Oil. 35.9 × 28.5 inches.

DEGAS APPROACHES his ballet dancers so closely that the painting seems too small to contain them. The paradox of the pastels shown here are their abstraction. Although the close-up view emphasizes the tactile and chromatic values of the subject and we have sensual pleasure in contemplating the warm and deep pastel colors, nevertheless the figures are inexorably closed within themselves. We remain outside these fragile, inaccessible, and immaterial dancers, who, as Paul Valéry described them, "are not women but beings of an incomparable, translucid, and sensible substance, madly irritable glass flesh, floating silken domes."

In the large pastel (*above*) now in the Dresden Museum, we see how much the pure color is more important to Degas than the description of the figures. Joined into one form, the two dancers compose a single two-legged insect, in a splendid and goffered reddish pelage. Degas, however, was passionately fond of the ballet world. "It seems to me that everything is aging proportionally in me," he wrote on January 7, 1886. "And even this heart had something artificial. The dancers have sewn it in a pink satin bag, a somewhat faded pink satin, like their ballet shoes."

Edgar Degas. "Dancers in Blue." About 1898. Pastel. 25 × 25.35 inches.

Degas' ballet dancers, both close and distant, turning to the frail harmony of their arabesques, are portrayed in a slightly acid but marvelous color scheme.

By dividing the image into two,
the mirror offers a strange puzzle.

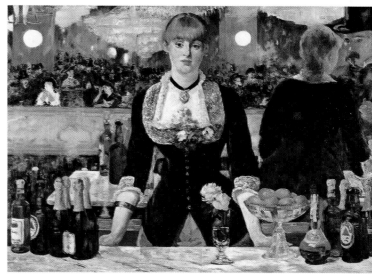

Edouard Manet (1832–83). ''Bar at the Folies-Bergère.'' 1881. Oil. 37.4 × 51.1 inches.

Pierre Bonnard (1867–1947). ''Torso of a Nude Woman Before a Mirror.'' 1916. Oil. 31.6 × 43.7 inches.

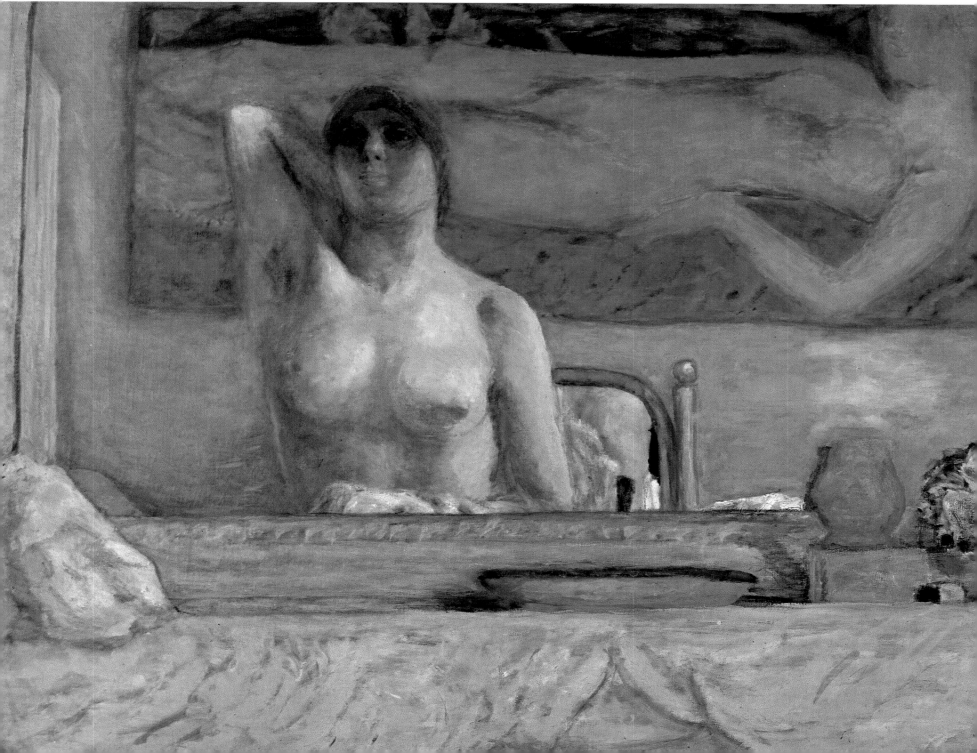

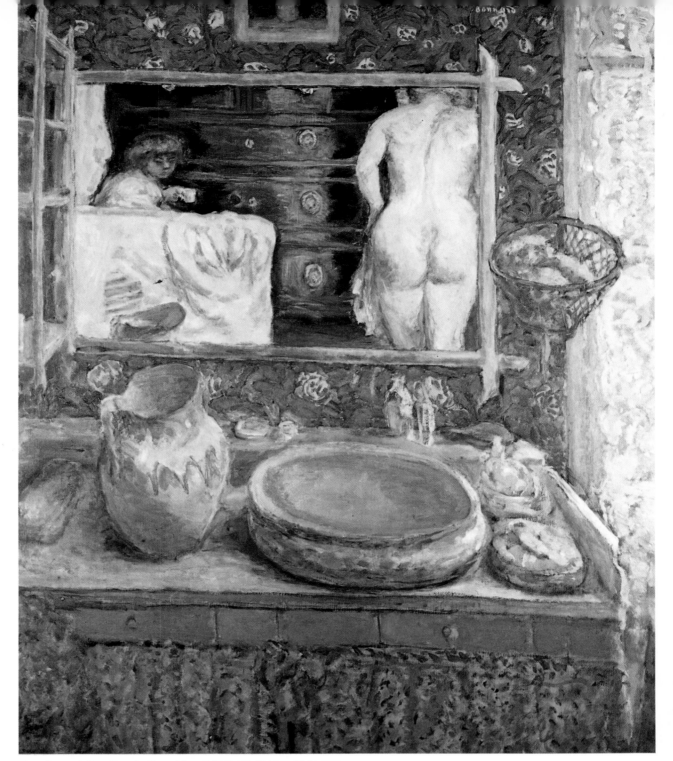

Pierre Bonnard. "The Dressing Room Mirror." 1908. Oil. 40.15 × 37.8 inches.

A MIRROR DISRUPTS our visual ground and places in unexpected and often brutal relationships sections of dissimilar reality. Thus the torso in Bonnard's painting (*left*) superimposes itself on a horizontal nude hanging on the wall. The unusual geometry in the painting above brings different depths to the front plane, and in the same whole depicts a window, a wall, a bit of a painting, a nude seen from behind, a chest of drawers, to name the most obvious. The sole person, invisible, not reflected in the mirror is the painter. Long before Bonnard, Manet, in his "Bar at the Folies-Bergère" (*left page,*

above) had experimented with complex space multiplied by reflection. This work shows the barmaid seen face on, though her reflection is off to the right. Seen in the mirror are reflections of some of Manet's friends in the background audience and the legs of a trapeze artist. It has often been observed that the figure of the barmaid seen from the rear should have been partially hidden by the foreground, but Manet disregarded any such logic. It is not so much immediate faithfulness to the scene that he strives for but rather a tension, a "curious perspective." The writer Jeanniot, who saw him paint,

related in *La Grande Revue,* in August, 1907, "The model, an attractive girl, posed behind a table loaded with bottles and food. . . . Manet, although painting his pictures from the model, by no means copied nature; I realize how splendid his simplifications were. The head of his woman is modeled, but his modeling was not obtained by means revealed by nature. Everything was abbreviated: The tones were clearer, the colors more lively, the values closer. This formed a tender and blond harmonious whole."

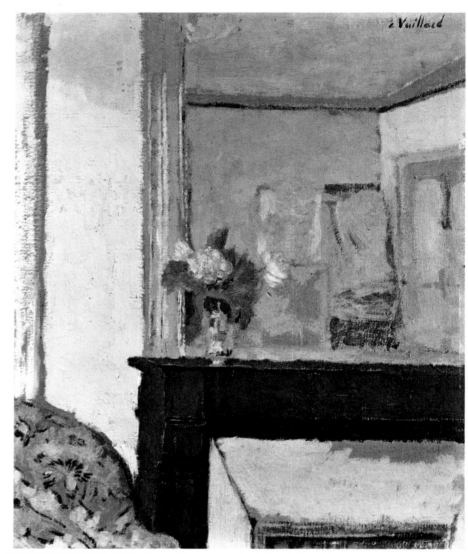

Edouard Vuillard (1868–1940). "Vase of Flowers on a Mantlepiece." 1900. Oil. 14.4 × 10.9 inches.

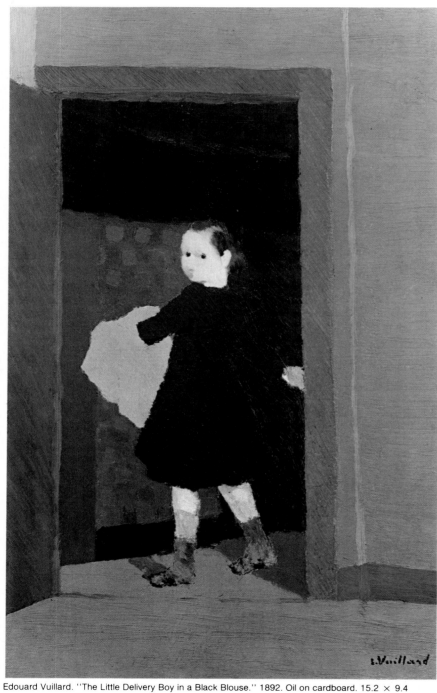

Edouard Vuillard. "The Little Delivery Boy in a Black Blouse." 1892. Oil on cardboard. 15.2 × 9.4 inches.

THE ARTIST'S EYE concentrates on intermediary spaces. Instead of directing his attention to the vase, the mirror, the armchair, he describes what is occurring in the neutral zones *around* the chair and the fireplace and the mirror. He sharply focuses the empty moments of vision when the eye, wandering from one object to another, fleetingly perceives the unexpected harmony of two verticals, or floats for an instant on a surface in which the elements of a right angle happen to overlap.

"The whole must appear as a fragment of a visible world haphazardly cut out," wrote the art historian Heinrich Wölfflin to qualify works of this type. Bonnard's and Vuillard's paintings are not based on the setting but develop an independent geometry, whose harmonies extend beyond the picture. Each axial intersection is the point of departure for a series of straight lines which escape from conventional painting limits. There is no attempt on the artist's part to describe a world but rather some close-up of a reality.

The painting becomes a marquetry of geometrical forms at the frontiers of abstraction.

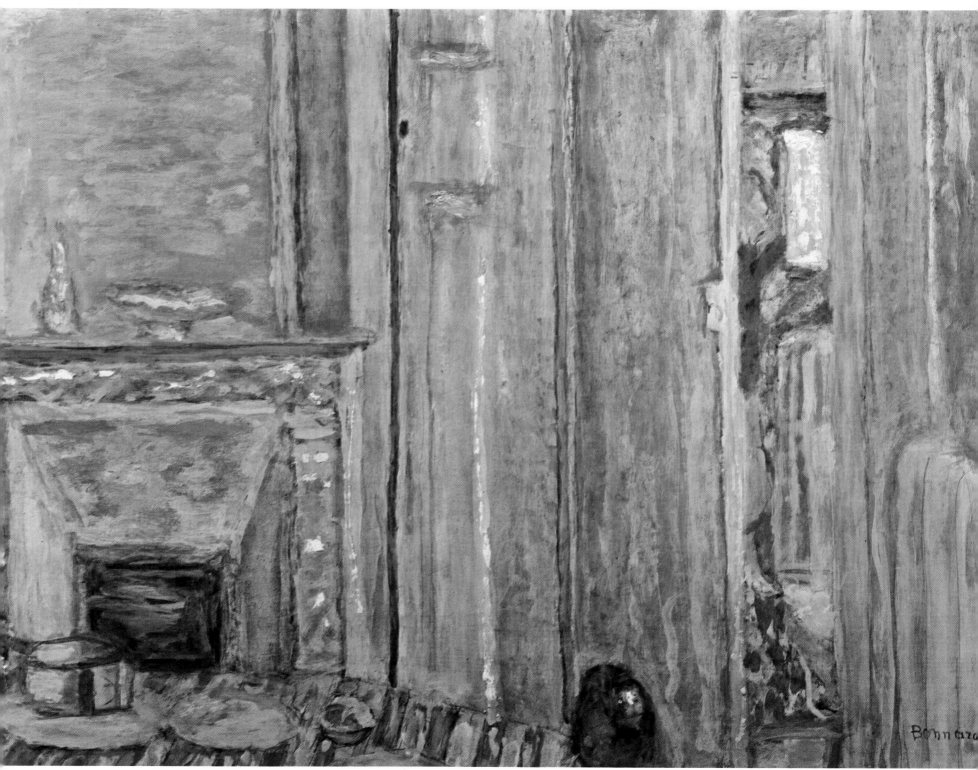

Pierre Bonnard (1867–1947). ''Interior.'' 1930. Oil. 21.45 × 27.7 inches.

The painter

minimizes perspective and
reduces space to
two dimensions.

For half a century painting experienced a strange adventure, gradually identifying itself with the surface of the picture. Long based on an illusionary concept—a two-dimensional representation of a three-dimensional space—it now fought against this convention. Perspective was shortened, distance became closer. Before becoming a subject, a theme, or a history, painting discovered its surface. Cézanne was the chief artisan of this mutation and Mondrian its end result.

"Cézanne's art," noted Charles Sterling, "drew attention to this essential truth which the naturalist intention had more or less concealed for centuries: Each brushstroke while contributing to form images of natural things belongs to the surface of the painting; it furnishes it to a certain extent and is part of a certain order of color and lines."

This is what Pierre Francastel showed *a contrario* when he described classic art as a "space in which the silhouette of objects and of individuals stands out against a decor." We are in the presence of a "nature-spectacle" in which the objects are spaced out and divided without merging with the background.

When Cézanne, in his letters and quotations, mentions his method, he often includes it in this conception emanating from the Renaissance. His definition of perspective could well be signed by Piero della Francesca. He "thinks" in Euclidian terms. His entire intellectual organization is part of this "geometrical unconscious," this natural bent which always brings us back to the models dictated by our education, itself in turn reflecting the most general conceptions of the period concerning matter and space.

These two visions—classic and modern—coexisted in Cézanne. This *petit bourgeois* of Aix-en-Provence wanted "to make of Impressionism something solid and durable, like the art of the museums." But as he painted daily from nature his concrete experience contradicted this "art of the museums." Empirical knowledge of reality, nourished on the great currents of modern thought, such as Positivism, could scarcely be based on classical canons. Cézanne was a prodigious "looker." According to Joachim Gasquet, the painter would spend long minutes before the subject, then apply the first bit of paint. He himself said, "My eyes are so stuck to the point I am looking at that they are on the point of bleeding. . . . Only night removes my eyes from the ground, this corner of earth which has become a part of myself. . . . The artist's brain, free, should be like a sensitive plate, a purely recording device, the moment he sets to work. But this sensitive plate has by skillful paths been taken to the point of receptivity where it can impregnate itself with the conscious image of things." It was all as though Cézanne had literally attempted to blend with nature and sought to become a part of the cosmic flux which surrounded him. This man, who reacted furiously and morbidly the moment someone inadvertently touched him, protesting there was an attempt "to hook him," appeared to seek through the eye to communicate passionately with the profound geological sources of matter. "I and my painting are one," he stated. "We are an iridescent chaos. I lose myself before the subject. My thoughts are vague. Sunshine invades me like some distant friend to warm my laziness and to impregnate it. . . . We germinate. . . . The landscape reflects itself, humanizes itself, thinks in me. I objectivize, project, fix it to my canvas. . . . The chance play of rays, movements, the infiltration and incarnation of sunshine in the world, who will

Johannès Hackaert. L'Allée de frènes."
Seventeenth century.
With Hackaert the placement of the trees allows for deeply receding space. Two centuries of development will lead to Monet's frontal view of a row of poplars (pages 254–55).

Robert Delaunay. "The City of Paris." 1910–12.
After the death of Cézanne, the Cubists returned to his language and developed it. With Delaunay planes float in space and objects are inextricably intermingled.

James Ensor. "Still Life in the Studio." 1889.

Jan Toorop. "Return to Oneself." 1893.

Charles Filiger. "Chromatic Notation." 1903.

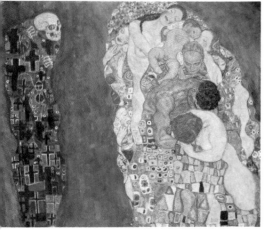

Gustave Klimt. "Death and Life." 1908.
The adversary of any prosaic reference to daily reality,
Symbolist art, stemming for the most part from Gauguin,
rejects the third dimension and tends toward flat areas. The
minimizing of perspective emphasizes the artificial and
dreamlike character of the atmosphere. If necessary, artists
turned to Pre-Renaissance formulas borrowed from Byzantine
models.

ever paint this, who will relate it? It would be the physical history, the psychology of the earth."

This aesthetic of cosmic fusion, with its contemporary echo in the poetry of Lautréamont and Rimbaud, was directly opposed to the spatial order which had dominated Western painting for four centuries. Cézanne's entire tragedy lay in this tension, this conflict between a desire to base his vision according to the lesson of the masters and the violent pulsations which lay rooted in his very being. He tried to be a classical and orthodox painter and dreamed of "doing Poussin again after nature." The landscape decomposed before his eyes, the world slipped away. Ambroise Vollard, the Paris art dealer, having his portrait painted was made to pose for 115 sittings, then Cézanne abandoned the canvas in despair and acknowledged only that he was "not displeased with the shirt front." To Vollard he had said, "Try to understand me a bit, the outline escapes me." His desperate desire for order and logic clashed with the pitiless requirements of his "wild" look, with the honesty of his candid and strong soul. He could paint only what he saw—a world in flux, a whirling of matter. His whole culture suggested to him that he close the form, outline the object and define it, but his entire experience was opposed to this.

In order to prevent interference with his understanding of the world, he developed a method which led him to reproduce what he saw even before perceiving the meaning. Observation preceded deciphering. He could paint a red spot and not a house. "Left and right, here and there, everywhere I take the tones, the colors, the nuances [of the landscape], I establish them, bring them closer. . . . They become objects, rocks, trees, without my thinking about this. They acquire a volume. They have a value. If these volumes and values correspond on my canvas, in my sensibility, to the planes and spots there before my eyes, well, then, my canvas coheres. It does not waver. It passes neither too high nor too low. It is true, dense, full."

Taken in its main contradiction—the will and impossibility to establish and construct in the immutable surrounding reality—Cézanne attempted by every means to spread out before our eyes this mixed-up and elusive world. He stubbornly tried to clarify the obscure, the ambiguous, the troubling element, even at the core of the cosmic fusion which he saw in the subject. The Cézannian front view was the result of this need. The painter of Aix gave the greatest amount of information on each object, ready to infringe for the first time on a golden rule of painting established in Western art since the Renaissance, namely, the monocular point of view. Whereas the system inherited from Alberti postulated an immobile observer, establishing the landscape from a single site, Cézanne began to displace himself slightly around the subject. He turns toward us the fleeting outlines of the volumes, the curves which escape our vision, returning to the plane surface the lateral flanks of the Mont Ste.-Victoire. He presents both the outline and the upper part of a coffee pot, the façade and sides of a house. In the same composition we find an oblique and a front view (pages 260–61). Cézanne, in this early method of encircling the object, became the "primitive" of future times and the forerunner of Cubism.

"Here on the banks of the river," he wrote to his son, "the subjects increase; the same scene seen at different angles becomes a study of utmost interest and one so true that I believe it would keep me busy for months without moving, turning sometimes to the right and sometimes to the left." To emphasize the

Paul Cézanne. "The Orgy." 1864.
Even in his early period Cézanne gave great dramatic importance to his backgrounds. The cloudy element which occupies the upper part of the canvas tips the composition toward us.

Kung Hsien. "Swamp." China. Seventeenth century.
Using small vertical spots one above another, the artist constructs his composition.

Camille Pissarro. "Landscape." About 1852.
This sketch by the young Pissarro in Venezuela, twenty years before Impressionism, announces the Cézannian method of construction by spots without modeling (see page 269).

front view, Cézanne painted his distances as clear or even clearer than his foregrounds. Atmospheric phenomena—haziness, *sfumato*—cease to play their usual role and distance no longer confuses things. Quite the contrary. Cézanne uses a reversed perspective dear to the Japanese, for example, the side of a table toward the spectator will often be narrower than the rear (page 259 below). In many of his paintings, Cézanne even manages to give the same value to the full and empty spaces, to the objects he describes and to the spaces which separate them. "With him," noted Pierre Francastel, "appeared the unity of every part of the representational image."

To bind his planes spread out in space and to contract his perspective, Cézanne often uses a distinct parallel brushstroke (pages 112–13). Construction by means of texture is not new in the history of art. It is characteristic of Chinese painting *(opposite)*. It is also evident in some of Dürer's watercolors, in Poussin's wash drawings, and in eighteenth-century French landscapes (pages 32–33). It became a rule with Girtin, and especially with Cotman, in nineteenth-century British painting. And in many of Corot's landscapes (page 43) it makes a quiet appearance. Finally, as pointed out by Alfredo Boulton in his *Pissarro au Venezuela,* it reigned in the drawings of the young Camille *(opposite)*. There is an evident desire to treat nature by spreading out flat areas. This experience was to give Pissarro, during his beginnings in France, the authority and mastery which were later to inspire Cézanne. In 1876 he wrote to Pissarro, "The sun is so frightening that it seems to me that the objects come off as silhouettes not only in black and white but also in blue, red, brown, and violet. I could be mistaken, but it seems to me that this is the opposite of modeling." The paradox of this friendship between the two was that the painter of Aix would continue to advance in his researches to end up, as we shall see, with a new conception of painting, whereas Pissarro gradually fell back on the Renaissance perspective scheme and during the year gradually turned to a more conventional art.

Cézannian frontality was the origin of Gauguin's art. "I had but a slight sensation; Monsieur Gauguin stole it from me! . . ." complained the hermit of the Jas de Bouffan. As for Gauguin, on setting out to paint from the subject at Pont-Aven, he cried out, "Let us do a Cézanne." Possessing a still life by the master, still unknown at that time, he claimed he would hold onto it "like the pupil of my eye. . . . I shall get rid of it after my last shirt. . . ." (see page 259, *above left*). Cézanne released in Gauguin a will to abandon classic Impressionism and the desire to "dare all." Free of the constraints of perspective, he could turn his eyes to Japanese prints, Romanesque frescoes, and Egyptian painting. His landscapes without vanishing lines, composed in large flat areas, would have ended in decoration if at the same time he had not turned to a fresh means of color to create a different relationship between the spectator and the painting *(see* Chapter V). It was the turn of the Nabis and of the Symbolists to take Gauguin as their point of departure. After him it was Maurice Denis who, as though their spokesman, complained of the "annoying modeling mania." We shall clearly see (pages 246–47) how Gauguin's frontality was to inspire boldness in Sérusier and Bonnard. As for Vuillard, he took the art of flat areas to its limits. His figures fade into the wallpaper or the landscape (page 265). They disappear into the impasto (pages 262–63) and become one with the tapestries. The general use of the electric light at the close of the nineteenth century was to strengthen this development, since it tended to blend, flatten,

Piet Mondrian. "Dune IV." 1909–10.
The artist simplifies his outlines to give greater power to his form.

Henri Matisse. "Red Interior." 1947.
To emphasize the verticality of his composition, the father of Fauvism treats the floor and walls of his room as one continuous plane.

Piet Mondrian. "Composition in Blue." 1917.
Mondrian's squares overlap in an imprecise depth. For thirty years his painting was to oscillate between a light optical movement and the statement of a strictly front view.

Hokusai. "Fujiyama Seen in Fine Weather." About 1830.
Fujiyma does not occupy space. It is the *sign* of a mountain rather than a naturalistic attempt to reconstruct it.

and deepen the cold tones. This is what Vuillard painted. But artists could also combat this evanescence of form, make their color strident, simplify and free their outlines. Pierre Baque, in his thesis "The Creator, the Creation, and the Public" (1970), established a significant parallel between the general use of electricity in France (about 1907), thanks to the unification of public services, and the rise of pure color. Fauvism, Matisse's "Dance," Mondrian's "Dunes" (*opposite*) all date from this period.

Cézanne's genius was not his front view. If so, his feverish research in sixty paintings of Mont Ste.-Victoire would have resulted in something like Hokusai's print of Fujiyama (*bottom of page*). What could be more frontal? But we feel that Cézanne is seeking something else (pages 268–69). Emile Bernard's words enlighten us as to his true aims. "Planes were his constant preoccupation. 'This is what Gauguin never understood,' he insinuated. This reproach could also have been levelled at me, for I felt that Cézanne was right, there is no fine painting if the plane surface remains flat. The objects must turn, move off, live. This was the whole magic of our art."

"Turn, move off, live"—for Cézanne the world was not *fixable.* He refused to block in the immutable form. Each brushstroke postulated several readings. It signified both "very far" and "very close." Space was simultaneously convex and concave. Planes overlapped and telescoped. The artist showed the ambiguity of all depth, the ambivalence of all notation. His brushstrokes float in space. They describe a world with a moving foundation, indecisive hierarchies, a world in which the compactness and passivity of matter are denied by radiation. Cézanne inaugurated the aesthetic of instability which was to be one of the main currents of the twentieth century, the progress of which can be seen in Mondrian's fluid planes (*opposite*), and in the refracting surfaces of optic art.

The artist masterly utilizes the automatic mechanisms of seeing which make us reestablish and correct raw visual observations. At a distance of thirty feet a man is no larger than a fingernail. The true size is indicated by our faculties of compensation. The brain restores the scale which the optic nerve failed to perceive. Cézanne, by means of haziness, imprecision, and lack of determination, obliges his "reader" to commit himself actively to the process of "reaching" his painting. A choice is left to us in the interpretation of this or that red or green spot. It is we who establish its size and situation in the space described (page 269). Thanks to the rich ambivalence of possible solutions, the artist creates a living space, an "open work." The Cézannian opening, however, is best realized by the use of white. Toward the end of his life the painter refused more and more to cover certain surfaces. He used this method in many drawings as well as in several paintings (pages 236, 268, *below*). The white, with its many possible meanings, appeared to him *truer* than any pigmentary application which gave a single solution to the changing palpitation of life. In 1905, a year before his death, Cézanne stated, "The color sensations which give the effect of light are abstractions which do not permit me to cover my canvas or to continue the delimitation of the objects when the points of contact are tenuous and delicate." Only white, which also is pure light, transparency, impalpable, immeasurable saturation, can render a reality with such "delicate" articulations. The painter's white space here joins the immaculate white page before which Mallarmé dreamed. It became the site of every possibility.

Manet confines in a shallow space the terrible
banality of death.

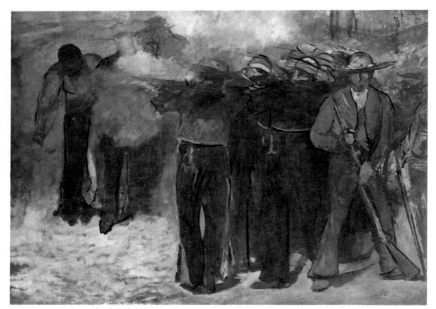

Edouard Manet (1832–83). "The Execution of the Emperor Maximilian." 1867. Oil. 76 × 101.7
inches.

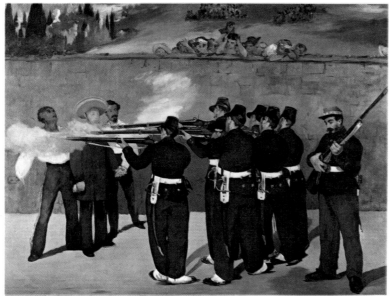

Edouard Manet. "The Execution of the Emperor Maximilian." 1867. Oil. 99 × 120 inches.

MANET BLOCKS THE horizon of his
paintings so that we may concentrate
on the foreground. In most of his works
the eye does not escape to the distance.
A thicket, a wall, a screen of smoke, or
a plunging perspective partitions off the
scene and emphasizes the close view.
"He was the first among the moderns,"
wrote Charles Sterling, "to flatten
painting and make it reveal its original
quality of a surface covered with color,
to suggest a certain independence of
line and colored spot." In the two
paintings entitled "The Execution of
the Emperor Maximilian," reproduced
above, the artist was inspired by the
famous "Third of May" painted by
Goya in 1814. Manet had visited the
Prado Museum in Madrid in 1865. Two
years later, after the announcement of
the courageous death of Napoleon III's
protégé in Mexico, he made a large
sketch of a firing squad (top) soon
followed by three versions all with

much greater precision. "Whereas Goya
offers us a frightful vision," noted the
writer Georges Bataille, "Manet paints
the death of the tragic emperor with the
same indifference he might have had for
a flower or a fish. . . . This painting is
the negation of eloquence." The
spectators hanging from the wall were
directly inspired by Goya's paintings of
bullfights.

The same handling of space is
evident in "The Explosion" (right) in
the Folkwang Museum, Essen. It dates
from 1871, and some critics question its
attribution to Manet. The theme was
borrowed from dramatic events of the
city of Paris in constant struggle that
year with the Prussians and the
National troops. These gesticulating
and dislocated silhouettes against a
white background form an astonishing
modern painting of violence and
announce the tortured outline of a Van
Gogh and a Soutine.

226

Edouard Manet. "The Explosion." 1871. Oil. 14.8 × 17.9 inches.

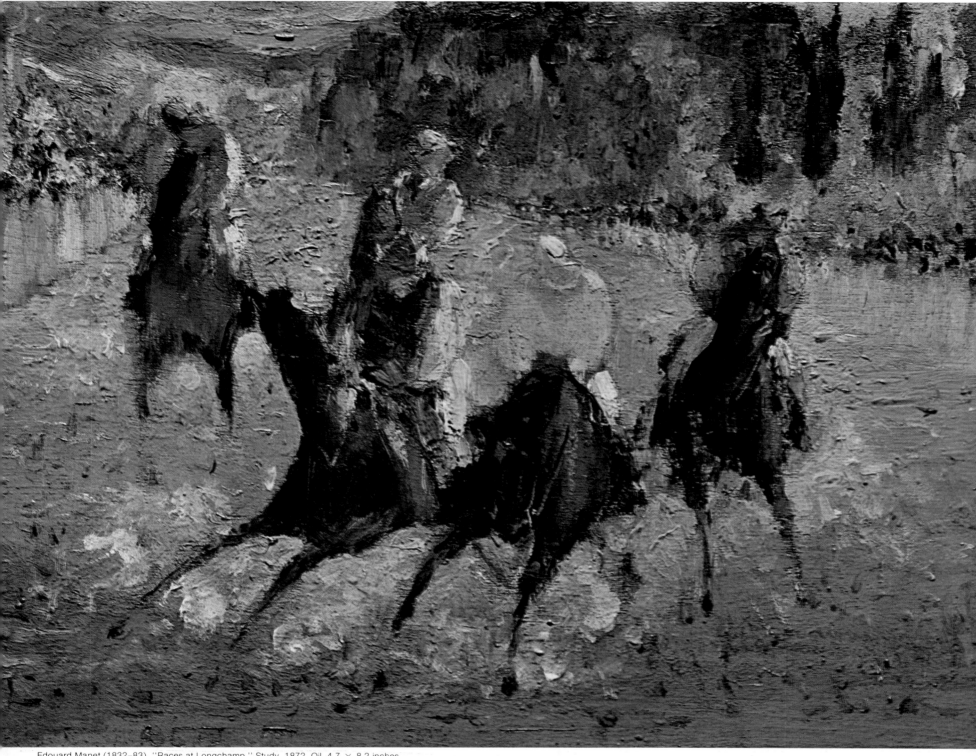

Edouard Manet (1832–83). ''Races at Longchamp.'' Study. 1872. Oil. 4.7 × 8.2 inches.

The painter's eye captures the horses' gallop.

PETRIFIED IN AN immobile gallop, distorted by the tension of the finish, Manet's horses seem to be seized by the brutality of a telescopic lens. In the painting reproduced below and even more so in the sketch on the left, in the National Gallery of Art, Washington, D.C., the artist seeks to capture the moment. He shows us what the retina registers when it takes in a scene of action in a quarter of a second. Forms and background blend in a generalized blur. The black masses crushed against the confused perspective of the low hills of St.–Cloud are movement before being outline. This frantic, indistinct cavalcade enables us to measure the development of French painting since the polished and detailed horses by Géricault.

The allusive treatment of the crowd standing as one heap of the grass (*below, left*) is related in a pleasant manner to the hallucinating processions painted by Goya for his "House of the Deaf Man."

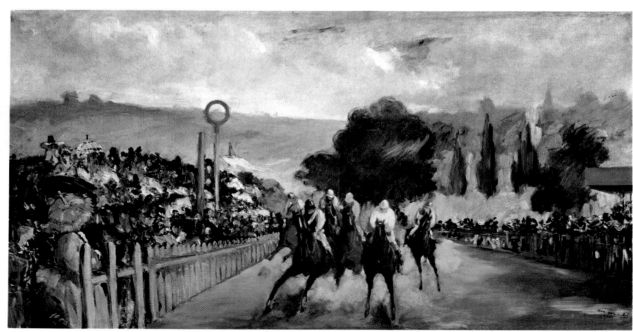

Edouard Manet. "Races at Longchamp." 1872. Oil. 17.2 × 32.8 inches.

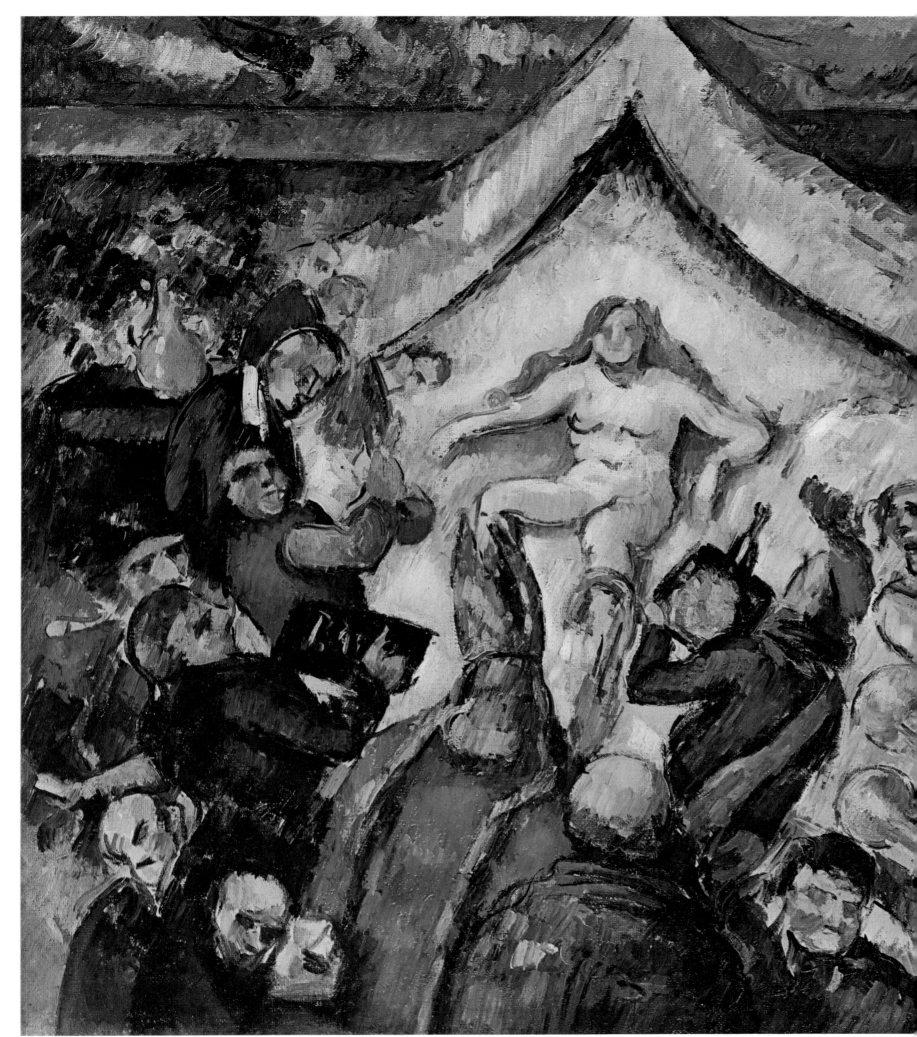

Paul Cézanne (1839–1906). "The Eternal Female." 1875–77 Oil. 17.5 × 20.7 inches.

Cézanne throws at the foot of the eternal female a pyramid of disorderly bodies.

To CONTROL HIS wild imagination and bubbling sensuality revealed in his youthful letters and in his early paintings, Cézanne submitted himself to a dual discipline. He inscribed his female allegory in the yoke of a triangular composition reinforced at the summit by the shape of a baldachin. The composition in its own manner is almost as strict and symmetrical as a "Coronation of the Virgin" by Fra Angelico. Cézanne arranges his figures around the nude woman, reducing perspective to a minimum and closing the whole design by a wall. The protagonists are crudely sketched. "Cézanne's figures," noted Pierre Francastel, "cease to be treated as human references in the center of a natural setting and become the elements of a homogeneous space."

"The Eternal Female" represents, at the foot of a triumphant nude, a group of worshipers including a bishop and a painter who symbolize various arts and crafts. The crude treatment, the violence of the brushstrokes could not help but seem intolerable to Cézanne's contemporaries, and his work was especially ridiculed during the Impressionist exhibitions of 1874 and 1877. The painter was resentful and discouraged and spent more and more time in his native South of France. "To work unworried by anyone and to become strong, this is the artist's goal," he wrote some years later.

During the period of "The Eternal Female," Cézanne was still under the influence of the "humble and colossal Pissarro," his elder by nine years and his chief support during his beginnings. During the time of Cézanne's extended stay at Pontoise, where he lived with Pissarro, it was the latter who made him abandon his dark palette and the thick texture of his early work. "Our Cézanne offers hope," he wrote in 1872, "and I have seen and have at home a painting of remarkable vigor and strength. If, as I hope, he will spend some time at Auvers, where he plans to live, he will astonish many an artist who condemned him too soon."

A screen of rustling foliage invades the visual field.

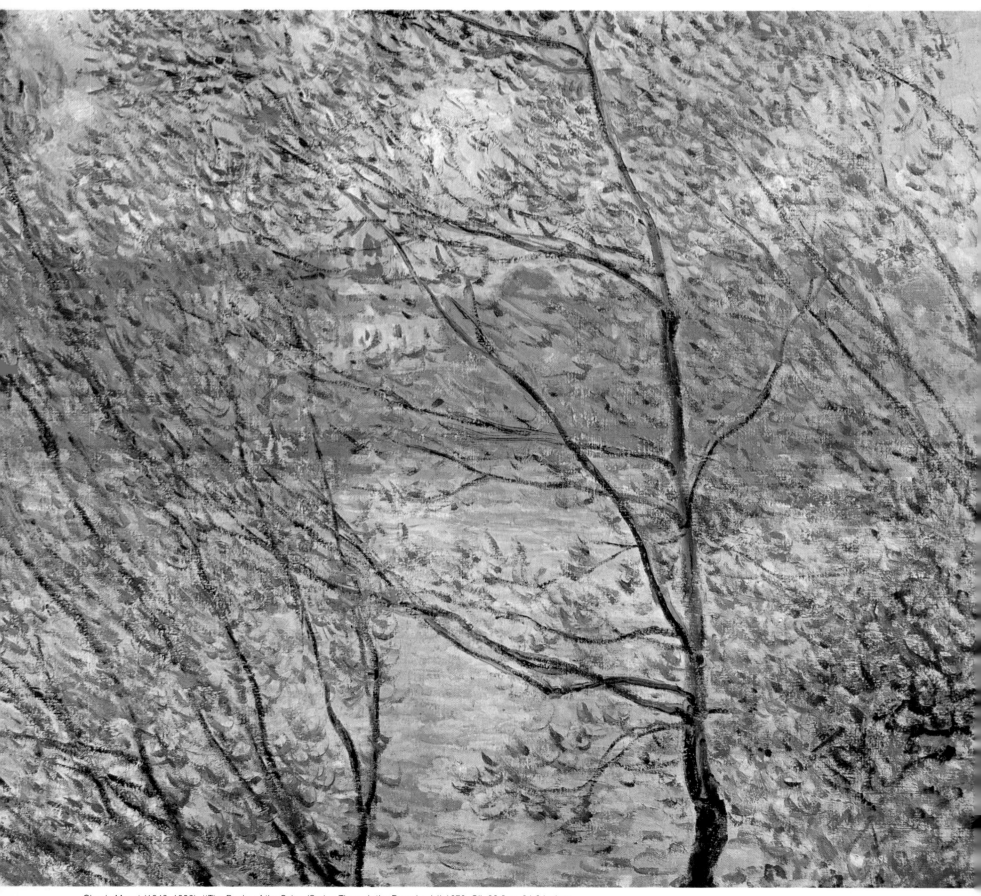

Claude Monet (1840–1926). ''The Banks of the Seine (Spring Through the Branches).'' 1878. Oil. 20.3 × 24.6 inches.

LANDSCAPE BECOMES indistinct, detail decomposes in the distance, hidden by branches and foliage which occupy the foreground. The interest lies in the abstract play of dark lines across the surface extended by a shimmering of colored spots. Some eighty years in advance, the painting opposite by Monet announces Franz Kline's and Jackson Pollock's abstraction.

Pissarro reveals the best of himself in modest and finely represented thickets as in the two paintings on this page. As early as 1868 Zola said, "One can hear the profound voices of the earth, one can sense the powerful life of trees. . . . One merely has to glance at such works to realize that there is a man in them, an upright and forceful personality, incapable of falsehood, making art a pure and eternal truth."

Pissarro, however, remained misunderstood. "What I suffered is unheard of," he wrote at the time when he painted the pictures shown here, "what I am suffering at the present time is terrible, all the more so that, being young, full of enthusiasm and ardor, I am convinced of being lost to the future. Yet it seems to me that, if I had to start again, I would not hesitate to follow the same path."

Sisley's fate was hardly more brilliant. In 1878 only one of his thirteen paintings at the Hoschedé auction fetched the sum of 251 francs. On the threshold of death, the most discreet of all the Impressionists anxiously wondered if his doctor bills would amount to more than two hundred francs.

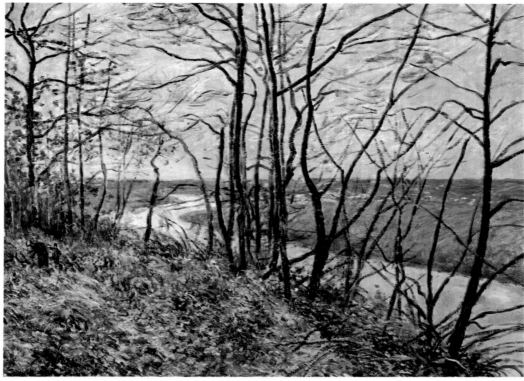

Alfred Sisley (1839–99). "Path on the Rocks." 1881. Oil. 21 × 28.5 inches.

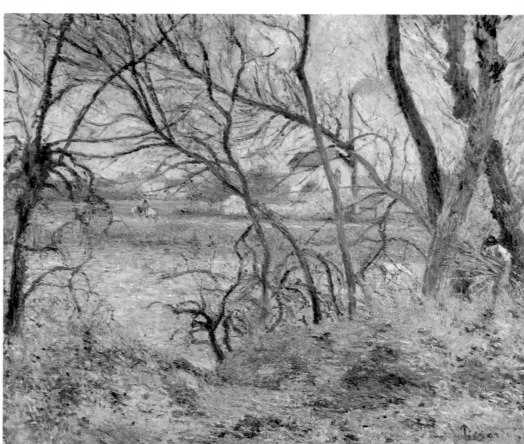

Camille Pissarro. "Banks of the Oise, Near Pontoise, Drab Weather." 1878. Oil. 21.45 × 25.35 inches.

Camille Pissarro (1830–1903). "La Côte des Boeufs à Pontoise." 1877. Oil. 44.9 × 33.9 inches.

233

From the convex to the flat area, the artist's geometricized face gradually merges into the decor.

IN PAINTING HIS self-portraits Cézanne gradually integrated the head into the background of the painting so that the face lost its compactness. The convex roundness of the head changed into a flat area. The decor acquired a geometrical aspect and gained in plastic presence. Between the model and the wall space diminished. As Pierre Francastel writes, "We can see background and figure on the same level. They are on the same plane of interest, at the same psychic distance from the spectator." At the same time space becomes finer. We go from a thickly painted face to a fluid, even transparent texture (*right page*), for example, the sleeves and the window. The psychological record becomes less precise for the benefit of a deliberately inexpressive and stereometric conception of the human figure.

Cézanne painted more than thirty self-portraits. A single-minded man, entirely devoted to his task, nevertheless he was not lacking in humor. Monet tells how one day at the Café Guerbois he shook hands with everyone except the elegant Manet, saying, "I shall not shake your hand, Monsieur Manet, I have not washed for eight days." Misunderstood, constantly wavering between modesty and pride, still considered in 1887 "an artist with sickly retinas," as Huysmans called him, Cézanne saw his influence on the new generation gradually supplant that of all other artists. Five days before his death, he wrote to his son in his aggressive and fiery style, "Compared with me all my fellow artists are a bunch of idiots. . . . I find that young painters are much more intelligent than the others; as far as the old ones are concerned, I am nothing more than a disastrous rival."

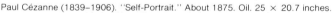

Paul Cézanne (1839–1906). "Self-Portrait." About 1875. Oil. 25 × 20.7 inches.

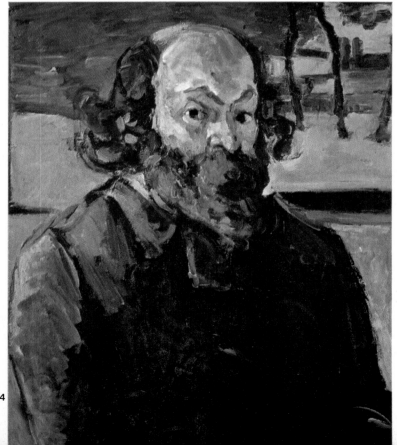

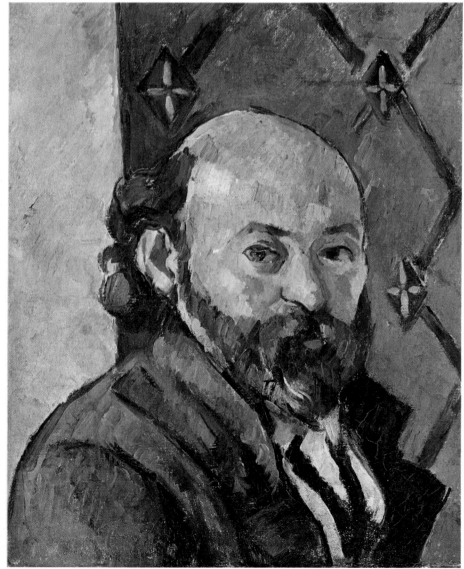

Paul Cézanne. "Self-Portrait." Between 1879 and 1882. Oil. 13.3 × 10.5 inches.

234

Paul Cézanne. "Self-Portrait with a Hat." Between 1879 and 1882. Oil. 25.35 × 19.9 inches.

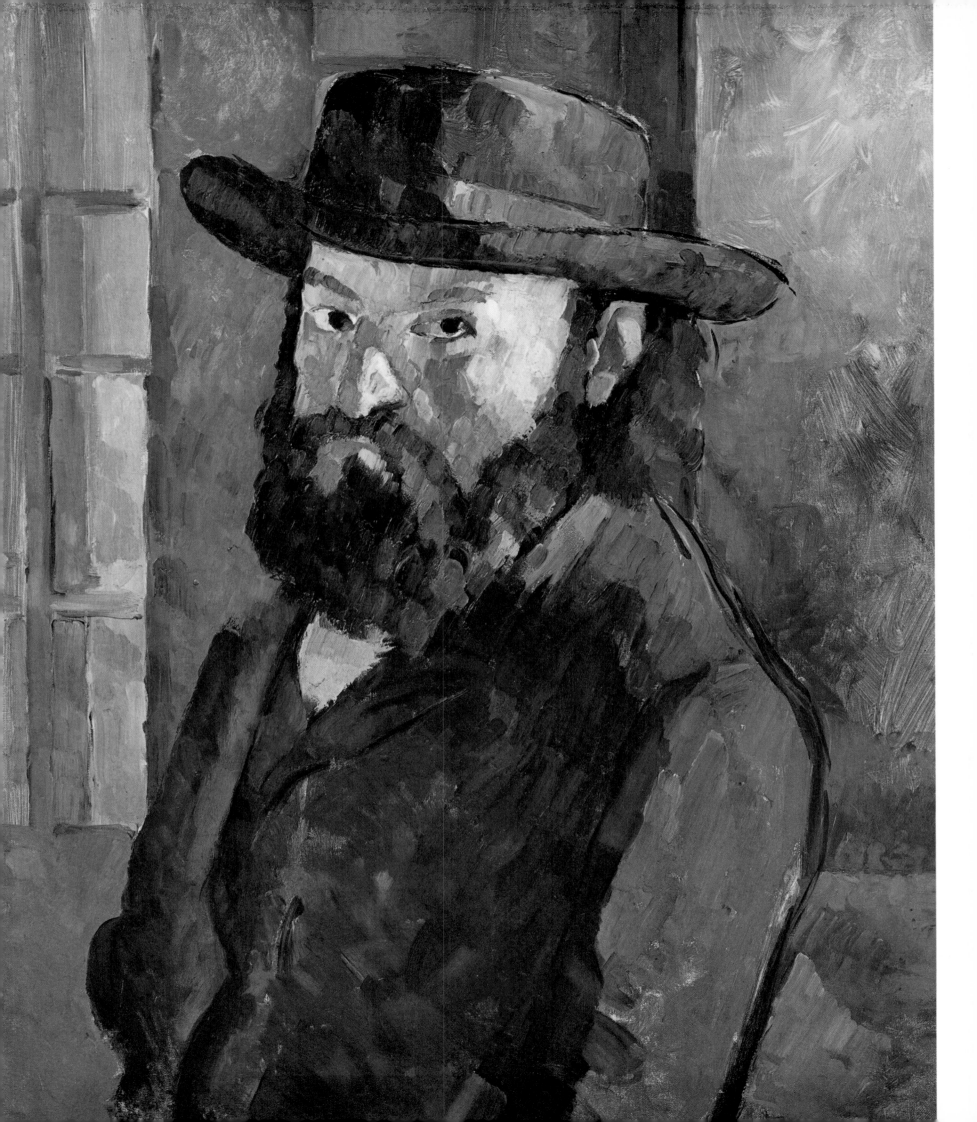

Cézanne's immobile figures are placed against an enclosing background.

Paul Cézanne (1839–1906). "The Old Gardener." 1902–6. Oil. 25.35 × 21 inches.

SET AGAINST THE decor, modeling retains an almost mineral stiffness. In the portrait of Chocquet (*right*) a play of lines encloses the hieratic silhouette of the collector, friend of both Renoir and Cézanne. The composition is based on horizontals and verticals, the few diagonals, reduced to a minimum (the legs, the arms of the chair, the hands), being sufficient to avoid monotony. A skillful color accent in the carpet in the foreground is repeated in the pattern of pear-shaped spots in the background.

Several axes of various depths converge in a single point, Chocquet's left hand. Utterly faithful to sensation, even at the expense of likeness, Cézanne does not paint at equal height the two fragments of black horizontals, right and left of the armchair, which mark the edge of the floor. "I see the planes overlap," he was to say, "and the lines often seem to fall."

Victor Chocquet, a simple employee at the Ministry of Finance, was one of the great collectors of the nineteenth century. He began to spend his savings to buy several works by Delacroix. In 1875 he asked Renoir, then still unknown, to paint a portrait of his wife. He bought two Cézannes at Père Tanguy's exclaiming, "These will look very well between a Delacroix and a Courbet!" The two men became friends and confessed a common admiration for

Delacroix who, as Cézanne stated, "served as intermediary between us." Together in the apartment in the Rue de Rivoli, tears in their eyes, they studied Delacroix's watercolors in Chocquet's possession. The latter was to own as many as thirty-two Cézannes. Théodore Duret described him, during the Impressionist exhibition of 1876, "approaching visitors he knew and introducing himself to others in an effort to have them share his conviction, admiration, and pleasure. A thankless role. . . ."

As for the old gardener (*left*) he was to be the model of the final "Portrait of Vallier" masterpieces (see page 92). "In painting Vallier in 1906, the last year of his life, either in oil or in watercolor," wrote Lionello Venturi, "one would think that Cézanne had painted and conversed with himself." On October 20, 1906, Marie Cézanne, the painter's sister, wrote to Cézanne's son, "Your father has been ill since Monday. . . . He remained exposed to the rain for several hours and was taken home on a laundryman's cart; two men had to carry him up to his bed. Next day, as soon as it was morning, he went into the garden to work on a portrait of Vallier, beneath the lime tree; he returned a dying man." Cézanne succumbed two days later.

Paul Cézanne. "Portrait of Victor Chocquet." Between 1879 and 1882. Oil. 17.9 × 14.8 inches.

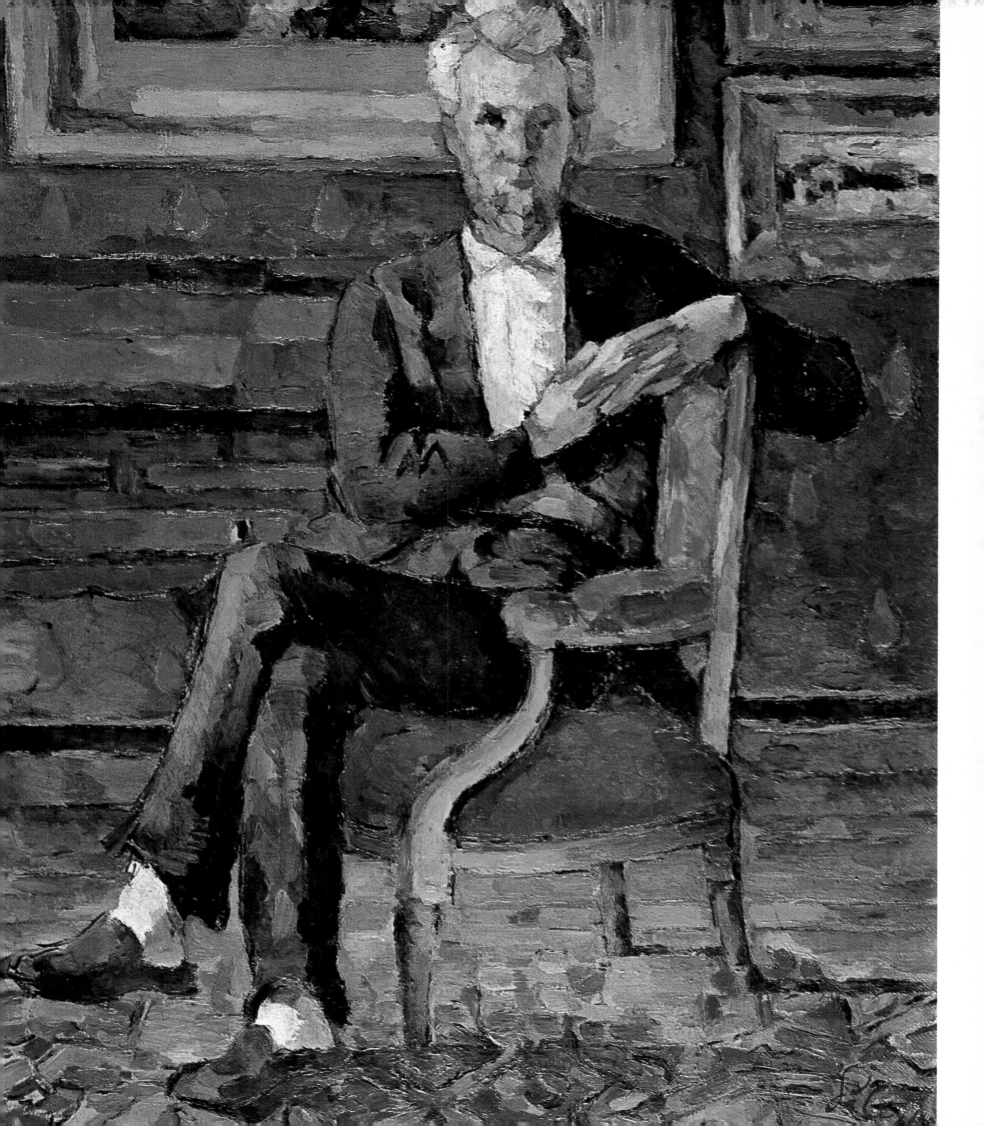

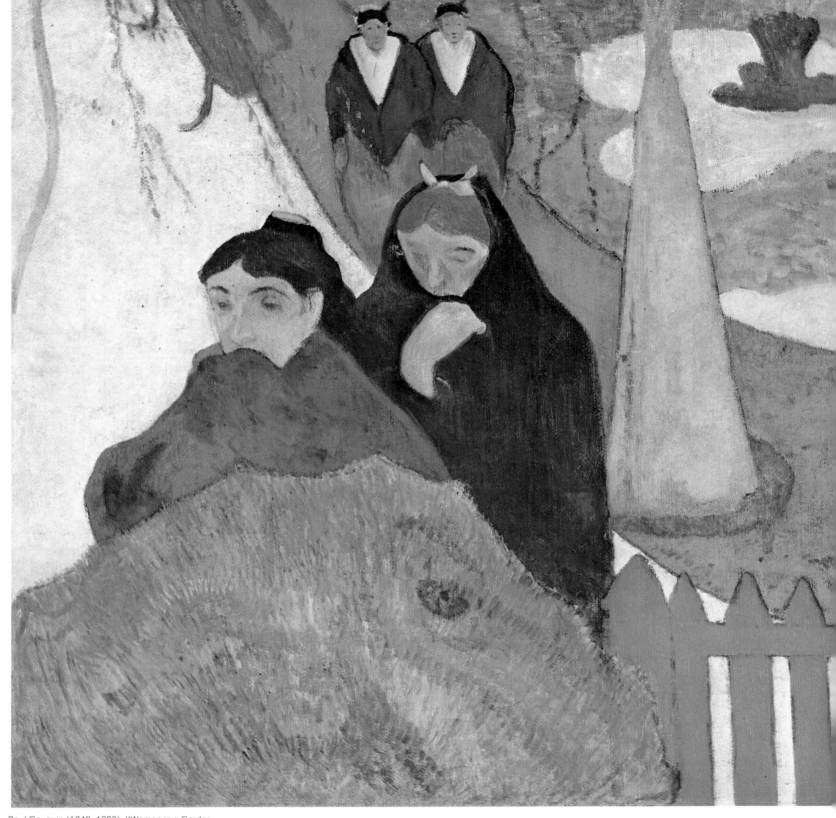

Paul Gauguin (1848–1903). "Women in a Garden, Arles." 1888. Oil. 28.5 × 35.5 inches.

With his plunging view the artist, inspired by Hokusai, changes the Arlesian women's promenade into a Japanese print.

"YOU KNOW, I feel as though I were in Japan," wrote Van Gogh to his brother Théo a few days after he had settled in Arles on February 21, 1888. And he soon wrote, "Japanese art, decadent in its homeland, is taking fresh root in French Impressionist artists." The painter, who had spent entire days at the Galerie Bing in Paris, in 1886, studying thousands of prints imported from the East, felt this influence to an even greater degree when Gauguin came to join him in the South of France. Gauguin and Bernard at Pont-Aven had experimented with Neo-Impressionism with its strong Oriental influence. Gauguin brought with him his young comrade's "Breton

Women in the Meadow" (*see* page 160) which formed the baptismal certificate of the new school. To grasp this doctrine, Van Gogh made a watercolor copy of Bernard's painting. Then he painted a composition inspired by Gauguin's "Women in a Garden" (*above*)—his "Promenade at Arles" (*right page, below*). By comparing the canvases we can easily see what Van Gogh borrowed from his friends—the rather offhand perspective, the absence of a horizon line, the figures in the foreground revealing only half their bodies. We also see, however, everything that separates them. Whereas Gauguin offers us a decorative, serene, rather cold scene with strange conical trees, Van

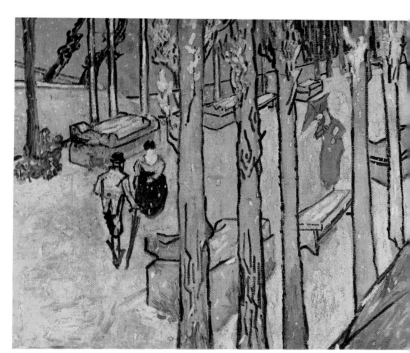

Vincent van Gogh (1853–90). ''The Alyscamps.'' 1888. Oil. 28.5 × 35.9 inches.

Gogh puts his whole feverish being into the work and offers us a composition full of twisted bushes and violent thick colors applied in rectangular small brushstrokes.

The Japanese influence is felt even more so in ''The Alyscamps'' (*above, right*) painted in November, 1888, reminiscent of the angular view seen in some of Hiroshige's vertical prints. Writing to his brother Théo, Vincent stated, ''I have painted two studies of falling leaves in an alley [the Alyscamps] of poplar trees and a third one of the entire alley, completely yellow but with an old chap and a woman fat and round as a globe.''

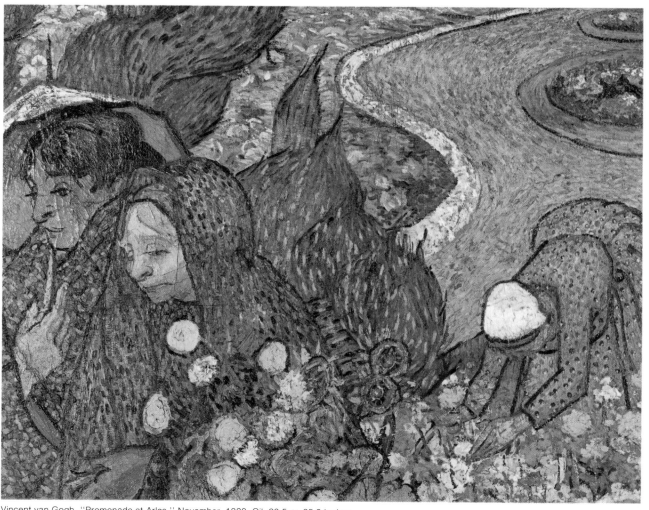

Vincent van Gogh. ''Promenade at Arles.'' November, 1888. Oil. 28.5 × 35.9 inches.

Cézanne insisted that his model remain "as motionless as an apple."
He treated the physiognomy of his wife and son as still life.

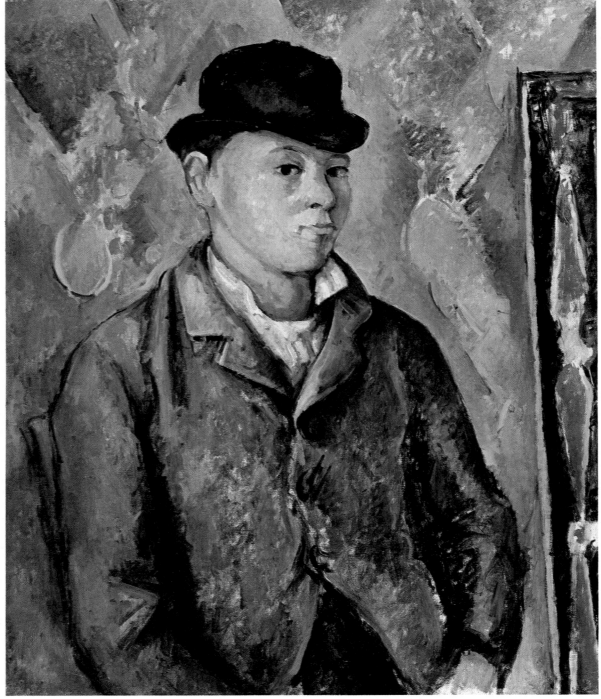

Paul Cézanne (1839–1906). "Portrait of Paul Cézanne, the Artist's Son." 1885. Oil. 25.35 × 21 inches.

IMMOBILITY WAS REQUIRED by Cézanne from his models. He conceived of portraiture as a special category of still life. The psychology of his figures mattered little; he was not interested in their thoughts but in their form. They had to remain "as motionless as an apple," and he would become angry if fatigue caused them to make the slightest movement. He tolerated no distraction: A barking dog or noise from a passerby made him furious. "When I work, I must be left in peace," he said. Worried, dissatisfied, he required from two- to three-hour sittings, eighty for the critic Gustave Geffroy, 115 for the art dealer Ambroise Vollard. To him he said, leaving the painting unfinished, "I am not displeased with the shirt front." He added, "try to understand a bit, Monsieur Vollard, I have a slight sensation, but don't succeed in expressing myself. I am like a man with a gold coin and unable to spend it." In a burst of anger, he would often rip the unfinished canvas, even throw it out the window. This attitude explains the tense expression of his figures, not without recalling on occasions the stiffness of a Zurbarán. When he was doing a portrait of Madame Cézanne (*right*)—whom he painted twenty-six times—or his son (*left*), the sittings were all the more painful since not one member of the family believed that the artist had the slightest talent. Hortense Fiquet, whom Cézanne had met in 1870, was to wait sixteen years before the artist, in fear of his father, legitimatized their union. She generally lived separated from a husband whose motivations escaped her. The son, born in 1872, presented by Cézanne as "a man of genius," was to become known chiefly for distributing his father's works. In these two portraits, angular forms, which represent partly concealed frames, balance the soft lines. The amazing vertical of Hortense's skirt and the foreground texture behind Paul Cézanne announce the hatched brushstroke of Cubist painters.

Paul Cézanne. "Madame Cézanne in a Red Armchair."
About 1877. Oil. 28.1 × 21.8 inches.

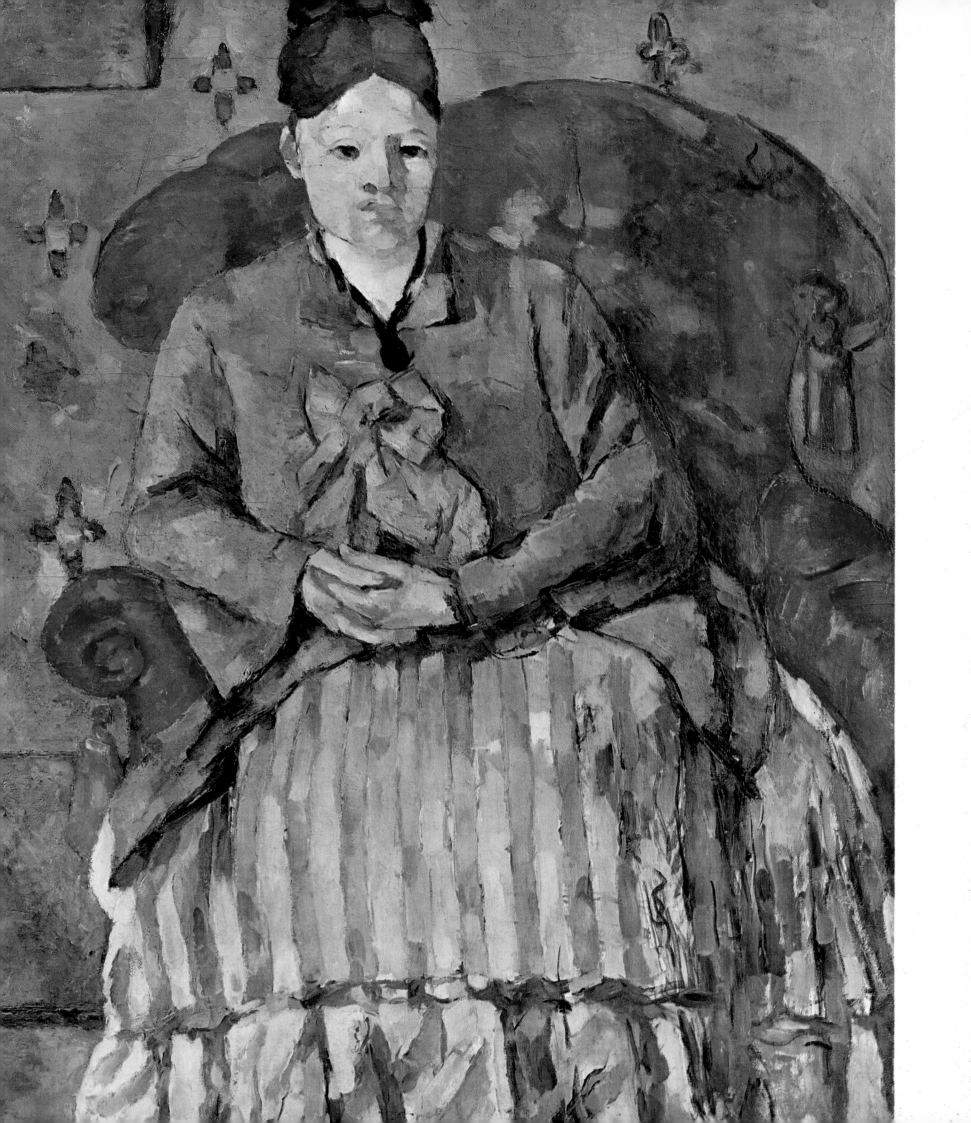

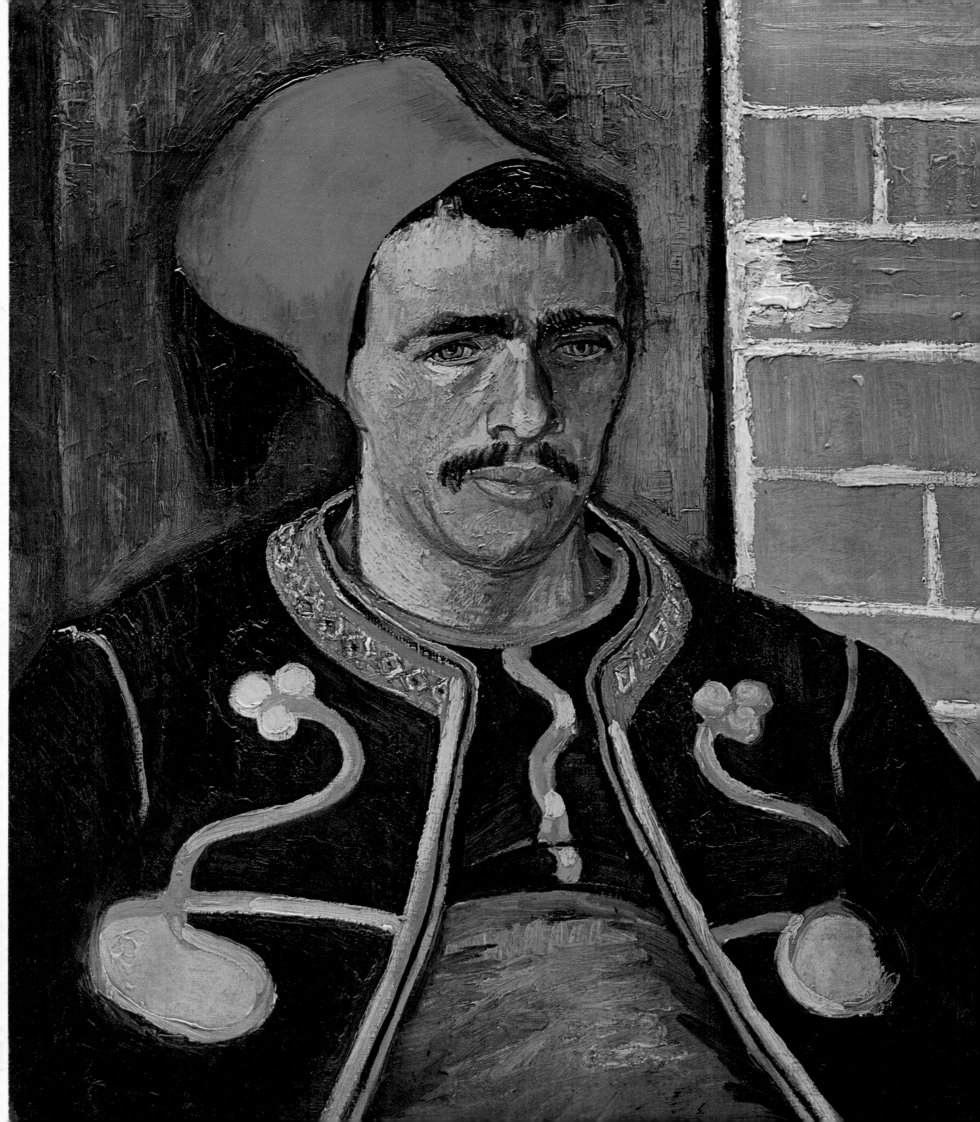

FASCINATED BY THE striking uniform of the Zouave Milliet, Van Gogh became his friend during the soldier's furlough after serving in the Tonkin campaign. The artist himself gave him drawing lessons and even asked him to pose. "The bust that I painted of him was horribly difficult, in blue uniform with blue enameled *Casserolles*, with light orange-red trimmings, two lemon stars on the chest an ordinary blue and difficult to do. The feline, very tanned head topped by a madder cap I placed against a door painted green and the orange brick wall. It is therefore a brutal combination of dissimilar tones not easy to control. The study I made of him seems to me very hard, and yet I should always like to work at vulgar and even flashy portraits like that." In the second portrait of Lieutenant Milliet the figure is placed against a white wall (*below*) in a spatial arrangement which Van Gogh returned to for his famous "Chair" (*right*). He considerably raises the floor as though to have it extend the wall. All traditional logic is absent in these two contradictory perspectives. The artist seeks merely to bring our eye closer to the subject, to project it to us, to justify an element of the setting—the pattern of light brown tiles—which in the actual room doubtless formed a strong contrast with the whitewashed wall. By the juxtaposition of clashing colors and the artifice of the raised floor, Van Gogh creates in the spectator a feeling of immediate proximity. His paintings summon us; the objects or figures described impose their presence on us with the same obsessional force that the artist spent in creating them. Lieutenant Milliet recalled that the artist was "a strange fellow, impulsive, like someone who had lived a long time in the sun of the desert. . . . A charming companion when he knew what he wanted, which did not happen every day. We would frequently take beautiful walks through the countryside around Arles, and out there both of us made a great many sketches. Sometimes he put his easel up and began to smear away with paints. And that, well, that was no good. This fellow who had a great taste and talent for drawing became abnormal as soon as he touched a brush. . . . He painted too broadly, paid no attention to detail, did not draw first. . . . He replaced drawing by colors."

"Vulgar" colors and false perspective give Van Gogh's figures the impact of a playing card.

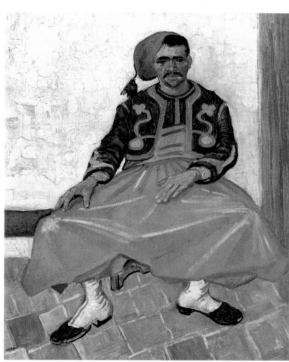

Vincent van Gogh. "The Zouave." 1888. Oil. 31.6 × 23.8 inches.

Vincent van Gogh (1853–90).
"A Zouave." 1888. Oil.
25.35 × 21 inches.

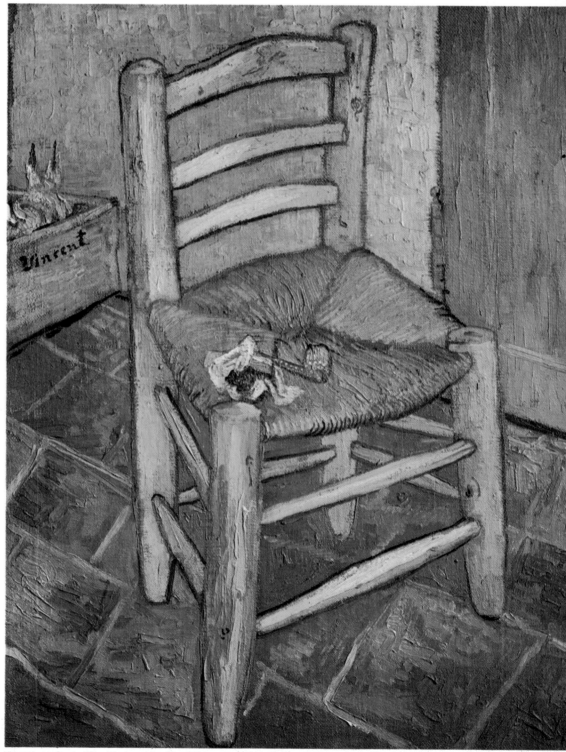

Vincent van Gogh. "The Chair and the Pipe." December, 1888–January, 1889. Oil 35.9 × 28.5 inches.

G. Caillebotte.

Gustave Caillebotte (1848–94). "The Balcony." 1880. Oil. 25.35 × 21 inches.

The painter carries the viewer away in a network of arabesques. Dynamic curves replace classical composition.

Paul Gauguin (1848–1903). "Still Life with Three Puppies." 1888. Oil on wood. 35.9 × 24.6 inches.

NEW COMPOSITIONAL methods appeared which would have seemed mad to Courbet's generation. Gustave Caillebotte, long considered a minor member of the Impressionist group, was chiefly appreciated for his generous and discreet aid to the most impoverished leaders of the movement. But some of his works bear comparison for their audacity with Degas' most inventive figures. Caillebotte's "The Balcony" (*left page*) expresses a visual spontaneity which only the twentieth century—the century of photography—could fully

appreciate. Instead of looking directly on the large space before the Opera House seen from his window (see page 77), the artist chooses as his pictorial theme the cast ironwork in the foreground. The subject of the composition becomes a vertical plane a few inches wide. No consideration of plastic order, such as balance and composition, questions what the eye actually sees. A light and shade effect—the dark railing, the light exterior—emphasizes the graceful design of the metallic curves which we feel

extend beyond this unusual close-up.

Using the same principle of dynamic curves, Gauguin takes our eye from one end to the other of his canvas (*above*). The curve of the puppies' tails counterpoints the pears and the roundness of the cups and of the terracotta bowl. A ternary rhythm—three cups, three pears, three puppies—enlivens the surface with, here and there in the tablecloth, curious outlines of leaves and plants which summon to mind the rubbings of a Max Ernst and the textures of a Paul Klee.

This work reveals various influences. The still life with fruit was inspired by Cézanne, while the animal scene seems to have come from a Japanese print by Kuniyoshi. "It already reminds us of Matisse or Bonnard's work in *La Revue Blanche*," wrote Françoise Cachin. ". . . This will to paint a naïve picture and the black outline of the puppies certainly belong to the 'childish painting' which Emile Bernard and Paul Gauguin announced to Van Gogh."

Paul Sérusier (1864–1927). ''Landscape of the Bois d'Amour (the Talisman).'' 1888. Oil. 10.5 × 8.6 inches.

Nature is depicted in spots of color.

GAUGUIN LED HIS followers to the path of abstraction. The subject was now nothing more than a pretext. The artist sought to release "the mysterious affinities between our brain and arrangements of colors and lines." Overlapping as in a puzzle, the subtle feminine forms of "Above the Chasm" (*below*) communicate with the jagged spot in the center of the composition. The crushed perspective—the cow and boat are practically on the same plane—is meant to remove all realistic character from the described space. We are no longer before a landscape but in the presence of a combination of colors. Ruled by Gauguin, Sérusier took this formula to its conclusion. His "Landscape of the Bois d'Amour" (*left page*) played an essential role in the development of the Nabis group. The student in charge at the Académie Julian, Sérusier was still a traditional painter when he visited Pont-Aven in the summer of 1888. Under Gauguin's severe presence, he composed the amazing rapid sketch (*opposite*). "How do you see this tree?" asked the elder painter. "It's quite green. Then use green, the best green on your palette. And this rather blue shadow? Don't be afraid to paint it as blue as possible." This was simplification and elimination of modeling. Never was

Sérusier to do better and the master himself was never to go further in the realm of nonrepresentational art. Remove a few tree trunks, the roof of a house, and we find ourselves in the presence of a contemporary painting which could almost be that of Joseph Lacasse, Serge Poliakoff, or Nicolas de Staël.

Sérusier's "Landscape of the Bois d'Amour" created a sensation in Paris in October, 1888. "When we returned, Gauguin's name was revealed to us by Sérusier back from Pont-Aven," related Maurice Denis. "He showed us, not without an element of mystery, a cigar box cover with a formless landscape because it was synthetically composed in purple, vermilion, Veronese green, and other pure colors as they leave the tube, almost without any mixing of white."

Sérusier's "Landscape of the Bois d'Amour" was to change radically the conceptions of the small group of beginners, Vuillard, Vallotton, Denis, Bonnard, all grouped around the elder Nabi, Sérusier. "We knew," wrote Denis, "that any work of art was a transposition, a caricature, the passionate equivalent of a received sensation." Fifty years later, thanks to the alchemy of color, Bonnard's work (*right*) still reveals the lesson of this early shock.

Pierre Bonnard (1867–1947). "The Garden." About 1937. 49.9 × 39.4 inches.

Paul Gauguin (1848–1903). "Above the Chasm." 1888. Oil. 28.1 × 23.8 inches.

Van Gogh relegates details of landscape to the edges of the composition. He liberates a tumultuous space in which he projects his solitude.

VAN GOGH's "Enclosed Meadow," like an expanding lung, seems to express his hopeless thirst for freedom which had overcome him during his last days in the St.-Rémy asylum. From his barred window he had made several paintings, in 1889, of the closed space spread out before him, bordered on the horizon by the flanks of the Alpines. The version painted in 1890 (*opposite*) best reveals the obsessive presence of a dyke wall which not without much difficulty canalizes the agitation of a field as tumultuous as the sea. After several terrible crises, Van Gogh requested to be admitted to the asylum in March, 1889, and remained often for weeks prostrated in his cell. "I need courage which I often lack," he wrote to his sister Wilhelmina. "It is also because since my sickness of feeling of solitude seizes me in the fields in such a dreadful way that I hesitate to go out. But as time passes this will change again. Only when I am working in front of my easel do I still feel some life. . . ." The violent work he produced during this period impressed his brother Théo, who **told him to moderate his efforts**. "How your brain must have worked and what risks you must have taken to the very point where dizziness is inevitable. . . . You must not risk these mysterious

regions which one can approach but not penetrate without impunity."

After his crisis of March–April, 1890, Van Gogh felt the increasing need to flee the debilitating atmosphere of the asylum. "I need air," he said. "I feel at the abyss of boredom and sorrow." It was during this period that he painted "Enclosed Meadow." His great compositional authority enabled him to **offer this audacious view of a space** entirely executed in hatchwork, relegating details of the landscape ordinarily thought dominant to the edges of the composition, the whole expressing the confused and organic business of nature. His whole being seems to have been engaged in the long slash which crosses the picture. Oriental influence is evident here. "The Japanese draw very quickly, like a flash of lightning," he wrote in June, 1888. "This is because their nerves are finer, their feeling simpler."

A few days after finishing this work, Van Gogh left St.-Rémy for Auvers, where he arrived on April 21, 1890. He at once set to work. "I have painted huge wheat fields under troubled skies," he wrote to his brother Théo, "and I did not exert myself to express sadness and extreme solitude."

248 Vincent van Gogh (1853–90). "Enclosed Meadow." May, 1890. Oil. 28.1 x 35.9 inches.

ANGULAR AND TWISTED, tree trunks cross
the visual field and add a note of
uneasiness to the serenity of the
Provençal landscapes saturated with
sunshine. Modern cinema was also to
use the disturbing rhetoric of the
close-up view when, for example, the
camera panoramically films obstacles
which block the eye to reveal all at once
the open space in which a drama is
coming to a climax.

By introducing vertical elements in
the foreground, the artist brings his
composition to the fore. The painted
space—the trees—is identified with the
real space, namely, the flat canvas
surface. This formula was to be used by
Vlaminck, Dufy, Braque, Picasso, and
others. Mondrian, progressing by a
series of steps, was to make the tree one
of the chief subjects of his transitional
period between representational and
abstract art. Cézanne's and Van Gogh's
trunks offer a foretaste of the black lines
used by the father of De Stijl to
stabilize his geometrical constructions.
But Cézanne also created an ambiguous
space with his trees, thanks to the
branches which blend with the foliage
in the background. For him this offered
a means of blurring perspective. Van
Gogh's perspective, however, is more
solid. In copying Hiroshige's "Plum
Tree in Blossom," he assimilated the
Japanese layout. This durable influence
by no means effaced that of the master
of Aix. "Involuntarily what I saw of
Cézanne comes to mind because he
painted the raw aspect of Provence,"
wrote Van Gogh in the summer of 1888.

Vincent van Gogh (1853–90). "The St.-Paul Hospital." 1889. Oil. 35.1 x 27.7 inches.

Paul Cézanne (1839–1906). "The Twisted Tree." 1882–85. Oil. 17.9 x 21.45 inches.

Vincent van Gogh. "Park of the St.-Paul Hospital." 1889. Oil. 16.4 x 12.5 inches.

A foreground of twisted trees animates and lends a dramatic note to the Provençal landscape.

The abstract flight of a Japanese wave was utilized
by Gauguin as a decorative device.

Paul Gauguin (1848–1903). "Ondine (Woman in the Waves)." 1889. Oil. 35.9 x 28.1 inches.

GAUGUIN'S DECORATIVE virtuosity is strikingly evident in the layout of "Ondine" (*opposite*), painted at Le Pouldu in 1889. The same rear silhouette is seen in many woodcuts and paintings which the artist did during his Tahitian period when, turning to Japanese models, he tried to transcend Cézanne's influence. "He failed to understand me," Cézanne later said. "He is not a painter; he only makes Chinese pictures."

"Ondine" was one of the seventeen works exhibited by Gauguin in June at the Café des Arts, a brasserie inside the Universal Exposition of 1889 (the year of the Eiffel Tower). Dismissed from the official selection, the Synthetists had managed to convince the owner, Volpini, to hang some hundred of their works on the café walls. Writing about the show in *La Cravache*, Félix Fénéon stated, "It is not easy to approach these canvases on account of the sideboards, beer pumps, tables, the bosom of Madame Volpini's cashier, and an orchestra of young Moscovites whose bows unleash in the large room a music that has no relation to these polychromatic works."

Not a single painting was sold, but the exhibition, which included some twenty works by Emile Bernard, impressed the young Nabis who until now had no occasion to study Gauguin's style at close hand. Vallotton's women owe something to the outline of "Ondine," and it was here that Maillol, the future sculptor, was to find his Road to Damascus. The former pupil of Alexandre Cabanel at the Ecole des Beaux-Arts was amazed at what he discovered at Volpini's. "Gauguin's painting proved a revelation to me," Maillol later acknowledged. "The Ecole des Beaux-Arts, instead of enlightening me, had obscured my vision. Looking at his paintings of Pont-Aven I felt I would be able to work in the same vein. I told myself at once that what I was doing would be satisfactory when Gauguin would approve of it."

Maurice Denis devoted several pages to the prestige of the painter of Pont-Aven. "Gauguin was all the same the master, the uncontested master, the one whose paradoxes were collected and spread; we admired his talent, fluency of speech, gestures, physical force, scurviness, inexhaustible resistance to alcohol, and romantic appearance. The mystery of his ascendancy was to furnish us with one or two quite simple ideas at the very moment when we were totally lacking in teaching. . . . For our corrupted time he was a kind of Poussin without classical culture. Instead of leaving for Rome to study the ancients in a serene mood, he feverishly sought to discover a tradition in the crude archaic quality of the Breton calvaries, the Maiori idols, or even in the indiscreet coloring of the *images d'Epinal.*"

Aristide Maillol (1861–1944). "The Wave." 1898. Oil. 37.05 x 34.7 inches.

Claude Monet (1840–1926). "Poplars on the Banks of the Epte." 1891. Oil. 39.4 x 25.35 inches.

"MONET PAINTS OUR distance to things," wrote the critic Gustave Geffroy. In his Poplar series the artist succeeds in making us feel the impalpable presence of air which separates us from these tall and fragile trees rising in the light. Monet would set up his easel on the water level; this enhanced the presence of the large filiform trees whose outlines are eaten away by the solar rays. The reflection in the water emphasizes both symmetry and the picture plane. Never was this painter of the formless to go further in geometrical rigor than in the square canvas (*right*) reproduced here in its totality. The repetition of a rectangular structure, scarcely affected by the distant forms of a row of yellow trees, leads us to abstraction. The peasants of Giverny, who were well aware of Monet's passion for the surrounding countryside, gave him a hard time the moment they would see him become attached to a site. He had to pay for a few months to keep a haystack in order to study its changes. "Another time," related his step-son Jean-Pierre Hoschedé, "arriving in a boat on the Epte, where he painted his Poplar series, he noted that they had all been marked by an ax at the base of the trunk. After making inquiries, we learned that they were all to be cut down any day. Monet had to pay in order to delay this."

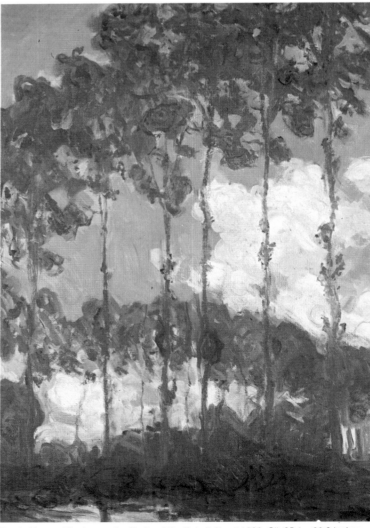

Claude Monet. "Poplars on the Banks of the Epte." About 1890. Oil. 35.1 x 28.9 inches.

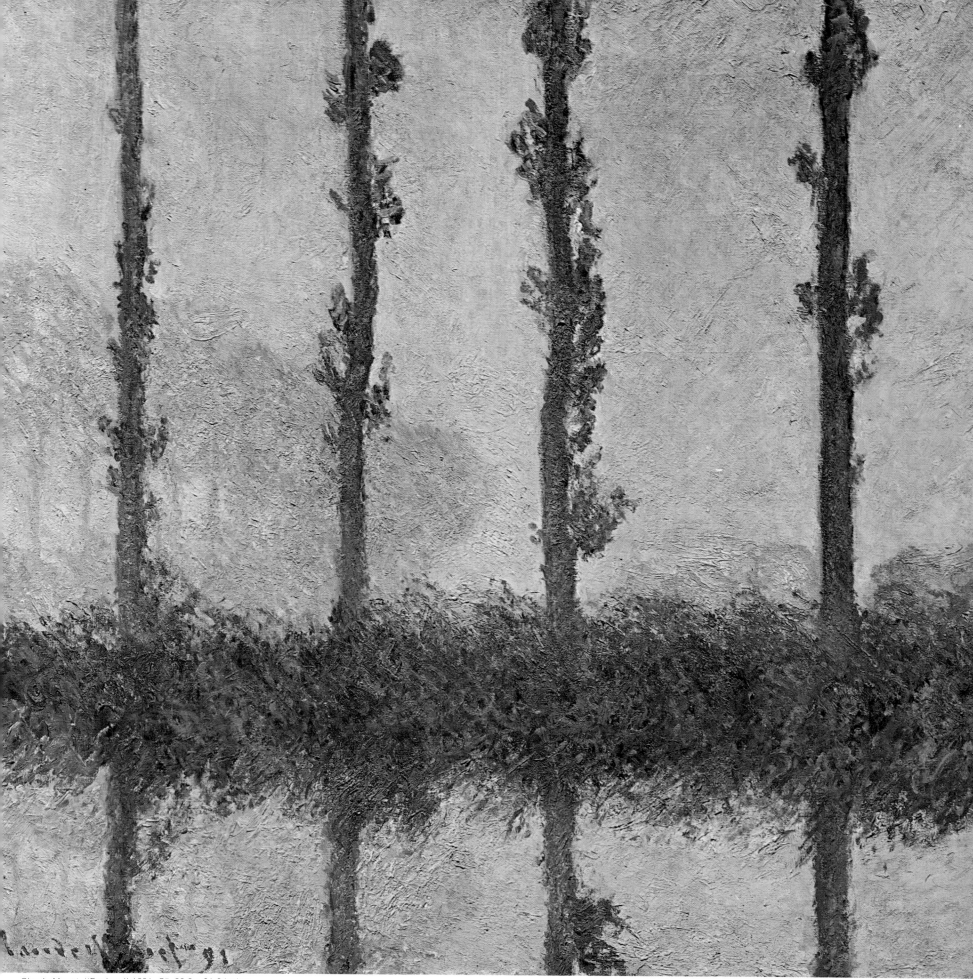

Claude Monet. "Poplars." 1891. Oil. 33.9 x 31.6 inches.

Monet erects his rustling trees in
the impalpable air.

Witnesses of familiar moments, the Nabis
expressed the congestion of 1900 interiors.

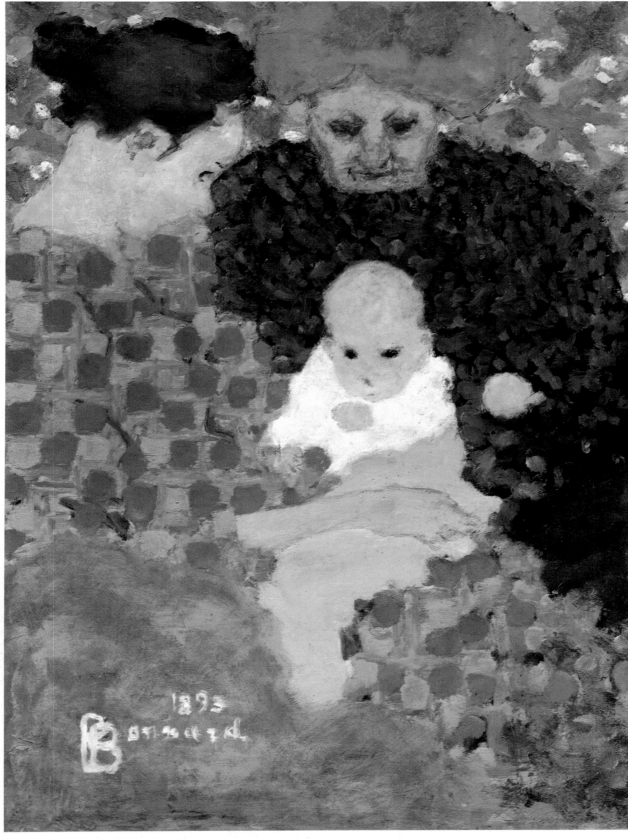

Pierre Bonnard (1867–1947) "The Three Ages." 1893. Oil. 17.9 x 12.9 inches.

EXPLORERS OF THE daily scene, Bonnard
and Vuillard sought their inspiration in
public squares, boudoirs, and children's
bedrooms. For both painters, observation
was only the point of departure. Their
compositions in which everything is in-
distinct and overlaps—the bouquet of
flowers, the tapestry, the women's blouses
(*right*)—were inspired by reality. Thadée
Natanson, who had many occasions to
observe Vuillard, said, "During the
course of a visit, the lighting of a lamp,
a creased blouse, a cushion, or even the
corner of a carpet were sufficient to
arouse his mind and set it to work. This
could become the banging of a drum in
him, whose enchanting result we would
inherit." The enchanting result, however,
was corrected by a Japanese influence.
The year 1890 saw the important re-
trospective exhibition of Japanese art
held at the Ecole des Beaux-Arts, and
the merits of Oriental composition left
a strong imprint on the entire new gener-
ation. Bonnard was called by his
comrades the Japanese Nabi. In 1903
Maurice Denis, a member and historian
of the new school, spoke of "*japonisme*,
that leaven which gradually invaded our
entire impasto."

The dress worn by the chief figure in
"The Three Ages" (*left*), painted by Bon-
nard when he was twenty-six, has a regu-
lar checker pattern. The painter disre-
garded the folds in the clothing created
by the model's seated position. This
manner of painting integrates the human
figure in the decor. What counts here is
the discreet harmony of tones and not
realistic rendering. The representation is
not eliminated from the canvas—this
would soon occur among abstract paint-
ers—but is absorbed there like a blotter
and becomes a component among others
in the play of spots.

Edouard Vuillard (1868–1940). "The Striped
Blouse." 1891. 25.35 x 22.6 inches.

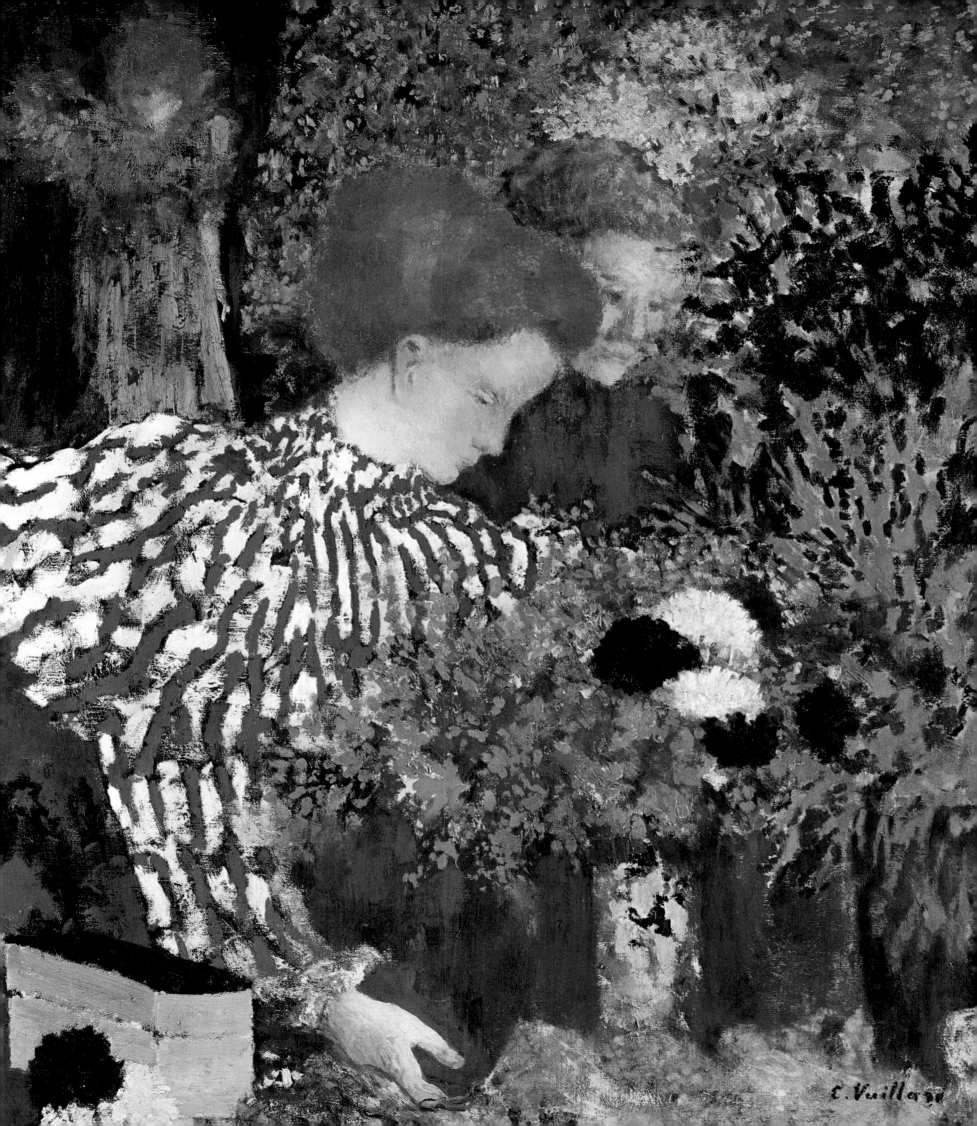

STILL LIFE, WHICH was Cézanne's major theme, offered him complete freedom to paint the subject as he wished. A skillful disorder, the result of a careful arrangement, characterizes the artist's compositions. As Charles Sterling wrote, "One cannot help believing that Cézanne constantly had in mind Dutch painters as well as Chardin when, before painting the objects, he would arrange on the table a white cloth which hangs from the edge. In reference to "Apples and Biscuits" (*below*) the same writer stated, "The arrangement here is of perfect simplicity and the composition is not closed, that is, a form—the dish of biscuits on the right—is cut by the frame. . . . In this painting we feel a wonderful ease, a grace, a joy of color and of harmony which recalls Mozart's music."

Whether severe, as in the painting once owned by Gauguin (*right page, above*), dominated by a white zigzag (*far right*), or based on the counterpoint of an oval and a play of broken lines (*right page, below*), Cézanne's composition is always seen from a superior view. The most lively colors are concentrated on the smallest masses, the rest of the painting being formed of generally soft tones and light hatchwork.

"In reading the accounts of Cézanne by his friends," writes Meyer Schapiro, "I cannot help thinking that in his preference for the still life of apples—firm, compact, centered organic objects of a commonplace yet subtle beauty, set on a plain table with the unsmoothed cloth ridged and hollowed like a mountain—there is an acknowledged kinship of the painter and his objects, an avowal of a gifted withdrawn man who is more at home with the peasants and landscape of his province than with its upper class and their sapless culture."

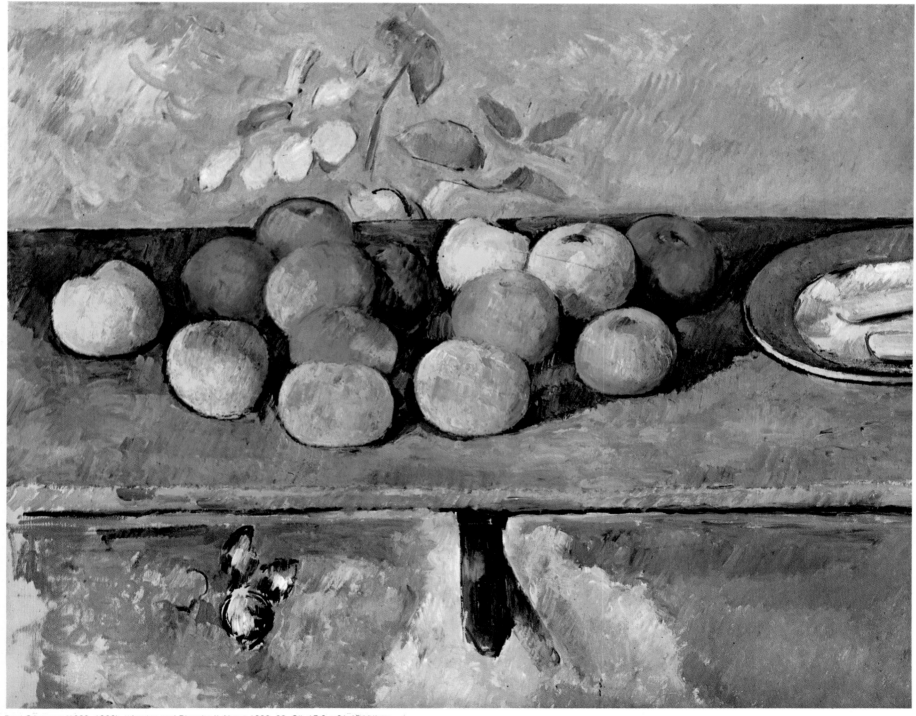

Paul Cézanne (1839–1906). "Apples and Biscuits." About 1880–82. Oil. 17.9 x 21.45 inches.

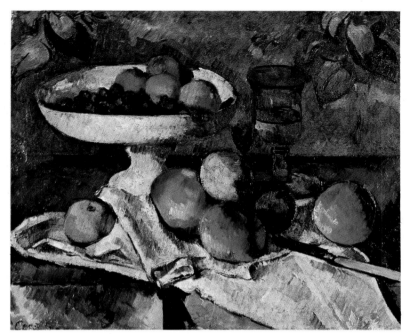

Paul Cézanne. ''Fruit Dish, Glass, and Apples.'' 1879–82. Oil. 17.9 x 21.45 inches.

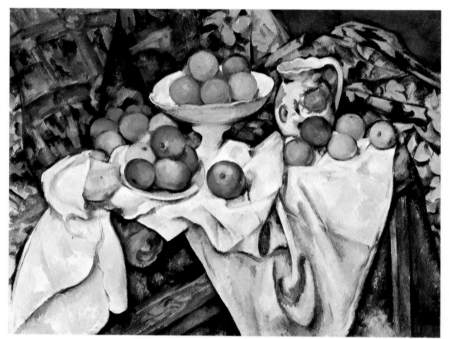

Paul Cézanne. ''Apples and Oranges.'' 1895–1900. Oil. 28.9 x 36.3 inches.

"I want to astonish Paris with an apple," stated Cézanne. With a few pieces of fruit arranged on a table . . .

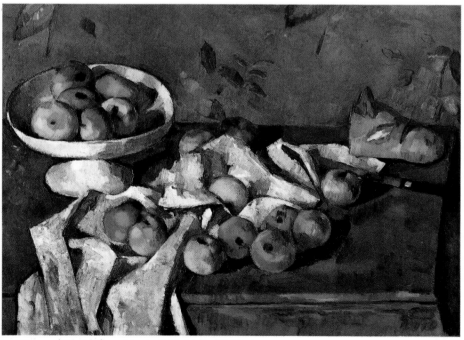

Paul Cézanne. ''Fruit Dish and Apples.'' Oil. 21.45 x 28.9 inches.

. . . he makes a battlefield where order
and chaos confront one another.

A TUMULTUOUS FORCE diagonally crosses the unusual still life seen here. Before Cézanne no one had dared such vehemence for static and familiar objects arranged on a table. The colored drapery seems to have been distorted by some uncontrollable vital energy. Something organic, linked to the pulsations of nature, underlies the dynamic quality of the composition.

Pissarro, writing about the retrospective exhibition which Vollard held of Cézanne's work, said, "The collectors are stupefied. They don't understand anything about it, nevertheless he is a first-rate painter of astonishing subtlety, truth, and classicism. . . . My enthusiasm is nothing compared to Renoir's. Even Degas has succumbed to the charm of this refined savage. Could we be wrong? I don't believe so. . . . As

Renoir said to me quite rightly, there is an indefinable something analogous to the Pompeii things, so crude and wonderful. . . . Degas and Monet bought some marvelous things. As for myself, I exchanged a few splendid Bathers and a portrait of Cézanne for a bad sketch of Louveciennes."

Recognized by his equals, Cézanne could at last begin to reassure himself. Three years before his death he wrote to Vollard, "I am obstinately working; I am catching a glimpse of the Promised Land. Will I be like the High Priest of the Hebrews or shall I be allowed to enter. . . . I have made some progress. Why so late and with such difficulty? In fact, is art not a priesthood which requires pure souls who belong to it entirely?"

Paul Cézanne (1839–1906). "Still Life with Flowered Curtain." 1900–6. Oil. 29.6 x 35.9 inches.

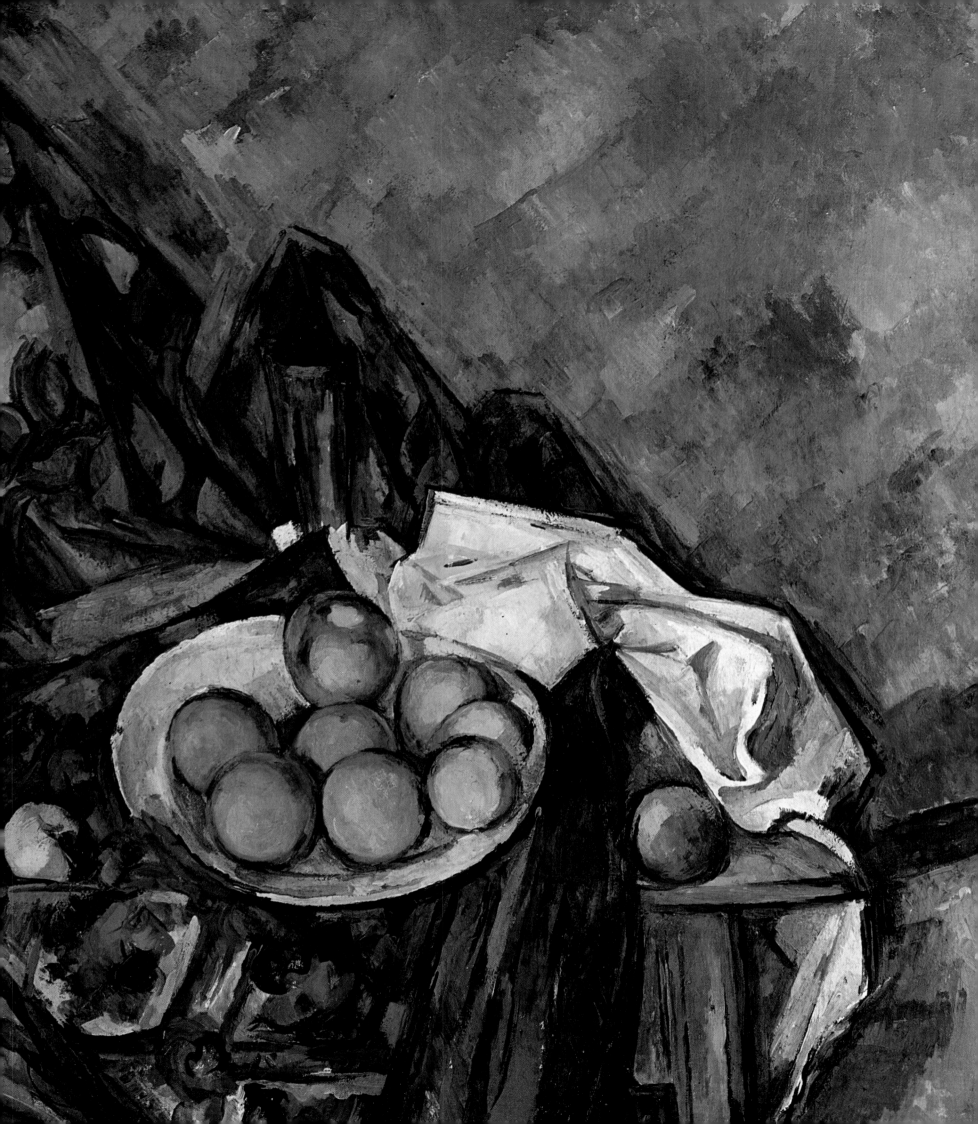

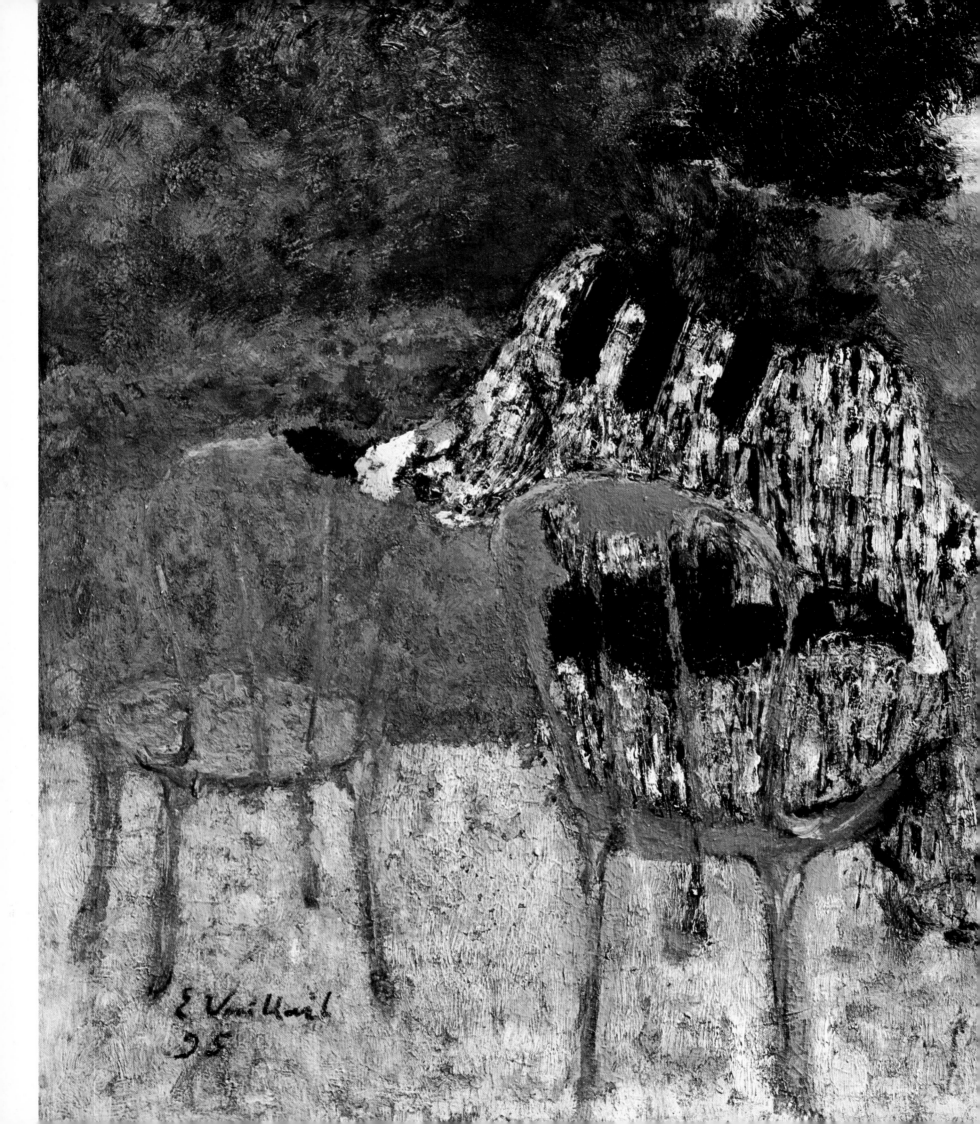

On fragile granular surfaces, Vuillard offers modest and now vanished perceptions.

VUILLARD'S ART IS an accumulation of spots heightened here and there by such deliberate dissonances as a child's scarf (*right*). His very subjective, secret, emotional vision bears comparison with the impressions of the young narrator Proust as he waits for Gilberte, his playmate, almost at the same period and in this same part of the Avenue des Champs-Elysées described by the artist (*left*).

Born in 1868, Vuillard was led to painting by Ker-Xavier Roussel, his fellow student at the Lycée Condorcet and his future brother-in-law. Vuillard was the most modest and silent of the Nabis. This group of young cultivated painters formed in 1888 to analyze collectively Gauguin's message. They would meet each week, first in a restaurant in the Impasse Brady, then beginning in 1890 at the home of the painter Paul Ranson, in the Boulevard du Montparnasse. Bound up with literary and musical Symbolism, they took an active part in the experiments of the Théâtre de l'Oeuvre, whose director, Lugné-Poe, was also one of Vuillard's former fellow students. They experimented in a fresh conception of the painted canvas, in which, to quote Maurice Denis, "*trompe-l'oeil* [illusion] gave way to an imaginative decor with its dreamy hangings." Vuillard, avid of technical innovations, developed his tempera painting.

Edouard Vuillard (1868–1940). "At the Champs-Elysées." 1895. Oil. 9.4 x 10.1 inches.

Edouard Vuillard. "Child Wearing a Red Scarf." About 1891. Oil. 11.7 x 7 inches.

Edouard Vuillard (1868–1940). "Vaquez Decoration." (Left panel:, "Woman Reading.") 1896. Oil. 83.8 x 60.4 inches.

Gustav Klimt (1862–1918). "The Park." Before 1910. Oil. 43.3 x 43.3 inches.

Neither depth nor modeling: Wallpaper changes into foliage and foliage into wallpaper.

WHETHER FOREST OR wallpaper, the external world becomes decorative and loses all its depth. In the strange painting (*above*) by Gustav Klimt, one of the champions of the Viennese Art Nouveau, almost the entire surface is covered by the foliage of the trees. If we hold our hand over the narrow horizontal bar running along the lower section of the painting, "The Park" changes into a wall that cannot be crossed, an opaque and disturbing proliferation.

Vuillard also used large flat planes with vegetal theme in the important panels executed for Doctor Vaquez's drawing room (*right*). He frames his floral themes in geometrical bands at the top and bottom. The Nabis' decorative vocation, since they were all anxious to leave the realm of easel-picture painting and turn to a mural scale, discovered in the Vaquez series an elegant transitional solution. As Maurice Denis wrote, "His paintings already expressed the picturesque and intimate interiors of our time. We are well aware now how he was able to decorate them and by which imaginative and artistic resources he managed . . . to produce these rich hangings like ancient tapestries."

Looking at such works, some have reproached Vuillard for delighting in rather a dull color range, far removed, for example, from the colored exploits of his friend Bonnard. "Vuillard is neither sad nor dull," writes the young French painter Martial Raysse. "[His work] is muted with great tonal depth and great textural quality. It is always more difficult to obtain a range of minor tones than to achieve a brilliant harmony. Vuillard's color is just right and it has an elegance, the taste for which has been lost in that for a multiplicity of tones. No one since has scarcely gone so far except Ensor and perhaps Fautrier. His is rather like a desperate attempt to make almost tactile notations of everything around him, furniture, objects, fabrics, and this to the point of accumulation and a swarming similar to that of ants. He tries to capture on the canvas a world he feels threatened and on the point of disappearing. That Vuillard was aware of the movements occurring in a transitional period in which everything was slipping away and coming apart, is proved to me in these paintings in which the tones are broken up and objects and figures interpenetrate."

Paul Cézanne (1839–1906). "*Le Château Noir*." Between 1904 and 1906. Oil. 28.5 x 35.9 inches.

Cézanne "germinates" with the landscape.
He explores the geological foundations. His
flat and vibrating brushstroke destroys perspective.

Paul Cézanne. "Lake Annecy." 1896. Oil. 25.35 x 31.6 inches.

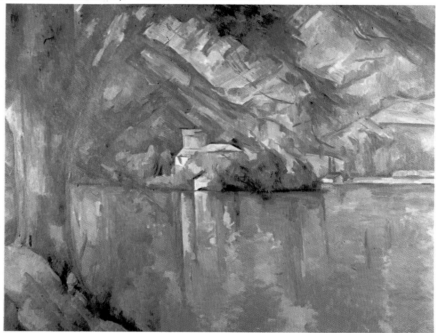

THE TWO LANDSCAPES by Cézanne on these pages are a complete break with Renaissance perspective. Both outline and vanishing point are muted. The space of "*Le Château Noir*" (*left*) is constructed by means of large, juxtaposed brushstrokes which express both the close and far. Two-thirds of the composition is filled by a confused green mass which the spectator "reads" and divides as he understands it in third dimension. By painting the building in the background more distinct than the foreground, Cézanne emphasizes the flat surface of the painting.

"Lake Annecy" (*above*) is divided horizontally into two large approximately equal planes. If we study the painting upside down, we will notice that the surface of the lake is treated as a wall. Cézanne makes no effort to offer an impression of depth. Quite the contrary. It is rather the upper section of the landscape, with the projecting section of the Château de Duingt on the bank, which appears closest to our eye. The mixture of branches, in the foreground, and of mountains in the distance emphasizes this spatial ambiguity, strengthened even further by the tree trunk which serves as a hinge between the upper and lower sections. "To paint a landscape well," said Cézanne, "I must first discover the geological foundations. Just think that the history of the world dates from the time two atoms encountered one another, when two whirlwinds, two chemical dances were combined. . . . Layers were established, the large planes of the canvas. I mentally draw the stony skeleton. I see the rocks just at the water surface, the weight of the sky. . . . The great classical landscapes, our Provence, Greece, and Italy as I imagine them, are those in which clarity spiritualizes itself, where a landscape is a floating smile of sharp intelligence."

The painter's scrupulous eye perceives the wavy, floating quality of nature. Each brushstroke designates several depths.

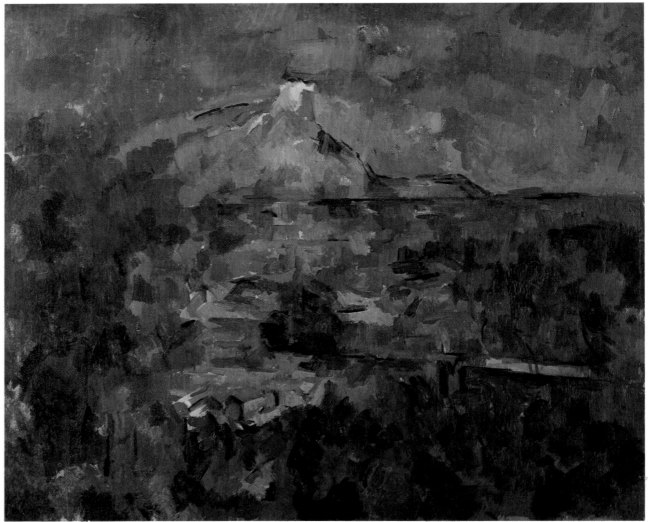

Paul Cézanne (1839–1906). "Mont Ste.-Victoire." 1904–6. Oil. 23.4 x 28.1 inches.

"A STUNNING SUBJECT is spread out facing east, the Mont Ste.-Victoire." In such terms Cézanne, then thirty-nine, pointed out to Zola the landscape which was to preoccupy him until his death. He painted the mountain sixty times and in his final versions dating from the years 1904–6 he achieved a radiating and vibrant conception; each plane seems to float in open space in a luminous reflection. Space is no longer something *set* but free. The brushstroke no longer represents this or that object but several depths at the same time. Taken in a cosmic mixture, each brushstroke is both earth and sky, reflection and matter, the ephemeral and the immemorial. "I remained for a long time without being able to paint, and without knowing how to paint, Ste.-Victoire," explained Cézanne to Gasquet, "because I imagined the concave shadow as the others who

fail to look, but look, it is convex, it vanishes from its center. Instead of heaping up, it evaporates, becomes fluid. It takes part, all bluish as it is, in the ambient breathing of the air. . . . Look, what *élan*, what urgent thirst for sunshine and what melancholy in the evening when all this weight falls. . . . These blocks were fire. There is still fire in them. Shadow, light, seem to withdraw trembling, in fear of them."

A detail (*right*) reveals Cézanne's unbelievable freedom in the treatment of the surfaces. Not only does he seem to paint disorderly dark spots but also he leaves small areas of the canvas untouched as though to make the pigmentary material "breathe." Here again we are asked to "read" and to place these white, untouched spaces in the third dimension.

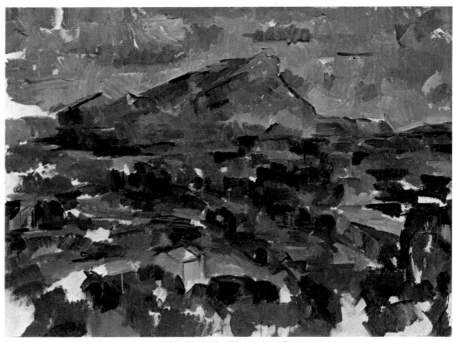

Paul Cézanne. "Mont Ste.-Victoire." 1905. Oil. 24.6 x 32.4 inches. Detail right page.

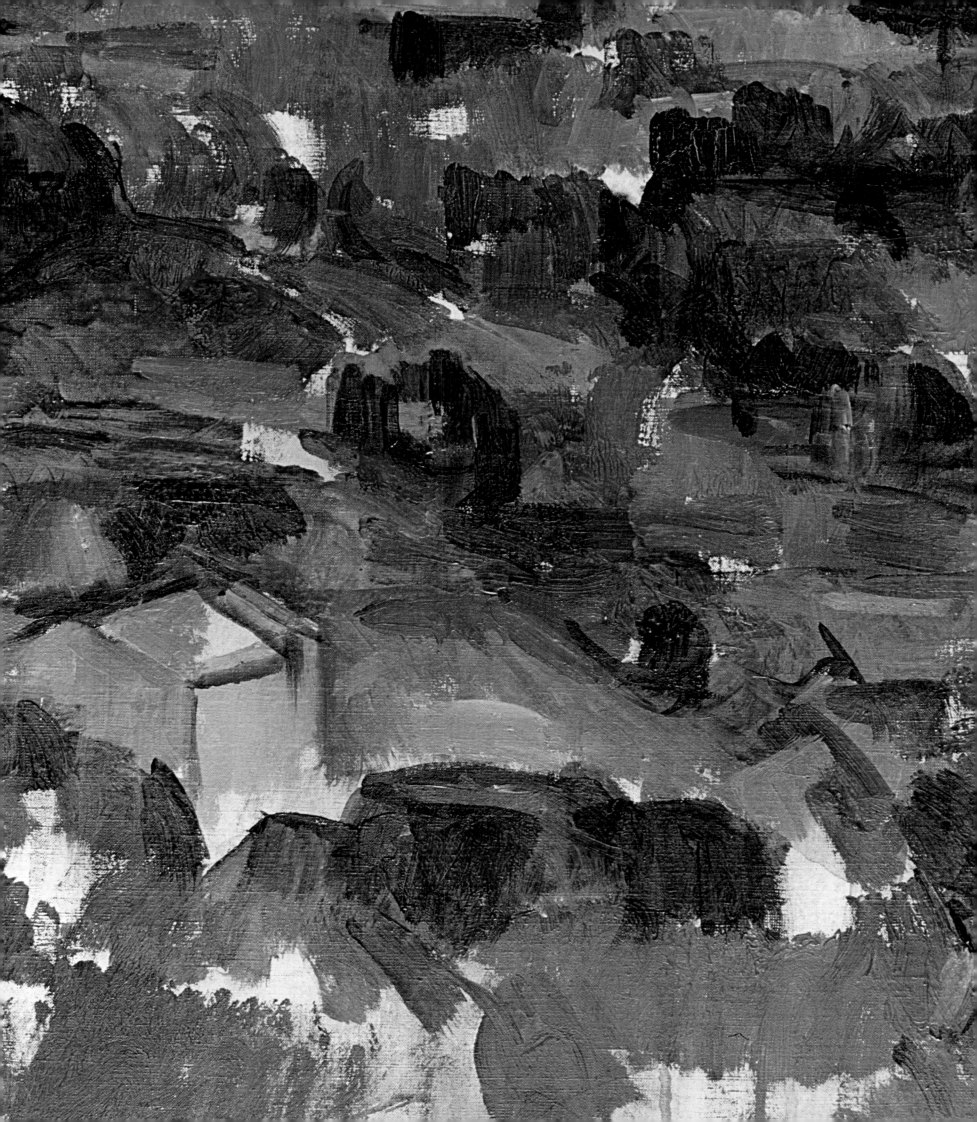

The artist solicits the
By methodically organizing
engages

spectator's optic nerve.
his colors, he
and disturbs his visual system.

Neo-Impressionism required a fresh physiological "commitment" from the spectator. By systematizing the Impressionist methods of separating brushstrokes, it placed the interest beyond the painting to the mechanisms of perception. Painting began to play with the optic nerve. To see became a complex act which solicited the spectator's active intervention. He *makes* his painting in so far as he has several choices and possible positions for its "reading." Seurat inaugurated a form of painting that necessitated a concentrated questioning by the retinal system.

The division of tones was not in itself a new method. It was occasionally seen in works by the Venetian painters; Constable, Delacroix, and Baudelaire clearly formulated the concept. "It is a good thing that the brushstrokes are not materially blended," wrote the poet. "They naturally blend at a desired distance by the sympathetic law which has associated them. Thus color obtains greater energy and freshness." Whereas by combining two tones on the palette (chemical mixture), one tends to gray, by placing them separately on the canvas (optical mixture), one vitalizes them. The eye, solicited simultaneously by chromatic waves of different frequencies, attempts to adapt itself alternatively to each.

In the extreme case of "simultaneous contrast," which deliberately juxtaposes on the canvas the colors of the spectrum with its more widespread frequencies (green and red, yellow and purple, and so forth), a struggle of influence occurs within the retina, which can go so far as to make it impossible to read the surface as a homogeneous whole. This is what occurred in the twentieth century with Op Art.

Victor Vasarely. "Majus M.C." 1968.
Op art exploits the principle of color contrast, taking it to its extreme consequence. It associates tones that are optically remote. No longer can the eye read them simultaneously. The result is a quivering and a pulverization of the surface.

These were the mechanisms which came to the attention of Georges Seurat and his friends, and formed the basis of their aesthetic. Their first aim was to systematize and codify a color concept which had been inspired by the experiments of such scientists of the period as Eugène Chevreul and O. N. Rood and had been discussed by art historians like Charles Blanc. It had been applied by Delacroix and the Impressionists in their paintings. "What the Impressionists did," wrote Signac, "was to admit on the palette only pure colors. What they failed to do and what remained to be done after them was to have utter respect, in every circumstance, for the purity of pure colors." Signac denounced in Monet and his companions the "fantasy" and "polychrome mess" in their work. It was indeed high time to put some order in the use of color, he thought. At the same time the Neo-Impressionists undertook to get rid of an essential aspect of classic Impressionism. The "small dot" of the Neo-Impressionists excluded the personal *touche* (brushstroke) and the gestural aspect (the painter's "handwriting," so to speak). In a painting by Monet each particle of pigment is individualized. It incarnates a physical movement, the activity of an arm or a body in motion. Neo-Impression refused this. As its principal theorist, the critic Félix Fénéon explained in 1886, "Here the *patte* is unnecessary, trickery impossible. No room for pieces of bravura. The hand may be numb, but the eye must be agile, perspicacious, and skillful."

For Monet the rapidity of the Impressionist manner was also the result of an aesthetic preference. It was a question of giving a quick rendering of the fleeting instant, the statement of impressions which required a hasty treatment. This ambition was rejected by the Neo-Impressionists. For Félix Fénéon, "The need to do a landscape in one sitting forced the Impressionists to make Nature wince to prove that the minute was an unparalleled one never to be seen

Charles Angrand. "Norman Courtyard." About 1907.

Robert Delaunay. "Landscape with a Disk." 1906.

The subject gradually becomes indistinct in the maze of brushstrokes, which acquire a value in themselves. The painting is surface before being landscape.

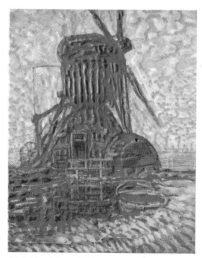

Piet Mondrian. "Windmill in the Sunshine." About 1908.

Profiting by the lesson of Neo-Impressionism, Mondrian divides his tones and reduces his color scheme to the primary colors: red, yellow, and blue. This emphasizes the canvas' propulsive power.

again. . . . Painters have not yet realized the absurdity of solidifying an anecdote in permanent material and generally [this is true of] any exceptional and transitory sight."

What the Neo-Impressionists contested, without as yet being fully aware of this, was that painting pretended to give a faithful representation of outer reality. "The theorists of Impressionism proclaimed that painting addressed itself first to the eye," explains André Malraux, "but [Neo-Impressionist] painting now addressed itself to the eye more as painting than as landscape." A kind of teetering of great importance occurs. We go from painting as a reflection of the visible world to an utterly fresh conception, namely, painting as surface, as a "thing-in-itself," a form of concrete reality concerned only with itself. The essential is no longer that relationship between nature and the painter's account of it but rather a confrontation of painting and spectator. It was no mere chance that at the same time and by completely different paths—the use of colored flat areas—Gauguin's Synthetism was also transcending classic Impressionism and seeking an immediate sensorial contact with the spectator's eye (see Chapter V).

In Neo-Impressionism's progress toward the independence of the painted surface—a progress that was destined to last for thirty years and conclude with Delaunay—Seurat's school developed not only a special color technique but also a specific conception of form. This proved to be a decorative and antirealistic conception which, as Félix Fénéon wrote, "sacrificed anecdote to the arabesque, nomenclature to synthesis, transience to permanency." The landscapes by Seurat (pages 282, 291), Signac (page 290), Van de Velde (pages 284–85) were no longer dramatic and part of time. Quite the contrary. There is no concentration on subject matter, or very little. A deliberately anonymous, commonplace subject appears to recede modestly before our eyes. Félix Fénéon found Seurat's seascapes "morose and so filled with air. They spread out monotonously, lappingly, calm and melancholy to the falling far distant sky . . . painting with little concern for any geniality of color or emphasis on execution, austere with a bitter and salty flavor." As one looked at these simplified works the word "abstraction" was soon pronounced. "A little reflection quickly proved to us that line is an abstraction," explained Seurat. "It is by the harmonies of lines and colors, which he can manipulate according to his requirements and will, that the painter should move us," Signac said soon afterward. Nature became less distinct, line became essential. Not satisfied to systematize color, the Neo-Impressionists sought to codify form and to give it an independent value beyond representation.

To establish this code the Neo-Impressionists first based themselves on classical canons. At the Ecole des Beaux-Arts Seurat was a pupil of Henri Lehmann, who had studied under Ingres. There he was trained to respect tradition. Jean Cassou saw in him "one of Ingres' most spiritual sons." He copied Piero della Francesca, studied Egyptian and Greek art, the Quattrocento, Poussin. This resulted in the monumental stiff figures, for example, in his "Bathing at Asnières" (pages 278–79) or his "Sunday Afternoon on the Island of La Grande Jatte" (pages 280–81). His "Woman Powdering Herself" is composed like a Memling (page 283). We are now in the pictorial heritage dominated by Raphael, seeking through the representational anecdote an independent formal structure closed on itself, based on values of balance, symmetry, and counterweight. "Harmony is the analogy of contraries," explained Seurat. The inventor of

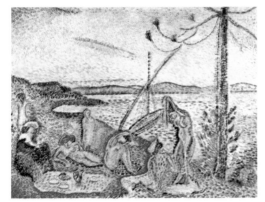

Henri Matisse. "Luxe, calme, et volupté." 1904.

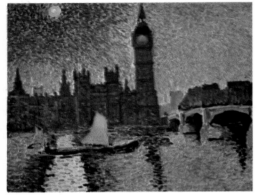

André Derain. "Big Ben." 1905.

Kees Van Dongen. "The Moulin de la Galette." 1904–6.

Matisse was initiated to Neo-Impressionism at St.-Tropez, in 1904, under the watchful eye of Cross and Signac, by painting his *"Luxe, calme et volupté"* (*above*). This initiation influenced Fauvism, which even exceeded the chromatic audacities of the preceding generation. Whereas Signac and Cross preserved a principle of harmony, even though heightening their tones, Matisse, Derain, and Van Dongen turned to an aggressive painting, one of utter defiance in which color should "speak by itself."

Neo-Impressionism offered a foretaste of the program of a Juan Gris or more so of a Mondrian who, with an almost identical vocabulary, was to exalt "harmony," "the unchangeable," "universal beauty," "rest," and "the balance of tensions."

This aspiration to plastic order was combined with the rationalist current of the period. The Neo-Impressionist hoped to define, once for all, every emotional mechanism and create a formal and chromatic code which would make art an exact science. Seurat was fascinated by the idea that "color, submitted to set laws, can be taught like music." There was a mingling in his mind of two influences, old-fashioned studio techniques inherited from the Ecole des Beaux-Arts and contemporary Positivism which aspired to determine constants based on methodical documentation. Here we encounter a strange and brilliant person, Charles Henry, Claude Bernard's former tutor, librarian at the Sorbonne, who in 1885, the year Seurat painted his "Grande Jatte," published his *Introduction à une esthétique scientifique*. Henry actually wanted to finish with intuition, inspiration, and vagueness and to find the equation of beauty. His program was, "Taking any lines, to find the combination capable of inevitably producing a definite expression." Signac worked alongside him and in 1889, for example, as Françoise Cachin explains, "He measured several thousand angles to break up the outline of vases from Cnidus, Thasos, and Rhodes which, as Signac explained, 'would teach beauty' and determine 'if the form is harmonious or not.'"

All these calculations were carried out on an absolute basis, and no one in Seurat's and Henry's circles bothered to ask himself whether Greek and Renaissance canons still corresponded to the forms of knowledge, the sensorial and psychological requirements of a period in full scientific and technical change. Their reasoning was somewhat like Ingres', "Other than art as it was understood and practiced in Antiquity, there is and can only be caprice and digression." Now this was the period of Maxwell and Marx and soon that of Planck and Einstein. In short, Henry, Seurat, and Signac, in their determination to lay the basis of a "scientific" aesthetic and to establish once for all a universal catalogue of forms and sensations they create, overlooked historical evolution. That is why their researches had an irrational and poetical character far removed from true science as it existed at the dawn of the twentieth century.

Henry's merit was to have pointed out and popularized this idea of the spectator's physical engagement in the rhythm of the work. This reality is as old as painting, for it is really the entire body which we mobilize when studying a painting by Tintoretto or Rubens. It was a reality, however, all too long concealed by representational themes. With Seurat the point of view is reversed; the subject is nothing more than a pretext. The anecdote is chosen to clothe the line and not the contrary. According to Seurat what counts is "the direction." He chooses his subjects in function of the linear network which he wishes to create. He paints "*Le Chahut*" and "The Circus" (pages 298–99) because he is tempted by the layout of a certain dynamic play of diagonals.

Seized in the abstract dynamic of lines, the spectator is even more so by the chromatic system which Neo-Impressionism offers. As Meyer Schapiro has written, Seurat's revolutionary character stems from the fact that he was the first painter in history to create paintings whose material was completely homogeneous. A Neo-Impressionist painting is chiefly a "screen, a sowing of

Paul Signac. "The Dining Room." Sketch, detail. About 1886.
At the very outset of Neo-Impressionism, Signac had a presentiment of its destructive possibilities. In this sketch of "The Dining Room" the tones clash instead of blending.

Giacomo Balla. "Young Girl Running on a Balcony." 1912.

Giacomo Balla. "Iridescent Compenetration." 1912.

The Futurists turned to the divided brushstrokes as a means of expressing the feverishness of modern life. Balla associated it with the stroboscopic vision inherited from photographic experiments. In his Iridescent Compenetrations, the tones are separated and the luminous radiation reduced to a geometrical and stylized pattern.

small spots," as Félix Fénéon wrote, between the eye and the representational subject. To read this regular pattern depends on two complementary variables: the distance of the eye to the painting and the size of the brushstroke. Seen at a distance of twelve inches the "Mona Lisa" is still the "Mona Lisa," but a Seurat is no more than a busy mass of small dots (page 286). It is the spectator who, by choosing his distance, chooses the version of the painting he wishes to see, a striking, abstract version, all in spots or, on the contrary, a synthetic version whose volumes form anew and with distance acquire their representational significance. Neo-Impressionism postulates a moving activity on the part of the spectator. The work is understood by an *action*, an experience, and no longer merely by passive contemplation.

As early as their first works, the Neo-Impressionists questioned themselves on this peculiarity of their brushstroke. The majority were thinking merely of the synthetic conception. They congratulated themselves that "two steps away the eye no longer sees the work of the paintbrush," wrote Félix Fénéon. They divided merely to assemble. They wanted to reinforce the activity, the density, the legibility of the surface and not break it down. Signac's merit, which offered a foretaste of the preoccupations of twentieth-century artists, was to question, as early as 1887, this concept of "pointillist" work. "One feels that the 'Grande Jatte' was painted in a small room with no space to step back. In fact, this remark was made by several members of *Les Vingt* [the group of avant-garde painters in Belgium]. They said to Seurat, 'We prefer your *Grande Jatte* close up rather than at a certain distance. We feel you didn't do it in a large room.' This exquisite, infinite division . . . becomes too petty for a large canvas of several meters."

We have a presentiment here of the dissolving characteristics of Neo-Impressionism. To the rule which states that the greater the distance between the eye and the canvas, the fewer the differences between the colors, responds the opposite rule, namely, the closer we approach, the greater the contrasts. The eye, unless overtaxed, no longer can read the tones at the same time. The colors struggle among themselves to the point of rupture. This is the optical disruption of the surface. On the one hand, each colored particle regains its independence, and on the other, the subject, with its perspective and its modeling, disappears in the "confetti." One more step and the surface is no more than quivering and flickering of independent spots. Activation changes into a destruction. Where Seurat wanted to create the fusion of tones in our eye, we now have a "cacaphony," an aggression and abstraction of pure color. By a strange paradox, Neo-Impressionism affirmed itself in modern art by going in a countercurrent to that of its inventor. All those who, after Seurat, sought to respect his conception of the dot finally became prisoners of Renaissance space and perspective, including men like Pissarro and Luce. All those who, on the contrary, proceeded to the pulverization of the surface coincided with the disturbing and questioning spirit characteristic of the upheavals and tumults of the twentieth century. Their efforts terminated in Delaunay's simultaneous contrast and in the disquieting plays of Op Art. It was Gauguin who, thanks to the flat plane, fulfilled the dream of color as formulated by Seurat. Seurat's descendants were to inherit another task, namely, to describe the pulverization of figure and surface, reflecting the instability of matter and the relativity of all perception.

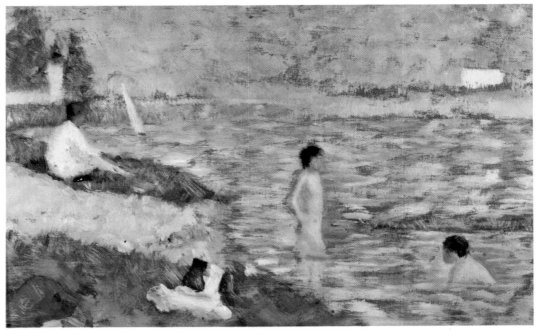

Georges Seurat (1859–91). "Boys Bathing." Study for "*Une Baignade.*" 1883–84. Oil. 5.85 x 9.8 inches.

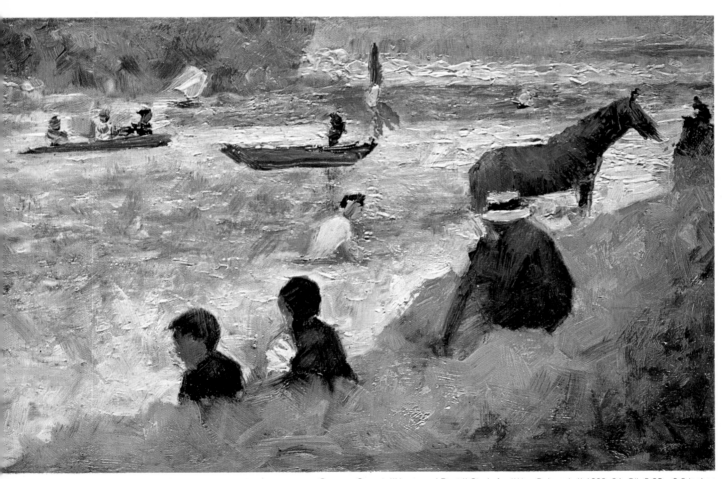

Georges Seurat. "Horse and Boat." Study for "*Une Baignade.*" 1883–84. Oil. 5.85 x 9.8 inches.

Georges Seurat. "Five Male Figures." Study for "*Une Baignade.*" 1883. Oil. 5.85 x 9.8 inches.

Seurat takes his colors and themes from
Impressionism . . .

THE REBEL SON of Impressionism, Seurat turned to Manet, Monet, Renoir, and Pissarro for inspiration. At the age of twenty-four he made fourteen preparatory sketches before launching into his first important composition, *"Une Baignade (*Bathing at Asnières),"* which he painted in his studio. Working from these *croquetons* (small but rapid oil sketches)—the banks of the Seine, near the Courbevoie Bridge, facing the island of La Grande Jatte—Seurat returned to the folklore of his elders. He portrayed peaceful suburbanites and members of the middle class who, without the slightest ado, are leisurely enjoying themselves along the riverbank.

These sketches reveal a sense of composition, geometry, and stiffness.

The figures have a compact and hieratic quality foreign to those painted by Pissarro and Renoir. Seurat cultivates "harmony" and the "analogy of contrasts," using the opposition of the horizontal (the sheet of water) and the vertical (the bathers). If we study these sketches and compare them to the final work (page 278), we can measure the artist's progress in escaping the fleeting impression and basing his composition on a monumental rigidity. The outline of the riverbank, the arrangement of the dark tones, the modeling of the bodies were all treated with great care: The lesson of Piero della Francesca is here combined with that of Puvis de Chavannes.

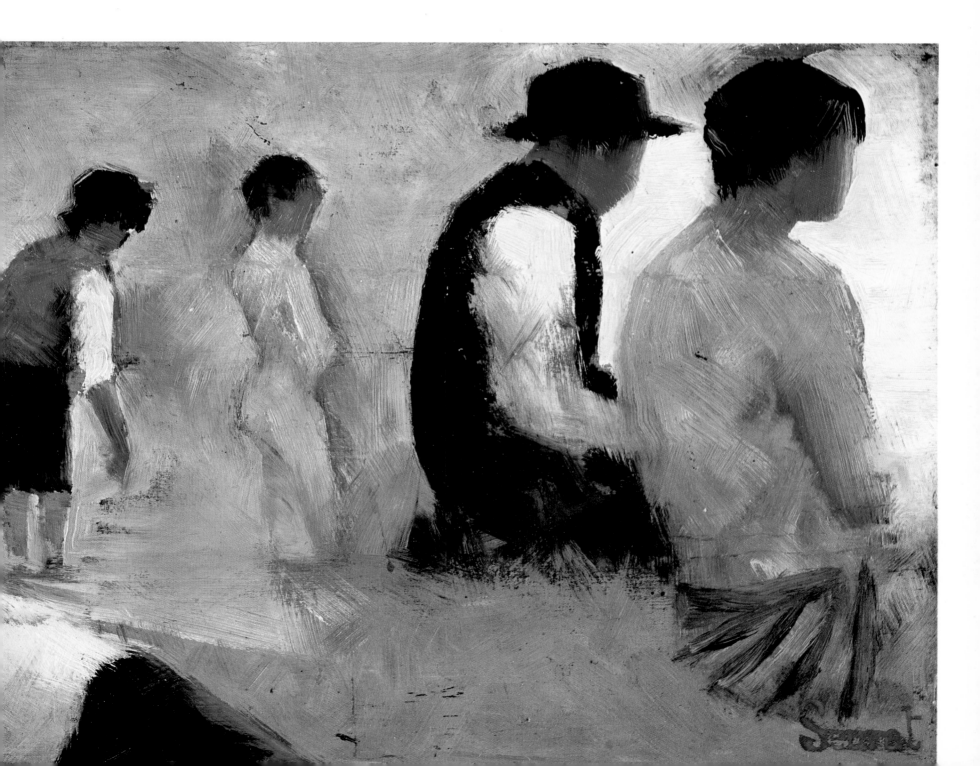

. . . but he produces a monumental and concrete new classicism.

THE PEREMPTORY STATEMENT of a new classicism, "*Une Baignade*" reveals unusual ambition on the part of the young Seurat. First of all, because of its size: The canvas measures more than six by nine feet. These still, anonymous faces, the figures separated from one another and motionless as objects, all express a waiting atmosphere which the artist imposes on the spectator, as though much time and silence separated us from this familiar scene. The cry uttered by the young bather (*see the detail on the right page*) seems to be addressed to some forgotten bank.

The entire scene is a huge still life organized around the hat which occupies the center of the canvas. It was from Puvis de Chavannes' *Doux Pays* (1882) in the Bayonne Museum that Seurat borrowed this cottony solemnity as well as the arrangement of the sheet

of water and the boats. Whereas Puvis de Chavannes filled his sacred woods with more or less Hellenistic figures, Seurat prosaically found his models in the northern suburbs of Paris. He emphasized their geometrical character, relating them to the structure of the painting. Refused by the Salon of 1884, "*Une Baignade*" was exhibited at the first Salon des Indépendants whose president was Redon. Even there it had little effect. "It was separated from the rooms and modestly relegated to the buffet," related Félix Fénéon. "Only a few drinkers, paying no attention to their glasses of beer, realized that a new manner of reading reality had just been produced and that a valid convention had been added to the repertory of conventions, no less valid but perhaps slightly worn out, on which painting lived." Among these curious spectators

was Signac, who met Seurat at the Salon des Indépendants. They became friends and formed the core of the future Neo-Impressionist group. "This painting," he later wrote, "was done in large, flat brushstrokes, one over the other and from a palette composed, like that of Delacroix, of pure and earth colors. By these ochres and earth colors, the painting was dull and appeared less brilliant than those painted by the Impressionists with their colors reduced to those of the prism. But observation of the laws of contrast, the methodical separation of the elements—light and shadow, local color and reflections—their correct proportion and their balance, all gave this canvas a perfect harmony." The small dots scattered on the bather's hat (*right page*) were added by Seurat in 1887.

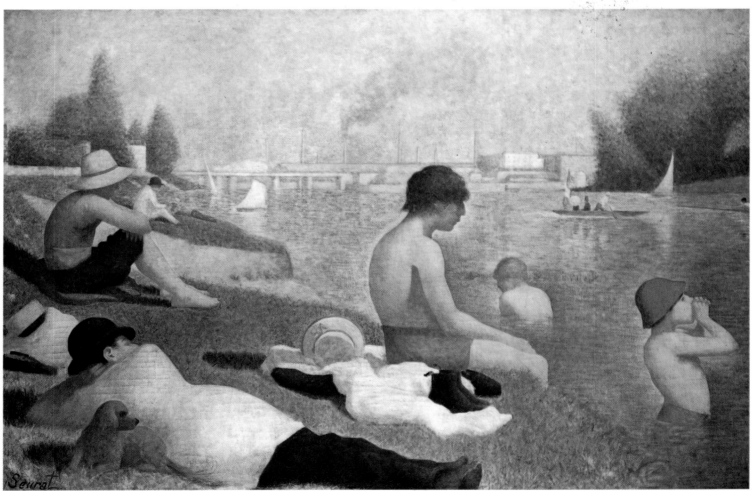

Georges Seurat (1859–91). "*Une Baignade (Bathing at Asnières).*" 1883–84. Oil. 6.6 x 9.8 feet.

Georges Seurat. "*Une Baignade (Bathing at Asnières).*" Detail.

THE MANIFESTO OF Neo-Impressionism, "Sunday Afternoon on the Island of La Grande Jatte" (*right page, below*), was like an explosion when it was shown at the final Impressionist exhibition in 1886. For the first time, on the confines of a movement which was beginning to break up and to have doubts about itself, a new school arose based on the regular use of "small dots" and on the methodical excitement of the retina, thanks to the separation of tones. For Seurat color henceforth was to blend in the eye and not on the palette. "Monotonous and patient spots," as Félix Fénéon described it, this huge composition was preceded by many careful studies on small panels in which Seurat used a modified Impressionist technique because of its rapidity (*below and right page, above*). In these *croquetons* the artist by no means respected classical perspective. The vanishing

point is eliminated, the ground almost vertical. Only in the final notations and in the finished canvas did he strictly observe the spatial scheme which had been handed down by tradition. Meyer Schapiro has observed that most of the figures in the foreground are represented in strict profile regardless of their situation in space, as though they had been arranged around the painter's easel, the artist himself on the right of the scene. Seurat relentlessly worked on the painting from 1884 to 1885. As John Rewald tells us, "For several months Seurat went every day to the island of La Grande Jatte. He was so absorbed by his work that he sometimes even refused to lunch with his best friends, fearing to weaken his concentration. Whenever he saw Angrand, who was then also painting on the island, Seurat greeted him without even putting his palette down,

scarcely detaching his half-closed eyes from his motif. Working on the island in the morning, Seurat devoted his afternoons to painting on the composition in his studio and hardly paused to eat a roll or a bar of chocolate. Standing on a ladder, he patiently covered his canvas (equal in size to '*Une Baignade*') with tiny multicolored dots, applied over a first layer of pigment which was broadly brushed in." He did the groups one after another as though they were separate paintings.

"Sunday Afternoon on the Island of La Grande Jatte" was poorly received by the critics who found the work "untellable." Octave Mirbeau denounced the "wooden fellows" of this "Egyptian fantasy." To quote Félix Fénéon, "..The intruder's anger, at first sparse, became localized, a poorly explained phenomenon, on the monkey

held on a leash by the lady in the foreground and especially on the spiral tail. It appeared that this beastly nostalgia and this tail were there to insult in particular anyone who crossed the threshold." For the artists, it created a sensation. "The Naturalists," related Signac, "regarded it as a Sunday spree of calico animals, apprentice butcherboys, and women in quest of adventure. Paul Adam admired the stiff figures of some pharaonic retinue, and the poet Jean Moréas, who had broken with the Symbolists to renew the Greco-Roman tradition, read it as a series of Panathenaic processions." For Seurat the subject was merely a pretext. "I could have painted," he said, "the combat of the Horatii and the Curiatii in the same harmony."

Georges Seurat (1859–91). "Sunday Afternoon on the Island of La Grande Jatte." Sketch. 1884–86. Oil on wood. 6.2 x 9.8 inches.

Georges Seurat. "Study for La Grande Jatte." 1884–85. Oil. 6.2 x 9.8 inches.

Georges Seurat. "Sunday Afternoon on the Island of La Grande Jatte." 1884–86. Oil. 6.75 x 9.2 feet.

The beginning of the Neo-Impressionist revolution can be seen in the solemn immobility of its friezelike figures.

To his rocks and women Seurat gives the same sculptural density.

AN UNUSUAL MOLECULAR density seems to weld the central subject in each of the two paintings on these pages. The human figure is no less compact and rigid than the stumpy rock which resembles some animal on the watch or, as Félix Fénéon described it, "oppressing the sea." One would think that by strengthening the mass of his forms, Seurat sought to escape the danger of optical dispersal. He used his "small dots" not to diminish the volumes, but, on the contrary, to increase their power, their luminosity,

and their vibration. In the portrait of his common-law wife Madeleine Knobloch, Seurat appears to have tried to transfigure all the vulgarity of the period, like the bamboo *bibelots*, the "sculptural" hairstyle, and the overelaborate toilet objects. "By bashing us with the imposing presence of a heavy-set *midinette* transformed into an icon," as Germain Viatte says, he obviously tried to win the wager of giving a kind of eternity to the most ephemeral anecdote, proving that the theme is far less important than the

manner in which the picture is constructed. In the frame hanging in the upper section of the picture, the artist originally portrayed his own face. On a friend's suggestion, he replaced it with an off-center still life.

Only after Seurat's premature death at the age of thirty-one did his close friends discover the existence of Madeleine and their child, then thirteen months of age. A man of severe and concentrated speech, Seurat expressed himself solely in monosyllables. His private life was impenetrable. Delacroix

had been his model. He had read Charles Blanc's essay on the great Romantic French painter who was described as "withdrawn into himself, silent, solitary, constantly inventing, drawing, painting and ever keeping his door bolted to be excited at his own ease." The abundance of a production which numbered more than 200 paintings despite the slow technique imposed by Neo-Impressionism, not to mention his early death, reveals how relentlessly Seurat had devoted his energy to painting.

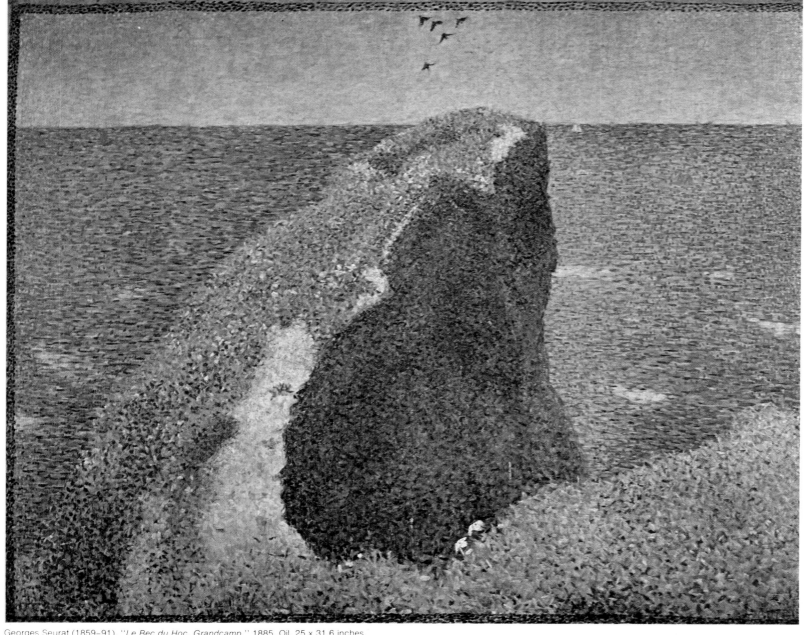

Georges Seurat (1859–91). *"Le Bec du Hoc, Grandcamp."* 1885. Oil. 25 x 31.6 inches.

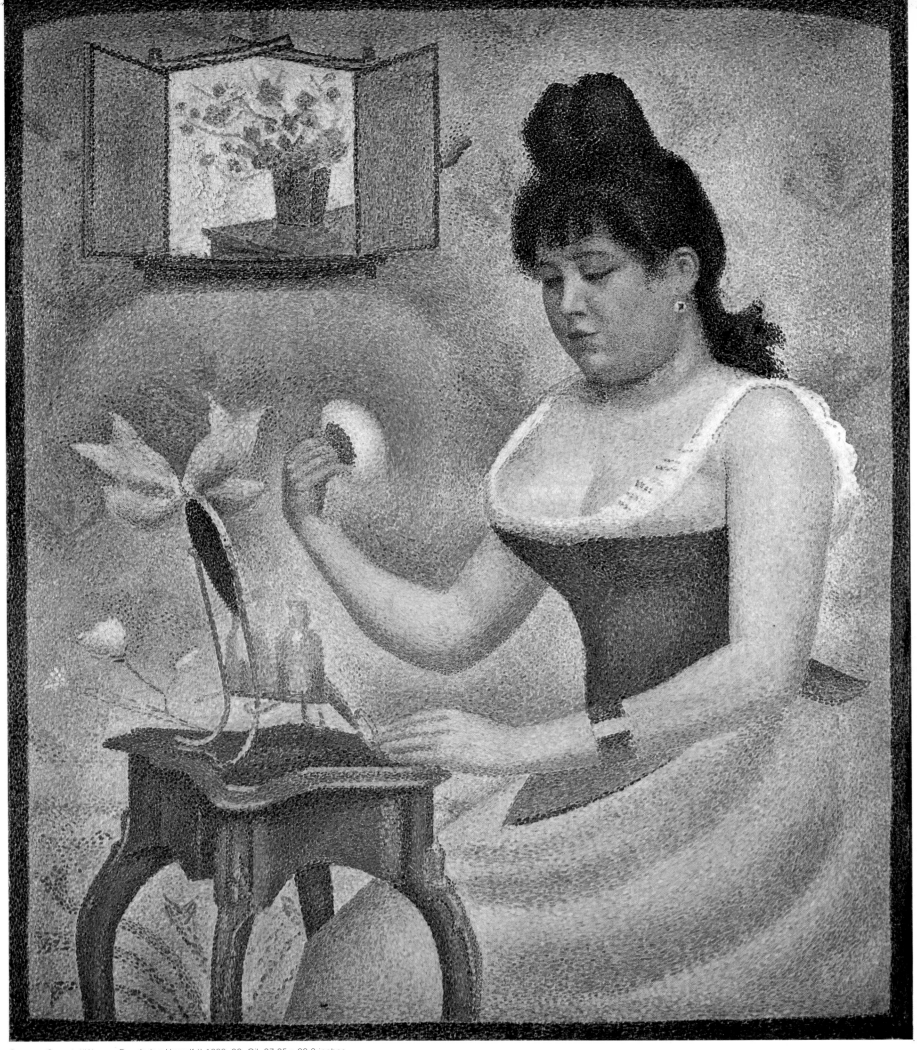

Georges Seurat. "Woman Powdering Herself." 1889–90. Oil. 37.05 x 30.8 inches.

With a dauntless zigzag,
Van de Velde frees a
desert of light in the heart
of the canvas.

IN VAN DE VELDE's "Blankenbergue" we admire the audacity of his composition. The large central area is a cut-out, which, as in a puzzle, joins angular surfaces and finds a precarious stability in the textural unity. Van de Velde's "small dots" methodically give the entire canvas an overall luminous and shimmering quality. In using an essentially blank area for the center of the composition, the artist exceeds even the boldness of Van Gogh in his "Enclosed Meadow" (pages 248–49).

Henry van de Velde was the chief exponent of Belgian Neo-Impressionism. He was twenty-four when he saw Seurat's "La Grande Jatte" at the Brussels exhibition of the group known as Les Vingt. He abandoned his rustic style inspired by Millet and launched himself into the "scientific" painting which Paris had recently discovered. Installed in his brother's bathing cabin at Blankenbergue, he studied and drew the entire beach spread out before his eyes and gradually trained himself to the new ideas.

A disciple of William Morris, Van de Velde was distracted from painting by social problems and preoccupations. As early as 1893 he became one of the chief mediators between the English Arts and Crafts and continental Europe. He ranks among the founders of Art Nouveau. He became increasingly distrustful of the aims proposed by the Neo-Impressionists, whom he reproached for adhering to an outdated artistic conception and basing their ideas on doctrines which were far less scientific than they actually appeared. Van de Velde was deeply disappointed. As John Rewald points out, he even doubted the rightness of his own views. Van de Velde is quoted: "I thought he [Seurat] was a greater master of the science of color. His gropings, his struggles with that science, the confusion of his explanations of his so-called theory threw me off. . . . Those who criticized the 'Grande Jatte' for its lack of luminosity were right, as those who noticed the weak interplay of 'complementaries' saw clearly." Yet Van de Velde later admitted that, to quote John Rewald again, "as chief of a school, Seurat had inaugurated an era of painting, that of *return to style*. Destiny had decided it that way. It had made him discover a technique, that of pigment which *inevitably* had to lead to stylization."

Henry van de Velde (1863–1957). "Blankenbergue." 1888. Oil. 27.7 x 39.4 inches

Seurat interposes a tight pattern of small dots between his models and himself. Distance creates the modeling.

Georges Seurat. "Model from Back." 1887. Oil. 9.8 x 6.2 inches.

Georges Seurat (1859–91). "Model in Profile." 1887. Oil. 9.8 x 6.2 inches. Detail left page.

SEURAT'S NEO-IMPRESSIONISM reveals an antlike patience. The small studies of female models now in the Jeu de Paume in Paris are among the artist's most exquisite works. The prodigious preciseness of his brushstrokes slowly created the delicacy of feminine outline. "The microscope," writes the curator Germain Bazin, "reveals that these brushstrokes were not juxtaposed but arranged in several layers and linked like the threads of a fabric. These works create an impression of absolute purity which summons to mind Vermeer's paintings." The dot in these works is smaller; it "breathes" better. Its elasticity avoided cracking which was frequent in the impasto of a contemporary like Van Gogh. In these preparatory sketches for the large "*Poseuses*," now in the Barnes Foundation, Merion, Pennsylvania, Seurat achieved a chromatic sensibility which the more drawn final work lacks. What the artist tackles here, beyond the recent heritage of Impressionism, is the tradition of the academic nude. He offers us a puritanical and restrained version of a nude's back and its curves, which Ingres, twenty years earlier, had used for his "Turkish Bath." With both painters the skeleton and the muscular tension are rather indistinct. The body is reduced to a play of tender curves.

Painters turn to Utamaro's simple formulas to
portray their friends' sensuous femininity.

Paul Signac (1863–1935). "Woman Dressing, Purple Corset." 1892. Encaustic on remounted canvas. 23 x 27.3 inches.

DURING 1892 SIGNAC and Cross each did a painting that was a homage to the Japanese style. A regular subscriber to *Le Japon Artistique*, Signac found in the review the decorative themes which he used to frame his young model (*above*). "The woman's folded arms in a diagonal arrangement are reminiscent of Japanese fans," writes Françoise Cachin in her monograph on the painter. The interlacing pattern of rushes on the faïence are from the same source. The work, however, evokes one painted by Seurat, who had died the previous year. The treatment of the bare arms recalls "Woman Powdering Herself" (page 283).

Since 1884 Signac had been on close terms with Seurat, his senior by four years. "If one were to make a kind of religion of what was still known as Pointillism [Neo-Impressionism]," wrote Thadée Natanson, "it would claim Delacroix and the Impressionists as its prophets: Seurat would be the Messiah, but Paul Signac would appear as St. Paul." As a youth passionately interested in the new researches, Signac was a pupil of Monet in his early paintings. As active, fiery, and eloquent as Seurat was taciturn, Signac gathered together the Neo-Impressionist school and turned its style into an international movement. He became

Cross' neighbor in the South of France and remained on regular terms with the modest and honest painter of "Woman Combing her Hair" (right).

After settling down at St.-Clair, on the slopes of the Alps, Cross, who had left Paris in 1891, inaugurated far from the noisy capital an extremely radical form of Neo-Impressionism in which Seurat's synthetic aims were gradually abandoned. In the painting on the opposite page, the simplification of the outlines is coupled with a development of the pattern which tends the painting toward abstraction. The regular waves of hair herald—in a much softer manner—Léger's geometricized woman.

ONE HAD TO HAVE Signac's temperament to launch into a canvas as striking and arbitrarily colored as the "Portrieux Roadstead" (below). It was painted in 1888, the year in which Van Gogh and Gauguin lived together at Arles. We see the same preoccupation of independent color as theirs, frankly freed from any documentary function. At the same time, however, Signac feels himself held by a strict discipline. Concerning the painting "Cape Lombard, Cassis" (*opposite*), which the critics found too refined and too linear, he wrote in his journal, "I believe that I have never made paintings so 'objectively exact' as those of Cassis. In this country there is nothing but white: The light reflected everywhere eats up the local colors and gray shadows."

Paul Signac (1863–1935). "Cape Lombard, Cassis." 1889. Oil. 25.7 x 31.6 inches.

Paul Signac. "Portrieux Roadstead." 1888. Oil 25.35 x 31.6 inches.

These deserted, anonymous seascapes have the aridity of pure form.

Georges Seurat (1859–91). "The Beach at Le Bas-Butin, Honfleur." 1886. Oil. 25.7 x 32 inches.

Georges Seurat. "Entrance of the Outer Port, Port-en-Bessin." 1888. Oil. 21 x 25.35 inches.

Théo van Rysselberghe (1862–1926). "Heavy Clouds, Christiana Fjord." 1892. Oil. 19.9 x 24.6 inches.

DESERTED BEACHES, peaceful landscapes: Neo-Impressionism turns away from the picturesque and exotic themes which during the same period were preferred by Gauguin. Seurat goes along the English Channel coast of France in search of rude and inexpressive spots on to which he projects timeless equilibrium and curious pale light. We merely have to compare his work with Monet's lyrical cliffs painted along the same Norman coast (pages 60–61), a few miles away, to realize how much Seurat detests Romanticism.

"Their immensity creates a note of anguish," wrote Félix Fénéon in referring to these "antilandscapes" which in their severe bareness seem to turn their backs to the spectator. Yet, if we examine them, they reveal much charm and skill. "Port-en-Bessin" (above, right) is based on a play of ovals which represent the shadows of clouds. They are preceded in the foreground by a truncated form, which seems to float like some flying saucer. The white note of the sails animates the translucid surface of the water. The same restraint is evident in "The Beach at Le Bas-Butin" (above) which recalls certain compositions by Hokusai.

Seurat was anxious to control the transition between his painting and the wall. Many artists were to take up the principle of his "small dot" borders painted on the canvas itself to bring out the neighboring tones. One example is that of the Belgian Van Rysselberghe in his painting of 1892 (right), which is his best work. The color is much more exalted than that of Seurat. The seascape is enveloped in a golden light which indicates the Nordic theme.

The "small dot" explodes into wild colors and
acquires its independence.

Paul Signac (1863–1935). "Breeze at Concarneau." 1891. Oil. 25.7 × 32 inches.

IN OPEN REVOLT against realism, Signac
and Cross tended to a conception of
color freed from any fidelity to nature.
"No, Monsieur Monet," wrote Signac in
his journal in 1891 "you are not a
naturalist. . . . Bastien-Lepage is much
closer to nature than you! The trees in
nature are not blue, people are not
purple. . . . And your great merit is in
fact to have painted them so, as you felt
them, and not as they are. . . ." A year
later he wrote, "The horror that I am
having more and more for the 'small
dot' is the hatred of dryness. . . ." And
three years later he stated, "The
progress to be made is to rid ourselves
more and more of impossible
imitation—and to become daring." In
"Breeze at Concarneau" (*above*)—which
recalls a seascape by Caspar David
Friedrich on the same theme—it is the
irregular rhythm of the large violet sails
which attracts our attention. As Fénéon
noted in 1890, "Signac wanted to create

specimen examples of an art whose
great decorative element sacrifices the
anecdote to the arabesque, the
nomenclature to the synthesis, the
ephemeral to the permanent."
 It was Cross—the best colorist of the
group—who was to adventure furthest
in escaping realism. The motley colors
of his "Wave" (*right*) would have
appeared incomprehensible to Seurat.
The small dots are enlarged to the
proportions of hatchwork. White small
spaces separate the brushstrokes to
prevent their being combined: We are
in Fauvism. In 1904 Matisse worked
with Cross and Signac in the South of
France in order to discover their
method (page 274). In 1905 Derain at
Collioure and Braque at L'Estaque and
at La Ciotat, soon followed by
Delaunay (page 273), continued the
efforts made by the Neo-Impressionists
to emphasize the independence of color.

Henri-Edmond Cross (1856–1910). "The Wave." 1907. Oil. 17.9 x 21.45
inches.

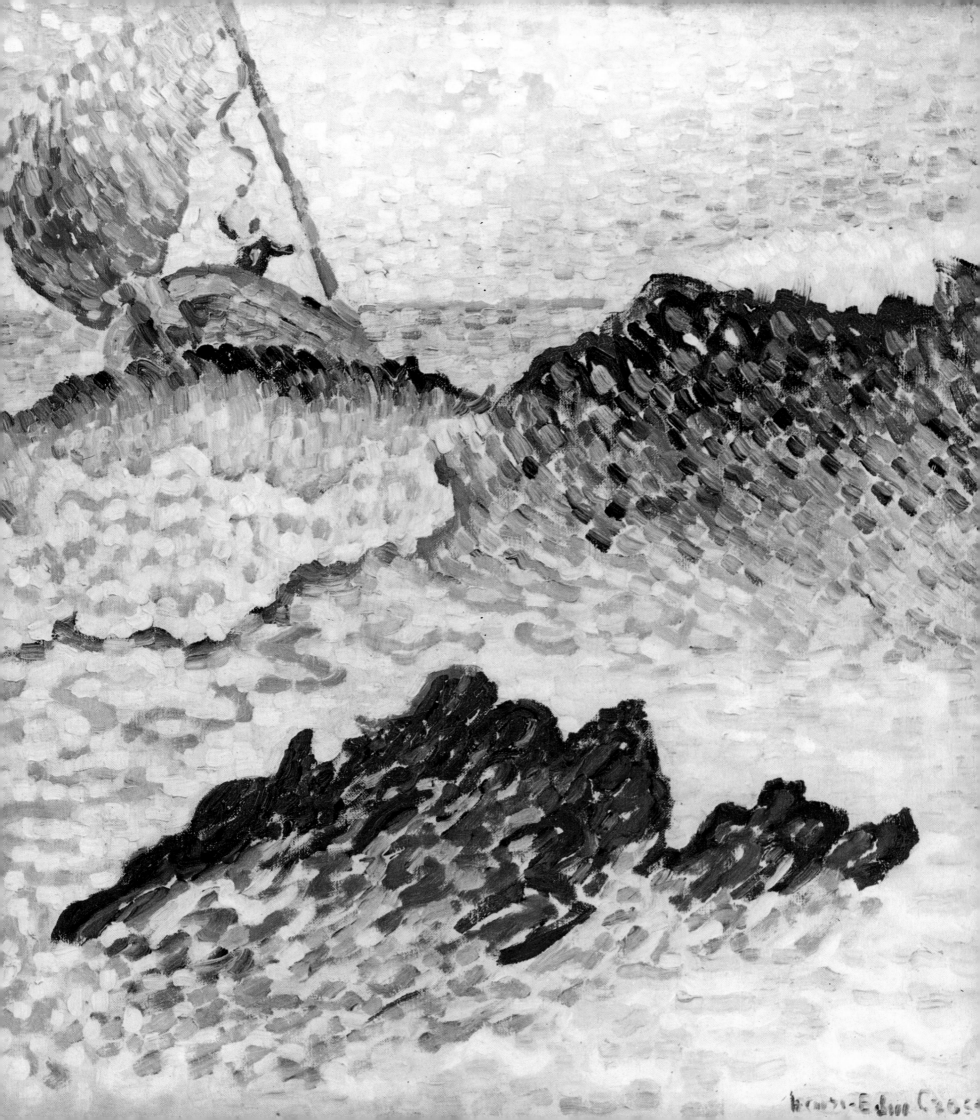

Henri-Edmond Cross

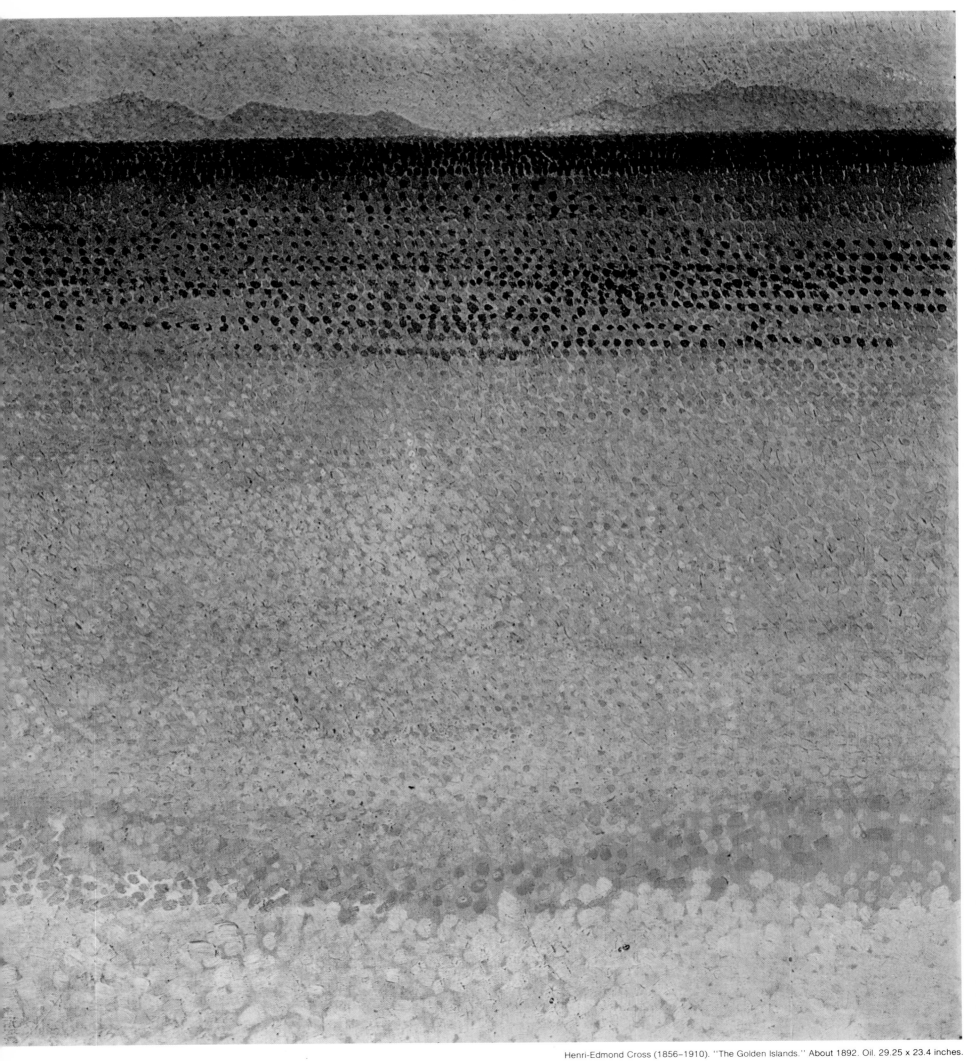

Henri-Edmond Cross (1856–1910). ''The Golden Islands.'' About 1892. Oil. 29.25 x 23.4 inches.

Landscape becomes surface and the painting a mosaic.

Georges Seurat (1859–91). "Study for Fort Samson, Grandcamp." 1885. Oil. 5.85 x 9.8 inches.

SEURAT'S FOLLOWERS FELT closer to his sketches made with heavy brushstrokes (*above, right*) than to his final paintings in which, as in "The Circus" (page 298), he blends the tones in the spectator's eye. The second wave of Neo-Impressionism by no means sought to render the treatment indistinct. On the contrary, the manner became the true theme of the painting. In his "The Golden Islands" Cross places each of his brushstrokes separately on a uniform background, and he aligns them meticulously as though to emphasize better their arbitrary character. Its parallel pattern in which dot and line gradually become the essential offers a foretaste of various systematic forms of art which were to be created in the twentieth century. "What does nature offer us?" asked Cross in his notebooks. "Disorder, chance, holes. To this disorder, this chance, these holes [we must] oppose order and fullness." In 1902 he added, "I am returning to the idea of chromatic harmonies utterly invented (so to speak) and beyond nature, as a point of departure."

What emerges here in Cross and his successors is the independence of texture. Landscape is no longer the essential but the point of departure. The history of this emancipation can be seen in the progression of the three works at right. With Kandinsky the brushstroke applied to the bare canvas has an opal luminosity. With Mondrian the dune is nothing more than a mosaic approaching nonrepresentational art.

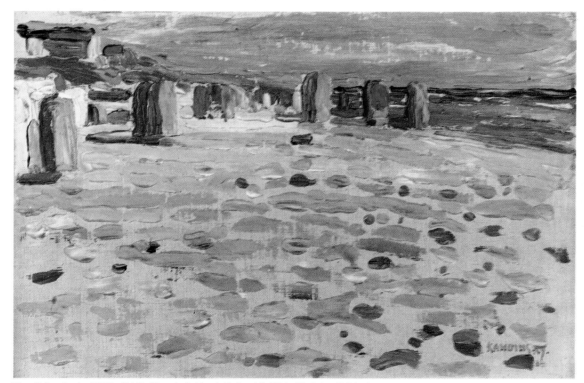

Wassili Kandinsky (1866–1944). "Beach Cabins in Holland." 1904. Oil. 9.4 x 12.9 inches.

Piet Mondrian (1872–1944). "Dune III." 1909. Oil. 11.3 x 15.2 inches.

A PARTISAN OF the Eiffel Tower at a time when its erection created violent hostility on the part of such well-known figures as Jean Louis Meissonier, Joris Karl Huysmans, and Charles Gounod, Seurat could not help but recognize in this splendid engineering exploit something of his own method. Meyer Schapiro has established a parallel between the artist's "small dot" technique and the erection of the tower based on the technique of assembling small exposed girders all of the same steel to form finally a single harmonious image. Erected at an amazing pace in

The artist enthusiastically greets the Eiffel Tower.

Louis Hayet (1864–1940). "Construction of the Eiffel Tower." 1887. Watercolor on sized calico. 6.6 x 9 inches.

Georges Seurat (1859–91). "The Eiffel Tower." 1889. Oil. 9.4 x 5.85 inches.

less than two years by two hundred workmen, the tower expressed the triumph of constructive rationalism and technical progress, themes familiar to the Neo-Impressionists.

At the time of the sketch above by Seurat, when work on the tower had almost ended, the huge framework had yet to receive its final aspect. Eiffel gave it a coat of encaustic of his own formula, the colors ranging from copper red for the first story to strong yellow for the summit. And something of this nuance is revealed in Seurat's study.

Louis Hayet. "Place de la Concorde." 1888. Oil. 7 x 10.5 inches.

Louis Hayet. ''Doors.'' 1889. Watercolor on tarlatan (with four different backgrounds). 7 x 4.3 inches.

A PASSIONATE INVENTOR, recently discovered thanks to Jean Sutter's work, Louis Hayet developed independently a series of modern methods which proved a foretaste of the research made by twentieth-century painters. Born into a poor milieu and self-taught, Hayet became a friend of the Pissarros despite his difficult character. At the very beginnings of Neo-Impressionism, he produced a series of surprisingly fresh paintings. His "Place de la Concorde" (*opposite*), consisting of whirling and light brushstrokes, is composed on five verticals half eaten away by a fluid light. One of these, in the background, is the Eiffel Tower under construction.

The most surprising of Hayet's paintings are those on fabric, like his sketch of the Eiffel Tower on calico (*left page, above*) and his "Doors" on tarlatan (*above*). As a youth, Hayet became interested in certain fire screen models, common in the nineteenth century, which represent either of two landscapes depending on whether there is a fire or not. He was acquainted with sheets of Carmontelle paper on which were large compositions painted in gouache and transparently readable. As the decorator of Lugné-Poe's theater, he had occasions to experiment on the stage with certain lighting problems. The work of 1889, reproduced here four times with four different backgrounds, was painted on a light fabric which

allows light to come through. Each time he changes the background, the artist upsets the balance of the pigments arranged on the tarlatan and offers in turn a composition with a dominating red, blue, yellow, or other hue. Each change increases or decreases the effect of the brushstrokes.

This variation of the same surface announces kinetic preoccupations, a feeling increased by the nature of the space represented as "Doors": floating planes, interpenetration of without and within, overlapping of luminous areas. All these formulas anticipate Robert Delaunay's "Windows" of 1912 and Gino Severini's "*Expansions sphériques*" of 1914.

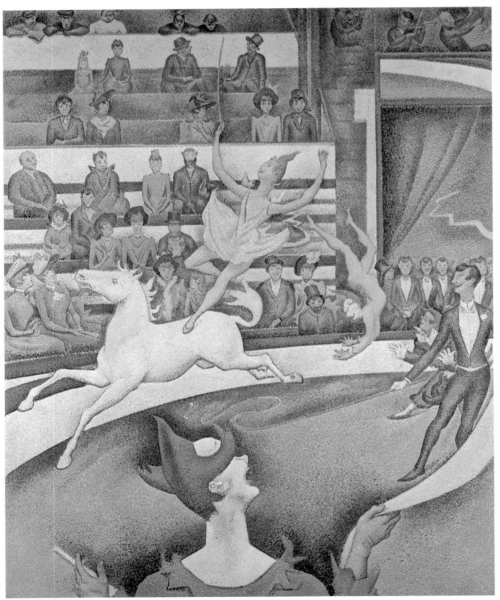

Georges Seurat (1859–91). "The Circus." 1890–91. Oil. 72.9 x 59.3 inches.

A mad geometry prevails in the noisy arabesques of Seurat's last work.

A FRENZIED GESTICULATION suddenly invades Seurat's art in the final two years of his life. In two large canvases the painter of logical rigidity and immutable landscapes reveals an explosive vitality which made him one of the fathers of the modern style. Seurat studied and collected Jules Chéret's posters, and their compositional form is felt in "*Le Chahut*" (*right*). The curled mustache repeated in the dancer's turned-up lips, the decorations and ribbons on the dancers' shoulders and shoes, the strange similarity of male and female legs, everything here expresses the taste for peculiar detail.

This exuberance, however, does not conceal the extreme rigor of the composition. In "*Le Chahut*," as in "The Circus" (*above*), Seurat inscribes his network of diagonals on a regular geometrical background. In both cases, a figure in the foreground stabilizes the composition. Between background and foreground breaks occur. Seurat arranges in the intermediary space of "*Le Chahut*" a series of arc-shaped curves created by the dancers' legs. In "The Circus" a diamond is formed by the principal figures. "Monsieur Seurat" wrote Félix Fénéon in 1889, "knows very well that a line, independent of its representational role, has an appraisable abstract value." Fénéon returned to the point of view of Charles Henry, the theorist and friend of the Neo-Impressionists, who attributed an exalting or depressing function to the axes of the paintings according to their direction. "The Circus" was Seurat's last work. He was a member of the

hanging committee of the Salon des Indépendants, and while carrying out this function he caught a fatal illness. It was there that Seurat found himself with Angrand in the last hall, mainly devoted to the Neo-Impressionists, when Puvis de Chavannes entered and began to examine some drawings by Maurice Denis. "He will notice," Seurat told Angrand, "the mistake I made in the horse," but Puvis passed without even stopping in front of "The Circus," which cruelly disappointed Seurat.

"*Le Chahut*" was sold for 400 francs in 1897 and "The Circus" for 500 in 1900. "Seurat's poor wife is quite anxious over the fate of her husband's large canvases," wrote Signac in his journal in 1898. "She would like to leave them to a museum. . . . But which museum today would accept them?"

Georges Seurat. "*Le Chahut*." 1889–90. Oil. 66.3 x 55.4 inches.

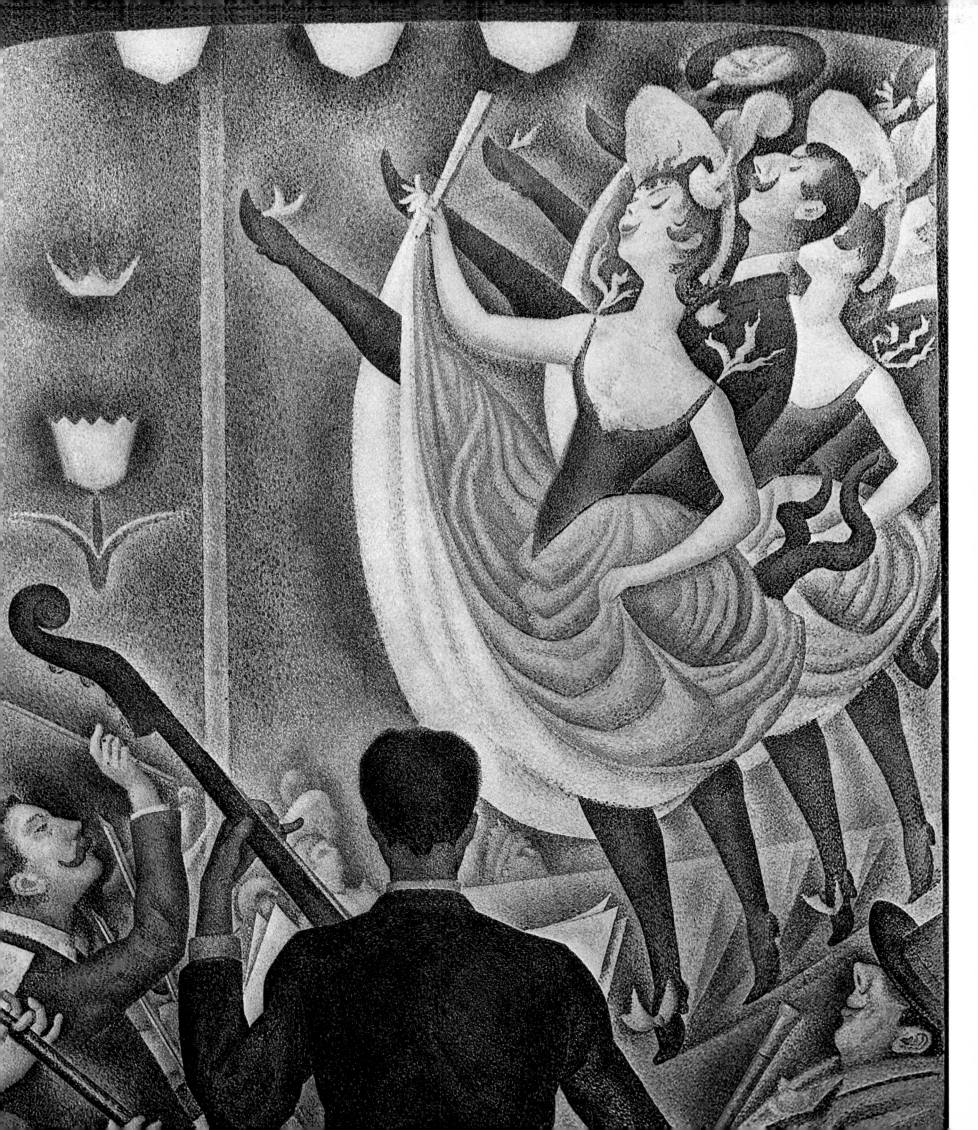

On the threshold of the twentieth century, the artist dreams of a science of art. The whirlwind of complementary colors announces the confusion of modern times.

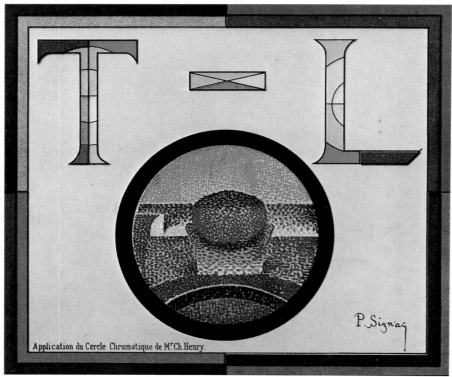

Paul Signac (1863–1935). "Program for the Théâtre-Libre." 1888–90. Lithograph. 6.2 x 7 inches.

SIGNAC'S PORTRAIT OF the great critic Félix Fénéon, the theorist of Neo-Impressionism, summarizes the atmosphere of the artistic milieu at the close of the nineteenth century. A few signs are significant: the Symbolists' huge cyclamen, the American Uncle Sam silhouette in a movement of stars, the dandyism of the goatee, the hat and the cane standing out against an amazing turning background, both decorative and astrological, inspired by a Japanese model. "What we have here," writes Françoise Cachin, "is a kimono decoration taken from an anonymous collection dating from the years 1860–1880. Signac did away with the traditional motifs, like the Yin and Yang, which would reveal their origin too literally, and substituted, in identical sections—the center of which is slightly off to respond to the needs of the golden number—regular motifs of arabesques suitable to serve his system of tonal contrasts." The complete title of the painting is "The Portrait of

Monsieur Félix Fénéon on the enamel of a rhythmic background of measures and angles, of tones and tints." Signac's logical aims appear in this title as well as the influence of the theorist Charles Henry, who sought to quantify emotions and make art an exact science. Robert Delaunay, Henry's friend and, it appears, also Fénéon's, returned, in his "Circular Forms" and his "Propellers," to the idea of the pure dynamics of color, taking the spectator's eye into an endless gyration.

In the lithograph made for the Théâtre-Libre, its dry and programmatic quality foretells some aspects of Bauhaus design. Signac in his composition utilizes a circle, placing on the flat part of the surface only the letters *T* and *L*. The colors are divided according to the order prescribed by Charles Henry, from bottom to top for the letter *T* and from top to bottom for the letter *L*. Inside the circle the rear view of a spectator's neck as he faces the stage of the theater is portrayed.

Paul Signac. "Portrait of Félix Fénéon." 1890. Oil. 28.9 x 37.05 inches.

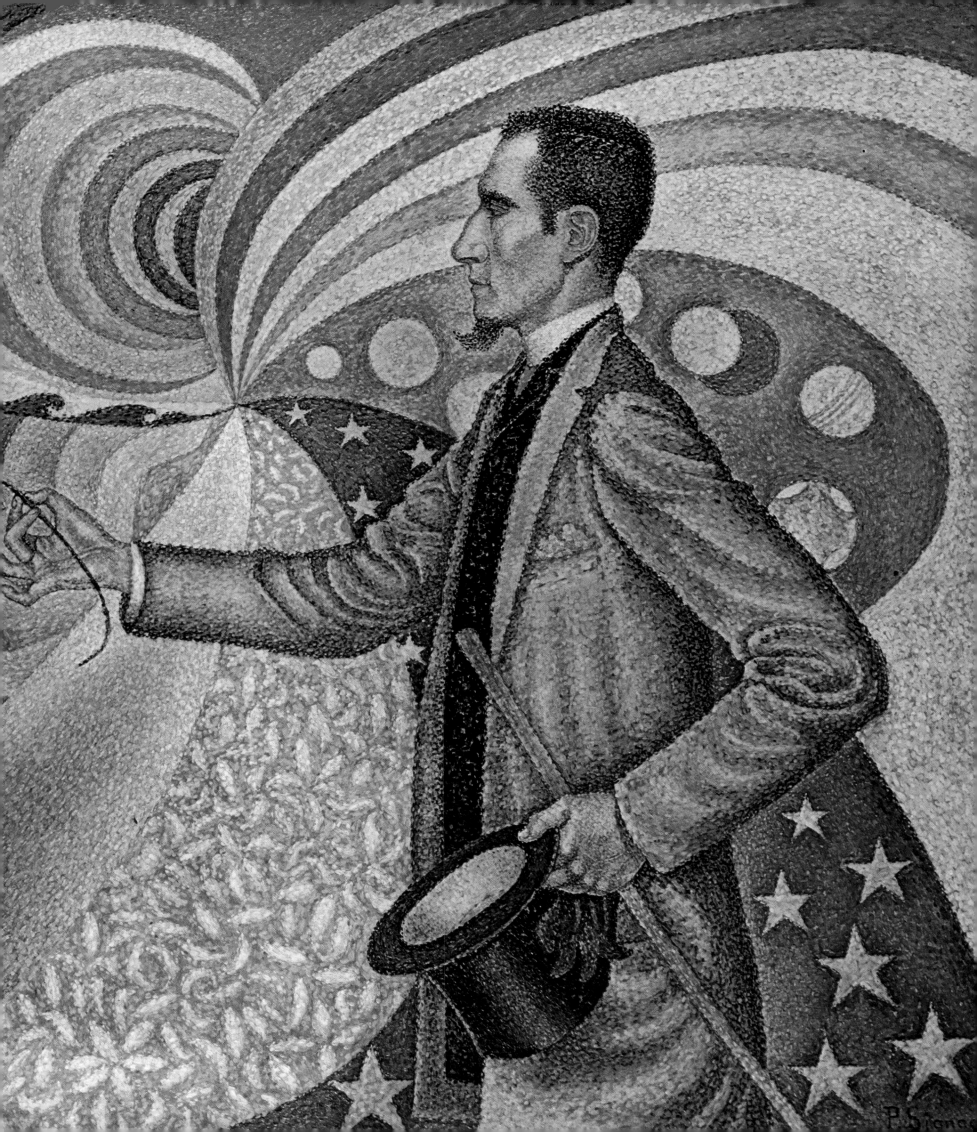

Prices

by François Duret-Robert

The sums given in francs in this text are those actually paid at the time of sale. Approximate equivalent values in dollars in 1972 are given in parentheses. Differences in the rates of conversion reflect changing values of the currencies.

About 1860 the collector of paintings was a happy man. Nothing was easier for him than to discover a painter's talent. He merely had to observe and then apply the recipes and formulas taught at the Ecole des Beaux-Arts.

The collector could even dispense with this effort. Personalities whose competence was unanimously recognized—members of the jury—took it upon themselves to safeguard the Temple of Art or, if we prefer, the Salon, by expelling the black sheep. These gentlemen took their professional duties to the point of establishing a strict hierarchy among those whose works they accepted, so that the visitor could correctly apportion his admiration. Thus with no fear of making a mistake one could sympathetically study the canvas of a painter who had obtained honorable mention, contemplate with interest the one who had won a medal—with all the nuances depending on whether this was a second-class medal or a medal of honor—and finally express enthusiasm in the presence of a masterpiece, namely, the work of a member of the Institute.

The prices of modern paintings were established after the same criteria. No serious collector would have dreamed of acquiring a painting refused at the Salon—Jongkind, who had sold a landscape a few days before the opening of the Salon, found himself forced to reimburse the buyer, since the painting had been blackballed by the jury—nor pay the same amount for a work which had won a second-class medal as that of an academician.

Thus all was for the best in the best of all possible worlds.

Alas, this splendid system which spared the collector any doubt was to be troubled by a certain Manet who was soon assisted in these nefarious enterprises by a band of disturbers known as Monet, Renoir, Cézanne. . . .

These gentlemen, real outlaws, intended to show their smearings to the public in private exhibitions without allowing the academicians a word. They practiced in a way an illegal form of painting. Faced with such a scandal, decent people adopted the only suitable attitude: They laughed. On seeing Manet's "Olympia" they burst out in a roar of laughter. They gaped at the Monets, the Renoirs, and the Cézannes on the occasion of the exhibitions organized as early as 1874.

The strangest thing was that about 1870 these so-called artists found a dealer in Paul Durand-Ruel, who, it was true, had already offered proof of his eccentric taste by defending Corot and the school of Barbizon. Now he was bent on imposing the works of such painters as Manet, Monet, and Renoir. He bought many canvases from them. The prices he paid for these were obviously not exorbitant—from 400 to 3,000 francs ($256 to $1,920) for the Manets, 800 francs ($512) for the Degas, 300 francs ($192) for the Monets, 200 francs ($128) for the Pissarros, Renoirs, and Sisleys. Even so, no one else would have thought of throwing away his money. For it goes without saying that these badly painted pictures were unsalable. Collectors could practically count on their fingers those who would consent to hang such horrors on their walls.

These included the singer Faure who spared no expense to make himself conspicuous. For had he not been so mad as to pay 6,000 francs ($3,840) for Manet's "*Le Bon Bock*" and 5,000 francs ($3,200) for Degas' "Ballet Class"? It is true that this last named deserved some indulgence, for Degas admired Ingres. And there was hope that after his youthful errors he would finally return to the right path, namely, that of Academicism. As for his friends, their case was hopeless. Serious minds agreed that their works were valueless. To be reassured, one merely had to read the prices obtained at public auction. At the Hôtel Drouot (the Paris auction house) the prices for Manet's works and for those of the Impressionists, after some fluctuation, practically fell to zero. During the Hoschedé Auction in June, 1878, one could buy a painting by Manet for 315 francs ($202), a Monet for 60 francs ($38), a Renoir for 31 francs ($20), a Sisley for 21 francs ($13), and a Pissarro for 7 francs ($4).

The reason was understood.

And yet, as early as the 1880's, events took a disturbing turn. The auction of what remained in Manet's studio in 1884 was not the "flop" which right-minded people had expected. Certainly the "Olympia" had to be removed from auction for lack of bidders at 10,000 francs ($6,400), but "*Chez le Père Lathuile*" fetched 5,000 francs ($3,200) and "The Bar at the Folies-Bergère" 5,850 francs ($3,744). Pessimists even felt certain indications of a return in favor of the Impressionists. After all had not Renoir, in the wake of his success at the Salon of 1879, been received in certain drawing rooms of important Parisians? And in 1886 certain collectors had even paid as much as 1,200 francs ($768) for a few of Monet's canvases. But there was no need to be overanxious. If necessary, certain events could be cited to prove that every collector and art lover had not lost his common sense. The first was Durand-Ruel's almost utter failure even though he had been fully warned. But neither warning from intelligent collectors nor his friends' advice could make him change his mind about supporting the Impressionists. As a result, he lost his last real clients. About to go bankrupt, he found nothing better than to sail for the United States—the land of Buffalo Bill and Indians—with his stock of unsold canvases. Especially to be cited was the rightful triumph in public auctions of important works by the great masters. In 1886 Jules Breton's "*Les Communiantes*" sold for 225,000 francs ($144,000). In 1887 Rosa Bonheur's "Horse Market" went for 268,500 francs ($171,840), while that same year Meissonier's "Friedland" fetched the sum of 336,000 francs ($215,040). In the wake of such a success, the academicians could scarcely make a fuss over the few thousand francs for certain Monets and Renoirs.

About 1890 matters became worse. Already during the course of the preceding years, there was occasion to deplore some actions of treason. The most positive partisans of the Great Art had begun to make a pact with the enemy. Georges Petit, whose sumptuous gallery had until then been one of the sanctuaries of Academicism, now decided to exhibit the Impressionists.

The public authorities themselves had lost their fine intransigence of former times. In 1892 the Fine Arts Director had the amazing idea of ordering a painting from Renoir and a few months later it was hanging in the Luxembourg Museum.

No sooner had serious-minded citizens time to swallow this insult than they were threatened by another danger of quite different importance. In February, 1894, Gustave Caillebotte died. In his will he left his collection to the State, that is, if a group of sixty-seven Impressionist paintings could be considered a collection. One month later the museum committee consulted recommended accepting the bequest. Despite commendable efforts by functionaries to cope with the threat, the venerable painter Léon Gérôme's solemn warning, and the public authorities' refusal after much deliberation

of eleven Pissarros, eight Monets, three Sisleys, two Renoirs, and two Cézannes, the catastrophe could not be avoided. Thirty-eight Impressionist paintings entered the Luxembourg Museum. Bouguereau, making no attempt to hide his amazement, even managed to say, "Yet there are people who like this since it sells!"

Alas, Bouguereau was right. Impressionist paintings began to sell. As early as 1892 the partisans of the new painting, without causing anyone to burst out in laughter, could speak of the "consecration" of Monet, Renoir, Pissarro. Sisley's death in 1899 gave the signal for a striking rise in Impressionist prices.

At the dawn of the twentieth century the Institute noted with consternation that Monets were easily finding buyers for 20,000 francs ($15,400) at Durand-Ruel's. The art dealer, instead of perishing with all his canvases in the distant United States, had discovered the road to fortune—Renoirs were now fetching 10,000 or 15,000 francs ($7,600 or $11,400) at the Hôtel Drouot, Sisleys 8,000 or 10,000 francs ($6,200 or $7,600), Pissarros 5,000 or 7,000 francs ($3,800 or $5,400). And if it were a question of a so-called masterpiece, these figures were pulverized. In March, 1900, the Comte Isaac de Camondo paid 43,000 francs ($32,200) for Sisley's "Flood at Port-Marly."

Even Cézannes now sold at mad prices, sometimes for as much as 5,000 or 7,000 francs ($3,800 or $5,400).

This was but the beginning.

For the period of some thirty years, the fervent admirers of the great academic masters—Meissonier, Bouguereau, Cabanel, to name the most famous—witnessed the gradual destruction of their idols, while the adversary continued to send victory bulletins. A Renoir, for example, in 1907 reached the 1972 equivalent of $61,000, in 1912 a Degas the equivalent of $276,000 and a Gauguin the equivalent of $20,000.

And yet that same year, 1912, saw a reassuring event. "Salomé" the work of a former Grand Prix de Rome, the more or less academic painter Henri Regnault, found a buyer for 480,000 francs ($307,200). Did this mean a return to common sense, the beginning of the end for the heretic painters? Alas, no. For as early as 1918 the price of Impressionist paintings took a sharp rise. To cite merely one example, in 1923 Durand-Ruel sold Renoir's "Luncheon of the Boating Party" for $200,000.

People outbid one another for the maddest works. In 1925 a Cézanne was sold at auction for the 1972 equivalent of $79,814 and in 1926 Dr. Albert Barnes paid the 1972 equivalent of $182,753 for Seurat's *"Poseuses."*

The last partisan of Academicism, if there remained one, had to admit the facts: The Impressionists and their immediate successors had definitely won the game.

As early as 1929, however, their prices dropped. This was not the consequence of seeing Impressionism fall into disgrace or the sign of a change in taste, but rather the result of an economic and financial cataclysm. In October, 1929, the New York Stock Market collapsed and the crisis was immediately felt in Europe. Everything lost value, though works of art appeared to have best survived the storm. When in December, 1932, the banker Blumenthal sold his collection, he lost 30 percent on the prices he had paid. When his friends expressed their regret, he retorted, "I'm delighted. This is an unexpected success, for my stock fell 75 percent."

As a matter of fact, certain Impressionist paintings did no better than the banker's stock. In 1936 a few Renoirs took a loss of 80 percent compared to the prices they had attained in 1925. These Renoirs, however, dated from the master's last and most debated period. The masterpieces did far better, all the more so as Durand-Ruel had launched a counteroffensive on the American market by agreeing to buy back canvases sold by him during the preceding years at the prices the purchasers had paid. Yet on the eve of the Second World War Impressionist paintings had not entirely recovered from the blow received during the 1929 crisis.

When, in May, 1952, Madame Walter paid 33,000,000 francs ($125,580) for a still life by Cézanne, there was almost a cry of scandal. A thousand explanations were offered for this senseless gesture, but a single one would have sufficed. The price paid for "Apples and Biscuits" was by no means excessive if one considered the recent development of Impressionist value (in the large sense of the term). For some years now, the consequence of the 1929 crisis had been overcome and Impressionist paintings began to rise in price. The surprise stemmed from the fact that people had forgotten to express prices prior to 1929 in current currency, not to mention a few person-to-person sales which had occurred since the end of the Second World War. The price for the Cézanne caused a sensation, and there was general agreement that Madame Walter had given the signal for the price race among Impressionists, Post-Impressionists and Neo-Impressionists.

From time to time the newspapers would announce that a new sales record had just been made. In 1964 Cézanne's "Great Bathers" was sold for 500,000 pounds ($1,400,000 at that time). In 1967 $1,411,200 was paid for Monet's "Terrace at Ste.-Adresse." As early as 1968, he was surpassed by Renoir, whose *"Pont des Arts"* was sold for $1,550,000. In 1970 Seurat made news when his smaller version of *"Les Poseuses"* was sold for 430,500 pounds ($1,033,000). That same year Van Gogh's "Cypress and Tree in Blossom" made a worthy performance when it was sold for $1,300,000.

If it is easy to follow the increase in Impressionist prices, it is more difficult to offer a serious explanation. Many who claim to be "in the know" will insist at once that the American tax system is responsible, since an American gains certain tax advantages when he gives a work to a museum. There is doubtless some truth in this explanation, and it well illustrates why Impressionist works worthy of hanging in a museum have done far better than minor canvases. But it also reveals a danger, for if this American tax system were revised, the prices of Impressionist works could fall sharply.

No consideration of fiscal order can fully explain the present prices for Impressionist works however, nor why a mediocre Pissaro often sells for a higher price than a good Courbet or an excellent Daubigny. To attempt to explain the triumph of Impressionism, we would have to sound the souls of present-day collectors, discover the reasons for their passion for out-of-door painting, their taste for country scenes, their disdain for historical and mythological subjects which were all the rage during the last century. In short, we would have to write a whole novel in which imagination would perhaps have the greatest part. It has seemed to us a more prudent idea to adopt an observer's attitude and to devote the following pages to short monographs which outline the special development of the prices of a few great Impressionists.

Manet

One fine day in 1872 Manet, entering the Café Guerbois, asked the crowd offhand, "Would you tell me who does not sell fifty thousand francs' worth of paintings per year?" All his friends replied in unison, "You!" They were mistaken. Paul Durand-Ruel had just bought 51,000 francs' ($32,640) worth of paintings. When the news spread in Paris, people thought that the dealer had lost his mind.

Until then the painter had scarcely had an occasion to sell his works. Fortunately he could manage otherwise. His family were members of the well-to-do middle class. Manet lived off the allowance which his father had granted him, then after the latter's death, from an inherited fortune. When he found himself short of money, he would "borrow" from his mother.

It is true that, if Manet sold few works, he sold them at relatively high prices. After the scandal created by his "Olympia" at the Salon of 1865, an Italian admirer of the painter asked him the price of the painting. "The sum of ten thousand francs [$6,400]," replied Manet. The lovely lady did not insist. Even when it was a matter of paintings of lesser importance, his prices were relatively high. In 1870, for example, Théodore Duret paid 1,200 francs ($768) for his "*Toreo Saluant.*"

But collectors of Manet's paintings were very few. Finally Paul Durand-Ruel arrived. "One day," he related (the scene took place in January, 1872), "I found two paintings by Manet at Alfred Steven's. Since this great artist received no one in his studio, he had asked his friend to try to sell them for him by showing them in his place. . . . The price asked was 800 francs [$512] for each of the two. I took them at once and, marveling at my purchase, for one cannot really appreciate a work of art until one possesses and lives with it. I went the very next day to see Manet. I found there a group of unusual paintings, several of which had already attracted my attention in the different Salons but seemed far more handsome to me since I had time to study the purchase of the previous day. I took everything that Manet had in his studio, that is, twenty-three paintings, for 35,000 francs [$22,400], accepting the prices he had asked. . . . A few days later, I returned to see Manet, who had collected there a certain number of paintings left among his friends and I bought a second lot from him. . . . The whole for 16,000 francs [$10,240]."

The prices which Manet had asked from the dealer for these paintings, which rank among his most famous works, varied from 400 to 3,000 francs ($256 to $1,920). Durand-Ruel's example was scarcely followed. A year and a half later, the painter wrote to Théodore Duret, "If among your relations you have a few collectors to take around, I am in the mood now to make some important concessions, for I am in need of money." The purchase en masse by Durand-Ruel scarcely led to a sudden rise in Manet's prices. Théodore Duret acted as intermediary to sell Henri Rouart "On the Beach." "When they discovered the price—1,500 francs [$960]—which I had obtained for this painting," wrote Duret later, "Rouart's friends said that I had taken advantage of his kindness."

Manet, however, had a few collectors, like Emmanuel Chabrier and Antonin Proust. But his most important buyer, not counting Durand-Ruel, was the singer Faure, who according to his contemporaries liked to be noticed and had begun by buying works by Delacroix, Corot, Millet, and others. In June, 1873, Faure sold his collection and decided to become interested in more controversial painters. In November he visited Manet in his studio and there bought five important canvases: "*Le Bon Bock*" for 6,000 francs ($3,840), "The Masked Ball at the Opera" likewise for 6,000 francs, "The Luncheon on the Grass" for 4,000 francs ($2,560), "*Lola de Valence*" for 2,500 francs ($1,600), and "Fishermen at Sea" for 2,000 francs ($1,280). Henceforth Faure continued to acquire Manets, either directly from the painter, from Durand-Ruel, or at public auctions where the artist cut a poor figure. During the Hoschedé Auction in June, 1878, Manets went for between 315 francs ($202) and 800 francs ($512), this last price having been paid for "The Beggar." In May, 1881, one of his canvases, "*Le Suicidé,*" fetched merely 65 francs ($42).

When Manet died two years later, he left debts. Fearing that the painter's widow would be short of money, Mallarmé offered her his entire savings.

Born into comfortable circumstances Manet died almost a poor man. The sole "capital" which he left was the work accumulated in his studio; these had to be sold quickly. The public auction was set for February 4–5, 1884. "It will be a flop," predicted Albert Wolff, the eminent critic of *Le Figaro.*

The results were beyond expectation: 116,637 francs ($74,648) for 89 paintings, 41 studies, 40 pastels, and a number of drawings. However, as Tabarant pointed out, "A single small Meissonier alone would have fetched more than this sum." Several paintings, it should be stated, were bought back by Madame Manet, and for lack of bidders the "Olympia" was withdrawn from auction for 10,000 francs ($6,400).

Was it profitable to have bought a Manet during the auction of what remained in his studio? To reassure ourselves, we merely have to glance at the prices for two paintings included in this auction.

"The Promenade," 1879. 36.3 × 27.3 inches
1884: 1,500 francs ($960)
1958: 89,000 pounds ($249,200 at that time)

"Veiled Woman," 1872. 23.4 × 17.9 inches
1884: 240 francs ($154)
1965: 20,000 pounds ($56,000 at that time)

Degas

We must be wary of accepting as true everything Degas said, especially when he bewailed his sad fate. "I will never be successful . . . I am bitterly reflecting over the way I have managed to reach old age without ever earning any money." During the last years of his life he practically admitted being "ready for the poorhouse." As a matter of fact, many of his painter friends would have envied his poverty.

When the young Degas was faced with the choice of a career, two possibilities were offered him: to enter the family bank headed by his father or work for a firm owned by his maternal uncles in New Orleans. He chose a third, namely, painting. The strange thing is that he had no reason to regret this. For Degas, who had an income, could have quite early lived from his art. We merely have to read the following lines, by his brother Achille, to convince ourselves. "On February 16, 1869, Edgar came with me to Brussels. He met Monsieur van Praet, the king's minister, who bought one of his paintings, and it is seen in one of the most famous galleries in Europe. This gives him a certain pleasure, as you can imagine, and finally some confidence in himself and in his talent which is real. He sold two others during his stay in Brussels and a well-known dealer, Stevens, offered him a contract of 12,000 francs ($7,680) per year. He is really on his way. . . ." The sum offered was substantial, and yet it seems that Degas refused this contract. In Paris a few of the art dealers, like the Père Martin and Portier, became interested in his work and as early as 1872 Paul Durand-Ruel took his paintings. Degas' prices, moreover, were much higher than those of the other Impressionists. Whereas Durand-Ruel bought Monet's canvases for 300 francs ($192) and those by Renoir, Pissarro, and Sisley for 200 francs ($128), he paid 800 francs ($512) for Degas' work. This proved a bit of luck for the

painter, who was to feel the effect of the family's financial situation. His father's death in 1874 revealed that the bank, of which he was the head, was in bad straits. To avoid bankruptcy, Degas was forced to pay large sums of money. To save the family honor, he agreed, in 1877, to reimburse monthly payments to a credit establishment to which the bank owed money. From that moment on, he had to count on the sale of his works in order to live. Happily, he had a number of admirers convinced of his talent, chiefly the singer Faure, who in 1872 ordered a painting from Degas similar to "The Ballet Examination." Degas delivered the canvas in 1874—a painting entitled "The Ballet Class"—for the sum of 5,000 francs ($3,200).

That same year the painter complained to the singer of being dissatisfied with six of his paintings which were on sale at Durand-Ruel's. Faure bought the six canvases for 8,000 francs ($5,120), then handed them over to Degas; in addition, he paid him 1,500 francs ($960) in exchange for which Degas was to paint him four large canvases.

During the rest of his life Degas watched, with a certain indifference, the continuous increase in the price of his works. We can gain a certain idea of this increase by consulting the records kept at Durand-Ruel's. Here are a few examples. In 1881 the dealer bought *Le Foyer de la Danse* for 5,000 francs ($3,200) and two other paintings for 3,500 francs ($2,240) each. In 1893 he paid 10,000 francs ($6,400) for "Carriages at the Races" and in 1911 he acquired "Before the Race" for 25,000 francs ($16,000).

Degas' increase appears even more clearly if we glance at a few price records during public auctions:

1874 "The Grandstand at Longchamps," 1,100 francs ($704)
1890 "The Lesson in the Foyer," 8,000 francs ($5,120)
1895 "The Laundresses," 11,000 francs ($7,040)
1899 "The Photographer," 22,760 francs ($14,566)
1902 "Backstage," $6,100
1912 "Ballet Dancers at the Bar," 435,000 francs ($285,000)

When Degas was informed of this last price, he said, "I don't believe that the man who did it [the painting] was a fool, but the one who bought it is an ass." This leads one to think that the painter was not gifted with a divinatory sense. For had he been able to foresee the prices paid for his works some fifty years after his death, he would have been forced to admit that the purchaser of an excellent Degas by no means deserved such a word.

We have valuable references to study the fluctuations in Degas' prices dating from the time of the painter's death, namely, the prices obtained during the dispersal of what remained in his studio (1918 to 1919). In general, in the period of decline during the years following these auctions, prices for Degas' works enjoyed fresh success beginning in 1927. As for their present prices, they represent in general 30 to 125 times those of 1918–19. Here are two examples.

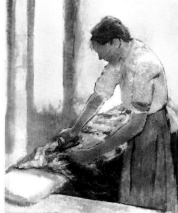

"Woman Ironing Against the Light."

About 1883. 31.6 × 25.35 inches.
1918: 21,000 francs ($6,220)
1968: 145,000 pounds ($348,000 at that time)

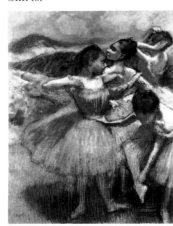

"Ballet Dancers, Pink Skirts."

35.1 × 25.35 inches
1918: 17,600 francs ($5,213)
1969: 68,300 guineas ($171,360 at that time)

Monet

At the age of fifteen, Claude Monet was famous. And the prices he asked for his works scandalized his parents, who were honest grocers and used to modest profit. It is true that his glory scarcely extended beyond the limits of Le Havre, where he lived with his family, and that the works in question were commissioned by well-known people in the city. Monet sold them for 10 or 20 francs ($6 or $12).

The year 1859 found him in Paris where he managed to live on sales of his caricatures. After two years of military service in Africa, he returned to the easel. His father proved understanding and agreed to pay him a monthly sum. But he warned him, "I want to see you in a studio, disciplined by a well-known teacher. If you go off on your own again, I shall at once stop sending you money." Consequently Monet was forced to frequent Gleyre's studio. He exhibited his work at the Salon of 1865 and won a certain success. His works, influenced by the Realism then in favor, thanks to Courbet, found favor in the public's eye and he managed to sell a few. Fortune, which had barely smiled at him, then turned against him. In 1866 he destroyed a good number of his canvases, fearing that his creditors would seize them and sell them at auction. Happily Bazille bought his "Women in the Garden" for 2,500 francs ($1,600). But he could pay this sum only in 50-franc ($32) monthly payments.

In 1867 the Salon jury accepted only one of his paintings. For Monet, who now had others to look after—his mistress, Camille Doncieux, had just given birth to a boy—things went from bad to worse. Nevertheless there were a few to buy his works. In 1868 Arsène Houssaye paid 800 francs ($512) for his "Woman in a Green Dress" and a Monsieur Gaudibert of Le Havre ordered a portrait of his wife.

In 1869 things were really bad. His failure that year at the Salon proved scarcely encouraging to the few who could buy his work. Renoir brought him bread. In September Monet wrote, "Desperate state. I sold a still life and can work a bit. But as always I've stopped for lack of paint. . . ." After the French defeat at Sedan in the Franco-Prussian War, Monet fled to London, where thanks to Daubigny he met Paul Durand-Ruel, who bought a few of his canvases for 300 francs ($192) each. The dealer continued to help him during the following years, but in 1874, finding himself in serious financial difficulty, he had to leave Monet to his sad fate. The period of 1874–80 proved catastrophic. Sales at the Hôtel Drouot revealed that collectors were hardly interested in his work. During the auction held on March 24, 1875, prices for Monet's work varied between 180 francs ($115) and 325 francs ($208).

During the Hoschedé Auction on June 5, 1878, one could acquire the "Village," 21.45 × 25.35 inches, for 60 francs ($38) and the "Young Girls in a Clump of Flowers," 21.45 × 25.35 inches, for 62 francs ($40). The record price—505 francs ($323)—was paid for "St.-Germain-l'Auxerrois," 31.2 × 39.4 inches. The painter increased his desperate appeals.

Did Monet have better luck in exhibitions? In 1876, during the second Impressionist exhibition at Durand-Ruel's, he managed to sell "Camille in a Japanese Robe" for 2,000 francs ($1,280). This was a short-lived success. Recalling these difficult times, Paul Durand-Ruel later related, "One day I bought five paintings by Monet which an intermediary offered me for 100 francs [$64]."

In 1881 Monet sold him twenty-two canvases at an average price of 300 francs ($192). During the following years the prices increased. In 1883 Durand-Ruel gave the artist 500 francs ($320) and even 600 francs ($384) for certain canvases. Difficult times, however, were far from over. The Monet exhibition organized in 1883 by Durand-Ruel was a "flop" as the artist described it, and in 1884, following a crisis on the art market, Monet's work sold for low prices.

In 1885, however, the artist achieved a definite success at the fourth international exhibition which was held at the Galerie Georges Petit, and in the following year, thanks to Petit, he sold several paintings, some for 1,200 francs ($768). In addition to Georges Petit, the dealers Knoedler, Boussod, and Valadon became interested in his work. Materially speaking, he was leading a far better life. This is revealed by the fact that in December, 1886,

Monet was able to return to Durand-Ruel, with whom he had had a few words, the 1,000 francs ($640) which the dealer had sent him.

The period 1886–90 marked the artist's definite success. In 1889 Théo van Gogh, the manager of a branch of the Galerie Boussod et Valadon, succeeded in selling one of his paintings for 9,000 francs ($5,760). In 1890 Monet was able to buy a house at Giverny. From that date on, the prices of his work continued to increase. In 1891 the artist exhibited his Haystack series at Durand-Ruel's. Three days after the opening every painting was sold. The prices were from 3,000 francs ($1,920) to 4,000 francs ($2,560). The year 1904 saw the exhibition of his "Views of London." News spread that the Comte Isaac de Camondo had bought them all. Actually he had acquired only one, but on the tenth day of the exhibition. Durand-Ruel sold ten canvases for 20,000 francs ($12,800) each.

When Claude Monet died in 1926 he was a rich man. To gain some idea of the increase which occurred between the 1880's—the period during which Monet lived in poverty—and the present time, we merely have to glance at the development of the sales price of one of his canvases, "The Port of Honfleur."

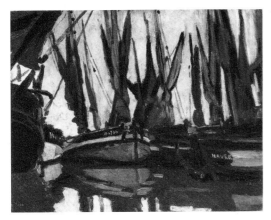

"The Port of Honfleur," about 1886–67.
1881: 72 francs ($46)
1899: 2,550 francs ($1,632)
1924: 15,200 francs ($9,728)
1966: 13,000 pounds ($31,200 at that time)

Let us now follow the increase in prices of two paintings from the years prior to the First World War to the present day.

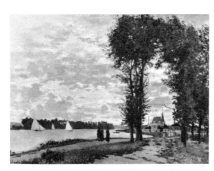

"The Banks of the Seine at Argenteuil,"
21 × 28.9 inches.
1912: 27,000 francs ($17,600)
1970: 240,000 guineas ($604,800 at that time)

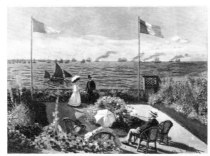

"Terrace at Ste.-Adresse,"
1886–87, 38.2 × 50.7 inches.
1913: 27,000 francs ($17,200)
1926: $11,500
1967: $1,411,200

Renoir

On March 18, 1872, Paul Durand-Ruel bought his first Renoir, "The Pont des Arts," for 200 francs ($128). On June 9, 1932, the painting was sold at auction for 133,000 francs ($16,500). On October 9, 1968, the painting was sold again at auction for $1,550,000. These three prices offer an idea of the increase in Renoir's works in less than a century. The last performance of "The Pont des Arts" has another merit, for thanks to this painting, Renoir takes a lead, with Cézanne, in the race of record prices during recent years of Impressionist works. He takes a slight lead over Monet—whose "Terrace at Ste.-Adresse" was sold, in 1967, for $1,411,200—and is well ahead of other competitors, like Pissarro and Sisley.

During his lifetime, Renoir had already appeared to his Impressionist friends as a privileged person, though only relatively, in that, unlike Monet, Pissarro, and Sisley, he never knew poverty. Not that he had an income, but even during the worst years he managed to sell a few paintings. He specialized in the human figure. Now, rather than buy a landscape from an unknown painter, one would more easily order one's portrait. And for the joy of seeing their faces, collectors often proved rather generous. This does not mean that Renoir lived like a king. In 1870 he confessed to Théodore Duret that he had to leave a few canvases as security in a studio because he had been unable to pay his full rent. Duret hastened to this studio, stopped before *"La Grande Lise"* and bought the canvas for 1,200 francs ($768).

Obviously this was a friend's price, that is, far superior to the one which other collectors would have agreed to pay. The painter was convinced two years later when, together with Monet, Sisley, and Berthe Morisot, he decided to try his luck at the Hôtel Drouot. The auction took place on March 24, 1875, and proved a disaster. The Renoirs went for 50 to 300 francs ($32 to $192). A second attempt, in May, 1877, was equally a failure. The Renoirs were sold for between 47 and 285 francs ($28 and $182). And the Hoschedé Auction which took place in June, 1878, offered collectors and art lovers an opportunity to buy Renoirs at even lower prices. "Girl in a Garden" was auctioned for 31 francs ($20) and "The Chatou Bridge" for 42 francs ($27).

Renoir's future appeared as anything but bright. And yet, a year later, he had become almost a ranking painter. Renoir owed his growing fame to a portrait—or rather to its model, Madame Charpentier. The wife of a much-talked-about publisher, she had agreed to pose with her children for her portrait, and Renoir sent the canvas to the Salon of 1879. (It is now in the Metropolitan Museum of Art, New York.) Madame Charpentier was not one to have her painting placed in a position unworthy of her. Consequently she took the precaution of "strongly shaking" a few members of the jury, with the result that the portrait, placed in a favorable position, enjoyed great success. And certain important members of Parisian society, following Madame Charpentier's example, did not hesitate to order their portraits from Renoir. Durand-Ruel who, since 1874, had been forced to stop buying almost any of their work, now began anew to help his painters. In January, 1881, he bought Renoir's "Woman with a Cat" for 2,500 francs ($1,600) and his "Luncheon of the Boating Party" for 6,000 francs ($3,840). Unusual prices for Renoirs, though it is true these were important works.

But the painter was not out of the woods completely. The following years had many an illusion in store for him. The mediocre success of his exhibition in 1883 at Durand-Ruel's, the art dealer's new financial difficulties, the serious crisis in 1884 of the art market, all contributed to making things difficult. And yet his fame grew. When in 1892 Durand-Ruel held a Renoir exhibition, the manifestation, according to Franz Jourdain, turned to apotheosis, for the unbelievable happened: The State ordered a painting.

The verdict at the Hôtel Drouot likewise proved encouraging. A few prices during auction from 1894 to 1900 offer an idea of Renoir's increase in value. *"La Toilette,"* sold for 140 francs ($89) in 1875, fetched 4,900 francs ($3,136) in 1894; "Anna," which Chabrier had bought from Renoir for 300 francs ($192) in 1883, was sold for 8,000 francs ($5,120) in 1896. In 1899, during the auction of the Count Armand Doria collection, *"La Pensée"* found a buyer for 22,000 francs ($14,080). It was said that Renoir had sold it to the collector less than thirty years before for 150 francs ($96).

In 1900 Renoir could be considered a successful painter.

Victory bulletins were to multiply during the following twenty years. Here are two of the most eloquent. "Madame Charpentier and Her Children"—the painting which had "launched" Renoir—was sold for 84,000 francs ($63,000) in April, 1907. The artist had received 1,500 francs ($960) for the work in 1879: Its value had therefore been multiplied some sixty times in less than thirty years. "The Pont-Neuf," which was sold for 300 francs ($192) in 1875, was sold for 93,000 francs ($22,888) on December 14, 1919.

The day before this auction Renoir died. The disappearance of the painter merely increased his prices. In 1923 Durand-Ruel succeeded in

selling Duncan Phillips "The Luncheon of the Boating Party" for $200,000. In 1925 the Hôtel Drouot was the scene of a memorable event, the auction of the collection of Maurice Gangnat, who had accumulated 160 Renoirs dating from his Cagnes period. The auction totaled more than 10,000,000 francs ($1,560,000).

The world crisis of 1929 interrupted this triumphal ascension. The results of the Gangnat Auction form valuable references for an idea of the repercussion which this crisis would have had on the prices of Renoir's work. In fact, some of the paintings which were outstanding reappeared later at public auction and seemed to have lost much of their magnificence.

Year in which the painting reappeared in public auction.	Title	Variation of value in respect to the price reached during the Gangnat Auction in 1925.
1933	"Head of a Young Girl," 1913	–69%
1936	*Amour en bronze,* 1913	–78%
	"The Path at Cagnes," 1907	–77%
1939	"Nude Drying Herself," 1912	–45%
	Jeune Fille Accoudée, 1911	–31%
	"Roses and Small Landscape," 1911	–61%
	"Woman Wearing a Red Hat," 1908	– 7%
	"Woman Reading," 1909	+ 2.5%

In other words, on the eve of the Second World War, the Renoirs had not yet recovered from the blow inflicted by the 1929 crisis. It is true that the paintings of the Gangnat Collection belonged to the artist's Cagnes period, the most controversial, and that for this reason they were vulnerable. The master's earlier works, it seems, had weathered the blow better. In any case, prices rose immediately after the war and led to the spectacular bids which are familiar to all. In the light of these prices, to appreciate the increase in Renoirs, the best is still to establish a reference date—for example, 1892, the date of the Durand-Ruel exhibition—then to choose among the paintings auctioned those whose bidded prices (or the prices paid by Durand-Ruel) are know on or about this reference year.

The price paid for	in	represents	that of
"The Mosque at Algiers"	1957	56 times	1892
"The Hothouse"	1957	117 times	1894
"Woman in a White Hat"	1959	89 times	1896
"Young Soldier"	1964	444 times	1894
"Girl in Profile"	1968	2,181 times	1890
"The Pear Tree"	1969	472 times	1892

Thus during the past fifteen years Renoirs have reached prices which on the whole represent 50 to 2,000 times those which they reached about 1892. But if we choose the year 1872, when Durand-Ruel bought his first Renoirs, instead of the period around 1892, we would have more spectacular results. An example seems conclusive. The price paid in 1968 for "The Pont des Arts" is some 12,000 times the one which the dealer paid the painter in 1872. It is true, however, that this canvas was of "museum quality" and that for this reason it was especially favored.

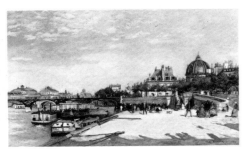

"The Pont des Arts"
About 1868, 23.8 x 39.4 inches.
1872: 200 francs ($128)
1932: 133,000 francs ($16,500)
1968: $1,550,000

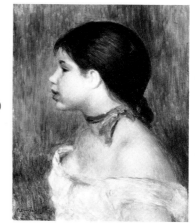

"Girl in Profile," 1888,
12.5 x 9.4 inches.
1890: 150 francs ($96)
1968: 1,070,000 francs ($239,600)

Sisley and Pissarro

For anyone exclusively concerned with price development, a sole event in Sisley's life offers a certain interest. That event is his death. Indeed, the disappearance of the painter created a strong increase in the price of Impressionist works. As for Sisley's existence, it can be summarized in one sentence: He was the poorest and least known among the Impressionists. Whereas as early as 1892 Monet, Renoir, and Pissarro were famous and well-off, Sisley continued to have a hard time to make ends meet. Certainly his exhibition in 1897 at the Galerie Georges Petit enjoyed a real success, and that same year some of his canvases fetched good prices at auction, but unfortunately it was his old paintings which were received with favor. And he still led a hand-to-mouth existence. A few months before his death, Sisley, a cancer victim, wondered whether his doctor bills would be more than 200 francs ($128).

Pissarro was somewhat more fortunate, at least during the last fifteen years of his life, for his fate prior to the year 1890 was scarcely more enviable than that of Sisley. In 1884 he summarized his situation in the following manner in a letter to his friend Murer, "Tell Gauguin that after thirty years of painting . . . I am hard up." He had to wait until the years 1888–89 to see his paintings sell for a decent price. The exhibition organized at the Galerie Durand-Ruel in 1892 marked his general acceptance, and several paintings were sold for prices varying from 1,500 to 6,000 francs ($960 to $3,840). From then on until his death the prices of his paintings continued to increase.

Beginning in the 1900's the value of Sisleys and Pissarros followed, with a slight delay it is true, a curve parallel to that which reflected the triumph of Monets and Renoirs. Their works enjoyed the same gain until 1929, the same vicissitudes caused by the world crisis, the same hours of glory beginning in 1950.

These identical fluctuations, however, should not conceal the essential difference: Sisleys and Pissarros sold—and still sell—for less than Monets and Renoirs.

Sisley: "Inundation, Road from St.-Germain,"

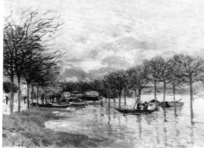

1876, 17.2 × 23.4 inches.
1880: 300 francs ($192)
1936: $2,000
1969: 60,000 pounds
($144,000 at that time)

Pissarro: "Tuileries Garden, Spring Morning,"

1899, 28.5 x 36.3 inches.
1899: 3,000 francs ($1,920)
1968: $260,000

Cézanne

In March, 1918, René Gimpel noted in his journal, "The origin of Vollard's fortune dates from the moment when, in Cézanne's studio, he found the artist depressed and bought from him about 250 canvases for an average of 50 francs each. He sold a few but kept the majority until he could sell them for between 10,000 and 15,000 francs each." Gimpel's words—which rather foresee the increase in prices of Cézannes in a few years—seem not far from the truth. When about 1894 Vollard decided to become interested in the painter, the latter scarcely had any collectors. Happily, he was able to devote himself to painting and not worry very much about money. Until the age of forty-seven, he lived on the small income which his father paid him.

In 1886 Louis-Auguste Cézanne died. Paul Cézanne was rich, for his share of the inheritance amounted to 400,000 francs ($256,000). "My father was a genius," said the painter, "he left me an income of twenty-five thousand francs ($16,000)." If Paul Cézanne measured genius by financial success, he had to admit to being a failure, for until then he scarcely managed to earn any money. Only a handful of collectors would take the chance of buying his works. Among these rare birds were Count Armand Doria, Dr. Paul Gachet, Paul Gauguin, and Théodore Duret. But the one who was most convinced of Cézanne's greatness proved to be the collector Victor Chocquet who, when he died, owned thirty-two works by his favorite painter.

Cézanne even had an art dealer. It is true that Père Tanguy was a color grinder, who accepted his painter-client's work in exchange for supplies, with the result that he was able to form an amazing collection of Cézannes as well as canvases by Renoir, Pissarro, and Van Gogh. To help his painter friends, Tanguy tried to sell a few of their canvases. If someone said he was interested in Cézanne, he would lead him to the painter's studio, as he had the key. In the early period, Tanguy, in order to establish a price, adopted a method which had the merit of being quite simple: He separated the Cézannes into "large" and "small," asking 100 francs ($64) for the first and 40 francs ($26) for the second. Later he asked for a higher price and even refused to sell the few Cézannes still in his possession, convinced that they represented "a priceless treasure." Unfortunately, the price which his widow was to obtain for this "treasure" proved quite modest. And yet when Tanguy died in February, 1894, the price for a Cézanne was increasing. During the auction of the Duret Collection on March 19, 1894, the painter's three canvases made a good figure, selling for from 650 to 800 francs ($416 to $512) each. But the results of the Tanguy Collection auctioned that same year were less brilliant; the six Cézannes were sold for from 95 to 215 francs ($61 to $138). A young art dealer bought five, marking the entrance on the scene of Ambroise Vollard.

Vollard had decided to organize the first Cézanne exhibition, which he managed not without some difficulty on the painter's part. The exhibition was inaugurated in December, 1895, and at once achieved great success . . . one of scandal. Nevertheless a handful of collectors, including some of the more important, like Auguste Pellerin, the sugar king, and Milan IV, the former king of Serbia, bought some Cézannes. Vollard's prices were not high. In fact for ten francs ($6.40) one could possess "a small study which represented a pot of jam" and for 400 francs ($256) "one of the finest canvases in the exhibition."

Encouraged by this relative success, Vollard set out on a search. His intention was to buy up all the canvases which Cézanne had presented as gifts to his fellow citizens at Aix. Vollard was less successful than he thought, though his time was not entirely wasted. He managed to buy a Cézanne whose owner, who "wanted a good price," asked for "less than 150 francs ($96)."

The time was not far off when Vollard could spend far more important sums to buy Cézannes since the value of his work was rapidly increasing.

In May, 1899, during the Doria Auction, Monet bought "Melting Snow, Fontainebleau Forest" for 6,750 francs ($4,320). Two months later the Comte de Camondo bid 6,200 francs ($3,968) for "The House of the Hanged Man" at the Chocquet Auction. In March, 1900, a "Still Life" was sold for 7,000 francs ($4,480) at the Stuchkin Auction.

Before his death in 1906 Cézanne realized that his works were not without value. And if the gods had granted him twenty-five more years to live, he would have seen their worth increase dramatically. The following three examples can scarcely leave any doubt. In 1900 Eugène Blot, a collector who ranked among the first to show an interest in Impressionism, decided to auction off his paintings. These included "The River, Banks of the Oise" which fetched 1,800 francs ($1,360). Blot bought back the painting and included it in the second auction of 1906; it was bought by Maurice Gangnat for 2,050 francs ($1,560). When the latter sold his collection in 1925 the painting went for 131,000 francs ($20,600).

The second Blot Auction included another Cézanne, "Village Road at Auvers." Bought at Portier's some twenty years earlier for 160 francs ($102), it went for 3,500 francs ($2,680). "I saw this painting again in 1930," related Blot in his *Memoirs*, "and the price asked was 340,000 francs ($36,600)."

The last example is that of Auguste Pellerin, who shortly after the exhibition of 1895 bought a Cézanne from Vollard for 700 francs ($448). Twenty-five years later he expressed his indignation to the dealer. "One of your colleagues tried to take me in. He had the nerve to offer me coldly 300,000 francs [$53,400] for this Cézanne." Pellerin's heirs had every reason to be grateful to him for refusing even more tempting offers and above all for not parting with another Cézanne, "The Great Bathers," since this painting was auctioned in 1964 for 500,000 pounds ($1,400,000 at that time). These figures offer an idea of the increase in prices of Cézanne's from the last decade of the painter's existence until the present day. A more precise insight can be obtained from the following record prices paid during his triumphal ascension.

1907 "Fruit Dish, Glass, and Apples" auctioned for 19,000 francs ($14,260)

1913 "Boy in a Red Vest," 56,000 francs ($35,600)

1919 "At the Far End of the Ravine," 41,000 francs ($10,080)

1925 "The Large Pine and the Red Land," 528,000 francs ($83,400)

1936 "The Cardplayers" was acquired by an American collector for $240,000

1952 "Apples and Biscuits" was auctioned for 33,000,000 francs ($129,600)

1958 "Boy in a Red Vest" (a painting other than the one auctioned in 1913) was auctioned for 220,000 pounds ($616,000 at that time).

1964 "The Great Bathers" was sold to the National Gallery in London for 500,000 pounds ($1,400,000 at that time)

1971 "Portrait of Louis-Auguste Cézanne" was acquired by the Metropolitan Museum of New York for an undisclosed sum.

Studying this list would lead one to imagine that the value of Cézannes enjoyed a continuous and regular increase. Nothing was less true. The development occurred in three periods: a strong increase from 1900 to the crisis of 1929, a slow increase from 1933 to the Second World War, and a spectacular upsweep beginning in 1952.

We now turn to the case of a few Cézannes whose appearances in public auction occurred at less significant dates. It was in 1899, as we have seen, that for the first time Cézannes fetched a relatively high price in public auction. The importance of their progression during the following twenty years can be estimated from a precise example. "At the Far End of the Ravine" auctioned for 1,500 francs ($960) on July 1, 1899, fetched 41,000 francs ($10,080) on February 24, 1919.

Let us study the case of a painting which first appeared in public auction the year after the painter's death.

"Fruit Dish, Glass, and Apples"
March 4, 1907: 19,000 francs ($14,260)
June 18, 1913: 48,000 francs ($30,600)

We cannot ignore the progress made by "The Large Pine and the Red Land." Sold by the Bernheims for 5,000 francs ($3,820) in 1906, it fetched 528,00 francs ($83,400) on June 24, 1925.

To measure the increase of Cézanne prices down to the present time we have a few indications. And yet, the destiny of the three following paintings appears significant.

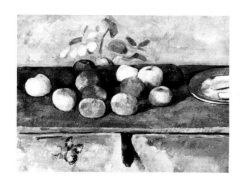

"Apples and Biscuits"
1913: 40,000 francs ($25,400)
1952: 33,000,000 francs ($129,600)

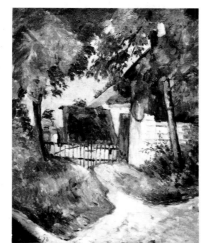

"Thached Cottage in the Trees," 23.4 × 19.1 inches.
1923: 1,600 pounds (approximately $7,200 at that time)
1968: $220,000

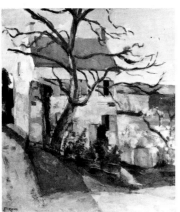

"House and Tree," about 1873–74
1900: 5,500 francs ($4,120)
1970: 180,000 pounds ($432,000 at that time)

Van Gogh

It is generally said that during his lifetime Van Gogh did not sell a single painting. This is both true and false. It is true in so far as one adheres to the formula of French law according to which "there is no sale without a sound price." Thus Vincent sold only a single canvas during his lifetime, "Red Vineyards at Arles" for 400 francs ($256) to Anna Boch during the exhibition organized in Brussels in 1890 by the Belgian group known as *Les Vingt.*

But if we admit that a sale can occur without a sound price, we can consider that Van Gogh sold several of his works. The evidence offered by his contemporaries is categorical on this point. First, that of Van Gogh himself. In July, 1888, he reminded his brother Théo, "I did the portrait of Père Tanguy which he still has, that of his wife (which they sold), of their friend (it is true that for this last portrait he paid me twenty francs). . . ." This then is proof that two Van Goghs were sold. And that is not all. In his *Memoirs* Eugène Blot related that in 1886 he "bought at Tanguy's for thirty francs [Van Gogh owed him twenty-eight francs' worth of color and he wanted cash for this] a wonderful bouquet of geraniums." In short, 20 francs for the portrait of Tanguy's friend, 30 for the geraniums. As for the portrait of Madame Tanguy, it was probably no more than 50 francs ($32). A few months after his arrival in Paris, Vincent had indicated this price to the painter Levens. "I found four dealers who exhibited my studies. . . . The present prices are fifty francs. Of course, this is not very much, but so far as I can see, one must sell cheaply at the beginning, even sell at cost price. . . . If I were to ask more, I doubt if they would sell." This proves how modest were Vincent's prices. He even lowered them when he later offered his works to the "art lovers" at St.-Rémy, the asylum where he stayed. Monsieur Poulet, the guardian, related how "he offered his paintings for fifteen francs, ten francs, and even for five francs. . . . Not a soul wanted them."

This then leads us to believe that the average price of Van Gogh's paintings was between 5 and 50 francs ($3.20 and $32). We would even have to lower this if we were to consider the results of the sole public auction during the artist's lifetime which included Van Gogh's work. It must be admitted that the conditions during which the auction took place were scarcely those that would lead to spectacular bidding. Vincent's obsession had always been

"to have his own exhibition room in a café." He was convinced that the common people would better appreciate his works than collectors. During his stay in Paris, he became the lover of a buxom Italian known as *La Segatori* who had a cabaret restaurant known as Le Tambourin. He wanted the walls to be constantly covered with his own canvases as well as with those of his friends, Louis Anquetin, Emile Bernard, and Toulouse-Lautrec. The adventure turned out badly. Le Tambourin went bankrupt. According to the account given by Emile Bernard, "Vincent's canvases were tied in bundles of ten and sold at auction for "from 50 centimes to one franc a bundle [from $.35 to $.70]."

Van Gogh's death was not an outstanding event of the year 1890. Nor during the year to follow did collectors rush to acquire his works. During the auction in June, 1894, after the death of Julien Tanguy, Vincent's canvases made a slightly better appearance. "Factories at Clichy" was sold for 100 francs ($64). A gifted and perspicacious art dealer—Ambroise Vollard—soon showed interest in Vincent's work and, in 1897, he organized a Van Gogh exhibition. "The public was anything but eager," noted Vollard. The most important painting, the famous "Field of Poppies," did not fetch even 500 francs ($320).

Vollard's example was followed by that of the Bernheims who, in 1901, held a retrospective exhibition of Van Gogh's work. The defense of Van Gogh—financially speaking—was in good hands.

As early as 1900 the prices bid at the Hôtel Drouot for Van Goghs were quite honorable. His "Hollyhocks" in particular was sold for 1,100 francs ($826). During the years to follow this rise increased. In 1906 "Hollyhocks" made a fresh appearance at public auction; its price of 2,500 francs ($1,920) proved more than twice that of 1900. The movement increased with record prices of 35,200 francs ($22,400) for a still life in 1913 and 361,000 francs ($44,800) for the "*Pont de Fer de Trinquetaille*" in 1932. The "Factories at Clichy," which had been sold in 1894 for 100 francs, fetched 180,000 francs ($20,800) in 1928. Another example, though less significant, is that of the "Still Life: Mackerels," which was sold in 1900 for 910 francs ($680), fetched 15,000 francs ($3,700) in 1919.

The depression initiated a period of decline. Between 1927 and 1931 "Windmill at Montmartre" lost 11.5 percent of its value and between 1933 and 1937 "Before the Hearth," dating from Van Gogh's Neunen period, fell 35 percent. Then values began to rise. In the later 1940's the prices of certain paintings by Van Gogh created a sensation. In 1948, for example, a collector made a purchase of "Study by Candlelight" for $50,000. This was followed in the early 1950's by a series of record prices: 132,000 pounds ($511,000 at that time) for "Public Garden at Arles" in 1958; 150,000 guineas ($438,000 at that time) for "Portrait of Mademoiselle Ravoux" in 1966; $310,000 for "Zinnias in a Vase" in 1969; $1,300,000 for "Cypress and Tree in Blossom" in 1970.

"Windmill at Montmartre,"
18.3 × 14.8 inches
1927: 77,000 francs ($8,920)

1931: 69,500 francs ($7,780)
1963: 15,500 pounds ($43,400 at that time)

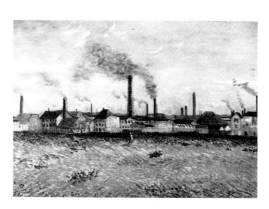

"Factories at Clichy," 1887, 21 × 28.1 inches
1894: 100 francs ($64)
1928: 180,000 francs ($20,800)
1957: 31,000 pounds ($86,800 at that time)

Gauguin

"Oh, if I were sure of selling all my canvases for 200 francs [$128]." Gauguin was fifty when, in 1898, he confided his hope to his friend Daniel de Monfreid. Among artists and writers he had acquired a definite fame. Some mentioned him as one of the most important painters of his generation, while others treated him as an unspeakable dauber, but almost no one thought of buying his works. And yet, when he had resigned from a brokerage office where he earned substantial sums and began to devote himself entirely to painting, Gauguin had not the slightest doubt as to his being able to live decently, thanks to his new profession. His firm intention to sell his canvases rather scandalized his painter friends, chiefly Pissarro, who had long been resigned to leading a miserable existence. He regarded Gauguin as a "terrible dealer." Gauguin was soon to sing another tune.

A few dealers, like Bertaux, Portier, and Tanguy, made an attempt to sell his canvases. The most obstinate was Théo van Gogh, Vincent's brother, who was in charge of a branch of the powerful Galerie Boussod et Valadon, but rare were the collectors whom he managed to convince of Gauguin's talent. Nevertheless he sent a victory bulletin to the painter in November, 1888: "You will doubtless be pleased to know that your paintings have been quite successful. Degas is so enthusiastic over your work that he mentions this to many persons and that he is going to buy the canvas which represents a spring landscape. . . . Now there are two canvases definitely sold. The one is a vertical landscape with two dogs in a meadow, the other a pond on the edge of a road. As there is an exchange agreement, I quote the first net for 375 francs [$240] and the other 225 francs [$144]. I could still sell the 'Circle of Young Breton Girls,' but it has to be touched up a bit. The collector will pay 500 francs [$320] for the framed paintings with a frame which costs almost 100 francs [$64]."

Friends and acquaintances would often buy a few paintings from Gauguin. In 1888 he succeeded in selling "Human Poverty" for 1,500 francs ($960). But in general his sales prices were low. In 1890, for example, the painter Boch bought five canvases from him for 100 francs ($64) each. In the following year, however, a happy event made Gauguin completely optimistic again, namely, a sale of thirty canvases at the Hôtel Drouot which proved to be an unexpected success. Prices ranged from 240 to 900 francs ($153 to $576); the latter was the sum paid for his "Vision After the Sermon." After paying expenses, Gauguin had 9,000 francs ($5,760), which enabled him to sail for Tahiti.

This success was not repeated. Although his wife, who had returned to Denmark, managed to sell a few canvases for rather substantial prices—a nude study entitled "La Suzanne" for 900 francs ($576), a "Breton Landscape" for 850 francs ($544)—Gauguin encountered in Paris one failure after another.

The first failure was that of the exhibition in November, 1893, at Durand-Ruel's. Sales did not even pay expenses, although Manzi of the Galerie Boussod et Valadon acquired the "Ia Orana Maria" for 2,000 francs ($1,280). Gauguin calmly explained to his wife, in December, 1893, the reasons for this lack of success. "The results of my exhibition were, in fact, not those one expected, but one must face things squarely. I had set the prices very high, an average of 2,000 to 3,000 francs [$1,280 to $1,920]. At Durand-Ruel's, with respect to Pissarro, Manet, and others, I could scarcely do otherwise, but many persons offered as much as 1,500 francs [$960]. What can one say? One must wait and after all I was right, for today a price of 1,000 francs [$640] does not seem enormous."

The second failure was that of the sale following the death of Père Tanguy. When his six Gauguins were auctioned on June 2, 1894, not a single one went for more than 110 francs ($70).

The third failure was that of the auction at the Hôtel Drouot on February 18, 1895. For lack of collectors, Gauguin had to buy back most of his canvases. The record price—for the painting actually sold—was 500 francs ($320) for the canvas entitled "Quand te maries-tu?"

Gauguin had lost his illusions. When, in 1896, he thought of appealing from Tahiti, where he had returned, to a group of collectors to pay him monthly sums in exchange for his work, he set the price at 160 francs ($102).

"If I cannot sell at this price, then I don't know what. . . ." The project was a failure. Gauguin, reduced to poverty, attempted suicide in January, 1898.

"Oh, if I were sure of selling all my canvases for 200 francs!" Gauguin's wish was fulfilled two years later, thanks to Ambroise Vollard. As early as 1894 the dealer had acquired a few of Gauguin's works and in May, 1900, made a verbal agreement according to which he would send the painter a monthly sum of 300 francs ($220). In exchange, Gauguin had to send him a certain number of canvases, the price of which was set at 200 francs ($150). A few months later, Vollard even agreed to increase this price to 250 francs ($188). In 1902 he bought Gauguin's masterpiece "Where do we come from?" for 1,500 or 2,000 francs ($1,120 or $1,500).

Obviously the "collectors" at Tahiti were scarcely prepared to pay such prices. When, after Gauguin's death in 1903, the few paintings found in his hut were sold at auction at Papeete, "Trois Vahinés" fetched the best price, 150 francs ($116), while the last canvas painted by the artist, "Breton Village in the Snow," went for seven francs ($5). This last is now in the Jeu de Paume Museum in Paris.

During the years following the painter's death, prices for his works rose regularly and reached a summit about 1930. After a severe drop caused by the Depression, prices rose again during the Second World War and in the 1950's took a sharp upward sweep. Here are a few memorable stages of this ascension.

1906	"Flowers of Tahiti" was auctioned for 2,900 francs ($2,200).
1912	"Papeete," 31,500 francs ($20,600)
1927	"The White Horse" was bought by the Louvre for 180,000 francs ($20,800). In the previous year a German collector offered 350,000 francs ($42,000).
1927	"The Cellist" was auctioned for 60,200 francs ($6,980).
1942	"Two Figures on the Cliff," 1,100,000 francs ($57,200).
1957	"Still Life with Apples," 104,000,000 francs ($393,200).
1971	"Portrait of the Artist Holding his Palette," $420,000.

Even more explicit is the price history of a painting included in the unfortunate Gauguin Auction held in 1895 "Mau Taporo."

"Mau Taporo," 1892, 34.7 × 25.9 inches
1895: 300 francs ($192)
1908: 2,005 francs ($1,460)
1957: $180,000

Here are two other paintings by Gauguin which were auctioned for important prices:

"Bonjour, Monsieur Gauguin," 1889, 29.25 × 21.45 inches
1923: $1,500
1969: 1,350,000 Swiss francs ($369,200)

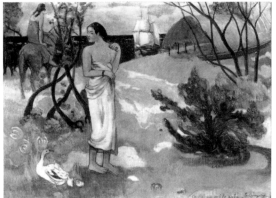

" Am Waiting for Your
eply," 28.9 × 37.05 inches.
959: 130,000 pounds
($364,000 at the time)

This last price would certainly have been surpassed during the twenty years following the Second World War if one of Seurat's masterpieces had appeared in public auction. This was not the case. Thus we shall limit ourselves to showing the performances made by a painting of lesser importance. In 1951 the Louvre bought *"Port-en-Bessin, avant port, marée haute"* for 16,000,000 francs ($71,000), which in 1923 was sold for 1,500 francs ($286). In less than thirty years this painting thus enjoyed an increase of some 24,300 percent.

At the present time there is scarcely an important canvas by Seurat likely to appear on the market. In the 1960's a few small studies were auctioned, and those of substantial quality went for about 600,000 francs ($120,000).

Seurat

To buy a Seurat in 1970 for $1,033,000 would be a good piece of business. At least this was the opinion of the Artemis Company which paid the equivalent of this sum for the smaller version of *"Les Poseuses"* during the auction held in London on June 30, 1970. This firm, specializing in investments of art works, promised its shareholders a benefit from their gains. The collector who had bought one of Seurat's masterpieces during the artist's lifetime would have left his descendants a heritage whose actual value would correspond to hundreds of times the sums paid. Unfortunately few persons had this idea. Happily Seurat's family were sufficiently well-off to enable their son to devote his time to painting without bothering about collectors. Moreover, we know very little about the prices Seurat asked for his work if a client happened to appear on the scene. We know, however, that during an exhibition organized in Brussels by the group known as *Les Vingt*, he sold *"La Grève du Bas-Butin"* for 300 francs ($192), and that in 1891 Van Rysselberghe's mother-in-law bought one of his seascapes of Gravelines for 400 francs ($256). These were not major works. For lack of sales records, we must estimate the prices of important canvases. Vincent van Gogh, for example, in October, 1888, strongly urged his brother Théo to buy Seurat's works. "In my opinion we must consider his large paintings of *Les Poseuses* and *La Grande Jatte*, but—let's see—say, 5,000 francs [$3,200] each." As a businessman Vincent, it is true, was never considered a good adviser. Seurat, moreover, was less demanding. In February, 1889, a collector showed promise of buying *"Les Poseuses"* and the painter indicated to Octave Maus the painting's "cost price." "As for my *Poseuses*" he wrote, "I am very much at a loss when it comes to setting a price. As expenses, I count a year's work at seven francs a day. You see what that comes to." Admitting that he never took a day off, that would "come to" 2,500 francs ($1,600). The collector never returned. If he had insisted on buying the work, he could have had it eight years later for a more reasonable price. In December, 1897, Vollard offered it to the painter Signac for 800 francs ($512). The painter declined the offer, and soon after the dealer sold it for 1,200 francs ($768) to a German collector. In other words, Seurat's death in 1891 led to no increase in the price of his works. In 1894 during the Tanguy Auction a "Study," 12.5 × 15.6 inches, went for 50 francs ($32). That same year the critic Meïer-Graefe bought *"Le Chahut"* for 400 francs ($256) and in 1899—during the exhibition organized by Félix Fénéon which included 300 Seurats—Signac acquired "The Circus" for 500 francs ($320), whereas *"La Grande Jatte"* was sold for 800 francs ($512).

One had to wait until the close of the First World War to see an important increase in the prices of Seurat's works. Here are a few stages of this ascension:
1922. *"Le Chahut"* was sold at the Hôtel Drouot on February 23 to Mrs. Kröller-Müller for 32,000 francs ($6,780), that is, some 25 times the price paid by Meïer-Graefe in 1894.
1924: An American collector, F. Clay Bartlett, bought *"La Grande Jatte"* for $24,000.
1926: Dr. Albert Barnes acquired *"Les Poseuses"* for $50,000.

"Fields in Summer."
1883, 6.2 × 9.8 inches
1941: 170,000 francs ($10,600)
1965: 36,000 guineas ($105,000 at that time)

"Peasants at Montfermeil," about 1882, 5.85 × 9.8 inches
1966: 36,000 pounds ($100,800 at that time)

"Les Poseuses" (small version)
1970: 430,500 pounds ($1,033,000 at that time)

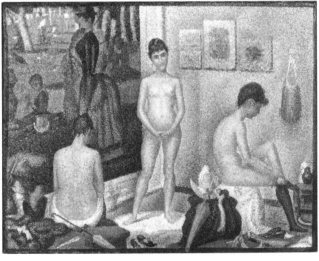

"Figures in a Meadow," about 1883, 6 × 9.6 inches
1963: 34,000 pounds ($95,200 at that time)

INDEX OF PAINTERS
Page numbers refer to illustrations.

BERNARD, EMILE (1868–1941).

Former pupil of Cormon's studio. A man of remarkably precocious talent, he became the friend, at the age of eighteen, of Anquetin, Toulouse-Lautrec, the Symbolist critic Aurier, and Van Gogh whose first posthumous exhibition he was to organize. His brilliant theories impressed Gauguin in 1888 at Pont-Aven and made Emile Bernard, who had turned against the complex researches of Neo-Impressionism, one of the initiators of Symbolist-Synthetic art and one of the men to inspire the Nabis movement. After a mystical crisis evidenced by a return to medievalism, Bernard broke with Gauguin in 1891. The second part of his life was chiefly marked by his meeting with Cézanne with whom he had an important exchange of correspondence, and by critical works on Van Gogh and Cézanne. (Pages 159, 160, 162.)

CAILLEBOTTE, GUSTAVE (1848–94). Pages 77, 244.
CARPEAUX, JEAN-BAPTISTE (1827–75). Pages 49, 93.

CÉZANNE, PAUL (1839–1906).

The son of a hatter who became a banker, Cézanne studied the classics at Aix, at the Collège Bourbon, where he made friends with Emile Zola. At first Cézanne was forced to study law, though he began at the same time to paint. In 1861 he settled in Paris, frequented the Académie Suisse, and met Pissarro, Monet, Renoir. Under Pissarro's influence he was initiated into out-of-door painting in 1872. Cézanne then settled at Auvers-sur-Oise and took part in group exhibitions. Poorly received by the public, he withdrew from the Impressionists in 1878, settled at Aix, and sought to reconcile a need of monumental construction inspired by classic art with the requirements of out-of-door painting. In 1887, now a rich man after the death of his father, he exhibited his works in Brussels with the group known as *Les Vingt*. But his consecration in the eyes of artists was the occasion of the exhibition organized by Vollard in 1895. Yet the public still remained cold. At the height of his powers, Cézanne painted during this period his "Cardplayers," the "Bathers," and many versions of *"Mont Ste.-Victoire."* In 1904 the Salon d'Automne was the occasion of the general recognition of his genius. In 1905 he finished his "Great Bathers." He died the following year after a stroke while painting out of doors. (Pages 92, 112, 113, 114, 115, 224, 231, 234, 235, 236, 237, 240, 241, 251, 258, 259, 261, 266, 267, 268, 269, 309.)

COROT, JEAN-BAPTISTE-CAMILLE (1796–1875). Pages 43, 48.
COURBET, GUSTAVE (1819–77). Pages 47, 146.
CROSS, HENRI-EDMOND (1856–1910). Pages 289, 293, 294.

DEGAS, EDGAR (1834–1917)

Born in Paris, the son of a banker who appreciated painting, Degas abandoned his law studies and in 1855 entered the Ecole des Beaux-Arts. He traveled in France and Italy. Influenced by Ingres, he painted mythological scenes. Beginning in 1861, Degas' inspiration changed; he painted horseraces, became a friend of Manet, and did his first pastels. About 1865 he started producing his off-center compositions, partly inspired by Japanese art. After 1868 he found most of his subject matter in the world of the opera and the theater. Degas took part in the first Impressionist exhibitions, but defending the rights to imagination and memory, he criticized what in his mind was an overfaithfulness to nature on the part of his friends. After 1880, troubled by poor eyesight, he turned to pastel and sculpture in which he tried to "capture movement." His works became simpler, purer; anecdote was sacrificed for harmony and exploration of new techniques. He devoted important series to his Ballet Dancers and Female Nudes whom he sought to surprise in natural poses as though he were a housebreaker. Almost blind, on poor terms with most of the Impressionists, Degas spent the last years of his life in solitude and retirement. (Pages 55, 62, 63, 64, 65, 66, 67, 68, 70, 72, 75, 80, 81, 174, 175, 189, 204, 205, 206, 207, 214, 215, 305.)

GAUGUIN, PAUL (1848–1903).

Born in Paris, the son of a journalist, Paul Gauguin joined the navy, then became a stockbroker. In 1873 he began to paint and showed interest in the Impressionists, whose works he collected. Thanks to Pissarro, who encouraged his early efforts, he took part in the group exhibitions. Beginning in 1883 Gauguin devoted himself entirely to painting. In 1886 he settled at Pont-Aven. After a trip to Martinique, he returned there in 1888. Purifying his technique and simplifying his color scheme, he invented, along with Emile Bernard, Synthetism, which was to have a strong influence on the Nabis. After a stay at Arles with Van Gogh, terminating in the episode in which Van Gogh slashed his ear, Gauguin returned to Pont-Aven in 1889. He then settled in Paris, where he knew Symbolist writers. He lived in harsh poverty and in 1891 departed for Tahiti. There he suffered illness, and in 1893 he returned to France. His Polynesian canvases reveal his theories on the "musical" and abstract character of pure color and composition. For Gauguin, the expression of "the states of the soul" by line and the play of tones was more important than faithfulness to immediate reality. He sailed again for Polynesia and painted several first-rate works under the worst possible conditions. In 1903 he died in the Marquesas Islands. (Pages 79, 147, 159, 161, 164, 165, 166, 167, 168, 170, 171, 173, 176, 177, 178, 179, 212, 213, 238, 245, 247, 252, 310, 311.)
GÉRÔME, LÉON (1824–1904). Page 17.

MANET, EDOUARD (1832–83).

Born in Paris, Manet received a bourgeois education. Despite his father's resistance to the idea, he was able to devote himself to painting as early as 1850. During his student years he was influenced by Goya and Velásquez. He took part in the Salon of 1861 and became interested in open-air scenes, producing "Music at the Tuileries," "Races at Longchamps," and "Lola de Valence." Next came the "scandals": his "Luncheon on the Grass," one of the landmarks of nascent Impressionism, refused at the Salon of 1863, then the "Olympia," rejected at the Salon of 1865. Manet was violently attacked, but an entire group of young painters, including Monet, Cézanne, and Renoir, passionately followed his efforts and were inspired by his style. Zola came wildly to his defense in several articles which created a great stir. Excluded from the Universal Exposition of 1867, Manet decided to present his works at the Pont de l'Alma; once again the crowd merely gibed at what they saw. The Salon of 1873 marked a certain change in favor of Manet, and in the following year he refused to take part in the first Impressionist exhibition at Nadar's. That same year (1874) he painted outdoor scenes alongside Monet at Argenteuil, before turning to those of brasseries which for a time were to be his favorite themes. "The Bar of the Folies-Bergère," exhibited at the Salon of 1882, was the triumph of a Manet already ruined by illness. After a surgical operation, he died in 1883. (Pages 13, 98, 99, 108, 109, 150, 151, 173, 189, 192, 193, 198, 199, 201, 216, 226, 227, 228, 229, 304.)

MONET, CLAUDE (1840–1926).

Born in Paris, Monet spent his childhood in Le Havre. It was in Normandy that Boudin initiated him into open-air painting. Having settled in Paris in 1859, Monet studied at the Académie Suisse and became a close friend of Pissarro. After his military service (1860–61), he painted out of doors with Boudin and Jongkind at Honfleur, and with Renoir and Sisley at Fontainebleau. At the latter place he did his great "Luncheon on the Grass." In 1866 he met Manet and came under not only his influence but that of Courbet as well. A mysterious suicide attempt in 1868 has been reported. Reduced to poverty, he devoted himself to Impressionism, made a trip to England and Holland, then settled down at Argenteuil (1871–78). Painting from his studio boat, he did many boating scenes. The

exhibition held at Nadar's in 1874 set him at once at the head of the Impressionist movement. During the following years, he went almost everywhere in France, devoting long months to the analysis of some river landscape or seashore. In his research of the instantaneous, he gradually abandoned emphasis on subject and form and concerned himself with light. He produced his Haystacks and Cathedral series, his scenes of Venice and London in the fog, and finally his many paintings of Water Lilies. A set of the last comprises the masterpiece of his final period, the whole forming at the Musée de l'Orangerie in Paris Monet's "Sistine Chapel." (Pages 54, 60, 61, 78, 82, 83, 93, 94, 95, 96, 97, 104, 105, 106, 107, 116, 117, 118, 119, 121, 134, 135, 136, 137, 138, 139, 140. 141, 142, 146, 152, 153, 155, 190, 191, 194, 195, 196, 197, 200, 232, 254, 255, 306.)

MONTICELLI, ADOLPHE (1824–86) Page 44.
MOREAU, GUSTAVE (1826–98). Page 51.

PISSARRO, CAMILLE (1830–1903).

Born in the Danish West Indies, Pissarro studied in Paris before turning to his father's business. In 1855 he returned to the French capital and met Corot. Two years later he discovered out-of-door painting. He met Monet in 1857 and Cézanne in 1861. During the Franco-Prussian War he settled in England, where he admired Turner's and Constable's landscapes. Pissarro was among the first to comprehend Cézanne's genius, as well as that of Gauguin and Van Gogh. It was he who at Pontoise initiated Cézanne into open-air painting. As early as 1874 he took part in the Impressionist exhibitions showing peaceful landscapes crossed by a shimmering light. In 1885 he rejected "romantic" Impressionism and chose the path of Neo-Impressionism and Seurat's strict principles. This period lasted for five years. Afterward, not without heartbreak in rediscovering "movement and life," Pissarro returned to his early style. (Pages 22, 120, 224, 233, 307.)

REDON, ODILON (1840–1916). Pages 51, 147.
RENOIR, PIERRE-AUGUSTE (1841–1919).

Born at Limoges, raised in Paris, Renoir painted porcelain and fans before entering the École des Beaux-Arts in 1862. He met Sisley, Monet, and Diaz and painted from the model. Together with Monet, he painted scenes of Paris and boating scenes. He showed an Impressionist work at the Salon of 1870. In 1874 Renoir exhibited at Nadar's then painted his important works of his Impressionist period, including the famous "Moulin de la Galette." In 1881–82, after a trip to Italy and North Africa, he drifted away from the group and, influenced by Raphael, Ingres, and Pompeian frescoes, evolved a linear style.

This is seen in his large Nudes dating from 1882–84. After 1890 he adopted a new fluid, blended "mother-of-pearl" style. A victim of arthritis, he settled down at Cagnes where he spent the last twenty years of his life. Almost paralyzed, he insisted on painting until his death, the brushes attached to his hands distorted by rheumatism. (Pages 74, 96, 100, 101, 102, 103, 110, 111, 121, 122, 123, 124, 125, 173, 307.)

RYSSELBERGHE, THÉO VAN (1862–1926). Page 291.

SÉRUSIER, PAUL (1864–1927). Page 246.
SEURAT, GEORGES (1859–91).

The son of a notary, a student at the École des Beaux-Arts, Seurat became interested in the scientific theory of color which Chevreul had formulated and which Delacroix had occasionally used. Beginning in 1882 he gradually began to develop his Neo-Impressionist "small dot" technique utilizing the optical mixture of colors. In 1885 he converted Pissarro to Neo-Impressionism, and he exhibited with the Impressionists during their last exhibition held in 1886. The famous "Sunday Afternoon on the Island of La Grande Jatte" met with almost unanimous hostility and made Seurat the leader of the Neo-Impressionists. By refusing the sensualism and instantaneousness of Monet and his friends, by finishing his works in his studio according to precise methods, Seurat—soon followed by many pupils—opened fresh paths to research which culminated in Robert Delaunay and Op Art. (Pages 276, 277, 278, 279, 280, 281, 282, 283, 286, 287, 291, 295, 296, 298, 299, 311.)
SIGNAC, PAUL (1863–1935).

The only son of a saddler-harness maker, Signac studied at the Lycée Rollin in Paris. In 1880 the Monet exhibition organized by La Vie Moderne decided his career. He refused academic guidance and was self-taught. During his Impressionist period, thanks to Gustave Caillebotte, he discovered the sea. An excellent navigator, the winner of countless regattas, he owned during his lifetime a total of thirty-two boats. The Salon des Indépendants of 1884 marked an important meeting for Signac. It was there that Seurat exhibited his "Baignade" and the artists became friends. Seurat explained his Neo-Impressionist ideas, while Signac drew his attention to the advantages of Impressionist clear color. Signac gradually became the spokesman of the movement inspired by Seurat. He became the friend of Van Gogh, who was influenced by him. Seurat worked with the scientist Charles Henry, who tried to establish "a scientific aesthetic." In 1892 he discovered St.-Tropez, a small harbor on the Mediterranean then still unknown, chiefly accessible by sea. Here he built a large villa known as La Hune where he spent much of his life, interrupted by long

cruises along the Mediterranean coast. Generous, enthusiastic, the author of a book on Stendhal, sympathizing with anarchy and Communism, Signac gradually freed himself from the rigor imposed by Seurat and developed a heavy brushstroke style, decorative and colorful, which forecast Fauvism. His book, From Eugène Delacroix to Neo-Impressionism, was to play an important role in the development of abstract art in the twentieth century. (Pages 275, 288, 290, 292, 300.)
SISLEY, ALFRED (1839–99).

Born in Paris, of English origin, Sisley entered the École des Beaux-Arts in Paris in 1862. Here he met Monet and Renoir and joined them in painting delicate landscapes, marked by the influence of Corot and Daubigny. After the Franco-Prussian War he decided to devote himself entirely to painting, saw much of Monet, and took part in the three first Impressionist exhibitions. He withdrew to the country. Modest, somewhat forgotten, unlike Monet, he was not to enjoy real success during his lifetime and died in poverty of a cancer of the throat. (Pages 90, 91, 233, 307.)

TOULOUSE-LAUTREC, HENRI DE (1864–1901). Pages 28, 64, 75, 180, 181.

VAN GOGH, VINCENT (1853–90).

Born at Brabant, the son of a Calvinist minister, Van Gogh did various jobs, finally being removed from an unsuccessful lay ministry. He then began to paint, imitating Millet, drawing miners and peasants. In 1886, already ill, he settled in Paris at the home of his brother Théo and entered Cormon's studio. He met Toulouse-Lautrec, Signac, Pissarro, and Gauguin. Influenced by the Impressionists, especially Pissarro, he began to abandon the dark and neutral tones of his early work. Later Van Gogh used color in the most arbitrary, simplified, and violent way. In 1888 he left for Arles, where he was joined by Gauguin. After a fit of madness, he slashed his ear. He requested to be interned in the St.-Rémy hospital, where during periods of lucidity he painted lyrical and violent canvases which were to become the source of Expressionism. In 1890 he settled at Auvers and under Dr. Paul Gachet's friendly surveillance he painted until his suicide. (Pages 54, 69, 73, 85, 126, 127, 128, 129, 131, 132, 133, 149, 154, 156, 157, 158, 191, 202, 209, 210, 239, 242, 243, 249, 250, 251, 309.)
VUILLARD, EDOUARD (1868–1940). Pages 76, 199, 218, 257, 262, 263, 265.

WHISTLER, JAMES ABBOTT MCNEILL (1834–1903). Pages 58, 59, 172.

List of Illustrations

Jacket
Front: Renoir, "Luncheon of the Boating Party" (detail). Phillips Memorial Gallery, Washington, D.C.
Back: Monet, "The Garden at Giverny" (detail). Private Collection, Paris.

The Events, The Men

The battlefield at Sedan, September, 1870. Bibliothéque Nationale, Paris 12
The sortie of the royal marines, late December, 1870 12
Napoleon III. Photo Le Point 12
The slaughter of an elephant from the zoo during the siege. **Bibliothèque de l'Arsenal** 12
Anticommunard propaganda dish: the fall of the Vendôme column. Musée de St.-Denis 12
Rue de Rivoli, Paris, May, 1871. Editions Robert Laffont 13
"The Barricade." Lithograph by Manet. Musée de St.-Denis 13
Execution of Rossel, Ferré, and Bourgeois at Satory. **Bibliothèque de l'Arsenal** 13
General Boulanger 14
Digging of the Panama Canal. 1881 (preparatory work for a lock) 14
Jules Grévy, President of the Republic. July 30, 1879. 14
Assault of the Saigon citadel in 1851 by the Franco-Spanish expeditionary corps. 14
The assassination of Sadi Carnot on June 24, 1894. Imagerie Pellegrin 14
Auguste Vaillant throwing a bomb in the Chamber of Deputies 15
Arrest of Ravachol 15
Karl Marx 15
Pierre-Joseph Proudhon 15
Cormon. "The Flight of Cain." Louvre. © SPADEM 16
Jules Garnier. "The Proof of Adultery" 16
Winslow Homer. "Copyists in the Grand Gallery of the Louvre." 1867. Wood engraving 16
Ernest Meissonier. "Lovers of Paintings." . . . 16
Fernand Knhopff. "Art, the Caress, the Sphinx." Musée Royaux des Beaux-Arts, Brussels 17
"Le Charivari ("The Impressionist painter." Bibliothèque Nationale, Paris 17
Léon Gérôme. "Young Greeks Arranging a Cockfight." © SPADEM 17
Edouard Detaille. "Surrender of the Huningue Garrison." 1892. Luxembourg Palace, Paris. © SPADEM 17
The Universal Exposition of 1889. Assembling of the Galerie des Machines. Sirot Collection, Paris 18
The Universal Exposition of 1889. **Bibliothèque Nationale, Paris** 18
The Universal Exposition of 1889. The Galerie des Machines 18
Johnson locomotive, 1889. England. Bibliothèque des Arts Décoratifs, Paris 18
Construction of the Garabit Viaduct (photograph taken in April, 1884). Sirot Collection, Paris 18
Construction of the Eiffel Tower. Sirot Collection, Paris 19
Construction of the Eiffel Tower. Sirot Collection, Paris 19
Construction of the Eiffel Tower. Sirot Collection, Paris 19
Dion-Bouton's steam dog-car. 1885. Bibliothèque des Arts Décoratifs, Paris 19
The Universal Exposition of 1889. Inauguration of the Palace of Various Industries. **Bibliothèque Nationale, Paris** 19
Edouard Manet, photographed by Nadar. Sirot Collection, Paris 20

Berthe Morisot in 1875. Private Collection, Paris . . 20
Edgar Degas in a street in Paris. **Bibliothèque National, Sirot Collection, Paris** 20
Henri Fantin-Latour. "The Studio at les Batignoles." Jeu de Paume Museum, Paris 20
Nadar's studio, 35 Boulevard des Capucines 20
Edgar Degas 20
Degas and the Fourchys in front of their country house. Bibliothéque National, Sirot Collection, Paris 21
Pierre-Auguste Renoir 21
Renoir painting in Fontainebleau, September, 1901. Sirot Collection, Paris 21
Renoir and Mallarmé photographed by Degas about 1890. Private Collection, Paris 21
Renoir and his model Gabrielle 21
Camille Pissarro. "Self-Portrait." Louvre, Paris . . 22
Camille Pissarro in his studio at Eragny. About 1897 22
Alfred Sisley 22
The pool of water lilies at Giverny 22
Claude Monet and Clemenceau 23
Claude Monet 23
Claude Monet 23
Claude Monet in his studio at Giverny in 1922 . . . 23
Cézanne's letter to Zola dated June 20, 1859. Private Collection, Paris 24
Paul Cézanne in 1861. Photo courtesy of J.-P. Cézanne 24
Paul Cézanne on the outskirts of Auvers, his paint box strapped to his back (photographed in 1873) . . 24
Paul Cézanne painting (Aix-en-Provence, 1904). Galerie Bernheim-Jeune, Paris 24
Photograph of Cézanne in 1877 seated in Pissarro's garden at Pontoise 25
Paul Cézanne at the end of his life. Photographed by Emile Bernard in 1904 25
Mont Ste.-Victoire, Aix-en-Provence 25
Maurice Denis. "Homage to Cézanne." Musée national d'Art moderne, Paris 25
Cézanne and Gaston Bernheim de Villers. Aix-en-Provence, 1902 25
Van Gogh (back view) at Asnières in conversation with Emile Bernard 26
The garden of the hospital at Arles 26
The room at Auvers in which Van Gogh died 26
The "yellow house," Place Lamartine, at Arles . . . 26
The graves of the Van Gogh brothers at Auvers . . . 26
Pont-Aven. The house where Gauguin stayed 27
Paul Gauguin 27
Paul Gauguin 27
A beach at Tahiti 27
The female Clown Cha-U-Kao. Print Room, Bibliothèque Nationale, Paris 28
Yvette Guilbert, Sirot Collection, Paris 28
Toulouse-Lautrec at the Moulin de la Galette with La Goulue 28
La Goulue's booth, decorated by Toulouse-Lautrec, at the Foire du Trône 28
Henri de Toulouse-Lautrec in Japanese dress. Print **Room, Bibliothèque Nationale, Paris** 28
Henri de Toulouse-Lautrec. "Self-Portrait Caricature." Pencil on paper. Unpublished 28
Traveling show at Chatou. Sirot Collection, Paris . . 29
Toulouse-Lautrec and a model in his studio. Bibliothèque Nationale, Paris 29
Georges Seurat. Anonymous photograph. Collection Madame Signac, Paris 29
Paul Signac about 1885–86. Collection Madame Signac, Paris 29
Paul Signac before his painting, "The Port of La Rochelle" 29

The Precursors

Achille-Etna Michallon. "View of a Sicilian Harbor." Louvre, Paris 32
Pierre-Henri de Valenciennes. "The Ruins of the Villa Farnese." Louvre, Paris 32
Pierre-Henri de Valenciennes. "Entrance to a Grotto" Louvre, Paris 33
Eugène Delacroix. "Saint George Destroying the Dragon," also known as "Perseus Rescuing Andromeda." Louvre, Paris 34
Eugène Delacroix. "The Death of Sardanapalus" (details). Louvre, Paris 34
Anne-Louis Girodet de Roucy known as Girodet-Trioson. "The Shadows of French Heroes Received by Ossian in Odin's Paradise." Louvre, Paris 35

Caspar David Friedrich. "Rocky Landscape in the Elbsand-steingebirge." Kunsthistorisches Museum, Vienna 36
Samuel Palmer. "The Magic Apple Tree." Fitzwilliam Museum, Cambridge, England 36
Philipp Otto Runge. "Birth of the Human Soul." Bühl, Baden-Baden 37
Adalbert Stifter. "Landscape of the Teufelsmauer." Osterreichische Galerie, Vienna 37
Joseph Mallord William Turner. "The Houses of Parliament on Fire." Cleveland Museum of Art . . . 38
Joseph Mallord William Turner. "Sea Funeral." Tate Gallery, London 39
Joseph Mallord William Turner. "Snowstorm, Avalanche and Inundation of the Aosta Valley." The Art Institute of Chicago 39
David Cox. "The Night Train." Museum and Art Gallery, Birmingham, England 40
David Cox. "Sun, Wind, and Rain." Museum and Art Gallery, Birmingham, England 40
John Sell Cotman. "Ganton Park, Norfolk." Museum and Art Gallery, Birmingham, England 40
John Constable. "The Grove in Hampstead." Victoria and Albert Museum, London 41
Théodore Rousseau. "Oaks." Indiana University Art Museum, Bloomington, Indiana 42
Charles-François Daubigny. "Sunset on the Oise." Louvre, Paris 42
Charles-François Daubigny. "Sunset on the Oise" (detail) 42
Jean-Baptiste-Camille Corot. "Windmills on the Picardy Coast." Louvre, Paris 43
Jean-François Millet. "Spring." Louvre, Paris . . . 43
Jean-François Millet. "Winter." Calouste Gulbenkian Foundation, Portugal 43
Paul Huet. "Landscape, the Elms of St.-Cloud." Musée du Petit Palais, Paris 44
Adolphe Monticelli. "Negress Holding Birds" or "The Palace of Scheherazade." Private Collection, Paris . . 44
François-Auguste Ravier. "Garden of a Roman Villa." Louvre, Paris 45
Antoine Chintreuil. "The Coast." Louvre, Paris . 45
Johan Barthold Jongkind. "Boat Wash House on the Seine." Boymans van Beuningen Museum, Rotterdam 46
Johan Barthold Jongkind. "Au Roi du désert." Gemeentemuseum, The Hague 46
Eugène Boudin. "Regatta at Antwerp." Musée Eugène-Boudin, Honfleur 46
Johan Barthold Jongkind. "View of Grenoble." Kröller-Müller Museum, Otterlo 46
Gustave Courbet. "Seascape." Private Collection, United States 47
Jean-Baptiste-Camille Corot. "Woman with a Pink Scarf." The Boston Museum of Fine Arts 48
Jean-Baptiste Carpeaux, "Nude Study," Musée du Petit Palais, Paris 49
Jean-Baptiste Carpeaux. "Portrait of Charles Carpeaux." Musée du Petit Palais, Paris 49
Pierre Puvis de Chavannes. "The Dream." Louvre, Paris 50
Odilon Redon. "The Birth of Venus." Musée du Petit Palais, Paris. © SPADEM 51
Gustave Moreau. "Salomé or the Spectre." Musée Gustave-Moreau, Paris 51
Odilon Redon. "The Spectre." Kröller-Müller Museum, Otterlo. © SPADEM 51

Chapter I
The Artist's Point of View Shifts

Claude Monet. "Still Life with Eggs." Private Collection, New York. © SPADEM 54
Honoré Daumier. "Crispin and Scapin." Louvre, Paris 54
Vincent van Gogh. "Shoes." Siegfried Kramarsky Trust Fund, New York 54
Nadar. "Views of the Place de L'Etoile" 54
Robert Demachy. "White Horse in a Meadow." Société Française de Photographie 55
Edgar Degas. Photograph of a girl. © SPADEM . 55
Jean Fouquet. "Book of Hours of Etienne Chevalier" (detail). Saint Martin. Print Room, Louvre, Paris . 55

Correggio. "The Ascension of the Virgin." Parma Cathedral. Detail of the central cupola 55
Anonymous. "Scene with Two Actors." Japanese print. Late seventeenth century. Private Collection, Paris . 56
Hokusai. "Two Fishing Barks on a Swelling Sea Opposite the Choshi Coast, in the Province of Shimosa." Collection Huguette Berès, Paris 56
Utamaro. "Flower Festival at Yoshiwara" (detail). Former Atheneum Collection, Hartford, Connecticut . 56
Leonardo da Vinci. "Man According to Vitruvius' Proportions," Academia di Belle Arti, Venice 57
Henri Matisse. "Les Capucines." The Museum of Modern Art, Moscow © SPADEM 57
James Abbott McNeill Whistler. "Caprice in Purple and Gold No, 2: The Golden Screen." Freer Gallery of Art, Washington, D.C. 58
James Abbott McNeill Whistler. "Nocturne in Blue and Gold: Old Battersea Bridge." Tate Gallery, London . 59
Claude Monet. "The Customhouse Officer's Cabin at Varengeville." Boymans van Beuningen Museum, Rotterdam. © SPADEM 60
Claude Monet. "The Customhouse Officer's Cabin." Private Collection, Zurich. © SPADEM 61
Claude Monet. "Cliff Near Dieppe." Kunsthaus, Zurich. © SPADEM 61
Edgar Degas. "At the Theatre." Collection Durand-Ruel, Paris. © SPADEM 62
Edgar Degas. "Miss Lola at the Fernando Circus." Courtauld Collection, National Gallery, London. © SPADEM . 63
Edgar Degas. "At the Café des Ambassadeurs." Musée des Beaux-Arts, Lyons. © SPADEM 64
Henri de Toulouse-Lautrec. "En cabinet particulier." Courtauld Institute, London 64
Edgar Degas. "Singer with a Glove." Fogg Art Museum, Cambridge, Massachusetts 64
Edgar Degas. "At the Milliner's." National Gallery of Art, Washington, D.C.© SPADEM 66
Edgar Degas. "Portrait of Madame Jeantaud." Jeu de Paume Museum, Paris. © SPADEM 67
Edgar Degas. "Ballet Dancers at the Old Opera House." National Gallery of Art, Washington, D.C. © SPADEM . 68
Vincent van Gogh. "Montmartre." The Art Institute of Chicago . 69
Edgar Degas. "Reclining Nude." Galerie Beyeler, Basle. © SPADEM 70
Edgar Degas. "The Morning Bath." The Art Institute of Chicago. © SPADEM 72
Vincent van Gogh. "Still Life with Plaster Cast." Kröller-Müller Museum, Otterlo 73
Pierre-Auguste Renoir. "Madame Monet and Her Son in Their Garden at Argenteuil." National Gallery of Art, Washington, D.C. © SPADEM 74
Henri de Toulouse-Lautrec. "La Toilette." Jeu de Paume Museum, Paris 75
Edgar Degas. "Two Bathers on the Grass." Jeu de Paume Museum, Paris.© SPADEM 75
Edouard Vuillard. "The Game of Checkers at Amfreville." Hahnloser Collection, Berne. © SPADEM . . 76
Gustave Caillebotte. "Rue Halévy." Private Collection, Paris . 77
Claude Monet. "Les Galettes." Collection Durand-Ruel, Paris. © SPADEM 78
Paul Gauguin. "Flowers and a Bowl of Fruit." The Boston Museum of Fine Arts 79
Paul Gauguin. "Fête Gloanec." Musée des Beaux-Arts, Collection Maurice Denis, Orléans 79
Edgar Degas. "The Tub." Jeu de Paume Museum, Paris. © SPADEM 80
Edgar Degas. "Ballet Dancers Climbing a Flight of Stairs." Jeu de Paume Museum, Paris. © SPADEM . . 81
Claude Monet. "Boating on the Epte." Art Museum, São Paulo. © SPADEM 82
Claude Monet. "The Blue Bark." Collection Thyssen-Bornemisza, Lugano. © SPADEM 83
Pierre Bonnard. "The Cup of Coffee." Tate Gallery, London. © SPADEM and © ADAGP 84
Vincent van Gogh. "Still Life. Drawing Board with Onions."Kröller-Müller Museum, Otterlo 85
Félix Vallotton. "Third Gallery of the Théeâtre du Châtelet." Musée national d'Art moderne, Paris. © SPADEM . 86
Giacomo Balla. "The Staircase of Good-byes." Collection Mrs. Barnett Malbin, Lydia and Harry Winston, Birmingham, Michigan 87

Chapter II
Objects and Environment Interpenetrate

Diego Valásquez. "The Infanta Margarita." Louvre, Paris . 90
Antoine Watteau. "Pilgrimage to the Isle of Cythera" (detail). Louvre, Paris 90
Alfred Sisley "Promenade." Musée Masséna, Nice . 90
Jan Vermeer. "View of Delft." Mauritshuis, The Hague . 91
Alfred Sisley. "The Road to Louveciennes" (detail). Jeu de Paume Museum, Paris 91
Ernest Meissonier. "Banks of the Seine at Poissy." Louvre, Paris . 91
Frans Hals. "Portrait of the Minister Langelius." Musée des Beaux-Arts, Amiens 92
Paul Cézanne. "Portrait of Vallier." Collection Mr. and Mrs. Leigh B. Block, Chicago 92
El Greco. "The Vision of Saint John." The Metropolitan Museum of Art, New York 92
Claude Monet. "View of London at Night." Galerie Beyeler, Basle. © SPADEM 93
Jésus Rafaël Soto. "Pénétrable." Musée de la Ville de Paris . 93
Jackson Pollock. "Convergence, from the 'New Poetry' by Alvarez." Albright-Knox Art Gallery, Buffalo . 93
Jean-Baptiste Carpeaux. "Descent from the Cross." Louvre, Paris . 93
Claude Monet. "Regatta at Argenteuil." Jeu de Paume Museum, Paris. © SPADEM 94
Claude Monet. "Regatta at Argenteuil" (detail). © SPADEM . 94
Claude Monet. "Impression, Sunrise." Musée Marmottan, Paris. © SPADEM 95
Claude Monet. "La Grenouillière." The Metropolitan Museum of Art. © SPADEM 95
Claude Monet. "A Field of Poppies." Jeu de Paume Museum, Paris. © SPADEM 96
Pierre-Auguste Renoir. "Road Through High Grass." Jeu de Paume Museum, Paris © SPADEM 96
Claude Monet. "A Field of Poppies" (detail.) © SPADEM . 97
Edouard Manet. "Claude Monet in His Studio Boat." Neue Pinakothek, Munich 98
Edouard Manet. "Claude Monet in His Studio Boat." Staatsgalerie, Stuttgart 99
Pierre-Auguste Renoir. "La Promenade." Frick Collection, New York. © SPADEM 100
Pierre-Auguste Renoir. "A Girl with a Watering Can." National Gallery of Art, Washington, D.C. . . 100
Pierre-Auguste Renoir. "Her First Evening Out." Tate Gallery, London. © SPADEM 101
Pierre-Auguste Renoir. "The Arbor." Pushkin Museum, Moscow © SPADEM 102
Pierre-Auguste Renoir. "Le Moulin de la Galette." Jeu de Paume Museum, Paris © SPADEM 103
Pierre-Auguste Renoir. "The Swing." Jeu de Paume Museum, Paris. © SPADEM 103
Claude Monet. "Turkeys." Jeu de Paume Museum, Paris.© SPADEM 104
Claude Monet. "Turkeys." Detail. © SPADEM . . . 104
Claude Monet. "Turkeys." Detail. © SPADEM . . . 105
Claude Monet. "La Gare Saint-Lazare." Fogg Art Museum, Cambridge, Massachusetts. © SPADEM . . 106
Claude Monet. "La Gare Saint-Lazare." Collection Mr. and Mrs. Peralta-Ramos, New York. © SPADEM 106
Claude Monet. "Le Pont de l'Europe. La Gare Saint-Lazare." Musée Marmottan, Paris. © SPADEM 106
Claude Monet. "La Gare Saint-Lazare," Collection Mr. and Mrs. Peralta-Ramos, New York. © SPADEM 107
Claude Monet. "La Gare Saint-Lazare." Jeu de Paume Museum, Paris. © SPADEM 107
Edouard Manet. "Lady Dressed in a Riding Habit." Collection J. Koerfer, Berne 108
Edouard Manet. "Lady Dressed in a Riding Habit." Detail . 108
Edouard Manet. "Self-Portrait with a Palette." Private Collection, New York 109
Pierre-Auguste Renoir. "The Luncheon of the Boating Party." Detail. Phillips Collection, Washington, D.C. © SPADEM . 110
Pierre-Auguste Renoir. "Dance at Bougival." The Boston Museum of Fine Arts. © SPADEM 110
Pierre-Auguste Renoir. "The Luncheon of the Boating Party." Phillips Memorial Gallery, Washington, D.C. © SPADEM . 111
Paul Cézanne. "Standing Nude." Private Collection, Paris . 112

Paul Cézanne. "Luncheon on the Grass." Collection Walter-Guillaume, Paris 112
Paul Cézanne. "Luncheon on the Grass." (detail) 113
Paul Cézanne. "Three Bathers." Musée du Petit Palais, Paris . 114
Paul Cézanne. "Five Bathers." Musée des Beaux-Arts, Basle . 115
Claude Monet. "Camille Monet on Her Deathbed." Jeu de Paume Museum, Paris. © SPADEM 116
Claude Monet. "Lady with a Parasol." Jeu de Paume Museum, Paris. © SPADEM 117
Claude Monet. "The Garden at Giverny." Collection Durand-Ruel, Paris. © SPADEM 118
Claude Monet. "Alice Hoschedé in the Garden." Private Collection, New York. © SPADEM 119
Camille ·Pissarro. "Boulevard Montmartre, Night Effect." National Gallery, London 120
Pierre-Auguste Renoir. "Les Grands Boulevards." Private Collection, Philadelphia. © SPADEM 121
Claude Monet. "Boulevard des Capucines." Pushkin Museum, Moscow. © SPADEM 121
Pierre-Auguste Renoir. "Bather." Sterling and Francine Clark Institute, Williamstown, Massachusetts. © SPADEM . 122
Pierre-Auguste Renoir. "Girl Combing Her Hair." Sterling and Francine Clark Institute, Williamstown, Massachusetts. © SPADEM 122
Pierre-Auguste Renoir. "Blond Bather." Kunsthistorisches Museum, Vienna. © SPADEM 123
Pierre-Auguste Renoir. "Nude with a Hat." Galerie Beyeler, Basle. © SPADEM 124
Pierre-Auguste Renoir. "Ode to Flowers." Jeu de Paume Museum, Paris. © SPADEM 124
Pierre-Auguste Renoir. "Sleeping Bather." Collection Oskar Reinhart am Römerholz, Winterthur. © SPADEM . 124
Pierre-Auguste Renoir. "Bather Seated on a Rock." Collection Durand-Ruel, Paris. © SPADEM 124
Pierre-Augustine Renoir. "Bather Seated on a Rock." Detail. © SPADEM 125
Vincent van Gogh. "Self-Portrait." Kunsthistorisches Museum, Vienna 126
Vincent van Gogh. "Self-Portrait." National Gallery, Oslo . 127
Vincent van Gogh. "The Park of the Insane Asylum, St.-Rémy." Folkwang Museum, Essen 128
Vincent van Gogh. "Olive Groves at St.-Rémy." Kröller-Müller Museum, Otterlo 129
Vincent van Gogh. "Dr. Gachet's Garden." Jeu de Paume Museum, Paris 129
Vincent van Gogh. "Starry Night." Museum of Modern Art, New York (Lillie P. Bliss Bequest) 131
Vincent van Gogh. "Road at Auvers." City Art Museum, St. Louis, Missouri 132
Vincent van Gogh. "The Ravine." The Boston Museum of Fine Arts 132
Vincent van Gogh. "Two Children." Private Collection, Paris . 133
Claude Monet. "Haystack in Winter." The Boston Museum of Fine Arts. © SPADEM 134
Claude Monet. "Haystack." Kunsthaus, Zurich. © SPADEM . 134
Claude Monet. "Haystacks at Sunset." The Art Institute of Chicago. © SPADEM 135
Claude Monet. "Haystacks at Sunset, near Giverny.", The Boston Museum of Fine Arts. © SPADEM . . . 135
Claude Monet. "Rouen Cathedral. The Portal, Morning Sunshine. Harmony in Blue." Jeu de Paume Museum, Paris. © SPADEM 136
Claude Monet. "Rouen Cathedral. The Portal and the Albane Tower, Full Sunlight. Harmony in Blue and Gold." Jeu de Paume Museum, Paris. © SPADEM . 136
Claude Monet. "Rouen Cathedral, Sunset." The Boston Museum of Fine Arts. © SPADEM 137
Claude Monet. "Rouen Cathedral. The Portal in Bleak Weather." Jeu de Paume Museum, Paris. © SPADEM . 137
Claude Monet. "Rouen Cathedral. The Portal and the Albane Tower. Morning Effect. Harmony in White." Jeu de Paume Museum, Paris. © SPADEM . 137
Claude Monet. "The Houses of Parliament. Effect of Sunlight in the Fog." Collection Durand-Ruel, Paris. © SPADEM 138
Claude Monet. "The Doges' Palace Seen from San Giorgio." Collection Durand-Ruel, Paris. © SPADEM 139
Claude Monet. "Yellow Nirvana." Folkwang Museum, Essen. © SPADEM 140
Claude Monet. "The Japanese Footbridge." Collec-

tion Walter Bareiss, Munich. © SPADEM140
Claude Monet. "Water Lilies. The Two Weeping Willows. Morning." Left section (detail), Jeu de Paume Museum, Paris. © SPADEM141
Claude Monet. "Water Lilies, Sunset." Detail. Jeu de Paume Museum, Paris. © SPADEM141
Claude Monet. "Water Lilies, Sunset." Detail. Jeu de Paume Museum, Paris. © SPADEM142

Chapter III
Color Acquires Its Independence

Gustave Courbet. "Still Life." Collection Emery Reves, Paris146
Georges Vantongerloo. "Composition with Light Refraction." Private Collection, Zurich146
Claude Monet. "Terrace at St.-Andresse." Detail. The Metropolitan Museum of Art, New York146
Paul Gauguin. "Riders on the Beach." Folkwang Museum, Essen147
Odilon Redon. "Vase of Flowers." Jeu de Paume Museum, Paris. © SPADEM147
Maurice Denis. "Sun Spots on the Terrace." Private Collection, St.-Germain-en-Laye. © SPADEM148
Jean Delville. "Orpheus." Collection Madame Anne-Marie Gillion-Crowet, Brussels148
Kees Van Dongen. "Liverpool Nightclub." Private Collection, Geneva. © SPADEM148
Henri Matisse. "The Black Door." Contemporary Art Establishment, Zurich. © SPADEM148
Vincent van Gogh. "Self-Portrait." Jeu de Paume Museum, Paris149
Fernand Léger. "The Tugboat Bridge." Musée national d'Art moderne. © SPADEM149
Maurice de Vlaminck. "Portrait of Derain." Private Collection, Paris. © SPADEM149
Robert Delaunay. "Circular Forms, Sun No. 2." Musée national d'Art moderne, Paris149
Edouard Manet. "Lola de Valence." Detail150
Edouard Manet. "Lola de Valence." Jeu de Paume Museum, Paris150
Edouard Manet. "Lola de Valence." Detail151
Claude Monet. "Jean Monet on His Wooden Horse." Collection Mr. Nathan Cummings, New York. © SPADEM152
Claude Monet. "Luncheon on the Grass." Detail. Jeu de Paume Museum, Paris. © SPADEM153
Vincent van Gogh. "Fourteenth of July in Paris." Collection Jaggli Hahnloser, Winterthur154
Claude Monet. "Rue Montorgueil". Musée des Beaux-Arts, Rouen. © SPADEM155
Vincent van Gogh. "Une Italienne (La Segatori)." Jeu de Paume Museum, Paris156
Vincent van Gogh. "Une Italienne (La Segatori)." Detail157
Vincent van Gogh. "Self-Portrait with Shaven Head." Fogg Art Museum, Collection Maurice Wertheim, Cambridge, Massachusetts
Emile Bernard. "Self-Portrait Dedicated to Van Gogh." Stedelijk Museum, Amsterdam. © SPADEM . .159
Paul Gauguin. "Self-Portrait. Les Misérables." Stedelijk Museum, Amsterdam159
Emile Bernard. "Breton Women in the Meadow." Formerly Maurice Denis Collection. © SPADEM160
Paul Gauguin. "The Vision After the Sermon (Jacob Wrestling with the Angel)." National Gallery of Scotland, Edinburgh161
Emile Bernard. "Black Wheat." Collection Monsieur and Madame Josefowitz, Lausanne. © SPADEM162
Paul Gauguin. "Bonjour, Monsieur Gauguin." National Gallery, Prague164
Paul Gauguin. "Bonjour, Monsieur Gauguin." Detail165
Paul Gauguin. "The Yellow Christ." Albright-Knox Art Gallery, Buffalo166
Paul Gauguin. "The Green Christ." Musée des Beaux-Arts, Brussels167
Paul Gauguin. "Christ on the Mount of Olives." Norton Gallery and School of Art, West Palm Beach, Florida168
Paul Gauguin. "Symbolist Self-Portrait with Halo." National Gallery of Art, Chester Dale Collection, Washington, D.C.170
Paul Gauguin. "Man with Ax." Collection Mr. and Mrs. Alexander Lewyt, New York170

Paul Gauguin. "Fatata te Miti (On the Beach)." National Gallery of Art, Chester Dale Collection, Washington, D.C.171
James Abbott McNeill Whistler. "Symphony in White. No. 2: The Little White Girl." Tate Gallery, London172
Paul Gauguin. "Girl Holding a Fan." Folkwang Museum, Essen173
Pierre-Auguste Renoir. "Lise with a Parasol." Folkwang Museum, Essen. © SPADEM173
Edouard Manet. "Nana." Kunsthalle, Hamburg . .173
Edgar Degas. "La Toilette." National Gallery, Oslo. © SPADEM174
Edgar Degas. "After the Bath. Woman Drying Herself." Private Collection, Zurich. © SPADEM175
Paul Gauguin. "The Lovers." National Gallery, Prague176
Paul Gauguin. "Still Life with Ham." Phillips Memorial Gallery, Washington, D.C.177
Paul Gauguin. "Eh quoi, es-tu jalouse?" Pushkin Museum, Moscow178
Paul Gauguin. "Annah la Javanaise." Hahnloser Collection, Berne179
Henri de Toulouse-Lautrec. "Admiral Viaud." Museum of Fine Arts, São Paulo180
Henri de Toulouse-Lautrec. "Messalina." The Los Angeles County Museum of Art181
Pierre Bonnard. "Studio with Mimosa." Private Collection, Paris. © SPADEM and © ADAGP182
Pierre Bonnard. "Nude in a Bathtub." Carnegie Institute, Pittsburgh, Pennsylvania. © SPADEM and © ADAGP182
Pierre Bonnard. "Woman with a Striped Tablecloth." Private Collection, Paris. © SPADEM and © ADAGP . .183
Pierre Bonnard. "The Bay of St.-Tropez." Musée Toulouse-Lautrec, Albi. © SPADEM and © ADAGP . .184

Chapter IV

The Work Is ... a Section of Nature Which Extends Beyond the Setting

Two illustrations from "La Perspective Practique" by Jean Dubreuil, 1642188
Edgar Degas. "Viscount Lepic and His Daughters." Bührle Collection, Zurich. © SPADEM189
Edouard Manet. "Path in the Rueil Gardens." Kunsthaus, Berne189
Claude Monet. "Torrent of the Little Creuse at Fresselines." Private Collection, New York. © SPADEM190
Jan van Goyen. "The Oak Struck by Lightning." Musée des Beaux-Arts, Bordeaux190
Claude Monet, "The Rock." Collection H. M. Queen Elizabeth, the Queen Mother. © SPADEM190
Raoul Dufy. "Acrobats on a Circus Horse." Musée national d'Art moderne, Paris. © SPADEM190
Claude Monet. "The Garden of Iris at Giverny." Private Collection, New York. © SPADEM191
Jan Vermeer. "The Music Lesson." The Royal Art Collection, Windsor Castle191
Francisco Goya. "Una Manola (Dõna Leocadia Zorilla de Weiss)." Prado, Madrid191
Vincent van Gogh. "Tree in Blossom." Stedelijk Museum, Amsterdam191
Edouard Manet. "Departure of the Folkstone Steamer." Philadelphia Museum of Art (Mr. and Mrs. Carroll S. Tyson Collection)192
Edouard Manet. "The Grand Canal in Venice." Private Collection, San Francisco192
Claude Monet. "The Artist's Garden at Vétheuil." National Gallery of Art, Washington, D.C.194
Claude Monet. "Corner of an Apartment." Jeu de Paume Museum. © SPADEM195
Claude Monet. "Etretat." The Metropolitan Museum of Art, New York. © SPADEM196
Claude Monet. "The Hollow Needle at Etretat." Private Collection, Paris. © SPADEM197
Claude Monet. "High Sea at Etretat." Jeu de Paume Museum, Paris. © SPADEM197
Claude Monet. "Cliff at Etretat." Musée des Beaux-Arts, Lyons. © SPADEM197
Edouard Manet. "La Serveuse de bocks." Jeu de Paume Museum, Paris198
Edouard Vuillard. "Café in the Bois de Boulogne." Formerly Maurice Denis Collection, Paris. © SPADEM 199

Edouard Manet. "At the Café". Collection Oskar Reinhart am Römerholz, Winterthur199
Claude Monet. "Rocks of Belle-Ile." Pushkin Museum, Moscow. © SPADEM200
Edouard Manet. "Rochefort's Escape." Kunsthaus, Zurich201
Vincent van Gogh. "Sunflowers." Kröller-Müller Museum, Otterlo202
Edgar Degas. "After the Bath." Phillips Memorial Gallery, Washington, D.C. © SPADEM204
Edgar Degas. "The Letter." Galerie Beyeler, Basle. © SPADEM204
Edgar Degas. "Woman Drying Herself." Collection James Archdale. © SPADEM205
Edgar Degas. "Before the Mirror." Kunsthalle, Hamburg. © SPADEM206
Edgar Degas. "Woman Combing Her Hair." Jeu de Paume Museum, Paris. © SPADEM207
Vincent van Gogh. "Forest Interior." The Cincinnati Art Museum (Mary E. Johnston Collection)209
Vincent van Gogh. "Grass in a Park." Kröller-Müller Museum, Otterlo210
John Constable. "Study of a Tree and Trunk." Victoria and Albert Museum, London211
Pablo Picasso. "The Burial of Casagemas." Musée national d'Art moderne, Paris. © SPADEM212
Paul Gauguin. "Where do we come from? Who are we? Where are we going?" The Boston Museum of Fine Arts212
Paul Gauguin. "La Belle Angèle." Jeu de Paume Museum, Paris213
Edgar Degas. "Two Ballet Dancers." Gemäldegalerie, Dresden. © SPADEM214
Edgar Degas. "Ballet Dancers." Collection Durand-Ruel, Paris. © SPADEM214
Edgar Degas. "Dancers in Blue." Pushkin Museum, Moscow. © SPADEM215
Edouard Manet. "Bar at the Folies-Bergère." Courtauld Institute, London216
Pierre Bonnard. "Torso of a Nude Woman Before a Mirror." Collection Bernheim-Jeune, Paris. © SPADEM and © ADAGP216
Pierre Bonnard. "The Dressing Room Mirror." Pushkin Museum, Moscow. © SPADEM and © ADAGP217
Edouard Vuillard. "The Little Delivery Boy in a Black Blouse." Private Collection, Geneva. © SPADEM . . .218
Edouard Vuillard. "Vase of Flowers on a Mantlepiece." National Gallery of Art, Washington, D.C. © SPADEM218
Pierre Bonnard. "Interior." Private Collection, Switzerland. © SPADEM and © ADAGP219

Chapter V

The Painter Minimizes Perspective ...

Johannès Hackaert. "L'Allée de frênes." Musée du Petit Palais, Paris222
Robert Delaunay. "The City of Paris." Musée national d'Art moderne. © ADAGP222
James Ensor. "Still Life in the Studio." Neue Pinakothek, Munich223
Jan Toorop. "Return to Oneself." Kröller-Müller Museum, Otterlo223
Charles Filiger. "Chromatic Notation." Collection Bateau-lavoir, Paris223
Gustav Klimt. "Death and Life." Collection Frau Preleuthner, Vienna223
Paul Cézanne. "The Orgy." Private Collection, Paris224
Kung Hsien. "Swamp." Cleveland Museum of Art, Andrew and Martha Holden Jennings Fund224
Camille Pissarro. "Landscape." © ADAGP224
Piet Mondrian. "Dune IV." Gemeentemuseum, The Hague225
Henri Matisse. "Red Interior." Private Collection, France. © SPADEM225
Piet Mondrian. "Composition in Blue." Kröller-Müller Museum, Otterlo225
Hokusai. "Fujiyama Seen in Fine Weather." Collection Huguette Berès, Paris225
Edouard Manet. "The Execution of the Emperor Maximilian." The Boston Museum of Fine Arts . . .226
Edouard Manet. "The Execution of the Emperor Maximilian," Kunsthalle, Mannheim226

Edouard Manet. "The Explosion." Folkwang Museum, Essen 227
Edouard Manet. "Races at Longchamp." Study. National Gallery of Art, Washington, D.C. (Widener Collection) 228
Edouard Manet. "Races at Longchamp." The Art Institute of Chicago 229
Paul Cézanne. "The Eternal Female." Private Collection, New York 230
Claude Monet. "The Banks of the Seine (Spring Through the Branches)." Musée Marmottan, Paris. © SPADEM 232
Alfred Sisley. "Path on the Rocks." Collection Durand-Ruel, Paris 233
Camille Pissarro. "La Côte des Boeufs à Pontoise." National Gallery, London 233
Camille Pissarro. "Banks of the Oise, near Pontoise, Drab Weather." Jeu de Paume Museum, Paris . 233
Paul Cézanne. "Self-Portrait." Jeu de Paume Museum, Paris 234
Paul Cézanne. "Self-Portrait." Jeu de Paume Museum, London 234
Paul Cézanne. "Self-Portrait with a Hat." Musée des Beaux-Arts, Berne 235
Paul Cézanne. "The Old Gardener." Emil Georg Bührle Foundation, Zurich 236
Paul Cézanne. "Portrait of Victor Chocquet." The Columbus Gallery of Fine Arts 237
Paul Gauguin. "Women in a Garden, Arles." The Art Institute of Chicago 238
Vincent van Gogh. "The Alyscamps." Kröller-Müller Museum, Otterlo 239
Vincent van Gogh. "Promenade at Arles." The Hermitage, Leningrad 239
Paul Cézanne. "Portrait of Paul Cézanne, the Artist's Son." Chester Dale Collection, Washington, D.C. . 240
Paul Cézanne. "Madame Cézanne in a Red Armchair." The Boston Museum of Fine Arts 241
Vincent van Gogh. "A Zouave." Van Gogh Collection, Laren 242
Vincent van Gogh. "The Zouave." Collection Albert Lasker, New York 243
Vincent van Gogh. "The Chair and the Pipe." Tate Gallery, London 243
Gustave Caillebotte. "The Balcony." Private Collection, Paris 244
Paul Gauguin. "Still Life with Three Puppies." The Museum of Modern Art, New York 245
Paul Sérusier. "Landscape of the Bois d'Amour (the Talisman)." Collection Maurice Denis, Paris . . 246
Paul Gauguin. "Above the Chasm." Musée des Arts décoratifs, Paris 247
Pierre Bonnard. "The Garden." Musée du Petit Palais © SPADEM and © ADAGP 247
Vincent van Gogh. "Enclosed Meadow." Kröller-Müller Museum, Otterlo 249
Vincent van Gogh. "The St.-Paul Hospital." Private Collection, Los Angeles 250
Paul Cézanne. "The Twisted Tree." Stoll Collection, Switzerland 251
Vincent van Gogh. "Park of the St.-Paul Hospital." Private Collection, Lausanne 251
Paul Gauguin. "Ondine (Woman in the Waves)." Collection Mr. and Mrs. W. Powell Jones, Gates Mills, Ohio 252
Aristide Maillol. "The Wave." Musée du Petit Palais, Paris. © SPADEM 253
Claude Monet. "Poplars on the Banks of the Epte." Private Collection, New York 254
Claude Monet. "Poplars on the Banks of the Epte." Tate Gallery, London. © SPADEM 254
Claude Monet. "Poplars." The Metropolitan Museum of Art, New York. © SPADEM 255
Pierre Bonnard. "The Three Ages." Private Collection, Paris. © SPADEM and © ADAGP 256
Edouard Vuillard. "The Striped Blouse." Private Collection, New York. © SPADEM 257
Paul Cézanne. "Apples and Biscuits." Walter Collection, Paris 258
Paul Cézanne. "Fruit Dish, Glass, and Apples." Private Collection, Paris 259
Paul Cézanne. "Apples and Oranges." Jeu de Paume Museum, Paris 259
Paul Cézanne. "Fruit Dish and Apples." Collection Oskar Reinhart am Römerholz, Winterthur 259
Paul Cézanne. "Still Life with Flowered Curtain." Galerie Bernheim, Paris 261
Edouard Vuillard. "At the Champs-Elysées." Private Collection, Paris. © SPADEM 262

Edouard Vuillard. "Child Wearing a Red Scarf." National Gallery of Art, Washington, D.C. © SPADEM 263
Gustav Klimt. "The Park." The Metropolitan Museum of Art, New York 264
Edouard Vuillard. "Vaquez Decoration." Left panel: "Woman Reading." Musée du Petit Palais. © SPADEM 265
Paul Cézanne. "Le Château Noir." The Museum of Modern Art, New York 266
Paul Cézanne. "Lake Annecy." Courtauld Institute, London 267
Paul Cézanne. "Mont Ste.-Victoire." Musée des Beaux-Arts, Basle 268
Paul Cézanne. "Mont Ste.-Victoire." Kunsthaus, Zurich 268
Paul Cézanne. "Mont Ste.-Victoire." Detail. Kunsthaus, Zurich 269

Chapter VI

The Artist Solicits the Spectator's Optic Nerve

Victor Vasarely. "Majus M.C." Galerie Denis René, Paris 272
Charles Angrand. "Norman Courtyard." Collection Pierre Angrand, Paris. © ADAGP 273
Robert Delaunay. "Landscape with a Disk." Musée national d'Art moderne. © ADAGP 273
Piet Mondrian. "Windmill in the Sunshine." Gemeentemuseum, The Hague 273
Henri Matisse. "Luxe, calme, et volupté." Collection Ginette Signac, Paris. © SPADEM 274
André Derain. "Big Ben." Collection Pierre Lévy, France. © ADAGP 274
Kees Van Dongen. "The Moulin de la Galette." Collection G. Fodor, Paris 274
Paul Signac. "The Dining Room." Sketch, detail. Private Collection, Paris. © SPADEM 275
Giacomo Balla. "Young Girl Running on a Balcony." Galleria d'Arte Moderna, Milan 275
Giacomo Balla. "Iridescent Compenetration." Collection Lydia and Harry L. Winston 275
Georges Seurat. "Boys Bathing." Study for "Une Baignade." Private Collection, Paris 276
Georges Seurat. "Horse and Boat." Study for "Une Baignade." Private Collection, Paris 276
Georges Seurat. "Five Male Figures." Study for "Une Baignade." Private Collection, Paris 276
Georges Seurat. "Five Male Figures." Study for "Une Baignade." Collection Pierre Berès, Paris 277
Georges Seurat. "Une Baignade" also known as "Bathing at Asnières." National Gallery, London . . 278
Georges Seurat. "Une Baignade" also known as "Bathing at Asnières." Detail 279
Georges Seurat. "Sunday Afternoon on the Island of La Grande Jatte." Sketch. Jeu de Paume Museum, Paris 280
Georges Seurat. "Sunday Afternoon on the Island of La Grande Jatte." The Art Institute of Chicago . . 281
Georges Seurat. "Study for La Grande Jatte." National Gallery of Art, Washington, D.C. 281
Georges Seurat. "Le Bec du Hoc, Grandcamp." Tate Gallery, London 282
Georges Seurat. "Woman Powdering Herself." Courtauld Institute, London 283
Henry van de Velde. "Blankenberghe." Kunsthaus, Zurich 285
Georges Seurat. "Model in Profile." Detail 286
Georges Seurat. "Model in Profile." Jeu de Paume Museum, Paris 287
Georges Seurat. "Model from Back." Jeu de Paume Museum, Paris 287
Paul Signac. "Woman Dressing, Purple Corset." Collection Ginette Signac, Paris. © SPADEM 288
Henri-Edmond Cross. "Woman Combing Her Hair." Musée national d'Art moderne, Paris. © SPADEM . 289
Paul Signac. "Cape Lombard, Cassis." Gemeentemuseum, The Hague. © SPADEM 290
Paul Signac. "Portrieux Roadstead." Private Collection, United States. © SPADEM 290
Georges Seurat. "The Beach at Le Bas-Butin, Honfleur." Musée des Beaux-Arts, Tournai 291
Georges Seurat. "Entrance of the Outer Port, Porten-Bessin." The Museum of Modern Art, New York 291

Théo van Rysselberghe. "Heavy Clouds, Christiana Fjord." Mr. and Mrs. Halliday Collection, Indianapolis 291
Paul Signac. "Breeze at Concarneau." Private Collection, London. © SPADEM 292
Henri-Edmond Cross. "The Wave." Collection Ginette Signac, Paris. © SPADEM 293
Henri-Edmond Cross. "The Golden Islands." Musée national d'Art moderne, Paris. © SPADEM 294
Georges Seurat. "Study for Fort Samson, Grandcamp." Collection Madame Nora, Paris 295
Wassili Kandinsky. "Beach Cabins in Holland." Stadtische Galerie, Munich 295
Piet Mondrian. "Dune III." Gemeentemuseum, The Hague 295
Georges Seurat. "The Eiffel Tower." Collection Mr. and Mrs. Germain Seligman, New York 296
Louis Hayet. "Construction of the Eiffel Tower." Private Collection, New York 296
Louis Hayet. "Place de la Concorde." Private Collection, New York 296
Louis Hayet. "Doors." Private Collection, Paris . . . 297
Georges Seurat. "The Circus." Jeu de Paume Museum, Paris 298
Georges Seurat. "Le Chahut." Kröller-Müller Museum, Otterlo 299
Paul Signac. "Program for the Théâtre-Libre." The Boston Museum of Fine Arts. © SPADEM 300
Paul Signac. "Portrait of Félix Fénéon." Collection Samuel Josefowitz, Lausanne. © SPADEM 301

Prices

Edouard Manet. "The Promenade." Sotheby's . . . 304
Edouard Manet. "Veiled Woman, Berthe Morisot." Sotheby's 304
Edgar Degas. "Woman Ironing Against the Light." Sotheby's 305
Edgar Degas. "Ballet Dancers, Pink Skirts." Christie's . 305
Claude Monet. "The Port of Honfleur." Sotheby's . 306
Claude Monet. "The Banks of the Seine at Argenteuil." Christie's 306
Claude Monet. "Terrace at St.-Adresse." Christie's 306
Pierre-Auguste Renoir. "The Pont des Arts." Parke-Bernet Galleries, New York 307
Pierre-Auguste Renoir. "Girl in Profile." Galliera Auction 307
Alfred Sisley "Inundation, Road from St.-Germain." Sotheby's 307
Camille Pissarro. "Tuileries Garden, Spring Morning." Parke-Bernet Galleries, New York 307
Paul Cézanne. "Apples and Biscuits." Galerie Charpentier Auction 309
Paul Cézanne. "Thatched Cottage in the Trees." Parke-Bernet Galleries, New York 309
Paul Cézanne. "House and Tree." Sotheby's 309
Vincent van Gogh. "Factories at Clichy." Sotheby's 309
Vincent van Gogh. "Windmill at Montmartre." Sotheby's 309
Paul Gauguin. "Mau Taporo." Parke-Bernet Galleries . 310
Paul Gauguin. "Bonjour, Monsieur Gauguin." Christie's . 310
Paul Gauguin. "I Am Waiting for Your Reply." Sotheby's 311
Georges Seurat. "Fields in Summer." Christie's . . . 311
Georges Seurat. "Peasants at Montfermeil." Sotheby's 311
Georges Seurat. "Les Poseuses" (small version). Christie's . 311
Georges Seurat. "Figures in a Meadow." Sotheby's . 311

Bibliography

The two general works on Impressionism are John Rewald's *History of Impressionism* and *Post-Impressionism* with important notes and a very detailed bibliography. We shall limit ourselves here to listing a few books and catalogues which have recently been published or reissued and which are not included by Rewald.

The three basic works by Pierre Francastel:

Peinture et société, 1951. Out of print for fifteen years, republished in 1965 by Editions Gallimard in their collection *"Idées."*

La réalité figurative, which includes an important article on Impressionism. Gonthier, 1965.

Etudes et sociologie de l'art, which includes an article written in 1952 in which the author returns to and develops his *Peinture et société.* Denoël-Gonthier in their collection *"Médiations."*

Other works consulted.

The *Journal de l'impressionnisme* by Maria and Godfrey Blunden, rich in documents and detail on the painters' daily life. The authors have not forgotten to point out the interrelation of politics and culture. Skira, 1970.

Bonjour, Monsieur Courbet! by Maurice Choury. Editions sociales. 1969.

Tout l'oeuvre peint de Manet by Rouart and Orienti. Flammarion, 1970.

Manet by Anne Coffin Hanson. Catalogue of the Philadelphia Exhibition. 1966.

Mon salon, Manet by Emile Zola. Presented by Antoinette Ehrard, new publication of a series of famous texts. Garnier-Flammarion. 1970.

Drawings by Degas by Jean Sutherland Boggs. City Art Museum of St. Louis. 1966.

Cézanne et l'expression de l'espace by Liliane Brion-Guerry. New publication of an important study of the stages of Cézanne spatiality in its relationships with medieval, Renaissance, Chinese, and other solutions.

Gauguin by Françoise Cachin. Hachette, collection "Livre de poche," 1968.

Gauguin and the Pont-Aven Group by Denys Sutton. Catalogue of the Tate Gallery. 1966.

Gauguin 1961; *Toulouse-Lautrec,* 1962; *Cézanne,* 1966; *Van Gogh,* 1968, *Renoir,* 1970. Five richly illustrated collective works published by Hachette-Réalités.

Pierre Bonnard by Denys Sutton. Catalogue of the Royal Academy of Art, London. 1966.

Les Oeuvres plus que complètes by Félix Fénéon. The best presentation of Neo-Impressionism. With a very documented presentation by Joan Halperin. Two vols., Librairie Droz, Geneva. 1970.

Le néo-impressionnisme, collective work headed by Jean Sutter. The most complete to date with an important study by Robert Herbert on Seurat's theories. Ides et Calendes.

Neo-Impressionism by Robert Herbert. Catalogue of the huge exhibition organized at the Guggenheim Museum in 1968.

Paul Signac by Françoise Cachin with firsthand documents. Bibliothèque des Arts. 1971. See the same author's *D'Eugène Delacrooix au néo-impressionnisme,* introduction to the theoretical work of Paul Signac and her *Au-delà de l'impressionnisme,* a collection of texts by Félix Fénéon. Both are published by Editions Hermann.

Signac by Marie-Thérèse Lemoyne de Forges. One hundred and forty works analyzed in detail. Catalogue of the exhibition at the Musée du Louvre. 1970.

Maurice Denis by Anne Bayez. Catalogue of the Musée du Louvre. 1970.

The Artist and Social Reform, France and Belgium. 1885–1898 by Eugenia W. Herbert. A summation of the relationships of the artist and politics at the close of the nineteenth century. Yale University Press.

Naissance des artistes indépendants by Pierre Angrand. A lively chronicle on the origins of the Salon which, in 1884 and 1886, launched Seurat. Nouvelles Editions Debresse. 1965.

Impressionnistes et symbolistes devant la presse by Jacques Lethève. The for and against as seen through the newspapers. Armand Colin. 1959.

Il sacro et il profano nell'arte dei simbolisti. More than three hundred documents on European Symbolism in painting. Galleria civica d'Arte moderna, Turin. 1969.

Esthètes et magiciens by Philippe Jullian. The chronicle of the "Mauve Decade." Librairie académique Perrin. 1969.

Credits

The author and publisher wish to express their grateful appreciation to the following persons for their assistance:

Monsieur Jean Chatelain, Director of the Musées de France,

Monsieur André Parrot, Director of the Musée du Louvre,

Monsieur Michel Laclotte, Chief Curator of the Department of Paintings in the Musée du Louvre,

Monsieur Maurice Sérullaz, Chief Curator of the Cabinet des Dessins,

Madame Hélène Adhémar, Curator of the Musée du Jeu de Paume,

Monsieur Foucart, Curator of the Painting Documentation Service in the Musée du Louvre,

Mademoiselle Adeline Cacan, Curator of the Musée du Petit Palais,

Monsieur Jean Leymarie, Chief Curator of the Musée national d'Art moderne,

Madame Cécile Goldscheider, Curator of the Musée Rodin,

Monsieur Jacques Carlu, Curator of the Musée Marmottan,

Madame Dane, Curator of the Musée Galliera,

Monsieur Francois Mathey, Curator of the Musée des Arts décoratifs.

The curators of the Musée Gustave-Moreau, Paris; the Musée Toulouse-Lautrec, Albi; the Musée Eugène-Boudin, Honfleur; the Musée Masséna, Nice; and the curators of the Musée des Beaux-Arts of Amiens, Bordeaux, Orléans, Lyons, Rouen, and Tournai.

We wish to express our grateful appreciation also to Monsieur Daniel Wildenstein, member of the Institute de France, Monsieur Charles Durand-Ruel, and Monsieur Francois Daulte for their valuable advice.

We wish to express our grateful appreciation also to the curators of the following museums:

Austria. Kunsthistorisches Museum, Osterreichische Galerie, Vienna.

Belgium. Musée Royaux des Beaux-Arts, Brussels.

Brazil. Art Museum, São Paulo.

Canada. National Gallery, Ottawa.

Czechoslovakia. National Gallery, Prague.

Germany. Kunsthalle, Bremen; Gemaldegalerie, Dresden; Folkwang Museum, Essen; Kunsthalle, Hamburg; Kunsthalle, Mannheim; Neue Pinakothek, Munich; Staatsgalerie, Stuttgart.

Great Britain. The Museum and Art Gallery, Birmingham; The Fitzwilliam Museum, Cambridge; The Courtauld Institute, The National Gallery, The Tate Gallery, The Victoria and Albert Museum, Collection H.M. Queen Elizabeth, the Queen Mother, London.

The Netherlands. Stedelijk Museum, Amsterdam; Gemeentemuseum, The Mauritshuis, The Hague; The Kroller-Muller Museum, Otterlo; The Boymans van Beuningen Museum, Rotterdam.

Norway. The Munch Museum, The National Gallery, Oslo.

Portugal. The Calouste Gulbenkian Foundation, Lisbon.

Soviet Union. The Hermitage, Leningrad; The Museum of Modern Western Art, The Pushkin Museum, Moscow.

Spain. The Prado, Madrid.

Sweden. The National Museum, Stockholm.

Switzerland. Musée des Beaux-Arts, Galerie Beyeler, Basle; Musée des Beaux-Arts, Berne; Galerie Vallotton, Lausanne; Musée des Beaux-Arts, St.-Gall; Collection Oskar Reinhart am Romerholz, Winterthur; Kunsthaus, The Emil Georg Buhrle Foundation, Zurich.

United States. Museum of Art, Baltimore; Indiana University Art Museum, Bloomington; The Museum of Fine Arts, Boston; Albright-Knox Art Gallery, Buffalo; Fogg Art Museum, Cambridge; The Art Institute of Chicago; The Cincinnati Art Museum; The Cleveland Museum of Art; The Columbus Gallery of Fine Arts; The Denver Art Museum; The Kansas City Gallery of Art; The Los Angeles County Museum of Art; The Frick Collection, The Guggenheim Museum, The Metropolitan Museum of Art, The Museum of Modern Art, New York; The Philadelphia Museum of Art; The Pittsburgh Museum of Art; The City Art Museum of St. Louis; The Norton Gallery of Art, West Palm Beach; The National Gallery of Art, The Freer Gallery of Art, The Phillips Memorial Gallery, Washington, D.C.; The Sterling and Francine Clark Institute, Williamstown, Massachusetts.

We wish to express our gratitude to the collectors for authorizing us to reproduce paintings in their private collection, especially Monsieur Pierre Angrand, Paris; Herr Walter Bareiss, Munich; Monsieur Pierre Berès, Madame Huguette Berès, Paris; Mr. Nathan Cummings, New York; Monsieur Jean Dauberville, Paris; Monsieur Charles Durand-Ruel, Paris; Frau Maria Fisher, Baden-Baden; Monsieur Gabriel Fodor, Paris; Herr Hans Hahnloser, Berne; Mr. Holliday, Indianapolis; Herr Jaggli Hahnloser, Winterthur; Mr. and Mrs. Powell Jones, Gates Mills; Monsieur Jacques Koerfer, Berne; Mrs. Kramarsky, New York; Mrs. Albert Lasker, New York; Monsieur Pierre Lévy, France; Mr. and Mrs. Alexander Lewyt, New York; Mrs. Barnett Malbin, Birmingham; Madame Nora, Paris; Madame Jeanette Ostier, Paris; Mr. and Mrs. Peralta-Ramos, New York; Herr Oskar Reinhart, Winterthur; Monsieur Emery Reves, Paris; Mr. and Mrs. Germain Seligman, New York; Madame Ginette Signac, Paris; Madame Arthur Stoll, Arlesheim; Baroness Fiona Thyssen-Bornemisza, Lugano; Madame Walter Guillaume, Paris; Mrs. Johana Weckman, Helsinki,

and to the Galerie Wildenstein and the Galerie Denise René, Paris, and to the Galleria d'Arte Moderna, Milan.

List of Photographers

ANDERSON-GIRAUDON: 57
ARCHIVES PHOTOGRAPHIQUES: 54
BASNIER: 295
BÉRENGER: 90
BERNHEIM: 24 [4, 5], 25 [4]
BEVILLE: 177, 204
BIBLIOTHÈQUE DES ARTS: 61, 77, 181, 205, 218, 219,
230, 235, 242, 244, 254, 256, 257, 262
BIBLIOTHÈQUE NATIONALE: 14 [5], 20 [5]
BLAUEL: 98, 140, 214, 223, 226, 295
BONNEFOY: 75, 222
BOUDOT-LAMOTTE: 25 [3]
BULLOZ: 34, 222
CAILLER: 46
CHADEFAUX: 12 [3], 36, 42, 95, 273 [1]
CHEVOJON: 18 [3]
COLOTHÈQUE: 291
CONNAISSANCE DES ARTS: 56, 209
COOPER: 190
DANVERS: 190
DAZY RENÉ: 15 [1]
DEGAS EDGAR: 55 [2]
DEMACHY ROBERT: 55 [1]
DESJARDINS: 40, 93, 94
DRAYER: 189
DURAND-RUEL: 22 [3], 23 [1, 2, 3]
ÉDITIONS CERCLE D'ART: 217, 239
FREEMAN: 37
GIRAUDON: 22 [1], 25 [4], 55 [4], 64, 78, 90, 91, 117,
148, 160, 175, 176, 197, 292
GRALL: 63
GUILLEMOT: 51
GUILLOT: 44, 56, 225
HACHETTE: 16 [1, 2, 4], 17 [4, 5], 20 [2], 21 [4], 22
[2], 24 [2, 3], 25 [1, 2, 5], 29 [3, 4]
HINOUS: 149, 272
HINZ: 115
HOWALD: 76
JACKSON-LEGROS: 106, 107, 109, 158, 243
JOSSE: 191
KLEINHEMPEL: 173
KLIMA: 275
LAFFONT (ARCHIVES ÉDITIONS ROBERT): 12 [2, 4, 5], 13
[2, 3, 4]
LECOUVETTE: 55 [3], 188
MARTINOT: 296, 297
MEYER: 40, 41, 126
MILCH: 147, 173, 227
MILLET: 149
MILLS & SON: 121
MORAIN: 93
MORKEL: 82
NADAR: 54
NAHMIAS: 114
NELSON: 146
NOVOSTI (AGENCE DE PRESSE): 102, 121, 178, 200, 215
RÉUNION DES MUSÉES NATIONAUX: 43, 92, 156, 224, 259,
289, 294
REUTLINGER-HACHETTE: 20 [3]
ROGER-VIOLLET: 14 [1, 2, 3, 4], 15 [2, 3, 4]
SALMON: 28 [6]
SCHNAPP: 12 [1], 13 [1], 17 [2, 3], 18 [2, 4], 19 [4,
5], 24 [1]
SIROT: 18 [1, 5], 19 [1, 2, 3], 20 [1], 21 [3], 28 [2],
29 [1]
SNARK: 20 [3], 21 [1], 93
STUDIO ADRION: 149
VAERING: 127, 174
WEBB: 39, 57, 172, 225, 243, 254 [3], 282
WILDENSTEIN: 42, 47, 193, 290, 296
WILLI PETER: 32, 33, 34, 35, 43, 44, 45, 46, 49, 50,
51, 54, 62, 67, 75, 79, 80, 81, 84, 86, 90, 91, 96, 97,
103, 104, 106, 107, 112, 116, 118, 124, 129, 136, 137,
138, 139, 141, 142, 146, 149, 150, 153, 162, 164, 166,
182, 183, 184, 195, 197, 198, 199, 207, 212, 213, 214,
216, 225, 232, 233, 234, 245, 246, 253, 258, 259, 261,
265, 273 [2], 274 [1, 2], 277, 281, 286, 287, 288, 293,
299
WYATT: 192
ZIOLO: 179